ROME IS LOVE SPELLED BACKWARD

ROMA
ROME IS LOVE SPELLED BACKWARD
AMOR

ENJOYING

ART AND ARCHITECTURE

IN THE ETERNAL CITY

JUDITH TESTA

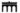

NORTHERN ILLINOIS
UNIVERSITY PRESS
DEKALB 1998

© 1998 by Northern Illinois University Press
Published by the Northern Illinois University Press,
DeKalb, Illinois 60115
Manufactured in the United States using acid-free paper
All Rights Reserved
Design by Julia Fauci

Full permission credit for the text illustrations
may be found on pages 273–75.

Map created by Terry Sheahan.

Paperback cover art: (front) Bernini, *Apollo and Daphne,*
Museum of the Villa Borghese —Alinari / Art
Resource, NY; (back) St. Peter's; (inside) Pantheon
—Alinari / Art Resource, NY.

Library of Congress Cataloging-in-Publication Data
Testa, Judith Anne, 1943–
Rome is love spelled backward : enjoying art and
architecture in the eternal city / Judith Anne Testa.
 p. cm.
Includes bibliographical references and index.
ISBN 0-87580-237-0 (acid-free paper)
ISBN 0-87580-576-0 (pbk.: acid-free paper)
1. Art, Italian—Italy—Rome. 2. Architecture—Italy—
Rome. 3. Rome (Italy)—Buildings, structures, etc.
I. Title.
N6920.T47 1998
709'.45'32—dc21 97-51755
 CIP

To the memory of Anna Santucci Testa and Emanuel E. Testa

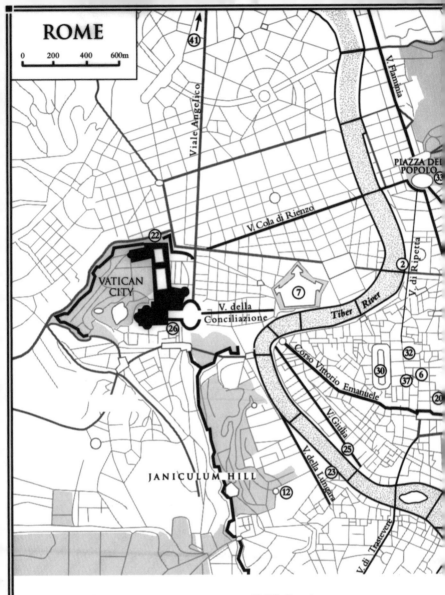

ROME

0 200 400 600m

V. Angelico

V. Flaminia

V. Cola di Rienzo

PIAZZA DEL POPOLO

VATICAN CITY

V. della Conciliazione

Tiber River

V. di Ripetta

JANICULUM HILL

Corso Vittorio Emanuele

V. Giulia

V. della Lungara

V. di Trastevere

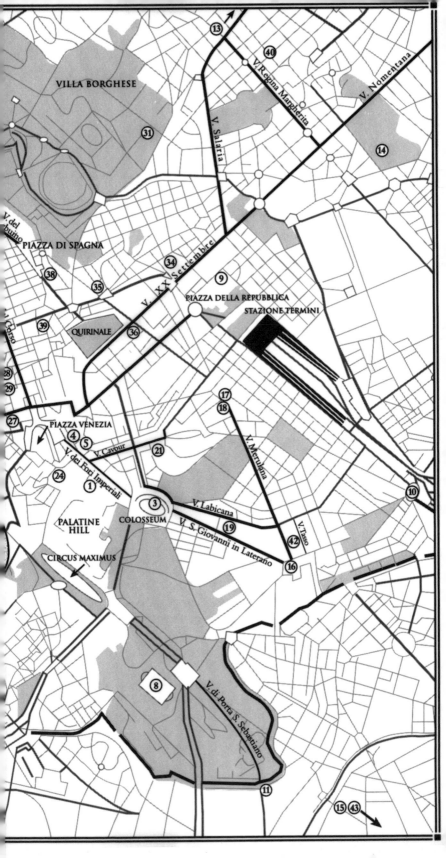

CONTENTS

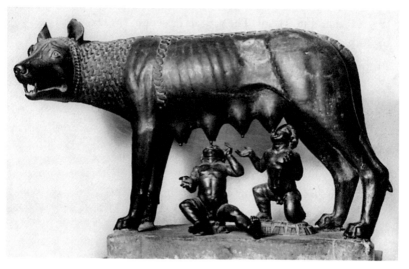

This bronze statue of a she-wolf nursing the twins Romulus and Remus, legendary founders of Rome, is not only a symbol of Rome's origins but also a vivid reminder of the Eternal City's many layers of history. Displayed on the Capitoline Hill for centuries by the ancient Romans, the fierce, watchful wolf may be a 2,500-year-old Etruscan original, but the babies were added in the Renaissance.

INTRODUCTION

Rome Is Love Spelled Backward

On my first visit to Rome, thirty years ago, I saw a poster with a curious logo at the top: ROMAMOR. At first it made no more sense to me than anything else in that great, sprawling, confusing, but marvelous city. Then it dawned on me that I was looking at a clever and, as I later found out, ancient play on words. The Latin name for Rome is *Roma* and the Latin word for love is *amor*. Rome, I realized, is *love* spelled backward.

The connection between Rome and love has always been strong for me. The moment I set foot in the Eternal City I fell in love with it and that love has lasted. As with those instant but enduring passions we sometimes experience for individuals, this was not a rational response, but one from the heart. My paternal grandparents came from the area around Rome, and my Italian grandmother grew up in a little town in the same Sabine Hills that produced the emperor Vespasian. Perhaps these family ties help to account for my feelings. Years later I found out from the *Oxford Classical Dictionary* that my family name has not changed a letter in two thousand years—a jurist named Gaius Trabatius Testa was a contemporary of Julius Caesar. No wonder I feel almost mystically at home in Rome.

The city gave me a bewildering and thrilling initiation. During the cab ride from the airport on my first trip in 1968 Rome seemed to wheel crazily around me, and throughout that stay I never quite succeeded in finding my bearings. Although I was constantly getting lost, that in itself was an adventure. A strange energy surged through me, a passion for the place which has never faded but only increased with each subsequent visit. Whenever I return to Rome, I experience that same anticipation, energy, and excitement. The familiar monuments do not just roll past but seem almost to reach out and embrace me. Hardly able to contain my pleasure at being there again, I feel as if I am returning not to a city but to the arms of a lover.

For me Rome has remained a difficult, complex, but endlessly fascinating lover whose charms are impossible to resist. There possibly are cities more beautiful than Rome and surely many that are simpler and easier to navigate, yet none has held my interest as Rome does. There is an Italian expression, *"Roma, non basta una vita,"* which means that even a lifetime is not long enough to understand and appreciate all the city has to offer.

I began this book as a result of my own experiences in Rome. The most important lesson I learned during my first, fumbling attempts to make sense of the city is that *what I did not understand I did not really see.* Some knowledge of the city's history, art, and architecture, as well as its topography, I realized, was the key to deepening my enjoyment. This is a case where knowledge means not power but pleasure. So I began to teach myself about Rome by reading about it and keeping a journal of my own observations during my stays. Thanks to my training as an art historian, I had a good basis for this kind of research. The result was a series of articles, combining personal observation with art historical data, which appeared in the Chicago area's Italian American community newspaper, *Fra Noi.* They are the core of the present book.

This volume is intended for the general reader with an interest in Rome. It is not a work of scholarship, although I have consulted many scholarly books. I have avoided long quotations, but on almost every page I am indebted to the research of others. In the course of more than thirty years of reading about Rome, I no doubt have absorbed phrases, perhaps even entire sentences, from the writings of others. I hope that this general statement will suffice as an acknowledgment of any inadvertent borrowings. Translations from Latin and Italian, unless otherwise noted, are my own.

In many cases I have included, along with hard facts, anecdotes about individuals and works of art which are impossible to authenticate—they may be true, or they may be legends. In a city as old and huge and complicated as Rome, separating facts from fictions is often difficult. This is true for events of both the distant past and more recent eras. Legends have gathered around Mussolini, for example, as surely as they have accumulated around Julius Caesar and Pope Julius II. In all such cases I have tried to distinguish clearly between factual information and anecdotes. I have also included personal observations and interpretations of many of the works covered, and I hope it is clear that these are my own opinions.

No book about Rome can be comprehensive and this one makes no claims to completeness. Many times I focus on a particular work of art or group of works within a church, palazzo, or museum, without attempting to discuss and sometimes without

even mentioning the many other things to be seen in the same places. There are innumerable remains of ancient Rome, ranging from such well-preserved monuments as the Pantheon to shreds and tatters of imperial grandeur scattered throughout the city. From the Christian centuries there are fifty catacombs, more than five hundred churches (nobody is quite sure of the total number), and hundreds of other structures including palaces, piazzas, and fountains, all constructed by various princes, popes, prelates, and governments. And then there is the anonymous urban fabric of the city: structures from the medieval through the modern period which form the tissue that holds the city together. From amid one of the densest collections of artistic and archaeological treasures in the world I have chosen to focus on those that are the most significant and the most interesting to me.

Because Rome's monuments are so numerous there are bound to be inclusions here that will surprise some, as well as exclusions that may disappoint others. Why, for example, did I include the Forum but exclude the Palatine Hill? Why have I provided a relatively large amount of detail about Raphael's frescoes in the Vatican and comparatively less about Michelangelo's more famous frescoes on the ceiling of the Sistine Chapel? In these and other decisions I have been guided by my own interests and what I believe will be most useful to the visitor to Rome.

The Forum covers a large excavated area in the city center and its fragmentary but monumental remains fairly cry out for some kind of guide to make sense of what was once the nerve center of the Roman Republic and Empire. No stay in Rome is complete without a visit to the Forum. The Palatine Hill, on the other hand, despite its significance as the residence of the rulers of Rome and all the history that transpired there, has always struck me as an excellent place for a picnic but not a site essential to understanding Rome.

One reason for the emphasis on the frescoes of Raphael in the Vatican over those of Michelangelo has to do with their relative degree of visibility. Raphael's frescoes are in smallish rooms where the paintings are more or less at eye level and easy to see. Michelangelo's Sistine ceiling, on the other hand, is seventy feet above our heads, so it is difficult to pick out details without binoculars. My experience has been that the most valuable information to bring to the Sistine Chapel is some sense of the meaning of its overall program of images, rather than a great deal of detail about each individual scene. The other reason for the emphasis on Raphael has to do with the tendency of many people to rush through Raphael's rooms in their haste to reach the Sistine Chapel. I hope to slow the visitor down a little and suggest that there are

masterpieces other than Michelangelo's deserving of attention.

My goals here are thus different from those of the usual guide-book. Information on itineraries, bus routes, restaurants, shopping, and the opening and closing hours of Roman churches, monu-ments, and museums is absent. The book is intended for the reader who wants more information about Rome's art treasures than is found in the average guidebook but who does not want to carry around a bunch of books devoted to particular monuments. Each chapter provides a brief but not excessively condensed body of in-formation. One may want to read this book before coming to Rome and then bring it along to consult on-site.

Taking as my theme the vast sweep of Roman art and archi-tecture from the late first century B.C. through the mid–twentieth century could make the resulting book too broad and unfocused. Thus I have organized the chapters to correspond with major pe-riods in the city's history. The works covered include famous monuments any visitor to Rome would want to see, as well as some lesser-known sites. I have perhaps stretched the definition of architecture somewhat to include chapters on the city's walls and aqueducts. These remains of the ancient city are easy to over-look but fascinating and impressive once one becomes aware of their existence.

My including biographical material on individuals—both artists and patrons—rather than concentrating exclusively on monu-ments, was intentional. I believe that cities develop in response to more than just vast, impersonal forces. Rome was built by *people,* of whom many are extraordinarily memorable. Some knowledge of the personalities behind a building (even a ruined one), a paint-ing, or a statue can bring these works vividly to life. Yes, it is possi-ble to appreciate the artistry of the Ara Pacis without knowing who Augustus was and the Pantheon with no knowledge of the emperor Hadrian, just as it is possible to enjoy a visit to St. Peter's or the Sistine Chapel without ever having heard of Julius II, Bra-mante, Michelangelo, or Bernini. Works of art exist independently of those who commissioned and designed them. But how much more resonant, meaningful, and moving they are when the visitor experiences them as the products of individuals whose passions, ambitions, and creative energies they embody.

Even to someone who loves Rome as much as I do, the city can be an overwhelming place. Sometimes it seems that wherever one puts one's foot, more than two thousand years of history lie beneath or beside it, and innumerable sites confront the visitor in a bewildering tangle. My goal is to help sort out that tangle, as well as to awaken in the reader an awareness of Rome as a living organism: not a static, open-air museum of isolated monuments,

but a complex and ever evolving fabric in which history, art, architecture, and human ambitions have constantly interacted to change its appearance. Above all, I want to share with readers my own enduring delight in the Eternal City as an inexhaustible source of pleasure. Falling in love with Rome, on a first visit or after many visits, can be the beginning of a lifelong passion. May those who read this for pleasure learn something and those who read for learning have pleasure.

ROME IS LOVE SPELLED BACKWARD

ROMA AMOR PART I

ANCIENT ROME

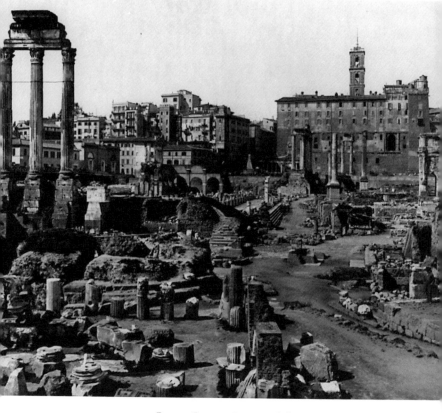

Roman Forum, view toward the west.

THE ROMAN FORUM

Stones That Have Seen the Caesars

This wonderful graveyard, where the heart
of the ancient world lies buried.
—H.V. Morton, *A Traveller in Rome*

"Oh no! Not *another* pile of broken marble!"
—Overheard in the Roman Forum

A visit to the Roman Forum, the heart and hearth of ancient Rome, offers an emotional experience few other sites can match. For this reason alone it is an excellent place to begin a journey through the city's monuments. So many characters in Rome's history once walked here that the whole area sometimes seems thronged with the ghosts of gods and heroes, priests and priestesses, orators and emperors.

In Latin the word *forum* means "a place out-of-doors" and comes from the root *foras,* meaning "outside." The Forum began as an outdoor meeting place, something like a village commons, where people from the various tribes who occupied Rome's hills in prehistoric times met to talk and trade, to discuss matters relating to the common good, and later to worship their gods and bury their dead. Its location is a low, shallow valley between the Palatine, Capitoline, and Esquiline Hills. Fed by springs and close to the Tiber River, much of the area was swampy. Perhaps there were a few conical thatch-roofed huts on the higher ground near the foot

of the Capitoline Hill, including one where the public fire was kept burning. There was a graveyard and altars to various gods. Winding paths connected this primitive market, meeting, worship, and burial place with the settlements in the surrounding hills.

The early history of the Forum is so mixed with myths that it can no longer be fully sorted out, but some stories have a factual basis. Legend credits several early kings of Rome, the Tarquins, with draining the swampy portions of the area in the seventh century B.C. by building a gigantic sewer called the Cloaca Maxima. Whether or not the Tarquins actually built it, the sewer still exists (much repaired), is still in use, and archaeologists confirm that it dates from the seventh century B.C. When the Tiber is low, its opening can be seen from a modern bridge, the Ponte Palatino.

Once the area ceased to be a swamp, the Forum expanded rapidly. The Tarquins gave it the trapezoidal shape it still retains, divided the borders into lots for shops, set apart an open area (the Comitium) for public meetings, and another (the Curia, or Senatus) for assemblies of the city's elders. At the time of the founding of the Roman Republic, according to legend in 509 B.C. with the overthrow of the last Tarquin king, the Forum was already the site for various governmental assemblies and communal activities of the Romans; the separate tribes were one people by then. The smelly fishmongers had departed to a market well away from the Forum, and as the Forum continued to grow, other mercantile activities also moved out to their own spaces. What remained were political, religious, and legal functions, and it is the fragments of buildings dedicated to these uses that survive.

Perhaps *survive* is too optimistic a word. The Forum is so ruined that the visitor's first question is often, "How did it get into such terrible condition?" To understand why the Forum today can seem an incomprehensible jumble of broken stones, it helps to consider its growth and decline, which parallels the rise and fall of ancient Rome itself, as well as some of the city's later history.

From the early fifth century through the first century B.C. the Forum expanded. As Rome's conquests brought in vast amounts of wealth, the temples, shrines, sanctuaries, law courts, and buildings housing political and governmental institutions all proliferated. Older ones were torn down to make room for new ones and structures destroyed in fires were replaced by even finer buildings. But by the middle of the first century B.C. the Roman Forum was proving inadequate for imperial ambitions and a rapidly growing population, so the rulers of Rome began building their own forums.

There are five of these, collectively called the Imperial Forums, to distinguish them from the original one, known as the Roman Forum. Built by Julius Caesar and the emperors Augustus, Nerva, Vespasian, and Trajan, they were larger and grander in some cases

than the Roman Forum and were all built close to it. With the completion of the Forum of Trajan in the early second century A.D., the total area covered by all the forums was about twenty-five acres. The zone included thirteen temples and three law courts (most of them faced with white marble and roofed with gilt bronze tiles), eight triumphal arches, the Senate House, the state archives, more than a mile of porticoes supported by well over a thousand marble and granite columns (many with gilt bronze capitals), public libraries, thousands of bronze and marble statues and monuments, painting galleries, and hundreds of shops selling necessities and luxuries from all over the empire. With this complex of buildings at its heart, it is little wonder that Rome at the height of its power was called *caput mundi*, the center of the world. There was nothing like it anywhere.

But the construction of the Imperial Forums diminished the role of the older Roman Forum. A fire in 283 A.D. did severe damage, and although the emperor Diocletian ordered extensive repairs about twenty years later, the old Forum area began to reflect the general decline of Rome itself. When Constantine moved the capital from Rome to Constantinople in 330 A.D., the fate of the Forum was sealed. Although subsequent emperors tried to keep it in repair, they did not have sufficient funds, materials, or skilled labor. Invasions in the fifth and sixth centuries did further damage to buildings already undermined by earthquakes and neglect. Although treasure-seeking invaders damaged buildings everywhere in the city, they often concentrated on the Forum because in their eyes it symbolized the lost power of the once-invincible Roman Empire.

Another factor in the ruin of the Forum was the abolition of pagan worship under the Christian emperors. After Constantine's Edict of Toleration, issued in 313, the authority of the Church expanded rapidly and all but one of the subsequent emperors were Christians. In 383 Gratian eliminated the privileges of the city's temples and their priests, as well as confiscating their revenues, and in 392 Valentinian II and Theodosius prohibited sacrifices to the ancient gods. Theodosius even dragged statues of the gods through the streets, tied to the back of his chariot. In 394 he ordered all temples closed, and although a few pagan cult centers continued to operate, most of the statues of the gods were removed from the deserted temples in the Forum and elsewhere.

After the sixth century, even halfhearted attempts to preserve the Forum ceased. Emperors and popes helped themselves to whatever the barbarians had left behind. The sack of the city in 1084 by the troops of Robert Guiscard completed the destruction of the Forum, which subsequently became a public garbage dump. Since it was in a low-lying area and the Cloaca Maxima had ceased to function, the accumulation of trash reached such a

height that the remains of most of the buildings disappeared. As the medieval city deteriorated into near anarchy, noble families claimed areas around the fragments of the Forum that still protruded from the ground and made them the foundations for defensive towers. Cowherds used the area as a pasture, from which it got the name Campo Vaccino. The nerve center of the greatest empire of the ancient world had become a rubbish heap. The only attention paid to the Forum during the subsequent six centuries was by those who plundered it for building materials. Modern archaeological exploration of the Forum began in the eighteenth century, and excavations continue. Those who visit the Forum annually are always intrigued by the changes, as old excavations are completed and new ones begun.

A good way to see the Forum is to walk around it counterclockwise from the entrance on Via dei Fori Imperiali, stopping to examine the remains of certain buildings, and giving oneself over to imagining some of the events and individuals associated with those places. A path descends from the modern street level, which is anywhere from twenty-four to seventy-two feet above that of the ancient pavements, to a spot where the Basilica Aemilia is on the right and the Temple of Antoninus and Faustina on the left. The latter is the kind of structure that seems surprising when first encountered in Rome but proves typical of this multilayered city. The emperor Antoninus Pius built the original temple in the mid–second century A.D. in honor of his deified wife, Faustina, and after his death it was dedicated to him as well. Across the front are ten marble columns, with an inscription above giving the names of the couple. The temple survived because in the eleventh century Christian builders incorporated it into a church, S. Lorenzo in Miranda. The front was rebuilt in the early 1600s; behind the ancient Roman columns stands the curving, rose-colored brick facade of a Baroque church.

To the right, looking west toward the Capitoline Hill, are the remains of the oldest building in the Forum, the Basilica Aemilia. Although little is left of the immense structure (325 feet long) except for a restored segment of the south wall and the stumps of some columns, the rectangular shape of this law court, founded in 179 B.C. by M. Aemilius Lepidus and M. Fulvius Nobilior, is still visible. Repeatedly rebuilt over the centuries, most of it disappeared in the Renaissance, when builders used its remaining marble to construct Christian buildings. The visitor who stands in front of the Basilica Aemilia is at the beginning of the original space of the Forum, when it was merely a meeting spot traversed by a muddy path, with nothing but swamps and wooded hills around it.

That path eventually became the principal road of the Forum and the oldest road in Rome — the Via Sacra, or Sacred Way, which

visitors can still use. In antiquity hordes of people crowded it every day as they went about their business in the Forum. It also served as a ceremonial route, along which each of Rome's generals awarded a triumph by the Senate for military victories passed in a splendid procession on his way to make sacrifices at the Temple of Jupiter on the Capitoline Hill. His head crowned with laurel leaves and his face painted red in honor of Mars, the god of war, the general rode in a chariot, preceded by captives and soldiers carrying the spoils of war and followed by his victorious army. Century after century, generals and emperors marched along this road, as Rome conquered first her neighbors and then the regions around the Mediterranean Sea and beyond.

Continuing west, past the Basilica Aemilia, one comes to the Comitium and the Senate House, or Curia, sites of the earliest po-litical activity of the fledgling Roman Republic. The Comitium was the original open-air meeting place where the representatives of the city's thirty Curiae, or districts, recorded their votes. To the north of the Comitium stands the tall and imposing Senate House, in a seemingly miraculous state of preservation. It is not the original Senate, built in the seventh century B.C., of course. The present structure dates from the first century A.D. and was re-paired by the emperor Diocletian after the fire of 283 A.D. What preserved it was its conversion into a church in the seventh cen-tury. When archaeologists removed the Christian shell in the 1930s, they found the ancient brick building almost intact within it; even the magnificent colored marble pavement had been pre-served beneath the Christian one.

Although the lower part was originally faced with marble and the upper with stucco, it was never ornate and had the austere ap-pearance associated with the Roman Republic. From this simple building Rome's Senate ruled the republic, assisted by two annu-ally elected consuls. Even after Augustus had become the first em-peror and the authority of the Senate gradually became a pious fiction, later emperors carefully maintained the institution. After Constantine the emperors no longer spent much time in Rome, but senators declaimed and droned on amid the crumbling build-ings of the Forum well into the seventh century. The immense bronze doors, cast during Diocletian's restoration of the Senate House, were removed in the mid-1600s and now adorn the main entrance of Rome's cathedral, St. John Lateran.

Past the Senate to the southwest stands the richly decorated Arch of Septimius Severus, behind which rises the Capitoline Hill. The arch was a relatively late addition to the Forum, con-structed in 203 A.D. in honor of some military victories of that ambitious, North African–born emperor and dedicated to him and his sons, Geta and Caracalla. Nine years after the construction

of the arch, Caracalla killed Geta and had his brother's name removed from this and every other monument in Rome on which it appeared. But the inscription at the arch's top, altered to remove the mention of Geta, still preserves a ghostly memory of the murdered man. Underneath a line of added praises for Caracalla the holes left by clamps that held the original letters in place are still visible. They spell out Geta's name.

To the left of the Arch of Septimius Severus is a long, low platform with a stone base. This is the Rostra (the origin of our word *rostrum*), the place where orators stood to address audiences in the Forum and from which proclamations of the Senate were read to the people. It gets its name from the curved metal ramming prows *(rostrA)* of ships captured in battle which were displayed there. In front of the Rostra on the left is the last monument erected in the Forum—the tall, white column on a brick base, set up in 608 A.D. in honor of the Byzantine emperor Phocas. The splendid column, no doubt pilfered from the ruins of an earlier imperial building, was probably placed here in gratitude to Phocas for his extraordinary gift to Boniface IV. The emperor had given the pope the Pantheon.

Behind the Rostra and to the south of a low, semi-circular wall constructed during the building of the Arch of Septimius Severus, is the site of the now vanished Milliarium Aureum: the Golden Milestone, put in place by the emperor Augustus about 20 B.C. This was a stone column covered with gilded bronze and engraved with the names of the principal cities of the empire and their distances from it. All the roads of the Roman world were supposed to converge on this spot. Although not all of them did, the existence of the Golden Milestone has given us the enduring expression "all roads lead to Rome."

At the western end of the Forum rises the plain, monumental facade of the Tabularium, built into the rocky flank of the Capitoline Hill in 78 B.C. It served as ancient Rome's record office, the depository of the clay and stone tablets and parchment scrolls that formed the state archives. Built of huge, rough stone blocks, it always must have looked like a fortress. The two surviving stories now serve as the base for a medieval building that was first a family fortress and later the Palazzo Senatorio, where the city's medieval Senate met, beginning about 1150. (The portion that faces away from the Forum, now covered by a facade designed by Michelangelo, forms part of the Renaissance reconstruction of the Capitoline Hill.)

Behind the Rostra and in front of the Tabularium are the fragmentary remains of several temples. Only three columns and a piece of the entablature still stand from a corner of a temple dedicated in 79 A.D. to the deified emperor Vespasian by his two sons,

Domitian and Titus. The columns make a fitting memorial to the humorous and slyly irreverent emperor whose dying words were said to have been: "My goodness, I think I am about to become a god!" To the left of Vespasian's temple are eight red and gray granite columns, all that remain of a temple dedicated to Saturn. One of the oldest temples in Rome, it was first built in 498 B.C., probably over an even more ancient shrine. What we see today are the remains of a building of the first century B.C., so carelessly reconstructed after the fire of 283 A.D. that one of the columns was replaced upside down. Saturn was originally an agricultural deity, the guardian of the primitive wealth of fields and flocks; in historic times he was the god who guarded money. His temple was the site of the state treasury.

Between the temples of Vespasian and of Saturn, an extension of the Via Sacra called the Clivius Capitolinus continues up the Capitoline Hill, toward the temples of Jupiter and Juno. The Via Sacra continues east, past the shattered remains of another huge basilica, this one dedicated in 54 B.C. by Julius Caesar during his extensive reworking of the Forum. Although he presided over the inauguration of the basilica in 46 B.C., he did not live to see it completed. In perhaps the most famous death in ancient history, he was assassinated in the Theater of Pompey on the Ides (15th) of March in 44 B.C. (At that time the Senate was meeting in Pompey's Theater because the Senate House was being rebuilt, at Caesar's orders.) After a fire, Augustus rebuilt the basilica in 12 A.D. and dedicated it to his two grandsons. But such was the power of Caesar's name that it has always been called the Basilica Julia. Although Julius Caesar never held the title of emperor and several times refused to be crowned king, the name Caesar became so closely identified with power and authority that the subsequent rulers of Rome always included it in their titles and it has entered several modern languages as a synonym for imperial ruler: *Kaiser* in German, *Czar* in Russian.

Next to the east side of the Basilica Julia is the Temple of Castor and Pollux, built in honor of the twin sons of Jupiter who according to legend helped the Romans win a great battle against the Tarquins. Although founded in the fifth century B.C., the surviving portions are from a rebuilding by the emperor Tiberius in the early first century A.D. Three tall and graceful fluted columns connected by a bit of the entablature are all that remain. The only columns in the Forum never to be knocked down, in the Middle Ages their shafts—sticking up from the rubble—were among the few indications of the Forum's existence.

Across the Via Sacra to the north from the Temple of Castor and Pollux is another monument to Julius Caesar, this one built as a memorial. Dedicated in 29 B.C., it marks the place where Caesar's

body was cremated and where Marc Antony gave the funeral oration best known to English-speaking people in Shakespeare's version. Here thousands of mourning Romans gathered to pay homage to their fallen leader. Even though little survives other than the (restored) round altar stone where the cremation took place, this spot is one of the most evocative in the Forum, a place where history seems to hang in the air.

Just past the southwest corner of Caesar's temple the Via Sacra angles slightly to the left and passes between the Regia on the left and the Temple of Vesta on the right. The Regia was the official residence of the Pontifex Maximus, the Roman chief priest, and also the site of the city's religious archives. Legend identifies it as the dwelling of Numa Pompilius, one of the early kings of Rome; hence the name Regia, from the Latin word for "king." Archaeologists have found structures here dating back to the seventh century B.C., and below those the remains of prehistoric huts, but what little is visible comes from the first century B.C. and a rebuilding of the third century A.D. Julius Caesar, who was acting as Pontifex Maximus, proceeded from this place through the Forum to the Theater of Pompey and his death at the hands of dagger-wielding assassins.

To the south, across the Via Sacra from the Regia, stands a reconstructed segment of the circular Temple of Vesta, the goddess of the hearth and of the sacred fire that symbolized the continuity of the Roman state. The cult of Vesta was among the oldest and most important in Rome and probably dates from long before the founding of the city. The temple's round shape preserves the form of a conical hut, perhaps the kind which sheltered the communal fire of the region's prehistoric hill dwellers. The remains we see today are from a rebuilding of the third century A.D., sponsored by Julia Domna, empress and wife of Septimius Severus.

The guardians of the temple's sacred fire were the six Vestal Virgins. Chosen as children by the Pontifex Maximus from the city's aristocratic families, they served for thirty years under strict vows of chastity. Their most important duty was to tend the sacred fire and make sure it never went out. The fire's extinction was considered the most fearful of calamities because it portended the destruction of Rome. Within the temple they also guarded the *adytum,* a secret place containing the city's most sacred objects, which the Romans believed were the source of their city's power and prosperity. Nobody is exactly sure what they all were, but they included an ancient image of the goddess Athena, supposedly brought from Troy by Aeneas. It symbolized the Romans' noble heritage, since Romulus and Remus, the legendary founders of the city, were descendants of Aeneas.

Just beyond the Temple of Vesta, to the southeast, is the House

of the Vestals, built into the north flank of the Palatine Hill and the living quarters of the priestesses entrusted with the well-being of the Roman state. Now partially restored, this delightful place features a colonnaded courtyard with living and service quarters laid out around it. The courtyard has ponds enlivened by goldfish and a garden planted with shrubs and rosebushes. A few battered statues of the Vestals, excavated from the ruins, have been set up again along the edges of the courtyard.

The Christian emperor Theodosius, who closed Rome's temples in 394, also banished the last Vestals from their house. Their fate, along with that of the sacred treasures they had guarded for so long, is unknown. We can only speculate on their emotions as they watched the flame die out on Vesta's altar, where it had burned for more than a thousand years, and faced a future in a world so different from their past. Whatever we may think of their beliefs, there is something sad about Rome's last pagans, people who lived to witness their faith discredited and their gods dragged through the dust.

Further east along the Via Sacra, past the House of the Vestals and across to the north from a large, overgrown area that may have once included shops and warehouses, stands the so-called Temple of Romulus, a structure of the early fourth century A.D. Although once identified as a temple built by the emperor Maxentius in honor of his son, Romulus, who died in 309 A.D., more recent archaeological opinion identifies it as an imperial audience hall. It has an unusual shape: a circular room flanked by two rectangular rooms that terminate in apses. Its fourth-century bronze doors, framed by dark red porphyry columns, are original. Like the Temple of Antoninus and Faustina, this ancient building was saved by its conversion to Christian use; in the sixth century it became part of the Church of SS. Cosma and Damiano.

At the southeastern end of the Forum a monument comes into sight whose history resonates to the present day: the Arch of Titus. Built about 80 A.D. by Domitian to honor the victories of his brother Titus and their father, Vespasian, in the war against Judaea a decade earlier, it serves as the Forum's eastern entrance and exit. Almost all its exterior decoration is a nineteenth-century reconstruction and the inscription on the side facing into the Forum records the restoration of the arch by Pius VII in the early 1800s. Although smaller and simpler than the Arch of Septimius Severus at the opposite end of the Forum, the event it records had much further reaching effects. The Romans' victory in their long and savage war with Judaea put an end to the Jewish state for nearly nineteen hundred years. Only with the foundation of modern Israel in 1948 was the result of Rome's triumph finally undone.

On the walls inside the single arched opening are two sculptured panels celebrating Titus and Vespasian's victory, during which

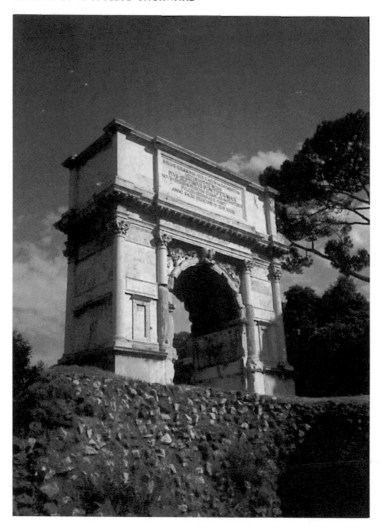

Arch of Titus, southeastern end of the Roman Forum. The arch is both a
reminder of the power of imperial Rome and a poignant testimony to the
defeat of the Jewish state.

Jerusalem was looted and nearly destroyed. One panel shows Titus
riding in a four-horse chariot, with the goddess Roma guiding his
horses, while the jubilant citizens of Rome crowd around him.
On the opposite side we see the start of the triumphal procession
that must actually have passed this way, although before the arch
was built. Soldiers carry the spoils of the war, which included the
altar table, silver trumpets, and the great seven-branched gold can-
delabrum plundered from the Hebrew temple in Jerusalem.

Among the other spoils of the Jewish War were thousands of captives. Many were put to work as slaves during the construction of the Colosseum (begun about a decade before the arch) and some may also have worked on the Arch of Titus—with what bitterness of heart we may easily imagine. The arch became a potent symbol of Jewish defeat, a place that the Jews of Rome avoided for centuries, refusing to walk under it to enter or leave the

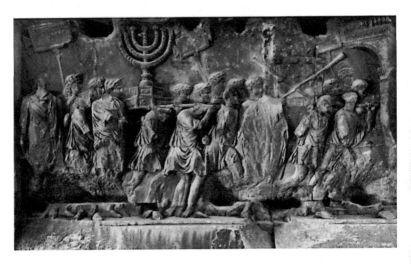

Arch of Titus, detail of sculptured panel showing the spoils of Jerusalem.

Forum. All this changed on May 14, 1948, the day the State of Israel was founded. As radios announced the rebirth of their ancient homeland, the Jews of Rome, some of them descendants of Titus's captives, spontaneously began pouring in from all over the city and converged on the Arch of Titus. Laughing, weeping, shouting, cheering, banging on metal pots or anything else that could make a noise, they skipped, ran, walked, hobbled, or had themselves carried through the Arch of Titus. Today, Israeli tourists snap each other's pictures in front of the arch, a place where history has turned a page.

As the visitor passes through or around the Arch of Titus and looks east toward the nearby Colosseum, on the left is the medieval convent of S. Francesca Romana and further to the east the ruins of the twin Temple of Venus and Roma. The unusual plan of this temple was a design of the emperor Hadrian himself from about 135 A.D., although what we see today is mostly from a reconstruction of about 300 A.D. Instead of a single building with an apse (the half-circular area where the image of the god was placed) at each

end, the temple is actually two temples, with their apses backed up against one another. The portion facing the Forum was dedicated to Venus; the part that looked east, toward the Colosseum, was dedicated to Roma, the goddess who personified the city. Today, just the twin apses survive. The one facing the Colosseum is visible after one exits the Forum; the portion facing the Forum has been incorporated into the convent of S. Francesca Romana.

Hadrian chose to combine the sanctuaries to these two goddesses in part because he wished to celebrate the relatively new goddess Roma by associating her with the more venerable Venus, but perhaps also because their names create a wordplay some two thousand years old. *Roma,* read backward, is *Amor,* and *Amor* refers to Venus, the goddess of love and the mother of Aeneas, the mythical ancestor of the founders of Rome.

After the visitor detours back around the convent of S. Francesca Romana, the largest structure in the Forum and the last to be built comes into view: the Basilica begun by Maxentius and completed by Constantine in the 330s A.D. The structure forms the northeast corner of the Forum. What remains of this law court is so gigantic that at first it seems like a nearly complete building, but it is only one triple-arched and vaulted side aisle of a structure that was originally more than three times as big. In the Renaissance its vast vaults impressed Bramante and Michelangelo, inspiring their designs for the new St. Peter's, a structure requiring such enormous amounts of stone that many of the buried buildings of the Forum were excavated and ransacked to provide it.

Continuing around to the west again brings the visitor back near the entrance/exit where the journey began. Not far along the Via Sacra from the Basilica of Maxentius and Constantine, the latest building in the Forum, the area's oldest remains can be seen: an Early Iron Age cemetery of the region's prehistoric inhabitants (located inconspicuously between the Temple of Romulus and the Temple of Antoninus and Faustina). Here, hardly a hundred yards from one another, are the remains of Rome's remotest age and the ruined remnants of the great empire Rome eventually became.

More than any other place in the city, the Forum reveals the vast sweep of Rome's history. It encompasses the city's prehistoric origins, its long, relentless rise to imperial power, its gradual decay, and its deliberate destruction. Perhaps most astonishing and moving of all, it documents survival. The Roman Forum is evidence that Rome has earned its status as the Eternal City.

THE ARA PACIS AUGUSTAE

Rome's Altar of Peace

On my return from Spain and Gaul ... the Senate resolved
that an altar of the Augustan Peace should be consecrated ...
in honor of my return and ordered that the magistrates and priests
and Vestal virgins should perform an annual sacrifice there.

—Augustus, *The Achievements of the Divine Augustus*

After a century of bloody civil and foreign wars that had brought about the end of the Roman Republic, Augustus, who had ruled as emperor since 27 B.C., seemed finally to have placed the Roman world under his own personal peace, the *Pax Augusta*. In recognition of this achievement the Roman Senate voted in 13 B.C. to build an altar dedicated to peace and to the emperor who had achieved it. The result, completed about four years later, was a fitting tribute. The Ara Pacis Augustae, the Altar of Augustan Peace, is Rome's most intimate imperial monument. Modest by the standards of the grandiose structures erected by later emperors, the Ara Pacis (a 35-by-39-foot rectangle) is a perfect example of the elegant and gracious style cultivated by Augustus. Justly proud of his altar, Augustus made mention of the circumstances that led to its creation in his *Achievements of the Divine Augustus,* the official autobiography he wrote about 14 A.D., near the end of his long reign.

The place where the Ara Pacis stands now, on the Lungotevere in Augusta (the east bank of the Tiber not far from Augustus's tomb), is only a short distance from its original location near the

ancient Via Flaminia, today called Via del Corso. That the Ara Pacis is standing at all is a miracle. Like so many imperial monuments, it had been destroyed during the barbarian invasions that laid waste to Rome in the fifth and sixth centuries A.D. and its existence had been forgotten. Although pieces of its sculptured friezes kept turning up during the construction of subsequent buildings on the

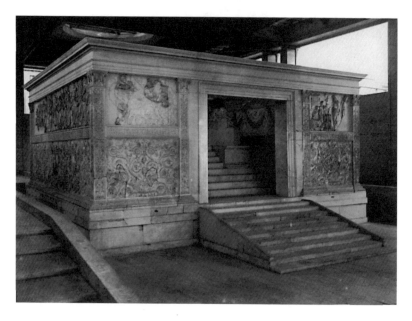

Ara Pacis Augustae, the elegant and beautifully preserved altar
dedicated to Rome's first emperor, Augustus.

same site, nobody recognized the fragments. Consequently some of them disappeared and others were carried off to such disparate places as Vienna, the Vatican, the Medici collection of ancient sculpture in Florence, and the tomb of a seventeenth-century priest in Rome's church of Il Gesù.

In the late nineteenth century archaeologists began suggesting that these scattered fragments belonged to Augustus's long-lost Ara Pacis, and efforts were made to collect as many of them as possible at Rome's Museo delle Terme. Although in 1903 archaeologists explored the original site of the altar, groundwater made excavation extremely difficult. Some three decades later, with active encouragement from Mussolini, who was eager to have anything associated with Rome's first emperor brought to light to enhance his own imperial claims, engineers hit upon an ingenious method of solving this problem: by means of huge refrigeration devices they froze the groundwater, making it possible between 1937 and

1938 for archaeologists to excavate the foundations of the altar. The reconstructed Ara Pacis now stands within a large, reinforced glass and concrete shelter, also the work of Mussolini's architects, designed to protect it from the elements and pollution.

The surfaces of the box-shaped Ara Pacis are covered with relief sculpture carved in white marble. The artists are unknown, but the level of craftsmanship is consistent and exceptionally high, leading archaeologists to suggest that they may have been Greeks, or at least Greek-trained. As with much ancient Greek sculpture, the reliefs were originally painted, which would have made the details stand out much more clearly than they do now.

The overall theme of the Ara Pacis is the ushering in of an era of peace, prosperity, and spiritual renewal, benevolently presided over by Augustus, with the assistance of his government officials and the support of his family. The ancient world offers few more fervent promoters of family values than the emperor Augustus. (That his tangled family tree would eventually produce some of Rome's most appalling rulers is another story, one best told by the second-century Roman historian Suetonius in his *Lives of the Twelve Caesars*.) Augustus worked tirelessly at reviving traditional religious observances. He restored more than eighty of the city's temples, encouraged marital fidelity, and—although the ancient Romans (like the modern ones) were enthusiastic practicers of birth control— tried to convince his fellow citizens to raise larger families.

The sculptural decorations of the Ara Pacis consist of two horizontal bands on each of its four sides. A lower, continuous band displays a scrolling pattern of branches and leaves, swarming with animal life, a lush world of flourishing plants and lively animals including birds, toads, lizards, and an occasional snake. It forms the foundation both visually and symbolically for the human figures and scenes in the upper band. The scrolls refer to the fertility of the earth during this presumed golden age brought about by Augustus.

The upper panels on the short front and back walls, the location of the two doorways to the sanctuary, show four scenes from Roman history and religion. All but one are in a poor state of preservation. On the front are the fragments of two scenes from the most ancient history of Rome: on the right Aeneas Sacrificing to the Penates (ancestral household gods) and on the left the god Mars with Romulus and Remus. Both scenes concern legendary founders of the Roman state. Aeneas, a hero of the siege of Troy (celebrated in Virgil's epic poem, the *Aeneid,* commissioned by Augustus), was regarded as the first settler on Italian shores. Romulus and Remus, the twin sons of Mars who were nursed by a she-wolf, were the founders of the city.

On the back wall are two reliefs: one beautifully preserved showing an earth goddess and one nearly destroyed probably

representing Roma, the goddess of the city. The earth goddess is among the loveliest of all Roman relief sculptures, a handsome, full-breasted young woman with two happy babies tumbling on her lap, domestic animals (a cow and a sheep) settled contentedly at her feet, and plants flowering on either side. The two females who flank the goddess are identified by the billowing cloaks behind them. They are the Aurae, personifications of the warm

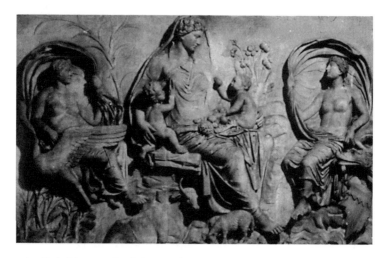

Ara Pacis Augustae, detail showing the earth goddess. This relief symbolizes the prosperity of the empire, which Augustus considered his finest achievement.

breezes that help the crops grow. This is the golden, ideal world of the *Pax Augusta,* the hoped-for era of eternal peace brought to Italy and the empire by Augustus.

The two ceremonial processions on the longer side walls are a portrait gallery of high-ranking officials and the imperial family. The most fascinating aspect of the Ara Pacis is the record it gives us of the ruling elite and the emperor's extended family. The faces are no mere conventional masks, idealized beyond recognition. These are portraits from life and they still retain their freshness and individuality. Augustus believed (somewhat presumptuously, in retrospect) that not only the prosperity but the very existence of the Roman state depended on the continuance of the imperial family. For this reason children play an important part in the imagery of the altar; they guarantee the empire's future.

The ceremony in which all these people are participating is the inauguration of the Ara Pacis itself, a reminder that familiar modern rituals such as the inauguration of a president have ancient Roman roots. The core of the word *inauguration* is *augur,* a word so old that it

may go back beyond Latin to the lost language of the Etruscans. It refers to a religious official whose duty was to determine the gods' attitudes toward particular enterprises and foretell the future by interpreting omens, predicting good or bad events through such sights as the flight of birds. In ancient Rome the celebration of the opening of a public monument always required the services of the *augures.* The *augures* performed an *inauguratio,* or taking of the omens, from which we get our English word *inauguration.* In the relief sculpture of the Ara Pacis, Augustus himself serves as the chief *augur.*

The panel on the right side, which shows the start of the procession and contains the figure of Augustus, is the most severely damaged. From the first third, only a few fragments of figures remain, although the heads are fairly well preserved. The emperor is shown slightly taller than the other men, since he liked to think of himself as *primus inter pares,* first among equals. His handsome face, although damaged, is recognizable from numerous other portraits. Preceding him are the ceremonial guards known as *lictors,* who can be identified by the emblem they carry over their shoulders: the *fasces,* bundles of reeds tied around axes. Although here the axes have been omitted in deference to the altar's peaceful emphasis, this symbol of authority has given us a sinister modern word: *fascism.*

Behind the emperor marches a group of religious officials, the *flamenes maiores,* priests of the three major Roman gods, Jupiter, Mars, and Quirinus. They can be identified by their curious headgear: a leather cap with a pointed extension on its top. A fourth *flamen,* distinguishable by his deeply lined face, is probably the *flamen Julialis,* the priest of the deified Julius Caesar, who had been declared a god by Augustus and duly deified by the Senate. Since Augustus was Caesar's great-nephew and adopted son, he probably included the elderly priest to honor the memory of his adoptive father.

Following the *flamenes* is a handsome but unidentified young man carrying a ceremonial axe. Behind him stands a tall, dignified man of middle age with a weary, haggard face, sometimes erroneously identified as Augustus. Other portraits, however, permit us to identify him as Marcus Agrippa, the son-in-law of Augustus and the emperor's most trusted adviser. (This is the man who built the original Pantheon, and whose name appears in the inscription on the present building.) Agrippa died before the dedication of the Ara Pacis and with the realism so typical of Roman art the sculptor has evidently shown him with the shadow of fatal illness already reflected in his face. He has his toga pulled up over his head, which indicates that he is acting as a priest. There was no separate priestly class in ancient Rome; major religious offices, including that of the Pontifex Maximus, or chief priest, were held by important government officials.

Modern viewers are often charmed by the group immediately next to Agrippa. A little boy with chubby cheeks, tangled curls, and a heavy torque (twisted gold collar) around his neck clings to Agrippa's toga, while turning in the opposite direction. An indulgently smiling man just behind him puts an affectionate, gently restraining hand on the child's head and a tall, pretty woman with long ribbons in her hair also turns slightly toward the boy, as if responding to the restless child.

The identity of this group remains elusive. Some art historians identify the boy as Agrippa's son, Caius, who was Augustus's designated successor and the woman who turns toward the child as Agrippa's wife Julia, who was Augustus's daughter. Others insist the woman is Augustus's wife, Livia, and that the slightly sour-faced man just to the right of her would then probably be Tiberius, Livia's older son from her first marriage and Augustus's eventual successor. Still other experts claim, however, that the boy's torque collar and long, tangled hair, held down with a single ribbon around his head, as well as the beribboned headdress of the tall woman next to him, identify both as foreigners. We know from written sources that the children of foreign rulers, usually those conquered by the Romans, were often sent to Rome, accompanied by their mothers, in order to learn Roman customs and manners. They were not prisoners but came voluntarily (in theory, at least), as a pledge of their people's friendship with Rome. Such a group, prominently and sympathetically displayed, would be suitable on an altar dedicated to peace throughout the empire. Whoever they are, we can relate to the situation of parents trying to keep a bored and restless child in line while waiting for a ceremony to begin.

The identity of the next group of people is easier to ascertain. The man in a tunic and military-style sandals is most likely Drusus, the younger of Livia's two adult sons from her previous marriage, and his wife, Antonia, holding the hand of their two-year-old son Germanicus. In contrast to the bored boy in the torque collar, this little fellow is a model of good behavior. Dressed in a tiny toga, he clings to two fingers of his mother's hand and seems to be doing his best to live up to the ancient Roman equivalent of: "we're letting you wear grown-up clothes today, so you'd better be VERY good!" The child's parents, on the other hand, seem to be chatting with one another, for a woman in the background between them puts one finger to her lips in what we recognize as the signal for "Shhhhhhh!!!"

The next child, a few years older than Germanicus and also clad in a miniature toga, is hanging onto the back of Drusus's cloak, while his mother keeps a hand on his shoulder. Although the boy's head is a modern restoration, he is probably Caius Domitius Ahenobarbus, a nephew of Drusus and the future father

of one of Rome's most notorious emperors, Nero. The plump, smiling child who seems to be looking down mischievously at young Caius Domitius has been identified as his sister, Domitia, but the very short hair and boyish face make this uncertain.

The procession on the left long wall has been drastically restored and none of the heads are original, so it is difficult even to speculate about individual identities. The procession consists almost entirely of men, probably high government officials who were members of the Roman priesthoods, as they seem to be carrying various ceremonial objects. Children appear with this group also: a solemn little girl being patted on the head by her father and slightly further on a graceful boy standing quietly at the side of a toga-clad man. The boy, about ten years old, may be a son of Agrippa by his first wife. Augustus forced Agrippa to divorce her in order to marry Augustus's daughter Julia. So much for the emperor's devotion to family values.

The severely damaged and in any case rather inconspicuous figure of a veiled woman standing just in front of this boy might possibly be Julia, the daughter of Augustus and wife of Agrippa. Julia was something of a trial to her father; after Agrippa's death Augustus eventually banished her from Rome, probably for her flagrant sexual adventures. Just in front of the veiled woman and gripped firmly by the hand of an adult male, is a very unhappy toddler. Far too young to be participating in such proceedings, this bare-bottomed, chubby little chap is wailing and tugging on the toga of the man in front of him, obviously tired and wanting to be picked up. Although he is sometimes identified as Julia and Agrippa's son Lucius, born in 12 B.C., it is probable that he, too, is an infant foreign prince being raised at the imperial court. Like the boy on the opposite side of the altar, he has long, curly hair and wears a torque necklace, the latter almost a signature identifying members of the northern (Gallic) tribes recently brought into the Roman Empire.

It may be significant that the two long-haired boys in torque collars are the only children on the altar who are portrayed as misbehaving. Perhaps the idea was to suggest that these youngsters and their fellow tribesmen from the wild northern reaches of the empire still had a lot to learn about proper Roman manners. But Augustus, his family, and his court are there to teach them, by example and by elegant works of art such as this one, the virtues, advantages, and civilizing effects of Roman rule.

Suggested reading

Erika Simon, *Ara Pacis Augustae* (New York, 1967).

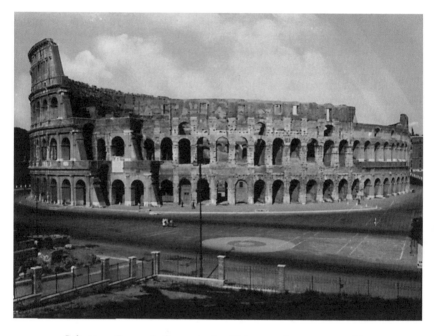

Colosseum. For nearly four centuries this huge stadium constructed by
the emperor Vespasian was the site of innumerable athletic events, spectacles,
and blood sports.

ROMA AMOR III

THE COLOSSEUM

> While the Colosseum stands, so does Rome.
> When it falls, Rome falls, and the whole world falls with it.
> —Attributed to an eighth-century English monk

If the Roman Forum served as the spiritual and political center of imperial Rome, the Colosseum was its popular hub, a monument that simultaneously calls to mind the greatest and the most repulsive qualities of ancient Roman society. A masterpiece of engineering and architecture, for almost four hundred years it was the site of innumerable spectacles, among them so-called sports events unrivaled for their murderous brutality. Although the Colosseum has earned its bloody reputation, not all the legends that have accumulated around this immense structure have any basis in historical fact. We know a good deal about the circumstances and methods of its construction, as well as the spectacles that took place within it, because the ancient Romans who wrote about it were as amazed by the place as modern visitors are.

The Colosseum was commissioned by one of the most appealing Roman rulers, the emperor Vespasian (70–79 A.D.). A shrewd, humorous, earthy, and eminently sane self-made man, Vespasian came from a modest family in the Sabine Hills north of Rome. A successful general, he became emperor in the middle of one of Rome's bitterest wars: the long struggle to subdue the Hebrew kingdom of Judaea. Once installed in the exalted role of emperor, Vespasian remained notably unimpressed with imperial pomp. When not involved in public duties, he clomped about the palace

in his old army tunics and the ancient Roman equivalent of carpet slippers. A widower of sixty when he became emperor, Vespasian flatly refused to follow the advice of his aides and exchange his favorite mistress, a plump, gray-haired woman who had been his companion for many years, for a glamorous young wife. A superb administrator who rescued Rome from the brink of anarchy, he is remembered in Rome as the emperor who slapped a tax on the city's public latrines; Rome's malodorous modern conveniences are still called *vespasiani*.

The Colosseum is a much more fitting monument to this excellent emperor and we may wonder why the structure is not called the Vespasiano. Its name, ironically, goes back to Vespasian's despised predecessor, Nero, whose huge statue (120 feet tall) stood near the site of the arena. Vespasian saw no reason to dispose of the statue. Instead he had Nero's head removed and replaced with a likeness of the sun god Apollo. It was this now vanished colossus that gave Vespasian's arena its enduring name: the Colosseum.

One of Vespasian's first decisions as emperor was to destroy the almost surrealistically extravagant Golden House of Nero and to use the huge declivity that had contained Nero's private lake as the site of a great amphitheater that would provide entertainment for all the people of Rome. Vespasian's personal frugality was legendary, so we can be sure his reasons for undertaking this vast project were practical. He must have felt that such an arena was a necessity, not a luxury for the Romans.

The Colosseum was not Rome's first sports arena. The tradition of ritualized combat between armed men (gladiators) or between men and animals existed as far back as the Etruscans and had flourished during the Roman Republic and under earlier emperors. Although others had tried, Vespasian was the first emperor to build a permanent, monumental site for these combats.

The architectural genius who designed the Colosseum is unknown. In imperial Rome it was the patron who counted; the architect often was merely an anonymous employee. Precisely when work began on the Colosseum is uncertain, but it must have been near the beginning of Vespasian's reign, perhaps about 72 A.D. Work proceeded swiftly, and the structure was more or less completed by 80 A.D., when the dying Vespasian, along with his son and successor Titus, inaugurated it with a mind-boggling orgy of slaughter that went on for one hundred days.

The Roman historians Suetonius and Dio Cassius have left us detailed descriptions of these events: first, the fabulous parade featuring Roman officials, animals, dancers, priests, and images of the gods, followed by the emperor himself; then, the incredible carnage that followed. It started with a mass slaughter of wild animals let loose in the new arena and hunted down. Suetonius claims that

five thousand animals were killed in just one day. Next came the human fighters, various types of gladiators, ranging from those in full armor and bristling with heavy weapons to slender, agile men armed with nothing more than nets and their own skill. And yes, they really did march up in groups to the imperial box and deliver their grim greeting to the emperor: *"Morituri te salutamus"* (We who are about to die salute you). The combats opened and ended to the harsh blaring of Roman war trumpets.

At the culmination of each fight, in theory the emperor had the right to decide if the fallen combatant should live or die, but in practice the mood of the crowd determined his decision. If thousands of thumbs went up, the emperor would graciously spare the defeated man's life, but if the crowd was feeling mean and the signal was "thumbs down," the emperor would indicate that the victorious gladiator should finish off his rival. And so on and on it went. Here was imperial Rome at its bloody and brutal worst, celebrating the opening of one of the most brilliant and influential structures the empire ever produced.

But we are getting ahead of the story. The architect's first task, before he could begin any construction, was to drain Nero's artificial lake into the Tiber; he did it so successfully that the site has never suffered any subsequent water damage. A phenomenal knowledge of hydraulic engineering was just one of the skills possessed by the architect. The amount of building material that went into the Colosseum is indeed colossal. Scholars have estimated that close to 300,000 cartloads of a local stone called travertine were needed just to face the external walls and that the building as a whole required more than 750,000 tons of common stone, 8,000 tons of marble, and 6,000 tons of concrete.

Such figures are difficult to imagine so it may help to consider the present state of the building. The Colosseum looks today as if something monstrous has been munching on it and has eaten away a good portion. The immense structure still standing represents the leftovers, for the building was used as a stone quarry for a thousand years—from the 500s until 1597, when Clement VIII officially (although not very successfully) banned the practice. By that time it had already provided stone for the rebuilding of St. Peter's, several great Renaissance palaces, and a large number of minor buildings.

Vespasian's architect proved equally efficient in designing the entrances, exits, and seating systems. There are eighty *vomitoria*. Popular myths to the contrary, these have nothing whatsoever to do with gluttonous ancient Romans regurgitating their food; they are the aptly named entrance/exit staircases and archways, all carefully numbered, which ensured that the vast stadium would fill and empty in an orderly fashion. All spectacles at the Colosseum

were free, but to assure crowd control each spectator received a numbered chit corresponding to a specific, numbered gate: one of the archways on the ground level. These Roman numerals are still in place on some of the archways. The Colosseum can hold fifty thousand people and some experts have calculated that the *vomitoria* could, so to speak, spew them all out in five minutes. The architect even saw to it that no spectators would collapse from sunstroke. Around the top of the stucture was a huge canvas awning. The process of extending this out over the audience and then reeling it back was so complicated that the task was always performed by highly skilled sailors from the imperial navy, the only people who could be trusted to "know the ropes."

Given the raw violence and mayhem that went on at the Colosseum, it is a wonder that most days did not end in riots and destruction. The organizational genius of the architect, however, prevented such happenings. There were five seating areas, segregated by class. The aristocrats held the best seats, closest to the action, and the *plebs*—Rome's ordinary citizens—had the ones higher up. Places of honor were reserved for the senators. The emperor, along with his family and his favorites, as well as the Vestal Virgins and the chief priest (the Pontifex Maximus whose title would one day be taken over by the popes), occupied the imperial box. The architect banked mass upon mass of seats steeply up some three hundred feet, interspersing them with a system of dividing walls that discouraged climbing and roaming about. Around the inside perimeter of the arena was a wall just high enough to prevent animals from leaping into the lower range of seats and overly enthusiastic spectators from leaping down into the arena, but low enough not to block anyone's view. There were also special balconies and catwalks patrolled by guards armed with bows and arrows. Their orders were to shoot animals—or spectators—who got out of control. The greatest tribute to the architect's design, however, lies in the complete absence of any records of riots at any time during the history of the building.

Who did the actual work of building the Colosseum? One frequently repeated but mostly erroneous answer is slave labor. The Romans used slave labor, of course, as did virtually every other ancient culture, but a significant portion of the work crews of imperial Rome consisted of skilled artisans, craftsmen, and groups of common laborers drawn from the general population and paid for their work. Scholars believe the slave labor employed on the Colosseum consisted of several thousand Jewish captives from the recently concluded war in Judaea. Today, certain of Rome's oldest Jewish families proudly claim descent from the captives brought to Rome by Titus and employed in the construction of the Colosseum.

Another and even more tenacious legend is that the Colosseum

was the site of innumerable bloody martyrdoms of early Christians. Modern scholars reject this assertion, and even the Catholic Church does not claim that any martyr definitely met death there. By the time the Christians were numerous enough to attract the negative attention of the Roman state, the games were in decline in Rome. Although the image of defenseless Christian men, women, and children being thrown to the lions is compelling, there is no evidence that this ever happened in Rome. Where, then, do these stories come from? Probably some Christians met their deaths this way in the Roman provinces, particularly in North Africa, where outbreaks of anti-Christian violence were much more frequent than in the imperial capital. Furthermore, the early Christians themselves seem to have felt a strange, ambivalent attraction to the blood sports of the arena. Some, to the shock and bafflement of their pagan contemporaries, were eager for this violent death, believing it would ensure their entrance into heaven. Early accounts of martyrdoms, many of them semi-legendary, often feature hair-raising accounts of death in the arenas of Roman provincial cities.

Constantine abolished the gladiatorial games not just in Rome but throughout the empire. He issued this edict in 326, probably in response to Christian pressure, but it is unlikely he was inspired by Christian piety or pity. His edict went on to indicate that the criminals who would have faced death in the arena would henceforth be sent to an equally certain but considerably slower death as slaves in the imperial mines. Furthermore, the entertainments of the arena were becoming an increasing burden on Constantine's treasury. The Christians merely gave him an excuse to do something he wanted to do anyway. It was the collapsing economy of the empire, and not Christian conscience, that finally put an end to Roman blood sports.

Eventually the Colosseum was abandoned, despoiled of its statues and decorations, its marble and travertine facings recycled into Christian buildings; even the metal clamps that reinforced its stonework were pried out. Its bulk became overgrown with weeds and trees. The vast subterranean chambers, which had once housed a miniature city—storerooms, kitchens, latrines, barracks for the gladiators, cages for the wild animals, an ingenious system of lifts that brought the animals up to the arena, and an equally efficient system of service rooms and passageways for disposing of the carcasses and corpses—all collapsed and slowly filled with rubble. But the damage of the centuries did nothing to dim the fame of the great arena. In ruins, its mythic qualities became even more powerful.

Medieval pilgrims to the battered remains of the Eternal City wrote of the Colosseum with awestruck admiration. Renaissance

architects copied its architectural elements even as they stole its stonework. Painters sketched it and innumerable poets, Lord Byron among them, rhapsodized over it. Excavation efforts started in the eighteenth century and increased in the nineteenth, accompanied by small-scale attempts at restoration. But it was Mussolini in the 1920s who finally stripped the Colosseum of 1,500 years of incrustations. With brutal efficiency the Fascists cleared the whole district and drove a broad new boulevard, now called Via dei Fori Imperiali, through the area. This exposed the stonework to hazards almost as harmful as the barbarians of earlier centuries: vibrations and automotive pollution. Although the immediate area around the Colosseum is now partially closed to traffic, the disintegration of the edifice continues. Considering all the crises proliferating today, perhaps we should heed the warning issued by that English monk, so many centuries ago: if the Colosseum falls, Rome will fall and take the world with it.

Suggested reading

John Pearson, *Arena: The Story of the Colosseum* (New York, 1973).

WHEN ROME RULED THE WORLD
The Age of Trajan

Let others meld and mould the breathing bronze to forms more fair,
Or trace with pointed wand the starry heavens.
But thou, O Roman, learn with sovereign sway to rule the world.

—Virgil, *Aeneid*

When Virgil wrote his words of praise in the late first century B.C., the Roman Empire was still growing. A little more than a century later the poet's proud boast came true and Rome indeed ruled the world as it was known to Europeans of that period, stretching from Spain in the west to Egypt and Mesopotamia in the east and from Scotland and Germany in the north to the Sahara Desert in the south. The empire reached its greatest extent during the reign of Marcus Ulpius Nerva Traianus, known to us as Trajan (98–117 A.D.). Some of Rome's best-preserved and most impressive monuments are those of Trajan's time.

After the assassination of the tyrannical and unpopular emperor Domitian in 96 A.D., the Senate chose a frail old man named Nerva to head the Roman state. Since he had no sons, Nerva adopted a successor and made a wise choice: the general Trajan. With the aid of accounts provided by Pliny the Younger and Dio Cassius, modern historians have pieced together a biography of Trajan. The first Roman emperor not a native of Italy, he was born in 53 A.D. in the province of Hispania (Spain), in a small town near Seville. His father was a Roman settler and his mother a local

woman. Statues and portrait busts show a robust, handsome man, probably of more than average height.

In addition to an impressive physical appearance, Trajan was energetic, practical, loyal, and experienced in both military and administrative matters. Although not an intellectual and subject to moments of grandiosity, he also must have been unusually fair-minded, to judge from his being the only pagan emperor enshrined in Christian legend. According to this story Trajan showed justice to a widow who had asked his aid in avenging the death of her son. Centuries later, Gregory the Great (590–604) heard this story while standing in Trajan's Forum and prayed that Trajan might be relieved of the eternal torment in hell he was condemned to suffer as a pagan. St. Peter heard the pope's prayer and assured him that his plea for Trajan's salvation had been granted, but warned him not to make any more such requests.

Although Trajan sponsored public works projects throughout the empire, many of the greatest monuments to his rule are in Rome. Trajan's Forum was the last and largest of the forums constructed by Roman emperors. Once one of the city's marvels, it is today a bewildering and half-buried ruin. The battered stumps of columns are all that remain from Trajan's great hall of justice, called the Basilica Ulpia in honor of Trajan's family name, Ulpius. The buildings—the Basilica Ulpia and two flanking libraries, one for Greek and the other for Latin books—were roofed with gilded bronze and adorned with innumerable statues. In addition to white marble, many of the columns were of veined or colored marble, interspersed with red and gray Egyptian granite. Soaring above the roofline of the Basilica Ulpia and between the two libraries, was the 128-foot-high Column of Trajan. Although damaged by pollution, it is still relatively well preserved.

It is a striking indication of the empire's international character in the second century A.D. that this forum was designed in Rome by a Greek from Syria for an emperor born in Spain. Trajan's architect, Apollodorus of Damascus, is one of the few imperial architects known by name, and his fame is justified. Trajan's Forum, begun in 107 A.D., awed contemporaries and remained one of the city's major attractions for at least five hundred years. It was still in relatively good condition in the sixth century, when Pope Gregory had his vision there of the Justice of Trajan. Perhaps the nobility of its architecture inspired noble acts. This was a place where Roman masters freed their slaves, where the emperors Hadrian and Aurelian burned lists of debtors and political prisoners, and where the emperor Marcus Aurelius auctioned off imperial treasures to avoid raising taxes to finance a war. From a poem by Venantius Fortunatus, who died in 609 A.D., we know that Romans of that time still gathered in Trajan's Forum to listen to Virgil's poetry being read aloud.

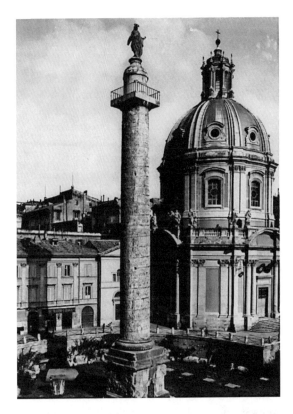

Column of Trajan. The relief sculpture on the column offers an unparalleled record of Roman military tactics, weapons, rituals, and codes of conduct and provides an account of the emperor Trajan's military victories over the Dacians.

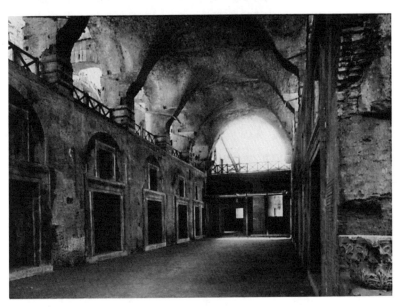

Markets of Trajan, interior. Trajan's immense markets were the world's first multilevel indoor shopping mall, the site of nearly two hundred shops that sold goods from all over the empire.

The creation of Trajan's Forum and its adjoining markets brought to fruition an enormous urban planning project, that of linking together two sections of Rome which had always been separated by a tall, narrow natural ridge of tufa rock, running from the Quirinal Hill to the Capitoline Hill. Apollodorus had the ridge cut out and carted away to make the level area for Trajan's Forum. Archaeologists estimate that some 800,000 cubic meters of stone and rubble had to be removed. An inscription on the base of Trajan's Column states that its height (128 feet, including the base) marks the original height of the ridge.

Abutting the west end of Trajan's Forum are the Markets of Trajan. This remarkable complex, whose original extent is unknown, still has 170 rooms extending in curving, radiating blocks arranged in tiers up the slope of the Quirinal Hill. The markets survive because various Christian organizations took them over in the early Middle Ages and used parts of the immense structure for convents. There are six levels, and visitors soon realize that they are in the world's first multilevel indoor shopping mall.

About 150 of the rooms were used as booths, stores, and offices. Merchants probably sold wine, oil, and flowers on the first floor and imports such as perfumes and spices on the second, which leads out onto a street called Via Biberatica, a name perhaps derived from *pipera,* the Latin word for "pepper." On the third level was the state welfare office; from here officials distributed food and money to the city's poor. One of Trajan's notable achievements was the institution of the *alimenta,* a system of providing food and funds to poor children, in addition to the adults already benefiting from the imperial dole. The fourth floor was for fish. There were two ponds, one with salt water piped in from the sea at Ostia, the other supplied with fresh water from an aqueduct. Two subterranean levels contained passageways for the carts that brought in produce and products and took away the day's garbage during the night.

Interesting as the markets are for the insight they offer into ancient Rome's daily life, it is the Column of Trajan that supplies priceless information on imperial history. Since Trajan's commentaries on his two Dacian campaigns are lost, we have to reconstruct them from the accounts of later Roman historians and the reliefs on the column. The sheer volume of data is prodigious. The column is a veritable hymn to the Roman army. From it we learn about tactics, weapons, uniforms, supplies, ships, and bridges. But the images of the column provide even more; we find out about military customs, rituals, and codes of conduct, as well as Roman soldiers' attitudes toward duty, authority, death, patriotism, and their enemies. Although the Romans had no love for enemies, they respected them and never made them into subhuman carica-

tures or monsters, which cannot be said for many modern states.

Roman attempts to expand the empire north of the Danube River, the border between modern Bulgaria on the south and Rumania on the north, generally came to grief. The tribes living to the north of this area, whom the Romans called the Dacians, were fiercely independent. The Dacian leader, Decebalus, had made peace with the emperor Domitian in 92 A.D., but by the beginning of the new century there came renewed rumblings of war from Dacia, which led to Trajan's first Dacian campaign, conducted between 101 and 102 A.D. and recorded on the lower half of the column. A second campaign, between 105 and 106, takes up the rest of the relief.

The Column of Trajan has been one of the city's major treasures ever since its dedication in 113 A.D. Generations of artists have studied its relief sculpture, and it made a particular impression on early Christian and medieval mosaic makers, who saw it when its reliefs were still brightly colored and highlighted with gold. The column consists of ten hollow marble drums, each about ten feet high and eleven feet in diameter, placed one on top of the other. The base, adorned with reliefs of captured Dacian weapons, houses a small chamber that once held a golden urn containing Trajan's ashes and those of his wife, Plotina. An internal spiral staircase, part of the drums, curls its way to the top of the column, once crowned by a statue of Trajan. A statue of St. Peter, erected at the orders of Sixtus V in 1588, now stands there. The designer of the column was probably the same Apollodorus of Damascus who designed Trajan's Forum, but the work of carving the reliefs must have been done by a large group of sculptors. The level of craftsmanship is uniformly high.

Today it can be difficult to see the reliefs on the column and it cannot have been a great deal easier in antiquity. Color would have made the figures stand out more clearly, but the column's height would have made the reliefs far above eye level impossible to read. Perhaps they were designed to be viewed from the balconies of the flanking Greek and Latin libraries, but even then, those viewing the reliefs would not have been able to see more than a segment of the cylinder at each level. Maybe the reliefs were made in the same spirit as the scenes on the high windows of Gothic cathedrals, which were visible only to God; it may have been enough to know that the story was there. Today, the best place to study the details of Trajan's Column is in the Museo della Civiltà Romana, in the Roman suburb of EUR (Esposizione Universale di Roma). There, a complete set of plaster casts arranged at eye level enables the visitor to get an excellent close-up view of the relief sculptures.

The relief on the Column of Trajan unfurls like a gigantic

length of upward-spiraling film. The band of relief is about three feet high at the foot of the column; it slowly expands to four feet high at the top to compensate in part for its distance from the viewer. If laid out end to end it would total more than 650 feet. It contains some 2,500 human figures, as well as images of architecture, military equipment, rudimentary landscapes, and animals. Although the narrative is continuous, the scenes are punctuated by ninety separate appearances of Trajan.

The campaign of 101–102 begins at the bottom of the column, with soldiers loading provisions onto ships: barrels of wine and the cereals used to make porridge, a staple food of the Roman legions. Next, the troops prepare to march over a bridge, seemingly held up by the head and torso of the enormous river god who personifies the Danube. Once across the bridge, the soldiers participate in a *lustratio,* a ritual of purification by sacrifices to the gods, and then listen dutifully to the *adlocutio,* a speech by their commander, Trajan. Then comes the first of several battle scenes, this one a Roman victory in which Jupiter, portrayed in the sky, sends thunderbolts against the Dacians. Perhaps this battle really did feature a thunderstorm; in any case there is no doubt whose side the gods are on.

A little further on a Roman soldier—naked to the waist, half-submerged in water, and with a long-suffering expression on his face—fords a river with his gear, including a dagger and helmet, balanced in his shield. More battle scenes follow, punctuated by scenes of river transport and Roman soldiers building a fortified encampment. After more battles and more Roman victories, we see several Dacians surrendering to Trajan.

The Dacians probably won some individual skirmishes, but no Dacian victory is ever shown. That the Romans suffered casualties and that the Dacians took prisoners we find out from a horrifying scene in which a group of Dacian women, with exultant expressions on their faces, hold flaming torches to the heads and bodies of naked, bound Roman captives. In another scene Roman soldiers bring Trajan the severed heads of two Dacian commanders. Eventually, in the spring of 102, Trajan's troops win a decisive victory and the Dacian leader sues for peace. Still tall and proud, Decebalus stands undaunted before Trajan. The first campaign ends with the image of a winged female who personifies victory writing on a shield encircled by a laurel wreath.

The second campaign, made necessary when Decebalus regrouped and captured several Roman garrisons, shows many similar scenes, with ships leaving Trajan's Adriatic port of Ancona, and then more crossings of bridges, sacrifices, speeches, and battles. Trajan himself ages in the course of the campaigns. Trim and still youthful looking at the opening of the first campaign, by the sec-

ond time around the commander in chief looks older and battle weary, his body thickened and his face deeply lined. In one scene we see him conferring with an aide, probably Lucius Licinius Sura; the younger man's thick, curly hair and smooth, handsome face contrast tellingly with Trajan's lank hair and haggard visage.

The second campaign is longer and more difficult than the first. Dacian resistance remains stubborn, but finally Roman troops storm the Dacian capital. Although many Dacians commit suicide, Decebalus escapes and the war goes on. Some Dacians surrender, bringing gifts to Trajan, and his acceptance of these marks his last appearance on the column. The drama now shifts to the Dacian king. As Roman cavalrymen pursue him, the still proud but now desperate Decebalus stumbles to the ground and, glaring defiantly into the face of an oncoming horseman, plunges a curved dagger into his own neck. Soldiers bring Decebalus's severed head into the Roman camp; a few more stray Dacians are captured, their camps are burned, and the Roman army marches toward home. The last images of the defeated Dacians are unforgettable in their expressiveness. Bearded men with deep-set eyes and high cheekbones, their faces full of sorrow and despair, they are shown with the sympathetic respect Rome always extended to worthy adversaries.

The last scene is the silence that follows war. The tumult and the shouting have died down, the captains and the kings have departed. Only animals remain—a wild boar roots in the ground, a goat munches grass. The frieze narrows upward to its final image of a stunted little tree. The Dacian war is over.

The successful end of the Dacian campaigns brought Rome a huge haul of captured gold and silver, which Trajan used to finance his vast building programs in Rome and throughout the empire, but it also brought a new, long frontier that would ultimately prove impossible to protect. But for the moment, at least, Rome ruled the world.

Suggested reading

Julian Bennett, *Trajan, Optimus Princeps: A Life and Time* (London, 1997).
Lino Rossi, *Trajan's Column and the Dacian Wars* (Ithaca, 1971).

THE PANTHEON
Temple of the Whole World

Once, while I was sitting at the base of the fountain in the center of Rome's Piazza Rotonda, I saw an exhausted young American join a group of his friends who were sprawled around the fountain. In one hand he held a limp, tattered map of Rome and with his free hand he jerked his thumb over his shoulder in the direction of the massive pile of masonry behind him. "What's that?" he asked, not sounding like he cared very much.

When none of his companions answered him, I had to resist the temptation to jump to my feet and tell them that they were a few yards away from one of the greatest buildings in the world—the Pantheon—an architectural marvel of ancient Rome equal to the pyramids of Egypt, the Gothic cathedrals of northern Europe, or our glass and steel skyscrapers. And if they went inside, they would experience one of the most stupendous spaces ever conceived and executed by human mind and hand.

At first sight the Pantheon can look dreary and forbidding. Long ago stripped of its splendid bronze decoration, its high base now at street level, its battered entrance portico often littered with garbage and host to souvenir stands and street people, the Pantheon seems an unlikely candidate for a list of all-time-great buildings. But its impassive exterior offers barely a hint of what will greet the visitor who passes through the doors to the awesome space within.

What is, or was, the Pantheon? Who built it, and when, and how, and why? Some of these questions can be answered with surprising ease, others can scarcely be answered at all. Like many great works of art, the Pantheon has its mysteries.

Across the front is an inscription in huge bronze Roman capital letters, modern but faithful reproductions of the original ones. It ought to help us, but instead it turns out to be misleading.

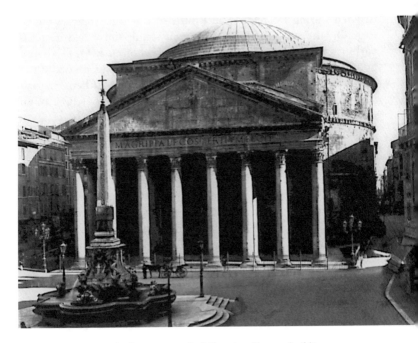

Pantheon. The best preserved of all ancient Roman buildings,
the Pantheon originally was a temple dedicated by the emperor Hadrian
to the major Roman gods.

Many visitors summon up their high school Latin and deduce that the inscription M·AGRIPPA·L·F·COS·TERTIUM·FECIT means that a man named Marcus Agrippa, the son of Lucius, built the Pantheon when he was consul for the third time. This translation is correct, but the information, at least with reference to the present building, is wrong. The inscription refers to a previous building that stood on the same site.

What kind of peculiar person would have a deliberately misleading inscription placed upon an important public building, an edifice that he himself had ordered built? The emperor Hadrian (117–138 A.D.), one of the most complicated and contradictory rulers of Rome, commissioned the Pantheon. Highly educated,

cultured, and intelligent, in love with classical Greek culture (and a Greek boy named Antinous), Hadrian was a poet and an architect as well as an outstanding administrator. A restless and difficult person who spent much of his reign traveling, he seems to have inspired respect but little love. He had a great passion for architecture, and ruins of the buildings he commissioned are scattered throughout the lands of the Roman Empire.

In a curious kind of reverse vanity he sometimes ordered his name omitted from the inscriptions on public buildings constructed during his reign. The Pantheon was one of those buildings. On the site where the Pantheon stands today had been an earlier sanctuary of the same name (*Pantheon* means "all the gods"), built by Marcus Agrippa, the son-in-law and adviser of the emperor Augustus, and dedicated around 25 B.C. When Hadrian decided to replace this sanctuary he repeated Agrippa's inscription on the new building. The most likely explanation is that Hadrian wished to honor the first building and its builder as well as, by extension, the first emperor, Augustus.

Archaeologists are able to date the Pantheon by means of brick stamps. The city's brickmakers stamped a certain number of their bricks with the names not just of the brickyards but also of the highest-ranking government officials (the consuls) currently in office. Since we know the dates of consuls' annual terms of office from other sources, we can date bricks bearing individual consuls' names. In the brickwork of the Pantheon most stamps date from the early 120s, and a few from the later 120s, which suggests that the enormous structure went up with considerable speed. The architect is unknown, but whoever he may have been, he was a genius.

The Pantheon owes its survival to its consecration as a church in 609 A.D. In the depths of the Dark Ages, when the splendid imperial capital of nearly a million people had dwindled to a ruinous and impoverished town of about 30,000 inhabitants (some say as few as 15,000), Boniface IV rededicated the Pantheon as the church of Sancta Maria ad Martyres. According to legend, "a multitude of devils" fled shrieking through the oculus—the great circular window in the center of the domed roof—the moment this pagan temple became a Christian church.

The conversion of the Pantheon into a church made it eligible for whatever limited maintenance the medieval papacy could provide. Although popes and emperors from time to time helped themselves to the building's bronze decorations, the basic soundness of the Pantheon's construction, combined with maintenance efforts, saved it. While the rest of Rome crumbled, the Pantheon survived and today it is by far the best preserved of all ancient Roman buildings. The reason it looks as if it has sunk into the pavement is that the street level around it has risen so much. The

collapse of nearby buildings, the flooding of the Tiber, and the cessation of the city's sanitation and other public services during the medieval centuries caused the rise in the ground level.

From the front the Pantheon looks like a Roman temple. A porch consisting of columns with foliage-form capitals, a frieze above them with the inscription referring to Agrippa, and the shallow triangular unit known as a pediment on top are the features that disguise a profoundly original building. Behind its facade lies not the expected rectangular and flat-roofed Roman temple, but an immense, domed cylinder. Between the porch and the cylinder is a third feature called, for lack of any better term, the intermediate block. This feature connects the square portico to the cylindrical body of the Pantheon. It is as wide and slightly less than half as deep as the porch, and as high as the cylinder. Today the modern Piazza Rotonda, which takes its name from the Pantheon's cylindrical body, extends right up to the porch. In ancient times, however, there was a paved forecourt, some four hundred feet long, surrounded on three sides by covered colonnades.

Hadrian spared no expense in the construction of the Pantheon. The outside of the dome was originally covered with gilded bronze tiles, but those were stripped off and taken away in 663 A.D. by the emperor Constans II. Sheets of lead now cover the dome; no wonder it looks dingy. The gigantic columns of the porch, each weighing forty-eight tons, were originally all monoliths (carved in one piece) made of red and gray granite quarried in Egypt. They have beautifully carved capitals and bases of white marble. Three fell and were replaced in the seventeenth century by red granite columns pilfered from the ruins of the nearby Baths of Alexander Severus. The inside of the porch roof contains a system of trusses and vaults, mostly dating from the seventeenth century, when Urban VIII had all the bronze stripped off the roof of the porch. According to one account the nearly two hundred tons of bronze went to cast eighty cannons for the papal fortress, Castel Sant' Angelo, but it is likely that the sculptor Bernini used most of it to cast the Baldacchino, the towering altar that stands under the dome of St. Peter's.

The intermediate block, the cylindrical rotunda, and the dome of the Pantheon are made almost entirely of concrete, a material the Romans did not invent, but which they perfected, and without which it would be hard to imagine the subsequent history of western architecture. The bricks that cover the exterior of the cylinder form a protective skin over the concrete. The Romans rarely left their monumental buildings with the brickwork showing; in ancient times the exterior of the rotunda may have been covered with stucco, or faced with marble or travertine, but if so, the covering disappeared long ago. There are also thick, strong vaults made of brick embedded in the concrete of the rotunda

cylinder, to help distribute the staggering weight of the dome. From outside these are visible on the upper part of the rotunda.

Some curious little windows and other openings occur in the rotunda and the intermediate block. Visitors are often puzzled by them, since they are not visible from the interior. Many rooms and passageways, none of them open to the public, honeycomb the Pantheon's structure. Their purposes are uncertain, but most were probably used by the maintenance crews who took care of the building. According to William L. MacDonald, the world's foremost expert on the Pantheon, the windows are not there just to let light into the service rooms; they are there, literally, to let the building "breathe"—to allow air to circulate so moisture cannot collect and to keep Rome's blistering summer heat from building up and expanding and ultimately cracking the cast cement.

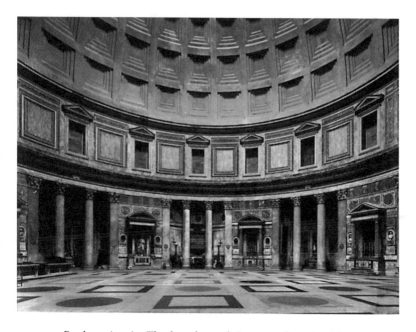

Pantheon, interior. The domed rotunda is a vast and awe-inspiring space.

After walking through the porch, the visitor encounters an immense set of bronze doors, which are original but somewhat restored and framed in white marble. Stepping over a threshold made of a huge block of portasanta marble and passing under a barrel-vaulted portion of the intermediate block, the visitor steps at last into the vast, uninterrupted space of the domed rotunda. This experience still leaves me standing in speechless awe, no matter how many times I repeat it.

No other enclosed space has quite the immediate impact of this one. Even the highest Gothic cathedrals—Chartres, Amiens, Cologne—need to be walked through slowly and their complex interplay of space, light, and mass perceived in increments, through time and the shifting of the observer's position. Not so the Pantheon. A single sweeping glance takes in the entire space. But it is an expanse far too large to be quickly grasped. The details come later. On ground level eight large recessed spaces pierce the continuously curving wall surface: one is the entrance, another is the semi-circular apse directly across from it. The other six are disposed to the right and left of this axis. Originally these niches held statues of the major Roman gods; today they contain statues of Christian saints.

The interior of the Pantheon resembles a giant, continuous, circular stage set for the performance of cosmic dramas. Nearly 1,500 years of Christian occupancy have done little to change it. Although the Pantheon is officially a church, it never seems like one. All the altarpieces, frescoes, and statues of saints become insignificant in this setting. The colored marble, the tons of somber cement, breathe an imperial hauteur that reduces centuries of Christian accretions to triviality.

Originally the entire interior wall surface of the Pantheon was encased in a sheath of multicolored marble panels—no garish hues here, only deep, rich tonalities. A subdued golden orange predominated on the walls of the rotunda, with accents of dark red porphyry and green-black marble, with discreet touches of gold. The bland painted stucco decorations on the second level date from the eighteenth century; a small restored section shows how much more lively the original design of this zone once was. The floor paving, an accurate nineteenth-century reproduction of the original, consists of alternating circles and squares of colored marbles and granites. There are no secret chambers below the floor, only an ingenious drainage system.

The climax of the Pantheon is the dome. Pierced at its center by a thirty-foot-wide circular opening called an oculus, the building's only light source, the dome is the architect's greatest triumph. About 150 feet in diameter and 150 feet at its highest point, the dome seems considerably bigger. This effect is due in large part to the coffering: the recessed series of box shapes impressed into the dome's surface. Looking up into this immense canopy it is easy to understand why people in the Middle Ages believed the dome had been built by devils, for it really does seem an achievement beyond human capacity.

How did the Romans do it? They had no need of infernal aid in this building project; besides his own extraordinary expertise, Hadrian's architect had at his disposal a virtually unlimited pool of skilled and unskilled labor, a veritable forest of scaffolding, and

some five thousand tons of concrete. The dome was built by pouring successive rings of concrete around and into a previously constructed and extremely strong wooden framework, the latter supported by immense numbers of huge beams and struts.

But the wooden forms were only the means to an end. The huge dome, with its blazing eye, captures sunlight and makes it into our central experience of the building. As one watches, the great cylindrical shaft of sunlight that pours through the oculus moves with majestic slowness, illuminating first one and then another segment of the interior, like a supernatural spotlight. Perhaps it is some unique quality of the Roman air, this property of holding light, of making it into something almost tangible and ultimately mystical. In this numinous place the visitor scarcely needs to be religious to feel somehow in the presence of divinity. As MacDonald put it, in prose that rises almost to poetry:

> The Pantheon was made for light. . . . It was the prize for which all this concrete was poured. The architect shaped his building to form and manipulate a great shaft of illumination, a visible, almost tangible rod of solar effusion. . . . Everything in the building is subordinated to it. As the earth rotates, Hadrian's sun show spins on.

The Pantheon may have had some further meaning, beyond its function as a temple to all the gods. We know that Hadrian sometimes used it as an imperial audience hall, and we can well believe that this emperor, who had a highly developed sense of the dramatic, timed his entries into the building to coincide with the moment (approximately 11 A.M., but changing with the season) when the solar spotlight falls on the entrance.

But the ultimate meaning of the Pantheon transcends such personal concerns. With its seamless, circular design, with its all-encompassing and protective dome, the Pantheon is a perfect metaphor of unity, continuity, and eternity. Perhaps Hadrian saw it as a symbol of the empire itself: the perpetual unity of gods, peoples, and states under the dominion of Rome. The Pantheon has a uniquely ecumenical quality and resists being commandeered by any religion. Built in honor of pagan gods, then rededicated to the Christian God, it transcends doctrines and dogmas. In the universality of its circular forms it belongs to everyone: truly, in MacDonald's words, "the temple of the whole world."

Suggested reading

William L. MacDonald, *The Architecture of the Roman Empire*, vol. 1 (New Haven, 1982).
William L. MacDonald, *The Pantheon: Design, Meaning, and Progeny* (Cambridge, Mass., 1976).

ROMA AMOR

VI

CASTEL SANT' ANGELO
The Tomb by Many Other Names

I was taken into a gloomy dungeon . . . which swam with water,
and was full of big spiders and many venomous worms.
They flung me a wretched mattress of coarse hemp,
gave me no supper, and locked four doors upon me.

—Benvenuto Cellini, *Autobiography*

What's in a name? Plenty, when the name is Castel Sant' Angelo. The huge circular mound of masonry that stands near the west bank of the Tiber not far from the road leading up to the front of St. Peter's has had many names and many uses during its nearly 1,900 years of existence. Although it began as a tomb, it became a fortress, a prison, and then a papal apartment complex. The most recent transformation turned it into a museum. It has been the site of murders and battles, theatrical productions and opera acts, fireworks and firing squads.

The original purpose of Castel Sant' Angelo was as a tomb for the emperor Hadrian and his family. Work probably began in the 120s A.D., about the same time as construction commenced on the Pantheon. To imagine *both* gigantic structures underway at the same time for the same patron gives some idea of the resources at the disposal of a Roman emperor. Progress on the tomb was slow. Hadrian died in 138 A.D., but his mausoleum was not completed until the following year, during the reign of his successor, Antoninus Pius.

The idea of a person building himself a tomb while he is still

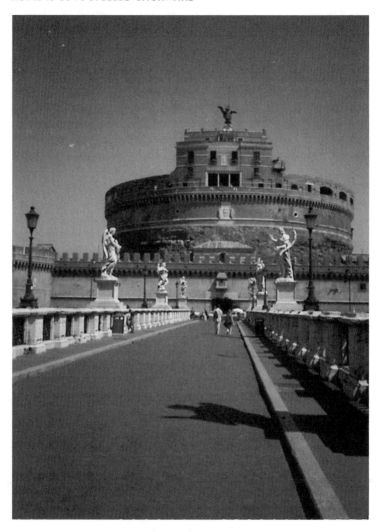

Castel Sant' Angelo. Originally designed as a tomb for the emperor Hadrian,
the building has served as a fortress, prison, papal apartment complex,
and finally, museum.

alive would strike most of us today as exceedingly morbid, but
Hadrian had ample precedents. About a century earlier, the Ro-
mans had swallowed up Egypt, the site of the grandest funerary
monuments of them all—the Pyramids—which Hadrian had seen
on his travels through the empire. In Rome the family tomb of
the emperor Augustus stood near the right bank of the Tiber, to
the northeast of the site Hadrian chose for his own monument.
Like Hadrian's tomb the mausoleum of Augustus was a round

structure originally faced with marble, crowned with a mound of earth planted with cypress trees and topped with a bronze statue of Augustus. Its dismal remains, surrounded by Mussolini-era buildings, today form the center of one of Rome's least attractive squares, Piazzale Augusto Imperatore.

The spot Hadrian picked out was on the opposite side of the Tiber, however, on the edge of a desolate area called the *ager vaticanus,* the Vatican fields. A few hundred yards to the west was the Circus of Nero, originally a race course of that emperor but used also for the public execution of Christians. Nearby were some scattered, relatively poor burial sites, including that of the Jewish fisherman whose faith that Jesus of Nazareth was the Messiah had brought him from Galilee to Rome and who had died about 65 A.D., crucified upside down in Nero's Circus. Although Hadrian of course was unaware that he was building his family mausoleum a few hundred yards from the grave of St. Peter, this coincidence would eventually link Hadrian's tomb with the papacy and determine much of the monument's future history.

Unlike the Pantheon, Castel Sant' Angelo was never consecrated. As a result so many changes have been made over the centuries that no one is sure of its original appearance. What remains of Hadrian's structure is a 300-foot-square concrete base surrounding a massive cylinder made of travertine stone only slightly smaller in diameter and nearly 70 feet high. Whatever was above this cylinder has disappeared, but archaeologists think it may have looked like a much larger version of the mausoleum of Augustus. The cylinder, once faced with white marble and decorated at its upper perimeter with relief sculpture and statues, probably resembled a gigantic planter, with an earthen hill covered with cypress trees on top, and surmounted by a huge gilded four-horse chariot driven by an equally colossal golden statue of Hadrian.

Hadrian's attempt to assure his immortality through this monument ultimately was a failure. The building's function as a memorial to Hadrian lasted little more than a hundred years. About 271 A.D. the emperor Aurelian ordered the construction of defensive walls around Rome and in his haste to get them in place he ordered his masons to incorporate anything in the walls' path that might serve the city's defense. Hadrian's tomb was in the way of Aurelian's wall and it had a decidedly impregnable look to it; thus began the second and longest phase of the structure's history. At this early stage Hadrian's name was still attached to the building. It was called the *Adrianum,* or sometimes the *Castellum Adriani,* as its fortress capabilities began to obscure its original purpose.

Aurelian's walls proved unequal to the task of keeping the barbarians at bay, and Hadrian's tomb was soon pressed into service as a defensive fortress. The first recorded use of the structure for military

purposes was in 359 A.D. and from then on it retained the name *Castellum*. In the year 537, in a battle against the Goths, the besieged troops of the Byzantine general Belisarius who were then occupying Rome used the statues adorning the tomb as weapons, hurling them down (quite effectively) on the invaders, one of the few recorded instances in history of death by works of art.

Another and more sinister name also came into use in the sixth century—*Carceres Theodorici*—because the Ostrogothic ruler Theodoric adapted the underground chambers of Hadrian's tomb for use as a prison. This purpose the building served only too well. Prisoners were incarcerated there by princes and popes throughout the succeeding centuries and, from the late nineteenth century until 1901, by the Italian government.

The name by which the structure is known today—Castel Sant'Angelo—goes back to the chaotic sixth century and a legend concerning Pope Gregory the Great (590–604). During a devastating epidemic of the plague the pope led a procession through the stricken city, praying for divine intervention. Near Hadrian's tomb he had a vision in which the Archangel Michael appeared on top of the structure, in the act of sheathing his sword. The pope interpreted this as meaning the plague would end, which it did. The Roman people attributed their salvation to the miraculous intervention of St. Michael the Archangel and so a new name for the site came into being, *Castellum sancti angeli*. Italianized, this eventually became Castel Sant'Angelo.

The accumulation of names continued. In the late 900s the structure received further fortification at the orders of an ambitious local warlord named Crescentius. From him the fortress received still another name, *Castrum Crescentii*, a title that persisted along with the name *Castellum sancti angeli* up through the 1400s. By the later Middle Ages the original purpose of the structure had been forgotten, and we find mention of it in French troubadour poetry under the curious appellation *Palais Croissant*. Translated literally, that would mean a crescent-shaped building, which makes no sense in reference to a round structure. The solution to the linguistic mystery is simple: the misnomer goes back to a too-literal rendering into French of the Latin name for the site, *Castrum Crescentii*.

For more than a thousand years whoever held Castel Sant'Angelo was the master of Rome, and no one understood this better than the popes, who frequently contested possession of the Castello with the city's secular powers. When the papacy returned to Rome in 1377, after its nearly seventy-year exile in Avignon, one of the conditions stipulated by the reigning pope was that the city government return the Castello to the papacy. The delegation of nobles who came to meet the returning pope approached him carrying a silver platter that contained the keys not

to the city of Rome, but to Castel Sant' Angelo.

The four tower bastions that flank the Castello were all commissioned by various popes during the Middle Ages, each tower piously named after one of the four Evangelists. In the late 1200s Pope Nicholas III Orsini, a member of one of Rome's nastiest noble families, conceived the idea of connecting the papal palace on the Vatican Hill with the St. Mark tower of Castel Sant' Angelo by means of an aboveground covered passageway constructed of stone. Its purpose was to allow the pope to escape from the unfortified Vatican Palace to the safety of the Castello in times of war or civic rebellion. It proved useful many times, since relations between the popes and the citizens of Rome were frequently stormy. Its last such usage saved the life of Clement VII, who made a dash through it during the Sack of Rome in 1527.

Clement suffered a self-imposed imprisonment in the modest apartments built into the Castello by earlier popes, and he managed to escape. Others over the centuries were not there voluntarily and few got out alive. The prison cells were terrible places in which condemned men were forced to crouch because there was neither enough height to stand up nor enough length to lie down. Executions, frequently without trial, were common.

Within the walls of Castel Sant' Angelo the man who almost succeeded in giving his name to the place (the enterprising Crescentius) was beheaded. Several early popes also lost their lives within its confines: John III (561–574) was starved to death, John X (914–928) was suffocated, and Benedict VI (973–974) was dragged inside and strangled. Cardinal Michiel, a nephew of Paul II (1464–1471), was poisoned there, and the unfortunate Giacinto Centini was beheaded, having been found guilty of trying to kill Urban VIII (1623–1644) by means of magic spells.

The Castello was a favorite place of execution for the Borgia pope, Alexander VI (1492–1503). Among his intended victims was Cardinal Giambattista Orsini. In an attempt to save the cardinal both his mother and his mistress made contact with the pope and offered him an extremely large and valuable pearl in exchange for the cardinal's life. Since Alexander loved jewels, he accepted their offer, took the pearl, and promptly returned the cardinal to his family. Everything went according to plan, except for one detail: Cardinal Orsini was already dead.

Many well-known personalities in Italian history spent time as prisoners in the Castello and at least some lived to tell about it. Among them were Bartolommeo Platina, a scholar who became the first head of the Vatican Library; Alessandro Farnese, the future Paul III; and Cardinal Gianpietro Carafa, who became the vile-tempered Paul IV—perhaps his experiences in the Castello added to his grudges against the world. Another and less fortunate prisoner was the

great scholar and freethinker Giordano Bruno, who was burned at the stake in 1600 by the Inquisition, in Piazza Campo de' Fiori. Perhaps the most famous prisoner was the sixteenth-century Florentine artist, soldier, and man-about-town Benvenuto Cellini, whose autobiography recounts his imprisonment in 1537 in harrowing detail.

During their early nineteenth-century occupation of Rome the French also used the Castello as a prison and place of execution. Opera lovers will remember the upper terrace of the Castello from the dramatic final scene of Puccini's *Tosca,* set during that period. Throughout the nineteenth century the Castello continued to serve as a prison and many rebel-patriots of the Risorgimento, Italy's liberation and unification movement, spent time there.

Not all popes used the Castello for bloody purposes. The genial Leo X (1513–1521) made it a place for presentation of theatrical entertainments. Paul III (1534–1549) had the papal apartments expanded and refurbished, turning them into a luxurious suite adorned with worldly fresco cycles. These rooms have been meticulously restored, and it is easy to imagine Paul (who as a young man had fathered numerous illegitimate children) at rest in his Castello bedroom, nostalgically contemplating his youthful indiscretions while admiring Perino del Vaga's frescoes of the erotic myth of Cupid and Psyche.

What happened to the remains of Hadrian is unknown. The room is now empty which once held the huge porphyry sarcophagus housing the urn with the emperor's ashes. The sarcophagus itself was moved down the Tiber and presently serves as the tomb of Innocent II (1130–1143) in the church of S. Maria in Trastevere. Its lid has remained nearby and today covers the remains of the Holy Roman Emperor Otto II, who died in Rome in 983 and is entombed in the grottoes under St. Peter's.

The visitor reaches Hadrian's tomb chamber by a long, circular ramp that leads down into the very heart of the Castello. This room now confronts the visitor with walls constructed from massive gray blocks of travertine. The marble facings have long ago disappeared, making the space look stark and almost primitive, not likely what the sophisticated and subtle Hadrian had in mind. Someone in modern times had the idea of attaching to one of the walls of this chamber a tablet containing the brief, poignant poem the dying Hadrian composed, addressed to his own soul. This touching memorial is the only remnant of the emperor left in his tomb.

A gigantic bronze angel in the act of sheathing his sword crowns the highest point of Castel Sant' Angelo and is one of Rome's most famous landmarks. The present angel is the sixth in a series of guardians and is relatively new. It is the work of an eighteenth-century Flemish sculptor named Pieter van Verschaffelt. The first angel, erected shortly after the miraculous apparition

to Pope Gregory in 590, was made of wood and rotted away rapidly. The next was of marble but was not secured properly, so it soon toppled down and broke into pieces. The third, also of marble, had bronze wings and was destroyed by lightning. A fourth, of bronze, suffered a particularly unfortunate fate in 1527: during the Sack of Rome, in an act reminiscent of the statue-hurling that had occurred back in the sixth century, papal troops defending the Castello melted down their guardian angel and used the bronze for cannon balls. The fifth, another marble figure with bronze wings, is now in battered condition and stands indoors. The sixth and present one has also suffered its share of indignities. In 1798 the French troops of Napoleon occupying Rome painted the angel with the red, white, and blue of the French flag, placed a beret on the poor creature's head, and renamed it "The Genius of France, Liberator of Rome." The angel underwent an extensive renovation in 1983, during which it was transported to the restorer's studio and then replaced in its lofty location three years later, both times by helicopter.

The founders of the modern Italian republic succeeded in breaking the link between Castel Sant' Angelo and the Vatican and requisitioned the old Castello for their own use. It became government property in the late nineteenth century and continued to serve as an army barracks and a prison until 1901. During this period the upper terrace was often used for displays of fireworks, despite the fire hazard this created. At the beginning of the present century an army officer, General Mariano Borgati, began a campaign to have the fortress declared an archaeological site and succeeded in having some restoration work started. As with the restoration of the Colosseum it was Mussolini who got things done; in 1933–1934 he ordered the Castello restored and adapted for use as a museum. The surrounding area was cleared of later structures, providing an unimpeded view and permitting visitors to appreciate how immense the building really is.

Despite its many names and many purposes over the centuries Castel Sant' Angelo in essence remains a monument to the emperor Hadrian. Its enormous size and the imposing qualities of its simple, circular shape, looming up as the visitor approaches it across the Ponte Sant' Angelo, are unforgettable. Like Hadrian's Pantheon, it stands as a witness to Rome at the height of its power and to Rome's remarkable ability to endure.

Suggested reading

Cesare d'Onofrio, *Castel Sant' Angelo in the History of Rome and the Papacy* (Rome, 1994).

THE BATHS OF CARACALLA
AND OF DIOCLETIAN

Bathing is good for you.

—Sign at a Roman bathhouse in the
North African city of Sabratha

Taking a bath in ancient Rome went far beyond popping into the tub for a quick scrub-up. Since only the homes of the city's wealthiest citizens had private bathing facilities, bathing was a public activity in ancient Rome, conducted in one of the hundreds of baths scattered throughout the city. A census of the first century B.C. counted 170 baths in Rome, and by the 400s A.D. the number had grown to more than 800. Most have vanished, but substantial parts of the two largest, the Baths of Caracalla (built in the early 200s A.D.) and those of Diocletian (early 300s) have survived. Built when the empire was in decline, these enormous hulks remind us that even in its waning centuries Roman culture was capable of amazing achievements in architecture and engineering.

It is helpful to have some understanding of what the baths and bathing meant to ancient Romans, because some of their attitudes about this basic human activity were quite different from ours. To the Romans, a bath represented refreshment of the mind and spirit as well as the body. It was a daily ritual; it was a social event, an opportunity to chat with friends; it was considered a vital part of any health regimen (on this subject the Romans held beliefs much like ours concerning the importance of cleanliness, good diet, and exercise);

and above all, the bath was a pleasurable sensory experience available to nearly everyone, regardless of sex, race, creed, or social position.

We know little about ancient Roman bathing practices before the second century B.C., but after their conquest of Greece in 146 B.C., the Romans adopted many Greek customs, including the belief that a daily bath is healthful and desirable. The basic idea of the public bath comes from the Greeks, and the two main sections usu-

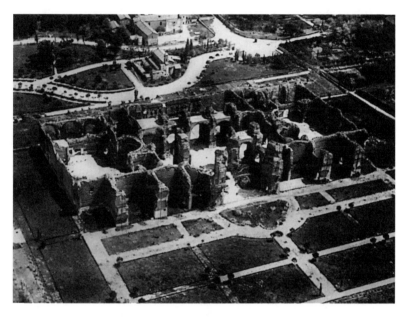

Baths of Caracalla, aerial view. Considered one of the "seven wonders of Rome," this vast bath complex was larger than some provincial Roman towns.

ally found in a Roman bathhouse bear Greek names: the *thermae* (bathing areas) and the *palestrae* (exercise areas). In Greece, however, these two places were separate and rather simple; it was the Romans who thought of putting them together and adding libraries, shops, lecture halls, and even art galleries to their sites, creating something like a city spa or community center. All Roman baths had either free access or only a small admission charge, so even the city's poorest citizens could use them. Some were subsidized by the state, others by wealthy private individuals. Public baths were reminders of the wealth and power of their builders, and yet they were also remarkably democratic, creating within their confines a classless world of nudity, relaxation, and pleasure.

Today public baths often have a rather bad reputation, unfairly associated with homosexual excesses or with people too poor to afford indoor plumbing. Some historians of the past believed the

public baths were sites of immoral behavior that led to the downfall of Rome. A long-standing city regulation, however, stated that men and women were not permitted to bathe together; women's hours were in the morning and men's in the afternoon. (The frequent re-iteration of this rule suggests that it was not always observed.)

There is little evidence to support the view that the baths con-tributed to the decline of Rome; nevertheless, they were geared to sensual pleasure. In addition to the pleasures of the bath itself were the swimming pools of various temperatures, the warm, moist air, the aroma of scented massage oils, the sunlight streaming through tall windows, the beauty of multicolored marble and mosaic sur-faces. But there were other pleasures available as well. Some an-cient Roman writers remark that prostitutes of both sexes worked the baths; other writers complain about the excessive drinking and gross behavior of some who used them. Seneca, a Stoic and a gen-eral killjoy when it came to worldly pleasures, grumbled about the numerous annoying noises emanating from a bath under his apart-ment window. Still another ancient writer describes a "love bath" with lots of wine and a rubdown, which sounds suspiciously like the activities of some modern massage parlors.

The area around the Baths of Caracalla still attracts pleasure seekers. Modern visitors, if they happen to drive past in the late evening, may be treated to the sight of numerous prostitutes, many of them garishly dressed transvestites, catering to the seamier denizens of Rome's nocturnal world. Across from the baths are two small churches, SS. Nereo e Achileo and S. Sisto Vecchio, their sturdy Romanesque bell towers jutting up aggressively from be-hind Baroque facades. Both of these modest churches were founded by the early Christians when the great, glittering baths across the way were still thronged with patrons. I can never help noticing, as I wander through the remains of the Baths of Cara-calla, that those two churches are still in use. The world of the spirit is alive and functioning within sight of the ruins of an im-mense structure devoted to the pleasures of the senses.

What was it like to patronize one of the great baths of Rome? Although many ancient writers describe the luxurious appearance of the imperial baths, today almost nothing remains beyond the brick-faced concrete shells of the buildings. But with a bit of imagination it is possible to re-create mentally the colored marble paneling, mosaic floors, bronze and marble statues, intricate stucco decoration, splashing fountains, glass windows, and polished bronze and silver fixtures. Archaeologists have produced pictorial reconstructions, some of them rather fanciful, but useful for visual-izing the various rooms.

The bathers entered through a vestibule, where an attendant collected any fee and directed them into one of the dressing

rooms, supplied with cubicles, in which clothes were left. At this point, they perhaps wrapped themselves in linen towels provided by bath attendants, and no doubt stepped into clogs since some of the floors were hot (warmed by an efficient system of below-ground furnaces). From here bathers might proceed from warm to hot and then to cold via a series of connecting rooms: the *tepidarium,* where the water was (you guessed it) tepid, followed by a trip to the *calidarium,* where the water was steaming hot, and then a bracing plunge into the *frigidarium,* where the water was cold. Some of these rooms contained large, shallow swimming pools, never more than about three feet deep, and others featured enormous stone bathtubs. Additional possibilities included a visit to the *sudatorium,* or sweat room, a massage with scented oils, or time in the *solarium,* where people could lie in the sun.

Athletically inclined patrons could precede their bath with a visit to one of the *palestrae* for some moderate exercise and follow it with a massage. Bathers who enjoyed shopping might take a turn through the area on the edge of the baths complex reserved for stores, while those who had worked up an appetite in the baths could purchase food and drink from any of the numerous vendors. Neighborhood gossips could trade tidbits, businessmen could discuss deals, and the intellectually ambitious could improve their minds in the libraries or lecture halls. The largest of the imperial baths provided something for everybody.

Such colossal establishments as the Baths of Caracalla and those of Diocletian required enormous numbers of service personnel to keep them running smoothly. The labor was provided in part by slaves and convicts, who did the hardest and most uncomfortable work in the network of service rooms, tunnels, and passageways beneath the baths. In semidarkness and hellish heat (relieved only partially by light and ventilation shafts), they stoked the wood-burning furnaces that heated the baths. The furnaces functioned continuously, because it took more labor and fuel to get them up to high temperatures each day than to keep them constantly hot. Huge stands of timber disappeared into those furnaces, wood that had to be transported into Rome from the countryside and sometimes even from outside Italy. The guild of salt workers in Rome's port city of Ostia was responsible for supplying the city's bath furnaces with wood.

Those who worked above ground at the bath complexes were more fortunate. Although some were slaves, others were salaried employees. These included door attendants, dressing room and latrine attendants, towel handlers, laundry workers, masseurs, and large contingents of cleaners. Epitaphs on the gravestones of working-class Romans sometimes mention, with pride, that the deceased had been employed at one of the imperial baths. Each

bath had a chief administrator called the *conductor balinei.* The operations of baths were spelled out in contracts, a few of which survive on stone tablets and which demonstrate concern for high standards of safety, service, and hygiene.

Given the possibilities for water-borne infections and the thousands of people who used the baths daily, the level of cleanliness maintained at these sites is astonishing. Much of the credit must go to an unlimited water supply and the nearly complete absence of standing water. Ingenious hydraulic engineering ensured a constant flow of fresh water into the baths and a corresponding outflow of the water used by the patrons.

What made this possible was another Roman engineering marvel: the water-supply system known as aqueducts. By the time of the emperor Trajan in 100 A.D., nine aqueducts carried water into Rome, enough to supply at least 300 gallons per day to every citizen. The gigantic baths of Caracalla and of Diocletian were both served by special branch aqueducts directly connected to the main ones. These water-supply systems were the true lifelines of the baths. The final ruin of the bath complexes of Rome came in 537, when the invading Goths cut the city's aqueducts.

According to a twelfth-century guidebook to the Eternal City, called the *Mirabilia Urbis Romae,* the Baths of Caracalla ranked as one of the "seven wonders of Rome." The site originally occupied thirty acres, an area larger than some Roman provincial towns, and could accommodate up to sixteen hundred bathers. Because of its location on what was in ancient times the edge of the city, the complex escaped major destruction and is today among the best preserved of all Roman baths. The name of Caracalla, one of the third century's most brutal emperors, became attached to this bath complex even though the structure was started in 206 by Caracalla's father, the emperor Septimius Severus. Still incomplete in 217, the baths were nevertheless inaugurated by Caracalla not long before his assassination that same year and were finished around 230, during the reign of Alexander Severus.

Because the site chosen sloped somewhat, the unknown architect had it leveled off and constructed the baths on a huge platform. The principal building materials used were concrete and brick, but the outer surfaces were originally faced with travertine and the inner walls with stucco, marble, and mosaic, virtually all of which has disappeared. The design is complex but nearly symmetrical and highly organized, with huge vaulted rooms, domed octagons, circular and semi-circular chambers, and columned porticoes. Beneath the gigantic piers and vaults of these rooms lies the formidable, multilayered subterranean network of service and storage rooms, tunnels, and corridors that made the functioning of the upper structures possible, as well as the heating plant with its fur-

naces, and the water-supply systems. Although none of these fascinating underground areas is presently open to the public, plans are underway to open at least some of them to visitors.

The main buildings of the Baths of Caracalla are symmetrically arranged around a huge, vaulted central hall and an open-air swimming pool. To each side of the central hall were two large *palestrae* for sports and exercise. These open courtyards were originally paved with black-and-white mosaics, fragments of which survive. The domed, circular *calidarium,* or hot-bath room, was 120 feet in diameter and had tall windows on two levels to receive the maximum amount of sunlight. Today half of this room remains: a vast, ruined apse. Until 1993 this part of the baths served as the stage for opera performances, now discontinued because of the damage they were doing to the site. Some idea of the size of this area can be gained from the production of *Aida* here, with a cast of hundreds onstage, and enough room left for a four-horse chariot to be driven on, turned around, and driven off again. Opera performances at the Baths of Caracalla began in 1937, during the rule of Mussolini. Although an anecdote claims the Fascist dictator enjoyed driving his car at top speed through one of the tunnels beneath the baths and emerging onstage, car and all, for the opera's opening night festivities, archaeologists working at the site have assured me that this would have been logistically impossible. The story is apparently one of those "urban myths," rather like the tales of alligators in the New York City sewers.

The Baths of Caracalla remained fairly well preserved into the sixteenth century but finally fell victim to the Renaissance desire for antiquities and its insatiable need for building materials. Pope Paul III, for one, wished to decorate his family residence, the Palazzo Farnese, with ancient statues and the Baths of Caracalla proved to be a rich source. In addition two great stone bathtubs plundered from the same site now serve as fountain basins in front of the Palazzo Farnese.

The largest of the imperial *thermae* in Rome are the Baths of Diocletian, begun in 298 A.D. by Maximian and finished between 305 and 306 by the emperor Diocletian. The cost was enormous, but work went on, even though by the opening of the fourth century the empire was in serious financial difficulty. Although the area covered by these baths is about the same as that of the Baths of Caracalla, the part devoted to bath structures is larger. At the Baths of Caracalla a large portion of the area was gardens. Diocletian's mammoth structure could accommodate about three thousand bathers.

Due to their location just east of the Viminal Hill, near Rome's central railroad station, the Baths of Diocletian have undergone much more alteration and destruction than those of Caracalla.

Despite these changes the outlines and substantial portions of the baths are still preserved in the surrounding streets, from Via Venti Settembre to Piazza del Cinquecento, between Piazza della Repubblica and Via Volturno. A glance at a map shows that this is a substantial chunk of modern Rome. The best way to get some sense for the size of the original complex is to walk around the vast, semi-circular Piazza della Repubblica, which Romans still call by its traditional name, Piazza Esedra, named for the exedra, or half-circle-shaped form of the *calidarium* of Diocletian's baths, whose outline it partially follows. This enormous area was only a fraction of the whole complex.

From the Middle Ages through the 1500s various popes used the rambling structures for monasteries, granaries, and even prisons. After 1600, however, the baths began to be used as a quarry and huge portions disappeared. Still more of the complex was demolished in the 1870s during Rome's large-scale urban development, which included the building of the city's first modern railroad station. But substantial portions still remain. One of the baths' octagonal halls served until recently as Rome's planetarium; two domed circular portions joined together form the church of S. Bernardo alle Terme, and another segment houses the Museo Nazionale Romano, one of the world's great collections of ancient sculpture.

The most striking use of a portion of Diocletian's baths began in the 1560s, when Michelangelo converted the main hall into the church of S. Maria degli Angeli. Although the building was altered and its orientation changed in 1749, it is still the best place to get a feeling for the size, scale, light effects, and dazzling splendor of an imperial bath. Michelangelo, full of respect for antiquity, preserved the immense vaulted hall, with its eight colossal red granite columns, and kept his own interventions to a minimum. The interior still preserves something of its colorful and exuberant pagan spirit. Visitors who take a moment to stand in the church with their eyes closed can almost hear the sound of water, smell the scented oils, and imagine themselves in an ancient Roman bath.

Suggested reading

Fikret Yegül, *Baths and Bathing in Classical Antiquity* (New York, 1992).

ROMA
AMOR
VIII

THE WALLS OF MIGHTY ROME

I sing of deeds of arms and of the man who
first from the beach of Troy, driven by fate,
came to Italy and the shores of Latium . . .
from him came the Latin race, the Alban fathers,
and the walls of mighty Rome.

—Virgil, *Aeneid*

At the time Virgil wrote his great epic that celebrates the origins
of "mighty Rome," the city had no walls worth mentioning. The
poet, a friend and admirer of the emperor Augustus, began the
work that became Rome's national epic in 27 B.C., the first year of
Augustus's reign. At that time Rome looked unimpressive, a
sprawling town where the frequently flooding Tiber River mean-
dered among crooked, muddy streets and ramshackle wood and
brick buildings. The "walls of mighty Rome" were no longer in
use and in some places had even disappeared.

Although archaeologists tell us that Rome has always been to
some extent a walled city, the history of the city's walls is compli-
cated. Excavations of the primitive settlements on the hills of
Rome suggest that as far back as 1500 B.C. these villages were en-
closed by wooden palisade fences or simple bank-and-ditch de-
fenses. The traditional date for the founding of Rome, 753 B.C.,
memorializes the union of these separate settlements by Romulus,
who surrounded the area with a wall made of large blocks of the
soft, easily excavated local stone called tufa. These walls have al-
most entirely disappeared.

The Roman historian Livy, a contemporary of Virgil and Augustus, claimed that the ruinous remains of the walls still visible in Rome in the first century B.C. were those built by Servius Tullius, one of the Etruscan kings of Rome, who ruled from 578 to 535 B.C. These massive fortifications had once encircled all of Rome's seven hills: the Capitoline, Palatine, Caelian, Quirinal, Viminal, Aventine, and Esquiline. Long out of use in Livy's time, the walls must have appeared ancient and could easily be identified with the only known defenses mentioned in the city's historical annals, those of Servius Tullius.

But Livy was wrong. The so-called Servian walls, which still bear this inaccurate name, were neither the only nor the earliest walls built around Rome, and they date from a time long after Servius. Well before the wall attributed to Servius was even contemplated, an earlier defensive system had been built, consisting of a massive earthen rampart with a broad ditch outside it. Only small sections of this wall have been found, much of it lying under the course of the Servian wall. Fragments of pottery and coins, found in this early wall during excavations for the building of Rome's main railroad station in 1861, have enabled archaeologists to date the construction to about 480 B.C. Therefore the earliest defenses of Rome date not from the reign of Servius Tullius in the 500s B.C., but from the first half of the 400s B.C.

At this time Roman military strength was receiving its first tests. Throughout the 400s B.C., in small-scale wars with neighboring tribes in Latium and later in a bitter but successful war against the heavily fortified Etruscan city of Veii, the Romans solidified their position as the lords of Latium. But they were about to experience a catastrophe almost as great as the one they had just inflicted on Veii. In 391 B.C. an army of Celts, made up of members of fierce tribes from north of the Alps, descended into the Italian peninsula and began moving toward Rome. In 386 B.C. they swept aside the Roman armies and, despite the earthen wall, had little difficulty in capturing the city. Destruction was extensive, but because the Celts had come south in search of loot rather than territory, they accepted a ransom of gold and departed. Nonetheless the Romans had learned a valuable lesson: they needed a much stronger defensive wall.

During the extensive nineteenth-century clearance that preceded the building of modern Rome, many stretches of an immense fortification wall came to light. Archaeologists concluded that this must be the wall Livy had claimed was constructed by Servius Tullius, and so they gave the name "Servian" to this set of walls, although they soon learned that it was from a later time. Analysis of the stone used in the wall showed that it had been

constructed largely of tufa from the quarries near Veii, a territory that came into Roman possession only in the 390s B.C., and not in the 500s B.C. Historians now believe this "Servian" wall was built shortly after the Celts sacked the city in 386 B.C.

For much of its course the wall was simply terraced into the hills it surrounds. The character of the masonry is rough and massive and there were no towers except over the gates. The visitor has a good opportunity to see the remains of the Servian wall when stepping out of the city's central railway station. There on the right, looking strange in contrast to the sleek lines of the modern terminal, stands a reconstructed section of the craggy, ancient wall.

The subsequent history of this wall was uneventful. There is no record of it actually being used as a defense for the city and it seems to have fallen into decay with little effort made to maintain it. During the centuries when the Roman Empire rose to the summit of its imperial power, the city of Rome itself had virtually no defenses. It is a telling commentary on Rome's power and how secure the Romans felt, that until late in the third century A.D. no one believed the imperial capital needed walls.

In the year 270 A.D. a tough, middle-aged veteran of Rome's interminable foreign wars named Lucius Domitius Aurelianus was proclaimed emperor by Rome's increasingly dominant army. He came to power at a perilous time. Throughout the third century ambitious soldiers, most of them with little claim or competence to rule other than the raw military power they commanded, had fought each other for possession of the imperial throne. All along the empire's overextended frontiers restless tribes eyed the spectacle of Rome's growing weakness and disarray. The bothersome and subversive sect of Christians was rapidly proliferating. In addition, serious economic ills, including runaway inflation and debased coinage, plagued the crumbling empire. Gaul, the German provinces, Britain, and parts of Spain had already fallen away. It is hard to imagine less promising circumstances for an imperial accession. Yet in his brief reign of four years Aurelian took on all these major problems and achieved some surprising successes.

A career military man, Aurelian was acutely conscious that the city of Rome had no defenses. On several occasions in the preceding century barbarian armies had penetrated northern Italy, and Aurelian knew it would be only a matter of time before one of them attacked Rome. He therefore ordered the construction of a massive new circuit of walls to surround the entire city, which had now grown far beyond the area included within the ruinous "Servian" walls. Work began in 271 A.D. and took about a decade to complete. Aurelian did not live to see his project finished, but the defenses he began remained the city's principal shield throughout

the rest of the empire's history and retained their military function down to the nineteenth century. Today when someone refers to the walls of Rome, they mean Aurelian's wall.

The new set of walls encompassed more than double the area surrounded by the earlier ones and protected all the important parts of the city as it then existed. Even today much of Rome lies within the circuit of Aurelian's walls and large stretches of these defenses survive throughout the city. In sheer mass they dwarf all earlier efforts; they are from thirteen to fourteen feet thick and more than sixty feet high. Originally there were eighteen gates, of which nine survive, and 381 watchtowers. With the usual Roman passion for personal hygiene, each watchtower had its own attached sanitary facilities. The towers were designed for the deployment of a particularly deadly form of Roman artillery: huge stone-hurling devices known as *ballistae,* from which we get the English word *ballistic.*

The construction technique used in Aurelian's wall was simple and sturdy. The core is an aggregate of tufa held in place with cement and the facing consists of mortared tiles and bricks. Stone was employed only in the principal gates. Any structures in the way of the wall became a part of it. These included at least one apartment house, a fort, an amphitheater, numerous private houses, aqueducts, and even tombs. Among the inclusions are the Pyramid of Gaius Cestius (a grandiose Egyptian-style tomb near the Porta S. Paolo), the more modest tomb of the baker Vergilius Eurysaces (next to the Porta Maggiore), and Castel Sant'Angelo.

Who did the actual building of Aurelian's wall? No inscriptions on the wall record anything about the building operations, but a sixth-century writer reports that Aurelian himself presided over the wall's construction and ordered the city's trade guilds to carry out the work, presumably with the help of military engineers and slaves. The emperor surely did not have enough soldiers available for such an enormous task.

The threat of a barbarian invasion, which had prompted the construction of Aurelian's wall, did not materialize immediately. The decades after the wall's completion saw changes made due to internal quarrels among rival Roman rulers, particularly the ones occurring in the early 300s between Maxentius and Constantine, over who was to be ruler of the Roman world. Between the years 306 and 312, when Maxentius occupied Rome, he had a galleried structure about twenty-five feet high, walled on the front and with a continuous arcade on the inner side, added to the top of the wall and above it a rampart walk protected by a parapet. A portion of this construction can be seen from inside Rome's Protestant Cemetery, located close to the Pyramid of Cestius. The city now had a protective shield that only the most determined

siege could hope to pierce. The enormous height gave an advantage in improved range and vision to the defenders and enabled a relatively small force to fend off a large attacking army.

Maxentius also improved several major gates in the city wall. The Porta Appia, now called the Porta S. Sebastiano, where the famous Via Appia enters the city, was transformed into a four-story structure, flanked by lofty towers with rounded fronts. Maxentius intended to enlarge all the gates, but Constantine's victory in 312 ended his rival's ambitious plans. Constantine had no interest in wall building, and no further work took place on the walls for the rest of the fourth century.

Although there were no serious threats of invasion or rival claimants to imperial power in the remaining decades of the fourth century, the fifth century opened with the invasion of Italy by a large Gothic army led by a chieftain named Alaric. By this time the imperial court no longer resided in Rome; the emperor Honorius had moved to Ravenna. Nonetheless, as alarm over Alaric's invasion spread, Honorius resolved to improve Rome's already formidable defenses. This would be the last major work of an emperor on the walls of Rome.

Honorius's efforts consisted mostly of repair and restoration, but his changes added dignity and impressiveness as well as strength to the city's defenses. Many of Aurelian's gates were incorporated into new and larger structures faced with white marble, rather than brick. Given the precarious situation of the empire at that time, it is significant that so much effort and expensive material should be lavished on these gateways. Undoubtedly the walls and gates were still considered indications of Rome's greatness and strength. They are among the last expressions of imperial Roman grandeur in the Eternal City.

In the year 408 Alaric again invaded Italy and this time his army besieged Rome. But the walls held firm and there is no evidence that Alaric tried to storm them. Instead he blockaded the city and waited for cold, disease, and starvation to demoralize the population within the walls. In December 408, the city leaders bought off the invader with a huge horde of treasure and such luxury goods as silk cloth and pepper. Alaric withdrew his troops but besieged Rome in 409 and again in 410. In August of that year Alaric's Goths broke into the city under cover of darkness, entering through one of the northern gates, the Porta Salaria. Although no culprits were ever found, there was suspicion that traitors within the city had opened the gate. The defenses had held, but some human defenders had broken down.

Although the proverbial "barbarians at the gate" would ultimately overrun Rome despite its massive walls, the city continued to use the walls for defensive purposes. Various popes repaired,

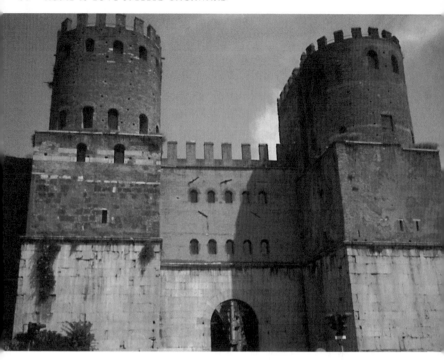

Porta S. Sebastiano. One of the gates in Aurelian's wall, added by Maxentius
in the early fourth century A.D., today houses a museum
devoted to the history of Rome's walls.

restored, and extended them, and one of the gates still visible to-
day, the Porta Pia, was rebuilt by Michelangelo in the 1560s. The
last time an army stormed the walls of Rome was in 1870, when
the forces of the new Kingdom of Italy breached the walls near
that same Porta Pia and clashed with papal troops trying to hold
the city. It was a largely symbolic struggle, for Pius IX had given
orders that only token resistance should be offered. (Perhaps Pius
had more exalted things on his mind; the First Vatican Council
had recently declared the pope infallible.) Other surviving gates
include the Porta Belisaria, now called the Porta Pinciana, which
is flanked by two cylindrical towers built in the sixth century by
the Byzantine general Belisarius to defend the city against the
Goths; the Porta Flaminia, the main entrance to the city from the
north, now called the Porta del Popolo; and the Porta Ostiense,
leading south to ancient Rome's port city of Ostia and known to-
day as the Porta S. Paolo, because of its proximity to the church of
S. Paolo fuori le Mura.

Visitors can examine considerable lengths of Rome's wall.
There are well-preserved segments near the Porta Pinciana and

Porta Nomentana on the north side of the city, another segment not far from St. John Lateran, and it can be followed through the Pincian Gardens and along the Corso d'Italia. Trains entering the main terminal offer views of the wall near the Porta Maggiore.

There is even a Museum of the Walls, located in the Porta S. Sebastiano, at the beginning of Via Appia Antica. One of the best preserved of the towered gates has been refashioned into a series of rooms with informative texts, photos, and models of the walls of Rome throughout the city's history. A door in the museum leads out onto a segment of the wall, and from between the battlements the visitor gets wonderful views of the Roman countryside. Visitors can walk along a portion of the ramparts, the same passageway once patrolled by Roman soldiers, look through the same slits (slightly modified for later use by artillery) through which ancient Roman eyes once searched the horizon for invading armies, and for a moment experience what it might have been like to guard the city that ruled the world.

Suggested reading

Malcolm Todd, *The Walls of Rome* (Totowa, N.J., 1978).

ROMA
AMOR
IX

ROME'S INDISPENSABLE AQUEDUCTS

> Just compare the vast monuments of this indispensable aqueduct network
> with those idle Pyramids of Egypt, or those famous but good-for-nothing
> structures of the Greeks!
>
> —Frontinus, *The Aqueducts of Rome*

These words of Frontinus capture a quintessentially Roman atti-
tude: works of art and architecture created merely to be impressive
or beautiful have their place, but a practical structure like an aque-
duct is far more valuable. The author, Sextus Julius Frontinus, was
Rome's *curator aquarum* (water commissioner) from 97 A.D. until
his death about 104 A.D. In his treatise he describes and celebrates
a great marvel of ancient Rome, the water-supply system known
as aqueducts (literally, "water carriers"), one of Rome's most en-
during and fascinating achievements.

Portions of aqueducts survive throughout the territories of the
Roman Empire and in the city of Rome itself there are still frag-
ments worth examining. Among the sights that greet a visitor who
comes into Rome by train are the remains of several aqueducts
near the Porta Maggiore, at the southeast end of the Termini rail-
road station. Portions of another aqueduct can be seen on the Jan-
iculum Hill, near the Villa Doria Pamphili Park, and fragments of
others are visible at various places around the city. These craggy,
pollution-darkened ruins are far from the most beautiful sights in
Rome, but over the years I have come to agree with Frontinus that
these "indispensable" structures are at least as worth seeing as any
temple or tomb. Perhaps the greatest tribute to these engineering

masterpieces is that several of them, restored and rebuilt, continue to supply Rome with its reliably excellent and abundant water.

Ancient Rome, with its hundreds of baths and fountains and acres of luxurious gardens, had a huge demand for water. Its system of aqueducts is therefore larger than that of any other ancient city. Beginning in 312 B.C., with the Aqua Appia built by Appius Claudius Caecus, the building of aqueducts continued for five hundred years; the last was the Aqua Alexandrina, commissioned by the emperor Alexander Severus in 226 A.D. The later emperors Caracalla and Diocletian, who needed vast amounts of water to supply their gargantuan baths, contented themselves with tapping into earlier aqueducts, a practice that no doubt left Frontinus flapping in his grave, but they also supplemented the volume of water by utilizing new sources.

Exactly when the aqueducts of Rome ceased to function is unknown, but their ruin was gradual. The beginning of the end was in 537, when the invading Goths cut all of them. Although some damage was repaired, the aqueducts seem not to have functioned as well subsequently. One by one they fell out of use: invasions, erosion, earthquakes, and neglect all played a part. By the eleventh century the Romans were again getting most of their water from wells, cisterns, and the Tiber, as they had done before the first aqueducts. Although the Aqua Virgo (which became known as the Acqua Vergine in Italian) continued to function throughout the Middle Ages, not until the sixteenth and seventeenth centuries did large-scale rebuilding of the aqueducts take place. Rome's rebirth in the Renaissance coincided with the restoration of its waters.

Each of Rome's aqueducts had a distinct personality; the waters differed in volume, temperature, taste, and degree of hardness. The Anio Vetus (Old Anio) begun in 272 B.C., for example, was not highly regarded; its often muddy waters were generally used for irrigating gardens and flushing out latrines. The Aqua Marcia, brought in by Q. Marcius Rex in 144 B.C., was popular because its water was clear, cold, and clean, although it was very hard. The Tepula, built in 126 B.C., takes its name from the unusual warmth of its water, and the Aqua Virgo, brought into the city by Agrippa in 19 B.C., gets its name from the water's extraordinary purity. The Aqua Alsietina, brought in by the emperor Augustus in 2 B.C. from Lake Alsietinus, was almost undrinkable and Frontinus wonders why the emperor bothered to build it. Probably most of its water went to fill the *Naumachia,* an artificial lake in which Augustus was fond of staging mock naval battles. The water of the Traiana, built by Trajan in the early second century A.D., comes from cold, clear springs above Lake Bracciano, and the Romans considered it excellent for drinking.

The portions of Rome's aqueducts visible today are fragments,

but even when the aqueducts were new, only a small part of their total length could be seen. An aqueduct ran underground for most of its length, carrying water for many miles from the distant lake, river, or spring that formed its source. The portions above ground generally ran on arcades, and the Roman engineers who designed them often created works of great beauty. As a result archaeologists and art historians sometimes treat them as if they were works of art, to be admired only for their appearance and not because they actually *did* anything. But aqueducts were, as Frontinus insisted, practical structures, created to supply Rome with water.

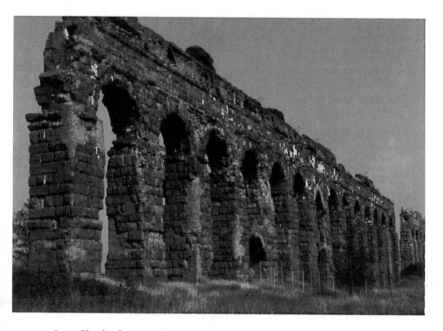

Aqua Claudia, fragment. The remains of ancient Rome's water-supply system offer impressive testimony to Roman engineering skills.

Aqueducts were expensive to build and maintain and therefore were commissioned mostly by rich private citizens or by emperors, the latter often using the wealth provided by military conquests. After a promising source of water—a spring, stream, lake, or river in the hills around Rome—was identified, the next step was to check the health of the local people, animals, and vegetation. Common sense suggests that if they were healthy, the water supply was good. Assuming the water tasted good, was reasonably clear, and flowed abundantly, the aqueduct builder was ready to proceed.

First the route had to be surveyed and the gradients calculated. Since Roman aqueducts operated by gravity, the channel had to

be carefully planned to maintain a slight, steady downward slope: overly steep and the water would build up too much pressure and break the conduits; too gradual and the water might be a mere trickle. Next the route was marked out, probably by stakes, and then the work of construction got under way. At the source several feeder branches were constructed to tap the water and lead it into a collection basin, from which it then entered the main channel and began its journey to Rome. Along the way were settling tanks, which slowed the water down and allowed impurities such as sand and gravel to collect at the bottom.

It was best to keep the water conduits underground as long as possible, where they were protected from weather and from those intent on destroying, damaging, or tampering with them. Eventually, however, the conduits had to be aboveground, to preserve the gradient and keep the level of the water high enough so that when it finally reached Rome it could still perform its useful services. This explains those seemingly endless arcades of the Aqua Claudia, completed by the emperor Claudius in 52 A.D., which march across the countryside southeast of Rome. The arcades begin at the latest point consistent with the channel maintaining an effective height when it arrived at the city.

Once in the city the water entered a complex distribution network of which very little survives. In Frontinus's time there were 247 distribution centers within Rome. From these points the water traveled to public fountains and basins as well as to a small number of homes and businesses, mostly through lead pipes, hence the derivation of our word *plumber* from *plumbarius,* which comes from *plumbum,* the Latin word for "lead." These lead pipes did not cause lead poisoning in ancient Rome, as some modern writers have claimed, since the insides of the pipes quickly became encrusted with calcium deposits.

Once an aqueduct was turned on, its waters ran continuously, shunted only so the channels could be cleaned out. Taps and spigots were uncommon; most Romans with running water had it running twenty-four hours a day. This practice may seem wasteful to us, but the constantly running water drained off into Rome's sewers, flushing them into the Tiber, an excellent reason not to drink from the river. Modern descendants of the perpetually running waters of ancient Rome range from the city's hundreds of large and small fountains to those many little open water spigots to be found on streets all over the city, still providing pedestrians with a safe and welcome way to quench their thirst.

The citizens of ancient Rome did not get this bountiful water supply free of charge. In theory at least, each site where the water drained off was fitted with a device something like a nozzle, made in varying widths, which served as a primitive water meter. The

wider the opening (and the pipe connected to it) the greater the amount of water and the more that individual paid. But Frontinus tells us some Romans were experts in figuring out ways to get around paying their water bills or to get more water than they paid for. In his account Rome seems full of people busily widening their water-supply openings, a practice the city officials tried to prevent by having the openings cast in bronze. Frontinus fumes at length about the illicit diversion of water from the aqueducts by private individuals for what he considers frivolous or even downright disgraceful purposes. Some people tap the conduits, he indignantly reports, just to water their gardens; brothel keepers supply water for their disorderly houses, and others use it for "purposes too vile to mention," by which he presumably means people who help themselves to the city's water to flush out their latrines. He claims that secret pipes run all over the city, installed by shady *plumbarii* whom he calls "puncturers." He asserts that such parasitic little pipelines sometimes deprived the aqueducts of so much water along the way that by the time they reached their public distribution points there was hardly any water left.

Although Frontinus emphasizes the abuses of Rome's water-supply system, it functioned well, to judge by the number of aqueducts in use in ancient Rome and the many legitimate purposes they served. The baths and fountains probably consumed the most water, with crop and garden irrigation a close second. Next came fullers and laundries and water mills for grinding grain. Fountains and basins all over the city, and spouts in the courtyards of apartment buildings, assured an ample supply of water for people whose living quarters did not have running water, and that was most of Rome's citizens. The city's numerous public lavatories received a constant supply of run-off water, which eliminated the need for manual cleaning.

One place in Rome where the remains of an aqueduct are visible is on the Janiculum Hill, where the Aqua Traiana enters the city. Some remnants of the Traiana can be found along Via Aurelia Antica, a narrow street that forms the northern boundary of the grounds of the Villa Doria Pamphili, Rome's largest public park. Those who pluck up their courage in the face of heavy traffic and walk along Via Aurelia will see remains of the aqueduct imbedded in the wall on the south side of the road.

Beyond this fragment of the original Traiana, the arches of the Acqua Paola begin to appear, the Traiana's seventeenth-century replacement. About 1610 Paul V restored Trajan's aqueduct, using portions and materials from the ancient channel, and celebrated the occasion by ordering the construction of a magnificent fountain, designed by Flaminio Ponzio and Giovanni Fontana, to mark the place where his aqueduct enters the city. The official name of

the monument is the Fontana Paola, in honor of the pope, but the local people simply call it the *Fontanone,* the big fountain.

The Fontana Paola is an excellent example of the continuous recycling of materials which the Romans have practiced for so long. The four large columns that flank its three central arches come from the front of Old St. Peter's, which had been demolished to make way for Maderno's facade for the new church. The two smaller columns on the ends come from the inside of Old St. Peter's. Both sets of columns no doubt had come from some still earlier classical monument that had served as a source of building materials for the church. From three broad slits below the arches, the regathered waters of Trajan's aqueduct pour forth into a handsome Baroque basin and now supply the residents of both the Janiculum Hill and Trastevere neighborhoods with excellent water. It also provides water for the fountains in front of St. Peter's.

The best place for a visitor to examine the remains of the aqueducts is in Piazza della Porta Maggiore. A noisy traffic circle, the incursion of several busy roads, and a lot of intersecting tram tracks combine to unnerve anyone hoping to make a leisurely tour, yet it is this very complexity that makes the area so interesting and alive. Nearly two thousand years ago, eight of Rome's eleven aqueducts entered the city here. Three of them—the Appia, the Anio Vetus, and the Alexandrina—came in still at ground level or below and so remain hidden. But the Claudia, Anio Novus, Marcia, Tepula, and Julia arrived on tall arches, with the Anio Novus riding atop the Claudia and the Tepula and Julia in channels above the Marcia.

At the point where the towering, muscular-looking arcades of the Claudia and the Anio Novus crossed two major Roman roads, Via Praenestina and Via Labicana, two arches received a monumental treatment that celebrates the arrival of the waters in the city. For the length of three piers dull tufa stone gives way to brighter travertine. The surface is decorated with stones cut in the rough, rusticated style favored by Claudius and elaborated with attached half-columns. These immense arches, still topped by the channels of the two aqueducts, were later incorporated into Aurelian's wall as a city gate called the Porta Praenestina. Known today as the Porta Maggiore, the structure still dominates the piazza. The portion of the city wall linked to the travertine arches of the Claudia and Anio Novus preserves short sections of the other three elevated aqueducts, which come in at a right angle to it; the Marcia, the Tepula, and the Julia also entered the city here, stacked in a triple-decker arcade. They are visible in a broken cross section on the east side of the piazza, just outside the Aurelian walls, with the square channel of the Marcia on the lowest level and the smaller, curved channels of the Tepula and Julia above. The piggybacking of

Porta Maggiore. Constructed to celebrate the arrival of the waters of the Aqua Claudia into the city, the Porta Maggiore was later incorporated into Aurelian's wall. The remains of three aqueducts are visible in its upper story.

aqueducts saved time and material. When a fresh source was tapped close to an older one, the engineers sometimes built the new channel on top of a previous one.

In addition to these ancient remains there exists a modern hydraulic structure near the Porta Maggiore. At the southern edge of the piazza is a receiving reservoir for the modern Acqua Marcia. A Latin inscription dates this building to 1923, the second year of Fascist rule, and compares it to the ancient Aqua Marcia. Here, Rome's ancient and modern water suppliers face each other, with the new paying tribute to the old.

The sight of these great, severed arteries that once carried the city's lifeblood can be unexpectedly moving. They speak as eloquently as any written text about the reasons for the decline of ancient Rome. The remains of this extraordinary system offer a glimpse of one of Rome's true lifelines. The city could get along without this or that temple; it could still function with the Forum and the Palatine Hill in ruins; but during the centuries when it was deprived of most of its water, the Eternal City very nearly perished.

Suggested reading

Peter J. Aicher, *Guide to the Aqueducts of Ancient Rome* (Wauconda, Ill., 1995).

Harry B. Evans, *Water Distribution in Ancient Rome* (Ann Arbor, 1994).

A. Trevor Hodge, *Roman Aqueducts and Water Supply* (London, 1992).

EARLY CHRISTIAN AND
MEDIEVAL ROME

ROMA AMOR

X

THE CHRISTIAN CATACOMBS

Beneath some of the sun-drenched, traffic-clogged, noisy streets of modern Rome lies another city entirely—chilly, silent, and plunged in perpetual darkness. This is the mysterious, legend-encrusted world of the catacombs. These vast subterranean cemeteries, built over the course of about two hundred years (between the second and fourth centuries A.D.) still have not been fully explored, and only a tiny fraction of their total area is open to the public. Archaeologists estimate that some six hundred miles of passageways honeycomb the tufa on which Rome is built. No one really knows how many catacombs originally existed in Rome, but more than fifty have been discovered.

The curious word is of Greek origin: *kata kumbas* means "at the hollows." In ancient times this definition referred to the natural hollows at the side of Via Appia, near the church of S. Sebastiano. The earliest Christian community of Rome buried its dead there. The term for that burial site, latinized as *Ad catacumbas,* has given us the English word *catacomb.* Because they believed in bodily resurrection, the early Christians rejected the pagan custom of cremation.

Rome had strict laws concerning the disposal of corpses. A dead body could neither be buried nor burned within the city. Most pagan Romans preferred to be cremated and have their ashes placed in small urns kept in family vaults above ground, but Christians insisted on the burial of their dead, hence the location of their burial grounds well outside the city walls.

Popular legends about the catacombs, largely inaccurate, have proven persistent. Most of us have heard, read, or seen in old

movies those tales of the early Christians using the catacombs as places of refuge in times of persecution. But the Roman authorities knew where the Christian catacombs were; a permit from the city government was required to construct a catacomb and Roman authorities could have pursued the Christians into such hideouts if they had cared to. Christian burial grounds were protected by Roman law, however. Curious and contradictory as it may seem to us, the same system of Roman law that permitted the persecution of Christians also protected their tombs. All burial places were sacred to the Romans and came under the protection of the Pontifex Maximus, or chief priest. Under Roman law the desecration of tombs was considered one of the most serious crimes. During the entire Early Christian period in Rome, which lasted some three hundred years, there are only two recorded instances of Roman authorities ignoring this ordinance.

On the face of it the inviolability of the catacombs should have made them excellent hiding places, but this was not the case, for a compelling reason. The Christians made little attempt to preserve the corpses they buried in the catacombs; they simply wrapped them in cloth, sprinkled them with lime, placed them in the shallow slot graves that line the catacomb corridors, and loosely sealed the openings with stone or clay plaques. Since the catacombs were in continuous use for more than two hundred years, the resulting stench of rotting bodies must have been overwhelming. Not only is the smell of putrefying human flesh one of the most nauseating and psychologically distressing of all odors but the gases produced by putrefaction are poisonous. Even though the catacombs contain air shafts for ventilation, no one could survive for long while breathing such foul air.

The construction of catacombs was not a random process. In addition to a permit from the city government, a group wishing to construct a catacomb needed the permission of the person who owned the property under which the site would be dug. Most catacombs seem to have been begun under the property of wealthy converts, among them the catacombs of Domitilla and Priscilla. These names of women derive from the aristocratic Roman names Domitius and Priscus. Some archaeologists suggest that Domitilla may have been a relative of the emperor Domitian (81–96 A.D.). If so, the catacomb may date back nearly to Apostolic times.

In addition to permits catacomb builders needed the services of professional diggers. These hardy fellows were known as *fossori,* or cave makers, and they had their own trade guild. Some *fossori* were buried in the same catacombs they had helped to construct. One, who proudly called himself "Diogenes the Digger," was buried in the catacomb of Domitilla. A wall painting from that catacomb, now lost but preserved in an eighteenth-century drawing, shows

him with a pick, the basic tool of his trade, in his right hand, and a small oil lamp in his left. Surrounding him are other tools, including hammers, axes, and the dividers used to mark out the sites. Behind him appear the results of his work, the neatly arranged graves called *loculi* (little places).

When one series of corridors in a catacomb became filled, others would be started. Certain individuals, perhaps the leaders of the early Christian community, must have been in charge of the excavations and would have decided when and where to expand. Since ownership of land included not only the surface but also the area below the ground, it was illegal to expand a catacomb past the boundaries of the property on which it began. As a result catacombs expanded downward rather than horizontally, like the descending levels in an underground parking garage. After an initial catacomb had been dug, the diggers excavated a second and sometimes a third or fourth one underneath it. In contrast to most other archaeological sites, the closer a catacomb is to the surface, the older it is.

Other popular misconceptions about catacombs are that they were a Christian invention and are unique to Christian burial. Neither is true. The Etruscans, the predecessors of the Romans, occasionally excavated small, family catacombs, as did the pagan Romans, although neither culture used catacombs as their principal places of entombment. A much closer relationship exists between Christian and Jewish catacombs. It is very likely that most of the earliest Christians in Rome were converts from the city's Jewish community, so it would be natural for them to continue some Jewish burial customs. (By the time the catacombs were being built and decorated, however, Rome's Jews and Christians seem to have formed separate communities; one piece of evidence is their separate burial sites.) In contrast to the culture of pagan Rome, where each family was responsible for the burial or cremation of its dead, a mainstay of Jewish tradition is communal responsibility for burial. The earliest Christians continued this Jewish custom.

The question of the exact number of Christians in the Roman population during the first three centuries of the modern era is difficult to answer, since reliable statistics on the city's population are nearly impossible to gather. Estimates of the total population of Rome in the 300s A.D. vary from 200,000 to 500,000, of which Christians constituted only about 10 percent. If we estimate that there were about 35,000 Christians in the imperial capital by the beginning of the fourth century, and even fewer in previous centuries, and that there was a death rate of roughly 10 percent per year, in two hundred years total deaths would amount to about half a million. And yet, scholars estimate that nearly *five million*

graves are to be found in the Christian catacombs. Where did all the rest of these bodies come from? One possible explanation, offered by biblical scholar Charles Kennedy, is that many Christians believed Rome would be the site of the Second Coming of Christ and thus Christians from all over the empire had their remains transferred to the Roman catacombs, there to await the Day of Judgment.

Still another misconception about the catacombs concerns the uses of the sites. Popular legend imagines a genuine "church of the catacombs," in which early Christians conducted much of their lives underground, and where they met regularly for religious services. Not true. Persecution of Christians was sporadic, not continuous, and even before Constantine legalized Christianity in 313, there were about forty churches in Rome. Many other groups of Christians met in private homes. The small chapels in the catacombs were used only for funerary rites and yearly memorial services for the deceased. Cold, dark, dampness, and the stench of rotting corpses must have ensured very brief funeral services.

Given such grim conditions, what possessed the Christians to decorate these burial sites with wall paintings? To answer this question we must understand that the early Christians did not live isolated from their Jewish and pagan neighbors. Both pagans and Jews decorated the interiors of their burial chambers, so Christians did it too and thus created the first Christian art.

What, then, is so different about the Christian catacombs? What is the source of their enduring fascination? Something about the art of the catacombs stirs the imagination, and not merely because of romantic misunderstandings. Christian art did have something fundamentally new to say and said it for the first time in the paintings on these underground walls. It gave visual expression to an idea so powerful it eventually won over much of the world: the conviction that the human soul can be delivered from death to an everlasting life.

Neither Judaism nor any pagan religion made such a claim. The Jewish faith puts little emphasis on immortality, and pagan beliefs about the afterlife were vague, uncertain, and sometimes dismal. In Greco-Roman religions most souls retained a shadowy existence in a cheerless limbo, although a favored few might attain the comparative luxury of the Elysian Fields. In sharp contrast, both images and tomb inscriptions of the Christian catacombs offer the promise of divine deliverance and eternal life. A comparison of the wording in pagan and Christian tomb inscriptions is revealing. Pagan inscriptions often suggest resignation, a sadness that a respected or beloved person is gone forever. The early Christians, however, who expected the Second Coming of Christ at any moment and for whom death was a temporary state, composed in-

scriptions that are notable for their optimistic, even joyous tone. Peace and a steadfast certainty of everlasting life radiate from these simple and often crudely carved words on the clay or stone plaques used to seal the graves. Bodies are not consigned to the earth permanently; they are "deposited" or "resting" in expectation of a future resurrection. The implication of a deposit is that it is temporary; when we deposit money in the bank we expect to get it back, with interest, and the implication of sleep is that we will eventually awake.

Visiting a catacomb can be both an unnerving and a thrilling experience. Even with such modern additions as electric lights, pathways, signs, and ventilation systems, the degree of cold, silence, dampness, and darkness can come as a shock. The visitor may pass in seconds from the sweltering heat of the Roman summer to the perpetual clammy chill of an underground cavern. Not even the loudest street noises penetrate this far underground. Only a few passageways are served by electric lights, and stretching away from them are innumerable others swallowed up in total blackness.

No one is ever permitted to enter a catacomb alone. Those open to the public are run by the Catholic Church, and it is generally a nun or a priest, warmly dressed in a winter parka and thick-soled shoes, who takes visitors through the accessible portions of the sites. Many religious organizations sponsor trips to the catacombs, so it is not unusual to hear the murmur of communal prayer or the singing of a hymn. Occasionally, one hears prayers and hymns in Latin, and the realization that people are addressing God in the same language as the original builders of the catacombs can make this a particularly moving experience.

The paintings of the Roman catacombs may startle some present-day viewers with their slapdash execution. Anyone expecting the exquisite refinement of classical Greek art or the impressive monumentality of imperial Roman art will be disappointed. Scholars continue to argue about the seemingly low artistic quality of much of the art of the catacombs. Is it the result of a conscious rejection of pagan standards of beauty? Or does it reflect the general decline of artistic standards in the Late Empire? Should catacomb painting be regarded as a popular and less accomplished art form, distinct from the professional painting seen in Roman houses? One thing is clear: the conditions under which catacomb painters worked surely must have been the worst any artists have ever had to endure. Chilly dampness, pitch darkness illuminated only by flickering oil lamps, and the ever-present stench of decay are hardly inspirations for great art.

If we keep in mind that the purpose of catacomb paintings was not to give the viewers a pleasant aesthetic experience but to prompt a *spiritual* experience we can come much closer to understanding

these works. Meaning, not form, is what is most important here. What is visible to the eye is less significant than what the images prompt the mind to recall. This art is symbolic and its symbols refer to the Christian belief in deliverance from death, the resurrection of the dead, and life in the world to come.

The principal source for the imagery of the catacomb paintings is the Old Testament. This is not surprising, since during their first centuries the Hebrew Bible was the only sacred book the Christians had, as the New Testament canon of scriptures was still in the process of formation. Only in the latest catacomb paintings, from the fourth century, do we find frequent use of specifically Christian imagery.

The Hebrew Bible provided the early Christians with many archetypical images of deliverance from the jaws of death: Noah rescued from the flood, Isaac from the hand of his father, Susannah from the wickedness of false witnesses, the prophet Jonah from the belly of the whale, Daniel from the lions' den, the three Hebrew children from the fiery furnace of the Babylonian king Nebuchadnezzar. Pagan funerary meals, eaten in honor of the deceased, offered Christians an image of the celestial banquet, a symbol of the peace, abundance, and refreshment to be expected in Paradise. Although spiritually justified by Christ's promise that his followers would "recline at table in the kingdom of God," some paintings make these banquets seem like rather jolly affairs. A painting in the catacomb of Saints Pietro and Marcellino shows an animated group of Christians around a table, waited on by two servants named Peace and Love. "Peace, mix me wine!" cries one of the guests, while another exclaims, "Love, give me warm wine!" The fear of death, such a notable feature of later Christian centuries, is conspicuously absent here.

Many new subjects appear for the first time in the Christian catacombs: the Good Shepherd, Baptism, the Eucharistic meal (during which the Christians shared bread and wine), and Orant figures (women praying with upraised hands). The Good Shepherd was a symbol of Christ, whom the early Christians were hesitant to represent in person; Baptism was the ritual of entry into the Christian faith and what one early Christian theologian called "the bath which insures immortality." The Eucharistic meal, which untimately developed into the elaborate ritual of the Mass, appears in the catacombs as a touchingly simple communal celebration. In one painting in a chapel in the catacomb of S. Priscilla, we see a small group of men and women gathered together to celebrate the Sacrament, no doubt in honor of a deceased person. Both sexes appear to participate equally in the *fractio panis,* or breaking of bread. On the table are simply a cup and two plates containing the bread loaves.

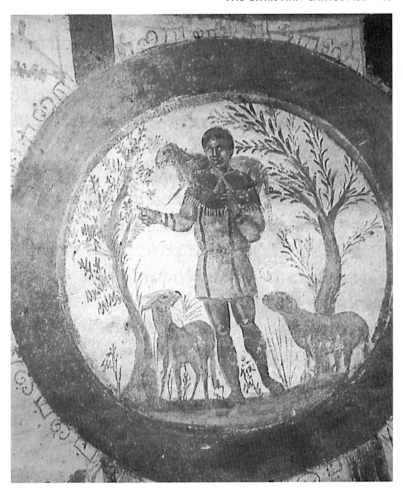

The Good Shepherd, ceiling painting, Catacomb of SS. Peter and Marcellinus. The paintings of the catacombs are among the earliest examples of Christian art.

The Orant is among the most interesting and mysterious images in the catacombs. Invariably female, these veiled figures stand with their elbows close to their sides and their hands raised and outspread. They are usually interpreted as symbols of the Church, or sometimes as symbols of the human soul, and their gesture as indicating prayer (the Latin word *orata* means "prayers"). A similar pose for prayer was also common among pagans and Jews. But this Christian gesture has another significance; it refers to the position of Christ on the cross. For more than four hundred years Christians refused to represent the Crucifixion, because of its disgraceful associations with the execution of common criminals, but when

they finally did, on the fifth-century wooden doors of the church of S. Sabina in Rome, we see Christ's arms in a nearly identical position. It is still the attitude assumed by the priest at the altar.

But why is the Orant female? One explanation is that the words for church and soul in Latin, *ecclesia* and *anima,* are feminine nouns. As contemporary scholarship has begun to revise traditional views of the early Church, however, another suggestion presents itself. Perhaps women had a more central role in the earliest centuries of Christianity than they have today.

The power of these images from the catacombs lies not in their physical impressiveness but in the message they convey. From the darkness and corruption of the tombs these crude little images dared to hurl at all the powers of the pagan world, and even at death itself, the joyful and defiant challenge St. Paul set down in his first Letter to the Corinthians (15:55–56): "O death, where is thy sting? O grave, where is thy victory?"

Suggested reading

Paul Corby Finney, *The Invisible God: The Earliest Christians on Art* (New York, 1994).
Walter Lowrie, *Art in the Early Church* (New York, 1967).

ROMA
AMOR
XI

THE JEWISH CATACOMBS

For most people the word *catacomb* conjures up images of the Christian catacombs constructed in the second and third centuries. There exist in Rome, however, other catacombs at least as old, and in some cases even older—those built by the oldest Jewish community in the Western world, the Jews of Rome. Through their paintings and inscriptions the Jewish catacombs reveal most of what we know about the ancient Roman Jews. The uniqueness of the sites makes them a particularly precious historical treasure. Neither of the two surviving Jewish catacombs is open to the public at present, however, and arranging a visit, while not impossible, takes considerable perseverance.

Nearly two centuries before the arrival of St. Peter in the imperial capital, the earliest Jewish immigrants had already settled there. Subsequent Roman conquests in Judaea, by Pompey in 65 B.C. and Titus in 71 A.D., brought thousands more Jews to Rome as captives, most of whom were eventually freed by their coreligionists in the city. Some historians estimate that by the late first century A.D. there may have been as many as fifty thousand Jews in Rome, more than in all of Italy today.

During the Middle Ages looters thoroughly plundered both Jewish and Christian catacombs, whose existence subsequently was forgotten. The first rediscovery of a Jewish catacomb in Rome occurred in 1602, several decades after the first unearthing of a Christian one, and in the succeeding centuries five more Jewish sites came to light. Of these six catacombs, four have disappeared again, buried by cave-ins and urbanization. The two sites remaining,

however, both probably date from the third century A.D. One lies beneath a private estate called the Vigna Randanini, on the southern edge of Rome, just off Via Appia; the other is located under the grounds of Villa Torlonia, on Via Nomentana, in the northeastern part of the city. An interesting historical irony is that, during the

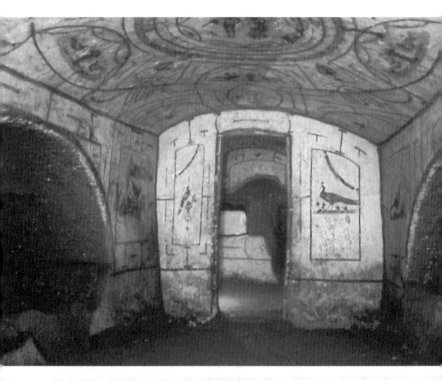

Jewish Catacomb of the Vigna Randanini, interior of a tomb chamber. The nearly unknown Jewish catacombs of Rome, contemporary with the Christian ones, offer a fascinating glimpse of life and death in the oldest Jewish community of the Western world.

period of fascism, Villa Torlonia was the residence of Mussolini. One can hardly help wondering whether Il Duce felt any emotion in knowing that, beneath the mansion where he lived and the gardens where he walked, stretched the corridors of a Jewish cemetery nearly two thousand years old, the resting place of people whose descendants he had denounced as "strangers in Italy."

In 1986, after long and complex negotiations among the Vatican, the Italian government, and the Union of Italian Jewish Communities, the administration of the Jewish sites passed from the Catholic Church to the Superintendency of Antiquities of Rome.

This was a case of one formidable bureaucracy replacing another.

It required two years of stubborn efforts before I received permission to visit the Jewish catacombs in 1988. The first year and a half I wasted in futile letters, phone calls, and runarounds among the various branches of the Superintendency of Antiquities of Rome. Then my colleague Jonathan Goldstein suggested that I was going about it the wrong way; instead of besieging the bureaucracy in Rome, I should begin at the other end, by placing my request with the American ambassador to Italy. When I protested that I had no contacts at that level, he assured me that he did; his congressman would see to it that my request reached the ambassador. Since Goldstein was teaching at West Georgia State University in Carrollton, his representative was Newt Gingrich. Congressman Gingrich (he later became Speaker of the House) was always ready to be of service to his constituents. Suddenly, with him on the case, doors began to open. Within weeks written permission to visit the Jewish catacombs was in my hands, along with the names of the two Italian archaeologists who would serve as guides through the sites. The visits proved well worth the effort.

Being inside the Jewish catacombs is different from visiting the Christian ones. Although restoration work was going on at the time I visited the Villa Torlonia catacomb, neither site has electric lights, pathways, signs, or ventilation systems. I therefore experienced the subterranean tunnels in much the same way that visitors did almost two thousand years ago, in total darkness briefly penetrated by the light carried by a guide. The degree of darkness inside these catacombs is unlike any other I have ever experienced. These passages are not dark the way the night is dark, or the inside of a closet, or even the Christian catacombs, which have the modern improvements just noted. Here is an absolute blackness that swallows up the beam of even a powerful flashlight the moment the holder turns a corner. In some places the walls are wet and in others they exude lime which has formed crusts over the surfaces. Some of the galleries, lined on both sides with graves, are so narrow that my shoulders brushed the walls on either side. Just as extraordinary as the physical sensations of being inside these catacombs is the moving sight of perfectly recognizable Jewish ritual objects, unchanged in two thousand years.

As the archaeologist's flashlight lit one area and then another, I saw painted decorations in the Torlonia catacomb that are of modest quality, but colorful and vigorous, the expression of unsophisticated people who were nonetheless proudly conscious of their Jewish heritage. The most striking (and familiar) images are of the menorah, the seven-branched candelabrum that burns beside the Ark of the Covenant in synagogues. The ceiling of one tomb chamber in the Torlonia catacomb displays as its central image a

circle containing a huge menorah with all its lamps ablaze. On each of the four sides of the square area are semicircles that enclose figures of dolphins wound around tridents. Between these are smaller circles, three of which enclose an *ethrog* (a citrus fruit used in the celebration of the Jewish festival of Succoth), while a fourth contains a shofar, the ram's horn trumpet used in the celebration of the Jewish New Year. Amid these circular and semicircular areas winds a tracery of vine leaves.

The grapevines, dolphins, and tridents are images derived from Greco-Roman sources. The ancient Romans believed that dolphins and other sea creatures carried the souls of the deceased across perilous waters to the Elysian Fields. The trident, a three-pronged spear that is often an attribute of the Roman sea god Neptune, also symbolized power over the elements of nature. Grapevines appear as decoration in pagan Roman funerary art and figure prominently in the Eucharistic symbolism of early Christian art as well. Modern viewers are often surprised by the appearance of Jewish religious images combined with pagan motifs, but evidently such mixings did not bother the ancient Roman Jews at all. Another painting in the Torlonia catacomb shows six Torah scrolls, among the most sacred objects in Jewish culture, enclosed by a shrine in the shape of a Roman temple.

Because the other Jewish catacomb, the Vigna Randanini site, provides no place to park a car, reaching the entrance requires a hair-raising walk along the narrow but heavily traveled Via Appia Pignatelli. But here too the effort is worthwhile, for this catacomb offers another fascinating glimpse into the ancient Roman Jewish world. The community that used the Randanini site apparently was more prosperous than the one that buried its dead in the Torlonia catacomb, so the painted decorations are more numerous and of higher artistic quality. The site also yielded a large number of inscriptions, most of them carved on stone plaques similar to those found in the Christian catacombs, and used to seal the openings of the graves.

The inscriptions give the name of the deceased and often other information, such as the person's age, profession, marital status, and position held in the Jewish community. More than three-quarters of the inscriptions are in Greek, not Latin or Hebrew. This should not surprise us, since most Roman Jews spoke Greek, the common language of commerce in the ancient Mediterranean world. Inscriptions reveal a variety of professions: scholars, sailors, butchers, sausagemakers, tentmakers, and all kinds of merchants and shop owners, as well as bankers who helped to finance the trade that passed through Ostia (then the port of Rome) and Pozzuoli, near Naples.

The inscriptions further inform us that many Roman Jews died

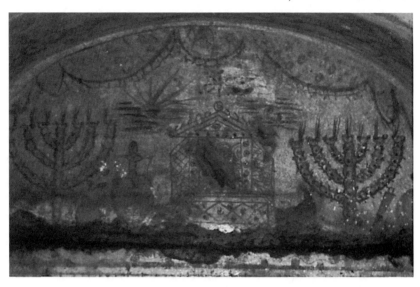

Jewish Catacomb of the Villa Torlonia, painting of the Ark with menorahs and other Jewish symbols. A striking feature of the imagery in the Jewish catacombs is the combination of pagan and Jewish elements. Here, the Ark of the Covenant is housed in a case resembling a Roman temple.

young. One mentions a man named Anteros who was sixteen when he married and twenty-two at his death. As in the Christian catacombs, the many tiny loculi tombs, often grouped together, offer sad testimony to the high rate of infant and child mortality. This epitaph served for two children who probably perished in an epidemic: "Here lie Fortunatus and Eutropis, children who loved each other. Fortunatus lived three years, four months, and Eutropis lived three years, seven months. They died on the same day. In peace be their sleep." Some people, however, lived to what would be considered a ripe old age even today. The epitaph of one man reads: "Here lies Parcharius, aged 110 years, lover of his people, lover of the Law. He lived a good life. In peace be his sleep." Another commemorates Menophilos, "who lived well as a Jew, spent thirty-four years with his wife, and witnessed his grandchildren." Although the epitaphs give some Hebrew names, only about 15 percent are of Semitic origin. Most of the Roman Jews had Greek or Latin names, indistinguishable from those of their neighbors.

Only a few of these plaques, with their revealing and often touching inscriptions, remain in the Randanini catacomb. Some disappeared in the centuries after the discovery of the site and nearly all the rest were removed during a program of repair conducted by the Vatican in the 1970s. They are now in various Vatican museums.

The paintings in the Randanini catacomb are so eclectic in their combination of Jewish and Roman imagery that when the site was first discovered scholars assumed the Jews had taken over a pagan burial place. In one room the ceiling decoration consists of a winged female figure crowning a nude youth, perhaps an athlete. Elegant and unselfconscious, these figures could easily have graced a pagan tomb chamber. The decoration of another ceiling shows the Roman goddess Fortuna holding a horn of plenty. Other walls and ceilings display baskets of flowers, floral garlands, cupids, fish, dolphins, fanciful winged horses, ducks, hens, and peacocks. Jewish imagery also appears, particularly the menorah.

Although some scholars have tried to find complex symbolic meanings in the imagery of the Jewish catacombs, others think we should view the images primarily as decorative elements, evidence of the degree to which the Jews of Rome had assimilated the cultural tastes of their neighbors. Religious images can be seen simply as emblems testifying to the Judaism of the deceased, while the motifs derived from pagan art reflect the prevailing tastes of the time. The Jews of Rome seem to have felt secure enough to borrow pagan imagery without feeling they were somehow surrendering or betraying their own heritage and traditions.

The survival of the Jewish community of Rome through more than two thousand years, with its religious traditions intact, offers eloquent testimony to both the strength of those traditions and the generally tolerant and humane attitudes of the people among whom the Roman Jews lived. Although the welfare of Rome's Jews varied with each emperor (and, after the empire became Christian, with each new pope), the Jewish community has a less harrowing history in Rome than in other parts of Europe. The severest test of the relations between Christians and Jews in Rome came during the period of the German occupation in 1944, when thousands of Romans risked their lives to hide and thus save many of their Jewish neighbors. Not even the grandest achievements of imperial Rome make me as proud of my Roman heritage as this knowledge does.

Suggested reading

Estelle Brettman, *Vaults of Memory: Jewish and Christian Imagery in the Catacombs of Rome* (Boston, 1985).
Harry Leon, *The Jews of Ancient Rome* (Philadelphia, 1960).
Sam Waagenaar, *The Pope's Jews* (LaSalle, Ill., 1974).

ST. JOHN LATERAN
The Pope's Cathedral

Anyone fortunate enough to be in Rome during a papal corona-
tion will learn something many visitors never find out: Rome's
cathedral is not St. Peter's but St. John Lateran. The Lateran is the
oldest of the Eternal City's major churches and site of the bishop's
chair, or *cathedra,* that gives the church its unique status. Since the
pope is also bishop of Rome, each new pontiff takes symbolic pos-
session of both his cathedral and the city by traveling in a splendid
procession that follows a time-honored route across Rome from
St. Peter's to St. John Lateran. The Lateran's deep ties with the pa-
pacy, its great age, imposing size, brilliant decoration, and eventful
history make it one of the city's major landmarks. Why, then, is the
Lateran not the spiritual focus of Christian Rome?

The reason for the failure of the Lateran to capture the alle-
giance of the Romans goes back to the church's foundation in the
early 300s, during the reign of Constantine. Although celebrated
by the Church as the ruler who granted toleration to Christians
and thus helped pave the way for Christianity's triumph, Constan-
tine was no saint. A man of enormous ambition, he dreamed of
reviving the glories of the earlier empire, possibly on a new, Chris-
tian foundation. His support of the early Church did not prevent
him from ruthlessly eliminating his rivals and from having his
wife, Fausta, strangled when she displeased him. He accepted bap-
tism only on his deathbed.

For reasons historians continue to debate, Constantine decided around 313–314 to use funds from the imperial treasury to build a large and imposing church for the bishop of Rome. At this time only about 10 percent of Rome's population was Christian; the Senate and much of the emperor's administration were still pagan, and the city's numerous temples were all functioning. Under such circumstances it would have been politically unwise for Constantine to have supported the construction of any major Christian buildings in the city center.

This is why the emperor chose as a site properties that were already in his possession on the eastern outskirts of the city—the former Lateranus family estate and the barracks of the imperial horse guards. In the mid–first century the Laterani had been accused of participating in a plot against Nero, and as a result that emperor had ordered the entire family executed and their estates confiscated. In 312 the horse guards, who then occupied the former Laterani estate, had supported Constantine's rival, Maxentius, and the victorious Constantine ordered their barracks burned. Thus, in one of the many ironies of Roman history, the city's cathedral was built over the remains of both a military barracks and a stable and took its name from a family of pagans who met a bloody end at the hands of an emperor notorious for his persecution of Christians.

No doubt in consultation with leaders of the Christian community the emperor and his architects turned to civic rather than pagan religious architecture as their models for the new church. The form they adopted was the basilica: an oblong structure with a peaked roof, flat ceiling, and wide central nave flanked on each side by two narrower aisles held up by columns. Basilicas had served for centuries as law courts and imperial audience halls and were therefore untainted by pagan religious practices. A large, resplendent Christian basilica would demonstrate to pagans and Christians alike the power of a new God and a new faith, what architectural historian Richard Krautheimer called "an audience hall for Christ the King."

Work on the Lateran basilica, along with its adjoining baptistery and papal palace, began about 314, and Pope Sylvester I consecrated the church a decade later. Originally dedicated to Christ, in the ninth century the dedication was changed to John the Baptist and in the twelfth century Pope Lucius II added John the Evangelist, hence the St. John portion of the church's name.

While the Lateran was still under construction, Constantine endowed another church, located on the Vatican Hill on the opposite side of the city and dedicated to St. Peter. Thus began a long rivalry between St. Peter's and the Lateran. Although the Lateran complex had primacy in terms of the date of its foundation

and also contained the papal palace and the bishop's chair, St. Peter's claimed to have something even more important: the body of St. Peter. The belief that St. Peter's was built over the tomb of the prince of the apostles gave that church a symbolic importance the Lateran could never match.

Although Constantine spared no expense for the Lateran, his choice of a site away from the city center proved unfortunate. He had established a religious and administrative headquarters for Christianity in Rome by imperial fiat, but he had selected it with his own political interests in mind. Most Christians in Rome did not and never would identify with the Lateran. Although the popes struggled to make the Lateran into the city's religious center, for the most part the city would develop to the west, toward the Vatican, while the area around the Lateran remained largely undeveloped until the late nineteenth century.

Early accounts describe a church richly adorned with colored marbles, mosaics, and paintings, but invasions, fires, and earthquakes repeatedly damaged it. Each time, however, that some natural or man-made disaster or just general decrepitude overtook their cathedral the popes made sure it was repaired. Nine reconstructions occurred between the fifth and the seventeenth centuries. The last major rebuilding took place in the late 1800s, when the ancient apse was replaced. A reconstruction of a portion of the north side of the Lateran basilica occurred in the early 1990s, made necessary after terrorists lobbed a bomb at the papal benediction loggia.

Five medieval Church councils took place at the Lateran. Among the most significant was the Second Lateran Council of 1139, which imposed celibacy on an unwilling and mostly married priesthood. Perhaps the most bizarre was the *Concilium Horribilis* of 897: the posthumous trial of Pope Formosus by his successor, Stephen VII. Not satisfied that his rival and enemy was dead, Stephen had the corpse of Formosus exhumed, dressed in full papal regalia, propped on a chair, and put on trial. When the cadaver failed to answer the papal lawyers' questions, this gruesome bundle of putrefaction was declared guilty, the three rotting benediction fingers cut off the right hand, and the remains tossed into the Tiber—not the Church's finest hour.

In the late 1580s Sixtus V had the original Lateran Palace demolished and replaced. He also raised the Lateran obelisk, the tallest (just over one hundred feet) and oldest (fifteenth century B.C.) in Rome. Brought from Egypt in 357 A.D. by the emperor Constantius II, the obelisk originally stood in the Circus Maximus. The pope's wizard of an engineer, Domenico Fontana, moved it in 1588 to its present location on the north side of the Lateran.

In the 1640s Innocent X gave Borromini the task of rebuilding

the Lateran basilica, and much of the church's present dazzling interior is the result of his interventions. Ordered to leave the magnificent gilded ceiling of the mid-1500s intact (it had been designed by a pupil of Michelangelo, Daniele da Volterra), Borromini transformed the rest of the basilica according to the tastes of the Baroque period. Whatever was left of earlier incarnations of the church disappeared under off-white marble paneling, giant piers and pilasters, carved panels of relief sculpture, dramatic paintings, and vigorously gesturing statues of the Twelve Apostles. Although the paintings and statues are not by Borromini, his plans made provision for them.

By the 1600s the Lateran had been accumulating the tombs of popes and cardinals for over a thousand years, and the interior had become very cluttered. Since there was no crypt to which the tombs could be removed, Borromini designed niches in the side aisles to hold them. These strange but often delightful amalgams of medieval or Renaissance statuary with Baroque architectural elements are among Borromini's most original creations.

Of particular artistic interest is the tomb of Portuguese cardinal Antonio Martinez Chiavez, located on the right side of the nave just before the transept. The recumbent effigy of the cardinal, who died in 1447, was created about 1460 by Isaia of Pisa, whose trademark is a nice, plump pillow under the head of the deceased. Three praying figures who represent Faith, Hope, and Charity stand behind the comfortable-looking cardinal, and dancing baby angels hold up the inscription on his coffin. This simple ensemble is now ensconced in a dramatically curving Borromini stage set consisting of a half-circular colonnade built into the wall below an immense oval window. On the wall above the window are relief sculptures of two gigantic cherubim with heads and wings larger than Chiavez's entire effigy.

Borromini did not design the exterior of the Lateran; the facade is the work of Alessandro Galilei who completed it in the 1730s. It is a more compact variant of the front of St. Peter's: a two-story portico with giant pilasters that flank a pedimented temple front. Along the roofline are fifteen of the largest post-antique statues in Rome: a twenty-four-foot image of Christ at the center between the two St. Johns, flanked by the twelve major theologians of the Greek and Latin churches. As noted in Chapter 1, the main entrance of the Lateran preserves the splendid fourth-century bronze doors of the Roman Senate House.

Like many early Christian churches, the Lateran is oriented with its altar end toward the west so that a priest celebrating Mass faces east, in the direction of Jerusalem. Such an orientation means, however, that the entrance of the Lateran faces east, away from the center of Rome, which gives the curious effect that the

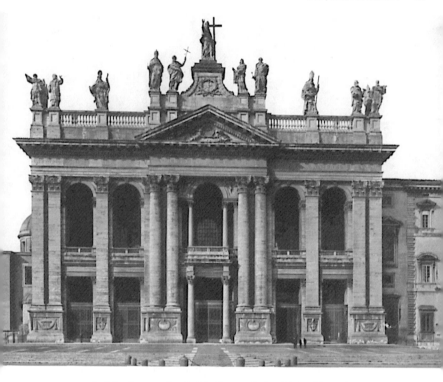

St. John Lateran, facade. The Lateran is the oldest of Rome's
major churches and the city's cathedral.

cathedral is turning its back on the city. Even the large papal
benediction loggia, constructed in 1586 by Fontana for the civic-
minded Sixtus V, is on the north side of the church; so it too faces
away from the city center.

With all its vicissitudes and odd features, the Lateran has never
ceased to function as Rome's cathedral. Behind the main altar the
early medieval episcopal throne remains in place, a touchingly
simple stone seat still used by the pope in his role as bishop of
Rome. Although since the 1500s the popes celebrate Mass at the
Lateran only on a few special occasions, when they do they call up
the most ancient pastoral associations of the papal office: the pope
as the shepherd of the Eternal City.

Suggested reading

Richard Krautheimer, *Rome: Portrait of a City, 312–1308*
 (Princeton, 1980).

S. Maria Maggiore
Rome's First "Mary" Church

When Celestine I (422–432) decided to build a church dedicated to Mary on the summit of Rome's Esquiline Hill, some women of the city still worshiped the mother goddess Juno Lucina on that site. Rome itself was recovering from the damage inflicted by Alaric and his Germanic troops in 410. The emperors no longer occupied the magnificent but crumbling buildings of the Palatine Hill; the imperial court had moved first to Milan and then to Ravenna, a northern coastal city surrounded by marshlands that the emperors hoped would be easier to defend than Rome. Beyond the walls of Rome what remained of the western empire was entering its death throes. A few decades later, in 476, the barbarian warrior-chief Odoacer entered Ravenna and deposed a pathetic eight-year-old boy named Romulus Augustulus, the last Roman emperor in the west.

In such a situation it may seem surprising that artworks of great power and beauty could be created. Although the Roman Empire was close to collapse, one institution had survived and prospered: the Christian Church. Paganism was as good as dead, and a new, Christianized Rome was being born. Increasingly the popes took the place of the emperors in Rome, both politically and as patrons of the arts. In another irony of Roman history the Christian Church preserved much of Rome's classical heritage and carried on an important artistic tradition of the pagan empire: the construction of immense, splendidly decorated buildings.

That the Christians destroyed so many Roman buildings to do so adds still another layer of irony.

It is against this backdrop that we should view the church of S. Maria Maggiore: classical antiquity reborn in the Christian spirit. Technically this is not the first church in Rome to be dedicated to Mary; S. Maria in Trastevere is almost a century older. But as its name implies, S. Maria Maggiore is the city's major Mary church, the largest and grandest of the many churches in Rome dedicated to the Virgin, and the first constructed under papal patronage. Although much altered in the course of fifteen hundred years (the exterior dates mostly from the seventeenth and eighteenth centuries), the interior retains its original combination of classical gravity and imperial grandeur to a remarkable degree.

A charming legend describes the founding of the church. On a sweltering August night in 356 the Virgin Mary appeared in the dreams of two important people in Rome: Pope Liberius and a wealthy Christian named John. She directed them to build a church dedicated to her at a spot on the Esquiline Hill, which they would find marked by a miraculous snowfall. (Anyone who has ever been in Rome in August knows that a snowfall in that month would *have* to be miraculous.) The next morning the two men found the site Mary wanted, with its plan marked out in the snow. The modern Catholic Church commemorates Mary's miraculous snowfall with a papal Mass held every August 5 in the Borghese Chapel of S. Maria Maggiore, accompanied by white flower petals floating down from the chapel ceiling in place of snowflakes.

The actual circumstances of the founding of S. Maria Maggiore were probably more practical than miraculous. Because the site had been for centuries a center of mother-goddess worship, it was the logical place to build a shrine to the greatest mother in Christian theology, providing an opportunity to replace a pagan cult center with a Christian one. Furthermore the Church at this time was moving toward greater recognition of Mary, a recognition that would be formally instituted at the Council of Ephesus in 431. This Church council, held in a city in Turkey for thousands of years a center of mother-goddess worship, declared Mary *theoutokos,* or Mother of God. In the same city, almost four hundred years earlier, St. Paul's preaching (described in Acts 19) had caused a full-scale riot among the goddess's outraged followers.

We do not know the precise date when construction began on S. Maria Maggiore. It may have been started in the 420s, or at the latest in 431, after the Council of Ephesus. The plan was probably drawn up at the orders of Celestine I, who died in 432, and the church was completed during the reign of the subsequent pope, Sixtus III (432–440), whose name appears in the mosaic decoration of the interior.

Significantly, the form chosen for the church was the Roman civil basilica, the same form used by Constantine for the city's first great churches constructed under imperial patronage in the previous century: St. John Lateran and St. Peter's. The original ceiling may have looked something like the present one, which was put in place in the early 1500s and gilded with the first gold Columbus brought back from the New World.

The builders of S. Maria Maggiore went to considerable efforts to assure that their church would convey both the solemnity and the splendor of their faith, qualities they had already seen embodied at the Lateran and St. Peter's. They believed the architectural and artistic vocabulary of imperial Rome would best accomplish this goal. Instead of the mishmash of unmatched columns looted from the ruins of various pagan temples, which so often support the interiors of Rome's early churches, the nave of S. Maria Maggiore displays thirty-six massive, perfectly matched columns of polished marble and four of granite, all topped with identical capitals in the elegant Corinthian double-spiral shape typical of the glory days of the second century A.D. The upper walls of the nave have a further classical touch; they are sectioned off by tall, slender pilasters, flat depictions of columns embedded in the walls.

The pilasters flank a series of Old Testament scenes executed in glass mosaic. More mosaics, illustrating Christ's first coming and early life, cover the triumphal arch, the portion of the wall facing the congregation at the beginning of the apse. The apse itself was rebuilt in the late 1200s and the original mosaics destroyed. The present apse mosaic is a brilliant Coronation of the Virgin as Queen of Heaven, accompanied by other scenes from Mary's life, designed in the 1290s by Jacopo Torriti.

As beautiful as Torriti's mosaics are, the real treasures of S. Maria Maggiore are its early Christian mosaics, executed between 432 and 440 under the patronage of Sixtus III. Their exquisite workmanship reflects a style rooted in the classical traditions of pagan Roman mosaics, wall paintings, and illustrated scroll manuscripts, with a nod in the direction of the narrative reliefs on the Column of Trajan.

Of the forty-two mosaic panels that once flanked the nave of S. Maria Maggiore, only twenty-seven remain. Nine that had deteriorated were replaced by mediocre paintings during a renovation in 1593. Six others, three on the left and three on the right, were destroyed to make the tall entrances into the two principal side chapels—both so huge that they are almost separate churches— the late sixteenth-century chapel of Sixtus V on the left and the early seventeenth-century chapel of Paul V on the right.

On the left nave wall the mosaic panels depict scenes from the lives of Abraham, Isaac, and Jacob: the fulfillment of God's promise that Abraham would become the father of a mighty nation.

Abraham's great-grandsons would found the twelve tribes of Israel, the Chosen People from whom the Messiah would come. On the right wall are stories from the lives of Moses and Joshua, which show God aiding his people against their enemies. The ancient Hebrews look remarkably like Romans; the men wear white togas, sometimes trimmed with purple, the Roman insignia of noble rank. Soldiers wear Roman tunics, sandals, and armor and carry Roman shields and spears. The episodes take place against toy-sized classical buildings and rudimentary landscapes. Such a style is to be expected, since the artists, although no doubt Christians, were also Romans trained in the city's own artistic traditions.

On a sunny day and armed with a pair of binoculars the viewer can make out some intriguing images. On the right side of the nave one sees Moses, clad in a gleaming white toga with blue and gray shadowing, parting the waters of the Red Sea with the dramatic gesture of a classical Roman orator. Behind him a crowd of Hebrews piles up on dry land while Pharaoh's army, complete with horses, chariots, helmets, spears, and cumbersome shields, pours out of a city gate and then flounders helplessly in the blue green water. In the familiar story of the fall of the city of Jericho, the walls "come tumbling down" with exemplary neatness: the left side of the miniature citadel shears away in one piece and topples toward Joshua's waiting army.

The program of mosaics comes together on the triumphal arch, where scenes from the life of Mary and Christ form a series of horizontal registers on either side of the semi-circular opening into the apse. Here is the fulfillment of God's promises in the advent of the Messiah born of the Virgin Mother who just recently had received the exalted title of Mother of God.

The story begins at the upper left with the Annunciation. The subject is barely recognizable here, for Mary has undergone a striking transformation. In place of the humble Jewish peasant girl of the Bible is an enthroned and crowned Roman empress, her golden robes encrusted with jewels. Two toga-clad angels flank each side of the throne; except for their wings and halos, they could be imperial chamberlains. The angel Gabriel, shown in profile, hovers overhead and the dove of the Holy Spirit descends toward Mary through orange, green, and gold clouds. On the right two more imperial angels inform Joseph of Mary's miraculous pregnancy.

Across the top, the next scene shows the Presentation of Christ in the Temple. Mary, still in her gleaming imperial robes, presents the Christ Child to Simeon and Hannah, who are accompanied by splendidly clad Hebrew priests in multicolored robes fastened with jeweled brooches. They look as though they would be right at home in the company of a Roman emperor or tending the cult

S. Maria Maggiore, mosaics of the triumphal arch. These mosaics showing scenes from the life of Christ are among the best preserved and most extensive in Rome.

image of Jupiter Optimus Maximus. On the far right an angel warns Joseph to take the Child and flee to Egypt.

The second register down begins with the Adoration of the Magi. The Three Kings wear a standard Near Eastern article of clothing that would have seemed most curious to fifth-century Romans: trousers. In this episode the young Christ sits like an infant Roman emperor on the purple cushion of an enormous, jewel-encrusted throne, far grander than the one occupied by Mary in the Annunciation scene. Mary has moved to the left side and sits subordinate to her regal Son, but she lays her left hand familiarly on the armrest of Christ's throne. At her side one of the Magi points to the Star of Bethlehem, which appears above Christ's head. Behind the throne stands the same honor guard of angels who had attended Mary at the Annunciation. On the right are the other two Magi and a mysterious seated woman dressed in a dark blue robe over a golden tunic. She rests her chin on her right hand and stares pensively past the Christ Child. Although sometimes identified as the personification of Divine Wisdom, her identity is uncertain. Across the arch from the Adoration is a non-biblical scene: the arrival of the Holy Family in Egypt, where Aphrodisius, the governor of the city of Sotine, recognizes the divinity of Jesus. This story, which first appeared in written form in the sixth century, must have been familiar to Sixtus and his mosaic artists from an unknown written source or through oral tradition.

The biblical narrative picks up again in the third register down, where the Massacre of the Innocents—the killing of all the male

children of Bethlehem under the age of two years, at King Herod's orders, in an attempt to kill Jesus—appears in a restrained version. A small group of soldiers wearing the cloaks and crested helmets of the Roman army moves toward a thickly packed crowd of Hebrew women clutching babies. On the opposite side of the triumphal arch the Three Magi appear before King Herod, who is identified by name in a mosaic inscription above his head. The scene is identified as the Magi inquiring about the birthplace of the new king of the Jews, although it is out of place in the sequence of events. In the biblical narrative, this event occurs before the Adoration.

In the narrow bottom parts of the triumphal arch are depictions of Bethlehem and Jerusalem. Each city has golden, jewel-encrusted walls surrounding an assortment of classical Roman temples, the whole assemblage Christianized by a jeweled cross hung at the top of each city gate. Bethlehem, hallowed as the place where Christ was born in fulfillment of Old Testament prophecy, is on the right. Jerusalem, where he died, is on the left and may also allude to the Heavenly Jerusalem, the City of God described in Revelation, the final, visionary book of the Christian Scriptures.

At the top of the triumphal arch stand Saints Peter and Paul, accompanied by symbols of the Four Evangelists and flanking an image of yet another throne, this one the most splendid of all, enclosed in a circle of blazing blue light. On its seat is a jeweled cross and below it a mosaic inscription in white letters against a black background: XYSTUS EPISCOPUS PLEBI DEI (Sixtus, bishop to the people of God). It can hardly be coincidence that the word *episcopus* is directly below the throne, thus associating and perhaps even equating the throne of Christ with that of the bishop of Rome, who was also the pope by this time.

What better symbol of the pope's assertion of his unique, divine authority as the head of the Church? In the 400s the right of the bishop of Rome to claim primacy and authority over all other bishops was by no means uncontested. The mosaics of S. Maria Maggiore announce forcefully, and for the first time in the visual arts, that the pope—in this case Sixtus III but by extension any pope—is the true successor to St. Peter, the head of the entire Church community, and thus the spiritual leader of all the "people of God" throughout the world. The emperors have abandoned Rome and in a few decades the western Roman Empire was officially to "fall," but in its place the Church is already employing imperial forms to proclaim its own spiritual empire.

Because in today's world the idea of the "imperial" Church may strike many viewers as outdated, a new addition to this ancient basilica, made during the restoration of 1991–1993, is particularly interesting: a large and colorful stained glass window designed by contemporary artist Giovanni Hajnal and located above

the entrance doors. It shows the Virgin and Child enthroned be-
tween a menorah and tablets of the law on the left and a chalice
and a cross on the right. An inscription identifies the figure as
Maria excelsa filia Sion (Mary, exalted daughter of Zion). This
handsome and forthright celebration of Christianity's Jewish roots
is very much in the spirit of the Second Vatican Council and is
particularly apt in a church that houses such a marvelous cycle of
Old Testament mosaics. Noticing the window on a recent visit to
Rome reminded me of the efforts of both John Paul II and the
late Joseph Cardinal Bernardin of Chicago on behalf of Jewish-
Christian harmony. No doubt Pope John Paul has admired the
window, and it surely must have pleased Cardinal Bernardin if he
saw it on one of his last visits to Rome.

Suggested reading

Richard Krautheimer, *Rome: Portrait of a City, 312–1308*
 (Princeton, 1980).

S. PRASSEDE

A Medieval Garden of Paradise

Of the twenty-eight prominent people whom Paul considered
it politic to greet [Rom. 16], ten were women.

—Karen Torjesen, *When Women Were Priests*

The last place we might think to look for a glimpse of paradise
would be inside a dilapidated-looking early medieval church
tucked away on a quiet side street not far from the din of Rome's
central railroad station. But those who make an effort to find the
church of S. Prassede, located on a street of the same name, are in
for a marvelous treat. Behind its doors are some of the most beau-
tiful mosaics in Rome, mosaics so marvelous they have gained the
church a nickname: the Garden of Paradise. In addition, a lengthy
historical tradition and more than one mystery attend this modest
structure.

Prassede, the woman for whom the church was named, has a
peculiar biography. Her church is one of the very few in Rome
dedicated to a saint whom the Catholic Church now says never
existed. According to legend Prassede was the sister of another
saint now considered nonexistent, Pudenziana (who also has an
interesting church dedicated to her, located just a few blocks
away). These women were the daughters of a Roman senator
named Pudens, an early convert to the Christian faith. Senator
Pudens, so the story goes, hosted St. Peter on his first visit to
Rome and the saint converted the senator's two daughters.

Later the daughters also played host to St. Peter and gave refuge to Christians during times of persecution. In the courtyard of her house Prassede is supposed to have buried the corpses of a group of Christians the Roman authorities had massacred there and to have mopped up their blood with a sponge. Modern archaeological excavations in fact have recovered the remains of some thirty mangled bodies from an ancient well, marked by a slab of porphyry in the pavement of the present church, which would seem to argue for the truth of the story. Nonetheless, during some ecclesiastical housecleaning conducted by the Church in 1969 Prassede and Pudenziana were declared legendary rather than historical figures.

Whatever the historical reality of these two women, a religious shrine has been on this site since about 150 A.D., and a church was in existence here by the fifth century. The present building dates from the 820s. Although it has been repeatedly restored, it still retains its special character as the best representative of a particularly significant epoch in Rome's history, and it contains one image that is a fascinating enigma.

The centuries after 476 (when the western Roman Empire ceased to exist) were disastrous for Rome, but the city, sacked repeatedly by various invading armies, had somehow survived. Eyewitnesses describe a desolate and largely uninhabited city in which magnificent buildings were crumbling into ruins, aqueducts and sewers no longer functioned, garbage lay rotting in the streets, and whose wretched inhabitants crept about in constant fear of floods, disease, starvation, or death at the hands of thugs and bandits.

By the latter part of the eighth century conditions had improved, largely due to the efforts of some capable and energetic popes. At Christmas Mass in St. Peter's church in the year 800, Leo III placed a crown on the head of the visiting Germanic ruler Charlemagne and declared him *Carolus Augustus, Imperator Romanorum* (Charles Augustus, emperor of the Romans). The exact circumstances and significance of this act have been endlessly debated by historians, but by this action the pope revived the Roman Empire in the West. From that moment on, Charlemagne began to behave less like a tribal chieftain and more like a Roman emperor. Among his most significant acts with regard to Rome was to make generous gifts to Leo III, increasing the wealth and prestige of the Roman Church.

Although Charlemagne died in 814 and Leo III in 816, their legacy lived on in a renewed and invigorated Rome. Leo's successor, Paschal I (817–824), was determined to make the again-imperial city a worthy successor to the Rome of antiquity and the early Christian Rome of Constantine. Among the numerous churches Paschal ordered built or remodeled was S. Prassede.

Beginning in 822 Paschal had the earlier church replaced with a small basilica, a miniature version of the immense fourth-century basilica of St. Peter's, built during the reign of Constantine. The columns of the nave and the architrave (the horizontal band above the columns) are all *spolia,* a Latin term for materials looted from Roman buildings, which add to the imperial atmosphere of the church. But the glory of S. Prassede is its mosaic decoration. The vault of the apse, the surface of the triumphal arch leading into the apse, and especially the chapel of St. Zeno are decorated with some of the most splendid and colorful mosaics in Rome.

From the vault of the apse a full-length figure of Christ towers above the saints assembled on either side of him. The scene takes place against the deep blue sky of heaven, enlivened by red, pink, white, and blue gray clouds. The figures stand on a vivid green strip of earth planted with long-stemmed red flowers. Saints Peter and Paul introduce the two sisters, Prassede on the left and Pudenziana on the right, both sumptuously dressed in multicolored robes. Although such a gesture is fairly standard in scenes of presentation, there is something charming and somehow touching about the way the princes of the apostles drape their arms around the shoulders of the two women, as if they were all old friends. (If the legends have any truth, St. Peter actually *was* an old friend.) St. Zeno stands on the far right and on the left is Pope Paschal, his head framed with the square halo reserved for the living. In his arms he carries a model of the church. Below the holy figures white lambs symbolizing the faithful of the Christian community gaze upward at this heavenly vision. At the bottom is a dedicatory inscription in the classic Roman capital letters we still use today.

On the outer face of the triumphal arch is the Heavenly Jerusalem, its golden walls glittering with jewels. A figure of Christ floats above the center of the wall, flanked by images of saints, each bearing a crown of martyrdom. On either side angels present still more martyred saints to Peter and Paul. The abundance of martyrs probably refers to one of the most notable events of Paschal's reign: the transfer of the bones of thousands of early Christians from Rome's looted and crumbling catacombs to this church, where they were reburied in the crypt.

The inside of the triumphal arch displays a scene from Revelation: the Twenty-Four Elders offering their golden crowns to the Holy Lamb, which appears at the top of the inner surface of the arch, just behind the monogram of Paschal. The identical, touchingly awkward Elders, all clad in white togas, gaze raptly toward the Lamb of God.

The high point of any visit to S. Prassede is the chapel of St. Zeno—also built and decorated for Paschal I—on the south side of the nave. This tiny gem of a structure's appearance and original

purpose suggest the reason for the name Garden of Paradise for the church. The pope had the chapel built in honor of his mother, whose name was Theodora. Although she was still alive at the time, the chapel was to be, and is, her funeral monument. Few sons have ever given their mothers a more perfect resting place.

This is the only chapel in Rome where gold ground mosaics (made of clear or colored glass fused with very thin sheets of gold) sheath nearly all the inner surfaces of a building. When these irregular bits of gleaming glass reflect the flickering light of candles they fill the chapel with a most amazing radiance, but even when seen by electric light they offer the visitor an unforgettable experience.

One enters the chapel through a doorway in the nave flanked by two ancient Roman columns of red porphyry and topped with an exquisitely carved lintel that no doubt once adorned an ancient temple. Above the lintel is a double arc of mosaic portrait busts. The outer group consists of Christ with the Twelve Apostles, while the inner group displays the Virgin and Child flanked by two male and eight female saints, including Prassede and Pudenziana. Stepping inside makes it clear why the chapel is called the Garden of Paradise. The visitor—immediately and entirely surrounded by glittering, multicolored images of Christ, saints, and angels—seems to have stepped into heaven.

On each of the four walls we encounter male saints in brilliant white togas. In contrast the female saints wear elaborate garments in the richest colors: dark and light blues, brilliant yellows, greens, and reds. All of them seem to float against a background of gleaming gold. On the golden expanse of the ceiling four singularly imperious angels uphold a half-length image of Christ.

Not all the saints portrayed on the walls of the chapel of St. Zeno are named and some are difficult to identify. But one figure is carefully labeled and is the most intriguing of all: Theodora, the mother of Pope Paschal. Portrayed in a mosaic portrait bust to the left of similar images of Mary with Saints Prassede and Pudenziana, she wears a brick red robe and a gold necklace, and her head, modestly swathed in a white cloth, is set against a square blue halo, indicating that she was still alive when the portrait was made. Her name appears vertically, to the left of her halo. We know the chapel was designed to hold her tomb, so it is not surprising that she should be portrayed here, in the company of saints and angels and identified by a mosaic inscription. But it is the second part of the inscription that presents us with a mystery: running horizontally above her head is the word *episcopa*.

Most scholars make no comment about this inscription, despite (or perhaps because of) its extraordinary implications. The word *episcopa* is not a family name, although it is often translated that way, as if Theodora Episcopa were her full name. But this is impossible.

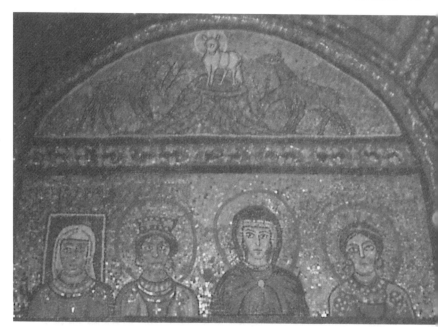

S. Prassede, chapel of S. Zeno. The mosaic shows a woman identified as "bishop" Theodora with the Virgin Mary and Saints Prassede and Pudenziana.

The word is a title and it means "bishop." In Latin, *episcopus* is the masculine form for *bishop,* and *episcopa* is the feminine form. The inscription should therefore be translated as "Bishop Theodora."

What we make of this apparent anomaly, a *female* bishop in the ninth-century Church, depends on how open we are to the possibility that the Catholic Church was once a very different institution than it is today. One option is to continue to accept the linguistically unwarranted assumption that Episcopa is Theodora's last name. Another hypothesis, now discredited, is that the word *episcopa* was added at some later date. An Italian archaeologist made a minute examination of the bits of glass that make up the inscription, frankly hoping to find that they were not contemporary with the rest of the mosaic, but his efforts, as he was honest enough to admit, proved the opposite: the inscription is original. What he *did* discover, however, was that sometime after the ninth century someone had removed the last two letters of Theodora's name and filled in the blank area with plain glass, in an effort to create a masculine name. What we read there today is "Theodo."

Still another way of solving the puzzle is to assume, as some traditional scholars of Church history do, that the title is merely honorary. Theodora was the mother of the pope, who is also the

bishop of Rome, and so her title would then refer to her son's clerical position and not to hers. It could therefore be interpreted as "Theodora [mother of the] bishop."

A more intriguing although more controversial possibility is that Theodora actually *was* a bishop. Contemporary historians of early Christianity are turning up increasing evidence that the first thousand years of Christian history were in some ways very different from the second millennium. Clerical marriage was common; clerical celibacy was encouraged but not enforced; abortion was allowed during the first three months of pregnancy because the soul was not thought to enter the body until the third month; and women held more prominent leadership positions than they do today. The Italian scholar Giorgio Otranto has claimed that there is evidence for the ordination of small numbers of women throughout the first millennium of Christian history.

It was a fairly common practice in the early Church to have women "overseers," the literal meaning of the word *episcopus/episcopa*. This was a holdover from apostolic times; readers of the letters of St. Paul in the New Testament will be familiar with how often and how respectfully he greets the female leaders of some of the earliest Christian communities. Whether such women were actually ordained as priests remains unclear. But the use of the title "bishop" for Pope Paschal's mother may offer us a valuable insight into that distant age, when women may have performed clerical functions now closed to them. Although in the twentieth-century Roman Catholic Church there is no place for a Bishop Theodora, in the Rome of a thousand years ago quite possibly there was.

Suggested reading

Dorothy Irving, "The Ministry of Women in the Early
 Church: The Archeological Evidence," *Duke Divinity School
 Review*, no. 2 (1980).
Joan Morris, *The Lady Was a Bishop: The Hidden History of
 Women with Clerical Ordination* (New York, 1973).
Karen Torjesen, *When Women Were Priests* (New York, 1993).

S. CLEMENTE
A Multilayered Marvel

I saw the conduct of life. I saw the things men do, . . .
I read the books, and know that all night long
History drips in the dark, and if you should fumble
Your way into that farther room where no
Light is, the floor would be slick to your foot.

—Robert Penn Warren, *Brother to Dragons*

One of the best places to experience the fascinating complexities of Rome's multilayered history is in the church of S. Clemente. Here, still within earshot of the roaring traffic that speeds past the Colosseum, is a quiet site with something to offer visitors interested in virtually any period of Rome's art and history. The experience can be exhilarating and informative but also disquieting and even uncanny. To enter S. Clemente is to wade into the living stream of history.

S. Clemente is unique among Rome's churches. Not just a single church, it is a series of different structures, each built atop the ruins of the other, over the course of more than a thousand years. Many Roman churches have interesting basements—foundations on the ruins of pagan temples, bathhouses, or even (in the case of S. Agnese in Agone), a brothel. But only at S. Clemente can the visitor descend through centuries, to a depth some thirty feet below present street level and almost two thousand years into the past.

Making sense of S. Clemente requires us to alter our normal

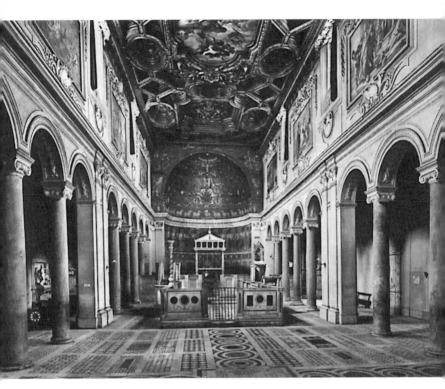

S. Clemente, interior. The present church has three more structures beneath it,
extending back to the first century A.D.

chronological sense, which is to move forward through time, and
instead to go both backward and forward. The building we enter is
a medieval church built in the early 1100s, but the frescoes that fill
the side chapels range in date from the fifteenth to the eighteenth
century. We are hardly inside S. Clemente and we have already en-
compassed seven hundred years.

Next to the south doors is a chapel dedicated to St. Catherine,
decorated in the 1420s by the Florentine artist Masolino. Here is
one of the few places in Rome where visitors can enjoy the
vividly realistic style that revolutionized Italian painting. Masolino
(ca. 1383–ca. 1435), a slightly older and less renowned contempo-
rary of the famous Florentine painter Masaccio, was invited to
Rome in 1428–1429 to decorate this chapel. The commission
came from Cardinal Branda Castiglione, a distinguished member
of a noble northern Italian family.

On the outer face of the triumphal arch (the area above the
entrance to the chapel) is an Annunciation surmounted by an im-
age of God the Father. On the left-hand pier of the archway is a

painting of St. Christopher and half-length portraits of the apostles adorn the archvolt (the inner surface of the entrance arch). Inside the chapel the central image is a Crucifixion, now badly damaged, flanked by four scenes from the life of St. Ambrose on the right and eight from the life of St. Catherine of Alexandria on the left. In the vault are the Four Evangelists and the Four Doctors (major theologians) of the Church.

The unusual program of images in the chapel reflects the personal history and interests of Cardinal Castiglione. The legend of St. Christopher, the gentle giant who unknowingly carried the Christ Child across a dangerous river, originated in northern Italy, the cardinal's native region. St. Ambrose, who lived in the fifth century, was also a northern Italian. A staunch defender of the faith against heretics, he was an early archbishop of Milan. Like Ambrose St. Catherine of Alexandria was associated with the defense of religious orthodoxy. The cardinal saw himself in a similar role, active in healing the Great Schism (during which the Church threatened to split into three parts) and bringing about the return of the papacy from France to Rome, after its almost century-long exile in Avignon during the 1300s.

Like so many other artists who came to Rome from elsewhere, Masolino was impressed by the city's wealth of ancient Roman, early Christian, and medieval monuments. The decorative patterns he used for the ceiling of the room in which the Annunciation takes place and the various painted borders that divide the scenes on the walls, for example, are derived from the designs executed in local colored stone (called Cosmati work) that appear frequently in the floors of Rome's medieval churches, including S. Clemente. The coffered ceilings in the scenes of St. Catherine Arguing with the Philosophers and St. Ambrose on His Deathbed were probably inspired by the interior of the dome of the Pantheon, and the scene of St. Catherine Arguing against Idolatry takes place within a domed rotunda obviously based on the Pantheon. The setting for St. Ambrose Elected Bishop of Milan is a typical early Christian church interior, similar to that of S. Maria Maggiore.

The most conspicuous feature of Masolino's compositions in the Castiglione Chapel is the artist's use of three-dimensional space. The science of one-point perspective was still new at this time; the Florentine architect Brunelleschi had developed the system barely ten years earlier. In comparison to the twelfth-century mosaics of the apse, Masolino's frescoes demonstrate the most obvious characteristic of Early Renaissance painting: the conquest of three-dimensional space. The intricate, spaceless surface patterns of the church's mosaics offer a strong contrast to the logically constructed rooms in Masolino's compositions.

The great glory of S. Clemente is its twelfth-century apse mosaic. Above and behind an altar area that includes an eleventh-century bishop's chair, a huge twelfth-century candlestick, and a sixth-century choir, soars a half-dome filled with a gleaming expanse of gold and multicolored mosaics. The central image is the crucified Christ, flanked by the Virgin Mary and St. John, but it is an image that bears little resemblance to the suffering Savior familiar to modern Catholics. Jesus seems to be sleeping rather than dying; his feet rest on a golden platform and his deep blue cross is festooned with white doves. This "living cross" conveys the essence of salvation, centered on the basic Christian idea of Christ's sacrifice redeeming the human race.

The base of the cross grows out of a thick, bright green bush. Watered by Christ's blood, it sends out a symmetrical series of spiraling tendrils that cover the entire surface of the dome. Among the branches of this vast vine all the world finds a place, for this is the Tree of Life. Under its protective shelter swarms a multitude of people and animals, all going about their daily activities. Brilliantly plumed peacocks strut; parent birds feed their nestlings; shepherds guard their flocks and milk their ewes; farm women feed their chickens. The members of a wealthy family, perhaps the unknown patrons of the piece, display their finery, and four seated figures clothed in black and white brandish pens and large books. Each of them is labeled; they are the four major theologians of the Latin (Roman Catholic) Church: Saints Ambrose, Gregory, Augustine, and Jerome. A few pagans are still around as well, in the form of small and perhaps unintentionally endearing little demons: scrawny, potbellied, winged boys riding dolphins or sitting on flowers. Even they seem to be under the benevolent protection of the Church's all-encompassing vine.

Above this teeming world the heavens billow open like a canopy, revealing the hand of God clasping a victory wreath. At the apex of the composition is the monogram of Christ, the Greek letters *chi* and *rho,* which correspond to the *CH* and *R* of the Latin alphabet and form the first letters of the word *Christ.* Directly above, on the flat wall surface, is a half-length image of Christ surrounded by stars and accompanied by symbols of the Four Evangelists. Lower down on this same wall, St. Paul sits with St. Lawrence on the left side and St. Peter accompanies St. Clement on the right. The prophets Isaiah (left) and Jeremiah (right) stand near the bottom, each holding scrolls containing messianic prophecies.

The familiar biblical text "Glory to God in the highest and on earth peace, good will to men" frames the apse mosaic. Below it, in smaller letters, is another Latin inscription, which attempts to explain the meaning of the mosaic, but which wanders off into

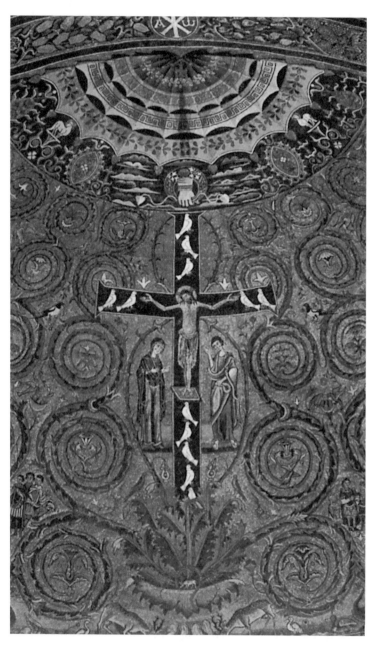

S. Clemente, detail of apse mosaic, *Crucifixion*. This exquisite mosaic portrays a "living cross" from which grows an immense vine symbolizing the redemptive power of Christ.

some bizarre information. It begins "Let us compare the Church to this vine; the Law made it wither but the Cross causes it to bloom." This is helpful, since it explains the vine image by contrasting the salvation offered by Christ with the Old Law of the Hebrews. But the rest of the text makes one wonder. It continues: "A piece of the true Cross, a tooth of St. James, and one of St. Ignatius rest in the body of Christ above this inscription." This is a reference to the once popular (and often very profitable) cult of relics, in which merchants did a brisk trade in purported fragments of sacred objects and saintly body parts. The apse mosaics have recently been cleaned, but if any workmen found wood splinters and a couple of human teeth embedded in the body of Christ, they kept quiet about it.

The voyage into the distant past begins when we leave the nave of S. Clemente and enter the vestibule of the sacristy. In the back on the right, a door leads to a staircase. To descend that staircase is to enter another world, for the S. Clemente we have just seen is only the beginning. Beneath the present church are three more levels, each one rich in artifacts and history.

Until the mid-1800s nobody had a clue to what lay beneath S. Clemente. In 1857 Fr. Joseph Mullooly, the abbot of S. Clemente, became convinced by the architectural style of the present church that it could not be the original one and that there must be earlier structures beneath his church. So he decided to poke around a bit. (If his name sounds un-Italian, this is because S. Clemente has been administered since 1677 by Irish Dominican monks.) Mullooly's discoveries were astonishing. Under the church he found the remains of another, larger church of the fourth century and below those the remains of an even earlier Roman building. Subsequent abbots continued the excavations, often carried out with great difficulty, and in 1910 the construction of a drain revealed still another layer beneath the previous three: the remains of a building from the first century, destroyed in the fire of 64 A.D. The astonishing rise in the ground level of Rome seen here can be explained by repeated destruction and rebuilding. Anyone who has watched the curbs begin to disappear as neighborhood streets are repaved can appreciate, on a much smaller scale, how the level of a city can rise over the course of centuries.

At last it became possible to reconstruct parts of the history of S. Clemente. Legends, combined with archaeological finds, enable us to fit the puzzle pieces together. St. Clement, who died about 100 A.D., was the third successor to St. Peter; this makes him the fourth pope. Peculiarities of his surviving writings suggest that his native language was neither Greek nor Latin; he was probably of Jewish background, perhaps a freed slave from the house of a cousin of the emperor Domitian (81–96 A.D.), a man named Titus

Flavius Clemens. As was the custom among freedmen of the Roman world, Clemens's former slave took his master's name. It is the large and imposing house of the Roman aristocrat Titus Flavius Clemens that lies at the deepest level beneath the church of S. Clemente.

In later centuries St. Clement became the subject of many dubious legends, which are nonetheless helpful in attempts to understand the numerous frescoes in both the lower and the upper churches. According to these legends Clement's missionary work in Rome caused the authorities to banish him from the city and send him off as a slave to the imperial mines in the Crimea. Once there, he continued his missionary efforts with such zeal that the Romans bound him to an anchor and tossed him into the Black Sea. Eventually the waters receded, revealing the saint's tomb, built by angels and with Clement's body intact inside it. In the 800s this legend inspired two more future saints—Cyril and Methodius, known as the Apostles to the Slavs—to search for Clement's body in the Black Sea. While they were in this region Cyril devised an alphabet for the Slavic languages, the alphabet called Cyrillic today. Cyril claimed to have found St. Clement's body, and he returned it to Rome, where it now lies beneath the main altar of S. Clemente.

St. Cyril is also buried in S. Clemente and his ninth-century tomb, in the lower church, bears what may be the only tribute to a Christian saint ever offered by a Communist leader. Todor Zhivkov, chairman of the Bulgarian Communist Party, had a plaque installed near the tomb in 1952, in recognition of the saint's achievements in giving the Slavs an alphabet.

What disaster befell the buried lower church of S. Clemente, a disaster so complete that the church disappeared from memory? The answer lies in Rome's (and Europe's) turbulent medieval history. In the eleventh century the papacy was locked in a struggle with secular powers over which one would have supreme authority. In 1076 Pope Gregory VII had humbled the German emperor, Henry IV, forcing him to beg for the pope's forgiveness, which earned the pope the emperor's bitter hatred. When their quarrel flared up again in 1083, Henry prepared to attack Rome and the pope appealed for help from the duke of Apulia and Calabria, a fierce warrior of Norman French descent named Robert Guiscard. The city paid a terrible price for this papal alliance. In 1084 Guiscard's troops routed the emperor's forces and "saved" the pope, but they did not stop there. They pillaged the city for three days, laying waste to large portions of it.

During this time the church of S. Clemente, along with many others, was destroyed. Not long afterward, about 1100, a new S. Clemente began to rise on the ruins of the old. What remained of

the fourth-century church was filled with rubble to the top of the nave pillars and on this foundation the present church was built. As is so often the case, out of sight is out of mind, and the old church lay forgotten for seven hundred years, until Fr. Mullooly rediscovered it.

The visitor descends into the lower levels of S. Clemente on a staircase built in the 1860s to give access to the hidden world Fr. Mullooly had uncovered. Despite electric lighting and the most modern dehumidifying devices, the subterranean S. Clemente is shadowy and extremely damp. Velvety green mold covers many of the wall surfaces and the few remains of wall paintings are fast deteriorating. We can be thankful that Fr. Mullooly ordered copies made of the various frescoes as they came to light, for the originals are now almost indecipherable.

One painting in particular is interesting enough to be worth the effort of examining it closely. Commissioned in the eleventh century by a Roman family named de Rapiza, it illustrates a legend of St. Clement, one of the few "saint stories" with elements of low comedy. According to this tale a Roman nobleman named Sisinnius became obsessed with the suspicion that his wife, Theodora, a convert to Christianity, was carrying on an affair with Clement. He followed her to a Christian meeting place, where he was struck deaf and dumb. Theodora then persuaded Clement to come to their house to heal her husband and the saint obliged. Far from being grateful, Sisinnius was so furious to find Clement in his house that he ordered his servants to tie up the saint and take him away. But God intervened again and the servants were led to imagine that some old columns lying about were St. Clement and his companions, so they proceeded to arrest the columns, tie them up, and drag them away, urged on in colorful language by the demented Sisinnius. *"Fili delle pute, traite!"* he roars in a still legible inscription on the painting: "You sons of bitches, pull!" This is a very famous inscription, not just for its earthy language, but because it is one of the earliest known written example of the transition from classical Latin to the vernacular. In these blunt words we witness the Italian language being born.

The present appearance of the lower church bears little resemblance to its original splendor. Not only have centuries of dampness destroyed most of the wall paintings but the squat brickwork supports added in the 1860s ruin whatever impression we might have had of the church's interior space. We must remember, however, that these supports replace the rubble (130,000 cartloads) that had buttressed the upper church from 1100 until its removal by Fr. Mullooly.

From the lower church, near the tomb of St. Cyril, we descend still further into the bowels of the earth, down a narrow circular

staircase of the fourth century, there to discover the ruins of the earlier Roman house upon which the lower church of S. Clemente is built. In this building, much of which remains unexcavated, are still more archaeological finds. Most important is a series of three cult rooms of the late second or early third century A.D., dedicated to the worship of Mithras, a Persian deity very popular with Roman soldiers. In one room the Mithraic altar still survives, bearing the image of the hero-god slaying a bull.

The Mithraic rooms are part of the imposing Roman house that was the property of Titus Flavius Clemens. The house burned to the ground in the great fire of 64 A.D., for which the emperor Nero tried to blame the Christians; the area was filled in with rubble and then rebuilt, forming the foundation of all subsequent structures on the site. Part of this layer has been excavated and when we reach the ground-floor rooms of Clemens's house we have at last reached the bottom of S. Clemente. A massive wall of the house runs parallel to Via S. Giovanni in Laterano, which is thirty feet and two thousand years above our heads.

Every surface is wet down here, and the sound of swiftly flowing water is very loud, effects that add to the uncanny quality of the place. The source of the water is unknown. It may be a hidden spring, an underground stream, or even an ancient, broken aqueduct, still pouring its waters into the eerie subterranean world beneath modern Rome. When American poet Robert Penn Warren made the enigmatic observation that "history drips in the dark," perhaps he was thinking of S. Clemente.

Upon returning to the surface, most people are happy to sit for a few minutes in the monks' peaceful, sunny cloister. Once there, the visitor can occasionally get a whiff of moldy yet familiar-smelling air. A stroll around the cloister reveals open grilles in the ground, installed there to allow fresh air to reach the regions below the church, and that also permit the subterranean vapors to rise to the surface. If history has a smell, this is it.

Suggested reading

Leonard Boyle, *A Short Guide to St. Clement's, Rome* (Rome, 1984).
Perri Lee Roberts, *Masolino da Panicale* (Oxford, 1993).

ROMA AMOR
PART III

LATE MEDIEVAL
AND RENAISSANCE ROME

ROMA
AMOR
XVI

S. Maria sopra Minerva

Here is a church that weaves together many disparate threads to create a memorable tapestry. A bit of ancient Rome, a trace of even more ancient Egypt, strands of the late Middle Ages and the Renaissance, some threads of the Baroque, and an overlay of nineteenth-century pseudo-medievalism all somehow combine successfully in S. Maria sopra Minerva.

The name suggests an ancient church built on the ruins of a temple dedicated to Minerva, the Roman goddess of wisdom, but as is often true in Rome the story is not quite so simple. The church really is built *sopra,* or above, a temple dedicated to Minerva, but its roots are sunk even more deeply into the past. We find a typical Roman pileup here: a church of the late 1200s that replaces a smaller church from the 700s erected on the ruins of a sanctuary of Minerva originally dedicated to the Egyptian mother-goddess Isis. Pompey the Great, a contemporary of Julius Caesar (and for a time a co-ruler of Rome with him) built the temple to Isis in the mid–first century B.C., to commemorate his victories in Asia Minor.

The Romans assimilated Isis into their own goddess Minerva and later rededicated Pompey's temple to Minerva. That temple became part of one of the first large imperial building complexes, begun by Agrippa during the reign of Augustus in the late first century B.C. and rebuilt in the second century A.D. under Hadrian. The centerpiece of Hadrian's project was the Pantheon, just to the west of the temple to Minerva and today virtually next-door to S. Maria sopra Minerva.

The transformation of the Pantheon into a church in 609 A.D. attracted various religious orders to the area and during the eighth century a small church was constructed amid the ruins of Minerva's temple. Around 750 Pope Zacaria, himself a Greek, gave the site and its church to a group of Greek nuns belonging to the Order of St. Basil. In the mid-1200s the church belonged briefly to a group of women known as *Repentite*—reformed prostitutes who had taken religious vows. By 1268 it belonged to the Benedictines, and by then several complexes of buildings adjoined it, housing both nuns and monks. The two groups did not get along; litigation ensued and the monks evicted the nuns.

Then in 1275 Bishop Aldobrandino Cavalcanti of Orvieto, a Dominican, confirmed the transfer of the church to the Dominican order, although the Benedictines did not give up the site without a struggle. More monkish squabbles followed over the property, but in 1276 John XXI confirmed Dominican ownership and the site has been in Dominican hands ever since.

About 1280 construction began on a new and much larger church, as well as on an expansion of the monastery complex. As difficult as it is to believe today about an area that lies at the congested heart of Rome, there were in the vicinity at that time large uninhabited tracts of land on which the monks could build. Two architects from Florence named Fra Ristoro and Fra Sisto, both members of the Dominican order, replaced the earlier church with the present one but retained the name S. Maria sopra Minerva. Nicholas III solicited members of the Roman nobility to contribute money toward the construction, and subsequently many different individuals left bequests to the church. Some also endowed the Minerva's side chapels, a practice that continued into later centuries and resulted in some remarkable works of art. The facade features doors from the mid-1400s. The rest of the surface, restored in the seventeenth and eighteenth centuries and most recently in 1992, is unusually simple and unadorned.

Although the architecture of the Minerva could be described as Gothic, most medieval Italians (and Romans in particular) regarded the Gothic style with deep suspicion and almost never adopted it more than halfheartedly; to them it was French and therefore not to be trusted. The term *Gothic* is itself an invention of Italian intellectuals of the fourteenth century, meant to imply that the French style we admire today in such buildings as Notre Dame of Paris had wandered so far from the principles of ancient Roman architecture that it looked like the work of the barbarian Goths. Given this prejudice, it is little wonder that S. Maria sopra Minerva is Rome's only Gothic church.

Actually most of what looks Gothic in the Minerva proves to be overly enthusiastic nineteenth-century restorations. The

pointed arches of the nave, the X-shaped ribs that support the vaults, and the colorful stained glass windows—the most characteristic features of the Gothic style—are all additions made during the restoration that took place between 1848 and 1855. Begun by a Dominican jack-of-all-trades named Girolamo Bianchedi, work continued after Bianchedi's death in 1849. The Dominican friars then hired a succession of other restorers, and the whole business got rather out of hand.

Despite its lack of architectural authenticity the interior of S. Maria sopra Minerva has its own kind of beauty. Thanks to the nineteenth-century restorers' efforts, a colorful decoration of rich surface patterning in red, blue, green, orange, and gold covers nearly all the wall surfaces and defines the ribs of the vaulting. The surfaces seem to be upholstered in Art Nouveau fabrics. The vaults of the nave are painted a bright blue, spangled with gold stars, and most have images of saints painted in them that are also works of the 1800s.

The flower-shaped stained glass windows on all four sides of the church (another nineteenth-century addition) are small in comparison to the great expanses of stained glass in French Gothic cathedrals but are richly colored in abstract patterns similar to those on the walls. Stained glass windows are unusual in Roman churches, and they add the richness of colored light. On the north and south sides of the nave are some larger windows glazed with clear or frosted glass, creating an unusually well-lit interior. On a sunny day the nave of the Minerva glows with a rich, golden light.

The colorful architecture provides the setting for handsome tombs and side chapels, as well as for a high altar of great historical interest. Under that altar lies the body of St. Catherine of Siena (1347–1380), the mystical Dominican nun who is the patron saint of Italy. St. Catherine played a significant role in the political events of her time, urging the popes to return to Rome from their exile in Avignon. She lived to witness this event, which took place in 1377.

Although the present high altar was rebuilt during the nineteenth-century restoration of the church, the saint reposes in a tomb carved about 1430 by Isaia of Pisa. Clothed in the black-and-white robes of a Dominican nun, her painted effigy sleeps on the coffin lid, a silver olive branch in her folded hands and her head pillowed on two red cushions. The serene appearance of her image belies the grisly events that befell her body. Resentful that Rome had possession of Catherine's corpse, some Sienese managed to make off with her head and one of her fingers, which are now revered as relics in the church of S. Caterina in Siena.

Other significant individuals who died in Rome are buried in the Minerva. The great fifteenth-century Florentine artist Fra

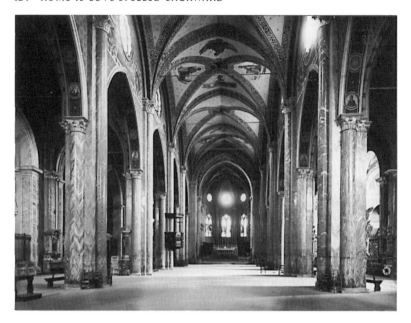

S. Maria sopra Minerva, interior, showing the high altar. Although described as a Gothic church, the Minerva is both older and newer than the designation implies.

Angelico, a Dominican, had been invited to the Vatican by Nicholas V to decorate a chapel. While in Rome, the monk-painter resided at the monastery of the Minerva and died there in 1455. His sculptured tomb slab, probably by the same Isaia of Pisa who carved the tomb of St. Catherine, was originally located in the floor of the church but now occupies a position about a foot off the floor in the Frangipane Chapel, to the left of the high altar. Although an incongruously modern bronze screen cast in 1975 and ornately formed of leaf and twig shapes surrounds the monument on three sides, the carved tomb effigy has a haunting beauty. The artist lies on his back, clothed in Dominican robes, his large, long-fingered hands crossed at the waist. His head, characterized by sunken eyes and strongly marked cheekbones, appears to be resting on a thick, comfortable pillow. A simple, classically Roman archway encloses the recumbent figure, its columns rendered in impeccable perspective.

Many more tombs are in the Minerva. Among the most interesting (although least conspicuous) are those of two Medici popes, Leo X (1513–1521) and Clement VII (1523–1534), located in the large chapel directly behind the high altar. This portion of the church was rebuilt under Medici patronage by the Florentine architect Antonio da Sangallo the Younger between 1536 and 1540, in order to accommodate the two wall tombs, which face each

S. Maria sopra Minerva, Carafa Chapel, with frescoes by Filippino Lippi. The Carafa Chapel contains the finest Early Renaissance fresco cycle in Rome.

other with Leo on the left and Clement on the right. Despite their imposing size these tombs have something apologetic about them; they seem to lurk in the gloom behind the high altar, with no illumination and with access to the chapel cut off by red velvet ropes. Although the oversize statues in full papal regalia are impressive, one searches in vain for any identifying inscriptions on the blank front surfaces of the pedestals. Given the disasters that

befell the Church and the city during their papacies (the Protestant Reformation began during Leo's reign and the Sack of Rome took place while Clement was pope), it looks as if someone decided the less said of them the better.

The Minerva also contains one of the finest examples of Early Renaissance painting in Rome: the Florentine artist Filippino Lippi's cycle of frescoes in the Carafa Chapel, which forms the right (south) transept of the church. Begun in 1488, the cycle was completed in 1493 for Oliviero Carafa, a Dominican cardinal from Naples. The chapel's entrance is through a striking archway flanked by marble pilasters. Around the arch runs an inscription that describes the dedication of the chapel to the Virgin Annunciate and St. Thomas Aquinas. Inside this handsome setting Filippino painted the vaulted ceiling, the two side walls, and a frescoed altarpiece on the back wall. Originally there were paintings on both side walls, but those on the viewer's left were destroyed to make room for the tomb of Paul IV (1555–1559), Cardinal Carafa's nephew.

How did a cardinal from Naples, resident in Rome, come to call on an artist from Florence to fresco his chapel? Cardinal Carafa belonged to a noble Neapolitan family and his uncle, Diomede Carafa, was a diplomat who spent much time in Florence. There the Carafa family made the acquaintance of the politically powerful Medici, including the two greatest Florentine art patrons of the century, Cosimo de' Medici (d. 1464) and his famous grandson, called Lorenzo the Magnificent (d. 1492). It was through Lorenzo that the cardinal first heard of Filippino Lippi.

Cardinal Carafa was notably ascetic, a believer in papal authority, and an admirer of the theology of St. Thomas Aquinas, the most famous member of the Dominican order and the greatest theologian of the medieval Church. He was also a devotee of ancient Roman culture. All of these aspects of Carafa's personality and character would come into play in the art he commissioned from Filippino Lippi.

The right wall, devoted to St. Thomas Aquinas, contains two scenes: the *Miracle of Chastity* and the *Triumph of St. Thomas*. The first, painted in the lunette below the vault, is based on an indelicate story and is therefore presented in an indirect, almost obscure way. According to the biography of Aquinas, his wealthy family was unhappy with his decision to become a monk, so much so that they had him kidnapped in 1244 and brought back to the family's fortress-palace. There Thomas remained for fifteen months, while his brothers tried everything to make him break his vow of chastity. The miracle shown here resulted when the brothers purchased the services of a prostitute and put her in Thomas's room. Thomas, who was short and fat, somehow found the strength to throw the woman bodily out of his room. He then

knelt and prayed for protection from such torments. Miraculously two angels arrived bearing a belt for Thomas, symbolic of perpetual chastity. The saint's brothers, who were listening outside, remained mystified by the strange thumps and rustlings emanating from Thomas's room.

Probably because a picture of a prostitute would have been unacceptable to Cardinal Carafa, Filippino omits her and shows Thomas serenely triumphant, kneeling on the left side of the painting, in the company of two angels. A portion of the miraculous sash is conspicuous on his right side. The second monk, exiting hurriedly from the saint's room, may be the one noted in the saint's biography who smuggled in fresh Dominican robes for the imprisoned Thomas. The figures on the right are probably members of Thomas's family; the women may be the saint's mother and sister, the turbulent youth one of his brothers, and the elderly man in a turban his father.

The *Triumph of St. Thomas* fills the lower wall on the right side. The saint sits enthroned in an elaborate structure, with personifications of Philosopy and Theology seated to his right and his foot planted on a white-haired man sprawled in front of him. Two women, representing Dialectic and Grammar, sit at his left. Numerous people, some in exotic costumes and others in contemporary dress, stand on either side and piles of books lie strewn across the foreground. The subject, a familiar one in earlier Italian painting, is the saint's triumph over heretics.

Among Aquinas's voluminous writings are refutations of the theological positions held by all those then considered major heretics. In the fresco Filippino presents these defeated individuals with books at their feet open to texts that identify them and their theological errors. Cardinal Carafa, an expert on Thomistic theology, probably provided the artist with these quotations. The artist and his patron thus present an image of the Roman Church triumphant, established on the doctrines formulated and clarified by St. Thomas Aquinas.

Standing out from the heretics is the tall, striking figure of a Dominican monk on the far right side. From contemporary portraits, he can be identified as Fra Joachim Torriani, the head of the Dominican order between 1487 and 1500. The Dominicans, in the forefront of the fight against heresy, continued that role beyond the fifteenth century. In 1600 in the Dominican cloister right next-door to S. Maria sopra Minerva, the philosopher Giordano Bruno was found guilty of heresy and condemned to be burned at the stake. Galileo was brought there in 1633 and threatened with torture until he agreed to deny his assertion that the earth revolves around the sun.

When Filippino Lippi came to Rome from Florence in 1488, it

was probably his first visit to the Eternal City, and clearly his art felt the impact of the city's monuments. In the background of the *Triumph of St. Thomas* Filippino included some detailed sketches of the Rome of his own day. There is a segment of a now vanished Tiber port on the right and in the left background we can see a portion of the church of St. John Lateran, with the famous equestrian statue of Marcus Aurelius which stood in front of it at that time.

The back wall of the chapel is devoted to the Virgin Mary. The *Annunciation* and the *Assumption* above it are directly over the altar. The graceful figures of Mary and the angel are flanked and framed by elaborately detailed pilasters decorated with *grotteschi*—small, tendriled ornaments derived from ancient Roman decorations beginning to be rediscovered in Rome's ruins. On the right side St. Thomas Aquinas presents Cardinal Carafa to the Virgin. Above this frescoed altarpiece the Assumption of the Virgin fills the lunette, bringing the chapel's decorations to a joyful conclusion. Mary kneels on clouds, held aloft by a jubilant crowd of music-making angels, while on the ground groups of apostles flanking the Annunciation look up in astonishment at this apparition in the sky.

The decorations of the Carafa Chapel form a unified artistic construct in which architecture, real space, the illusionistic space of the paintings, and the painted images themselves are integrated into a single environment. It is interesting to walk across the nave and look at the chapel from a distance. From this vantage point the ensemble of real and painted architecture is most striking. The walls of the chapel seem almost to disappear, and the painted images take on a convincing reality. The enthusiasm for ancient Roman art evident in these frescoes signals the beginning of a new era, one in which Rome would again achieve artistic sovereignty: the High Renaissance.

There is still more in the Minerva, including a statue of the Risen Christ begun by Michelangelo in Florence in 1519 and clumsily completed in Rome in 1521 by one of the artist's assistants. There are florid Baroque chapels and simple medieval wall tombs. A mosaic of the Madonna and Child gleams above the tomb of Bishop William Durand, who died in 1296, and in the Frangipane Chapel a sculptured marble panel of Hercules strangling the Nemean lion—probably a Roman copy of an ancient Greek original of the fifth century B.C.—adorns the fifteenth-century tomb of Giovanni Arberini. The Chapel of the Crucifix contains the tomb of Cardinal Micara, who died in 1965.

In the piazza in front of the Minerva stands a charming little statue of a baby elephant holding an ancient Egyptian obelisk on his back, a work designed in the 1667 by the sculptor Gianlorenzo Bernini and provided with an erudite Latin inscription by the patron, Alexander VII. The obelisk, of the sixth century B.C., had

been found a few years earlier in the ruins of the Isis temple whose precincts lie beneath the Minerva's. Playfully nicknamed *il pulcin della Minerva* (the Minerva's chick), the elephant and obelisk link the church to its ancient, pagan predecessor. The odd but attractive bonding of these two objects, separated by more than two thousand years, could serve as an emblem of S. Maria sopra Minerva, a church whose art takes the visitor through so many centuries of Rome's spiritual, secular, and artistic history.

Suggested reading

Gail Geiger, *Filippino Lippi's Carafa Chapel: Renaissance Art in Rome,* vol. 5 of *Sixteenth Century Essays and Studies* (Kirksville, Mo., 1986).

POPE JULIUS II
Prince of Art Patrons

*Anything that he has been thinking about overnight
has to be carried out immediately.... It is almost impossible
to describe how strong and violent and difficult
to manage he is. In body and soul he has the nature of a giant.
Everything about him is on a magnified scale,
both his undertakings and his passions.*

—Attributed to an early sixteenth-century ambassador to the Vatican

The excerpt above is not a description of a mythical king, a Roman emperor, or a grandiose Hollywood movie mogul. It comes from a Venetian ambassador's report on a Renaissance pope—some might call him THE Renaissance pope—Julius II, whose papacy (1503–1513) was a continuous whirlwind of political, military, and artistic activity unparalleled in the history of the Catholic Church. Although many ambitious popes have managed to leave their mark on Rome through their patronage of art, architecture, and city planning, only a few have left such a profound imprint of their personalities.

Born Giuliano della Rovere in 1441 in the Liguria region of northern Italy, the future pope came from a family well connected in Rome. Giuliano's uncle was Sixtus IV (1471–1484), a toothless, sinister-looking old schemer who was nevertheless a distinguished art patron responsible for the rebuilding of the Vatican Library and the construction of the Sistine Chapel. Sixtus promptly made his young nephew a cardinal. A painting of the 1470s by Melozzo da

Forlì, now in the Vatican Pinacoteca, shows Sixtus with four of his nephews, including Giuliano, as well as Bartolommeo Platina, the newly appointed Vatican librarian. Although the pope and his librarian are supposedly the main figures, the tall, imposing Cardinal della Rovere at the center dominates the scene.

Almost three decades passed before Cardinal della Rovere became Pope Julius II. In the meantime he amused himself with mistresses, fathered three daughters, and developed an appreciation for fine food and wine. He served as an advisor to Sixtus IV and then to the subsequent pope, Innocent VIII. In 1492, after the election of Roderigo Borgia as Alexander VI, Cardinal della Rovere left Rome in disgust. His loathing of Alexander was well founded, for the Borgia pope proved to be, to adopt a British phrase, one of the worst rotters ever to squat upon a papal throne. After the death of Alexander in 1503 Giuliano returned to Rome in time to participate in the election of Pius III, whose pontificate lasted only ten days.

After a great deal of unsavory behind-the-scenes maneuvering the next conclave chose Cardinal della Rovere as pope. He made the unusual decision of taking a papal name, Julius (Giulio), almost identical to his baptismal name, Giuliano. The name brought to mind Julius Caesar and the new pope seemed happy to confirm that association. A healthy and vigorous sixty-two years old at the time of his election, Julius consumed himself in the course of his decade-long papacy. He embarked upon such a multitude of vast and complex projects that a century would hardly have been sufficient to complete them. Aware of corruption in the Church, he attempted a program of internal reform. Within the city of Rome Julius curbed the power of the rebellious noble families and attempted to bring law and order to the city's crime-infested streets. A formidable wielder of the sword as well as the cross, Julius and his papal army marched up and down the Italian peninsula, recapturing territories that had formerly belonged to the papal states. His ultimate military ambition was to drive all foreign invaders, in particular the French, out of Italy.

In addition, Julius was determined to transform the physical appearance of both the Vatican and the city of Rome. A perpetual cloud of dust hung over Rome during the pontificate of Julius II, as the pope ordered old buildings demolished and new ones built. He replaced narrow, winding streets with broad, straight avenues such as the still elegant Via Giulia; he had a new aqueduct constructed and repaired several old ones. He strengthened the city's fortifications and even improved its sewer system.

The cardinals must often have felt they had elected a cyclone rather than a pope. Julius treated them, and through diplomatic dispatches all of Europe, to an astonishing spectacle. Here was a

pontiff who rode on horseback in full armor at the head of his troops, who quoted Virgil's *Aeneid* from memory to his generals, and who hurled blistering profanity (along with whatever else was handy) at anyone, clerical or secular, who got in his way. Those who merely felt the lash of the pope's verbal assaults were lucky. Julius also pushed people about and struck them over the head and shoulders with his papal staff of office. Vowing he would not shave until the last French soldier had been driven out of Italy, Julius grew a long white beard that made him look like an Old Testament prophet. This, combined with his unusual height and almost super-human energy, explains why papal diplomats referred to him as *il vecchione,* which means something like "the awesome old man."

Julius II was indisputably one of the very greatest of all papal art patrons. It is no overstatement to say that he created the High Renaissance, the lofty artistic style resonant with the forms and values of classical antiquity that would spread from papal Rome to the rest of Italy and ultimately to much of western Europe. Julius had an infallible instinct for finding and employing great artists, al-though his relations with these men were sometimes stormy. He often drove them unmercifully, but he also inspired them to go beyond themselves, to reach creative heights they might never have achieved without his demanding patronage. He shrewdly re-alized the role that architecture, painting, and sculpture could play in glorifying the Church and his own place in it.

Julius immediately put into effect his ambitious plans for the rebuilding of the Vatican. In 1503, the first year of his papacy, he hired the northern Italian architect Donato Bramante to design an immense courtyard to connect the Vatican Palace with the Belvedere, a papal villa situated higher on the Vatican Hill and nearly a thousand feet to the north. Two enormous corridors en-closing garden terraces, staircases, and fountains were to unite the two buildings. Although completed well after Julius's death (and not entirely according to Bramante's plans), the gigantic Belvedere Court is emblematic of the scale on which Julius conceived his ar-chitectural projects. He had inspired Bramante to design the largest structure since the reign of the emperor Hadrian. Today it houses part of the enormous collections of the Vatican Museums.

Although many artists received commissions from Julius II, the pope's name is most closely linked with one in particular: Michelangelo. The frequently embittered but productive relation-ship between these two strong-willed and temperamental men re-sulted in the creation of some of the greatest works of Renais-sance art—the statue of Moses for the tomb of Julius and the paintings on the ceiling of the Sistine Chapel.

How Michelangelo came to Julius's attention is uncertain. The pope had surely seen Michelangelo's *Pietà,* created in the late

1490s (then in Old St. Peter's in Rome), and had no doubt heard of the sensation created by the artist's colossal statue of David, set up in front of the town hall of Florence in 1504. Here was an artist who thought in the same monumental terms as Julius did, and the pope wanted Michelangelo for himself.

In 1505 Julius ordered the artist to come to Rome to execute a sculptural project so immense we can only wonder how either man ever thought it could be completed. Julius wanted Michelangelo to design and execute a tomb for him three stories high and containing forty figures nearly the size of the David. Simple arithmetic shows the project could never be done. It had taken Michelangelo three years to complete the statue of David and he would thus have needed 120 years to finish this work. The whole idea says a lot about the dreamlike mentality of the High Renaissance: neither the pope nor the sculptor showed any awareness of the impossibility of such a task.

The drawn-out and dreary story of what Michelangelo would later call "the tragedy of the tomb" is extremely complex. The project was not completed as Michelangelo and his patron had envisioned it but was finished long after Julius had died and in a much smaller and sadly altered form. Today only one statue by Michelangelo adorns the modest tomb of Julius II, located in the church of S. Pietro in Vincoli. That work, however, the famous statue of Moses—which the artist completed about 1515, shortly after the pope's death—has always served to make Julius's tomb the goal of innumerable visitors. According to a Renaissance chronicler, the Jews of Rome used to flock to S. Pietro in Vincoli to admire the statue of their biblical leader. The power the Moses exerts is still impressive; the figure almost leaps out from its mediocre setting, making the statues around it seem without strength or expression, as if intimidated by its *terribilità*. Perhaps the artist intended us to see in the face of the ancient Hebrew lawgiver something of the power, vehemence, and torrential energies of Julius II. In the words of papal historian Ludwig von Pastor, Michelangelo "has carved the name of Julius II in imperishable characters on this marble, and made it immortal."

The principal reason Julius lost interest in his tomb and cut off the funds Michelangelo needed to continue it was his simultaneous involvement in a project so stupendous that it dwarfed everything else: the rebuilding of St. Peter's. Ironically Julius had first become interested in that church because he wanted his own tomb built there. But Bramante deflected the pope's attention from the tomb and convinced him that repairs to the crumbling early Christian basilica would be futile. By the end of 1505 the pope had decided to tear down Old St. Peter's and replace it with a splendid new church.

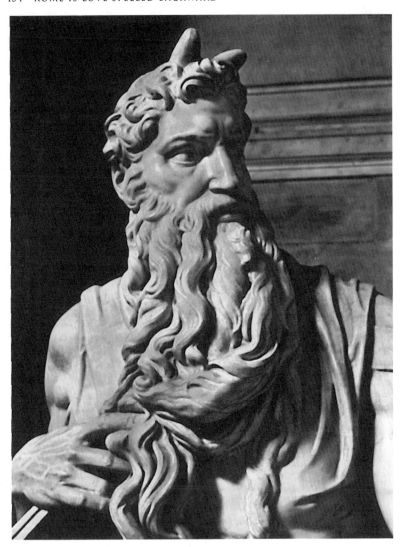

Michelangelo, *Moses,* detail of the head, Tomb of Pope Julius II, S. Pietro in
Vincoli. Some have seen in the face of Moses an idealized portrait of Julius.

True to his desire to see his projects carried out immediately,
Julius soon had Bramante's plans for the new church in hand and
within weeks Bramante's workmen were simultaneously tearing
down the old church and beginning the new one. The expenses
involved were enormous. One of Julius's sources of funds to fi-
nance the new church was money collected from the sales of in-
dulgences, a way for Christians to buy their way out of Purgatory.

This practice met with strong opposition in Germany, where people could not see why their money should go to finance extravagant Italian enterprises. In this case in his efforts to glorify the Church, Julius sowed the seeds of the Protestant Reformation.

Michelangelo, meanwhile, furious over Julius's abandonment of the tomb project, had gone home to Florence, vowing never again to set foot in the snake pit of papal Rome, only to be called back there again by Julius in 1508. Although suspicious and reluctant, Michelangelo obeyed. Julius's frequent and severe illnesses were making the pope more aware of his own mortality, and he now said he wanted Michelangelo to continue the work on his tomb.

Before Michelangelo would be allowed to return to that sculpture project, however, the pope wanted a little something painted on the ceiling of the Sistine Chapel. It was, after all, a della Rovere building, constructed during the reign of Julius's uncle, Sixtus IV, and here was an opportunity for Julius to put his own stamp on it. The ceiling was supposed to occupy Michelangelo for only a few months. Instead it occupied the artist for four years and progressed from a simple matter of some abstract designs to a scheme portraying the Twelve Apostles, then to the final, prodigious program of images that adorns the ceiling today, a work considered one of the supreme masterpieces of Western art. In the best-known scene from the ceiling, the Creation of Adam, some observers have suggested that the face of God bears a more than passing resemblance to Pope Julius II.

While Michelangelo was busy with the Sistine ceiling, Julius hired a young and relatively inexperienced painter named Raffaele Sanzio to decorate the walls of some audience rooms in the Vatican Palace. No one could have predicted that Raphael would be capable of producing a series of such powerful frescoes. Like Michelangelo's Sistine ceiling, these brilliant works define what we mean by High Renaissance art.

Julius was often away from Rome during these years, fighting at the head of his army in repeated and bloody clashes with the French. Whenever he returned to Rome, however, he checked on the progress of his various projects. He even scrambled up onto the scaffold in the Sistine Chapel, the better to badger Michelangelo about getting finished. Julius did not live to see the completion of Raphael's frescoes, but he was present when Michelangelo's frescoes on the Sistine ceiling were unveiled on October 31, 1512.

Sick and exhausted and suffering from wounds received in battle, Julius was still determined to honor the artist's achievement. Supported on either side by a cardinal, he staggered through the celebration of a Solemn High Mass beneath Michelangelo's magnificent paintings. He died less than four months later. The body of the old warrior-pope lay in state amid

the chaos of demolition and construction in St. Peter's, and according to witnesses as much honor was paid to him as if his body had been that of St. Peter himself.

According to some sources the mortal remains of Julius II vanished during the violence accompanying the Sack of Rome in 1527; according to others the body wound up in a mass grave in the sacristy of the new St. Peter's, the common resting place for all the popes whose graves had been destroyed (initially at Julius's own orders) as the old basilica was gradually torn down. But Julius's spirit survives in the city. The Sistine Chapel ceiling, the statue of Moses that adorns his empty tomb, the Belvedere Court of the Vatican, and above all, the great church of St. Peter's, all bear the stamp of his personality. They breathe a grandeur, a larger-than-life mentality that is the very signature of this pope who personified the Roman High Renaissance.

Suggested reading

Howard Hibbard, *Michelangelo* (New York, 1974).
Christine Shaw, *Julius II: The Warrior Pope* (Oxford, 1993).

RAPHAEL IN ROME

The Vatican Frescoes

Although Rome has produced few native artists or architects of note, the city transformed nearly every artist who ever lived there, and the painter Raphael was no exception. Born in Urbino in 1483 (the same year as Martin Luther), he was the treasured only child of a minor painter named Giovanni Sanzio, from whom he received his first artistic training. After studying in Perugia with Perugino, Raphael moved to Florence in 1505 and was soon among the city's most successful painters. In addition to portraits and altarpieces, a seemingly endless series of Madonna and Child paintings flowed from his facile brush in the next few years, each one prettier and sweeter than the next—entirely *too* sweet for the tastes of some modern viewers.

Raphael might well have gone on like this indefinitely, painting lovely but lightweight works and, according to his perhaps envious sixteenth-century biographer Giorgio Vasari, making love to a lot of beautiful women, but fate had more in store for this handsome, successful, and perhaps slightly superficial young man. About 1509 Julius II ordered Raphael to Rome. The projects the pope assigned him, and experience of the Eternal City itself, transformed the artist.

Soon after Raphael arrived Julius put him to work painting frescoes on the walls of four rooms, or *stanze,* in the Vatican Palace. Although Raphael's only experience in fresco painting had been as an apprentice in the studio of Perugino, the young painter

rose brilliantly to the challenge. The first two rooms he decorated, called the Stanza della Segnatura and the Stanza d'Eliodoro, are exactly contemporary with Michelangelo's paintings on the ceiling of the nearby Sistine Chapel. The other two rooms, the Stanza dell'Incendio and the Sala di Costantino, were completed later, however, mostly by members of Raphael's studio, and are of mediocre quality. The two rooms completed by Raphael contain masterpieces that reward close observation. To walk through the rooms is to enter into the world of High Renaissance Rome, a world that was highly intellectual, sometimes sincerely pious, and often redolent with pagan sensuality—one of those rare realms where the senses and the spirit are one.

Raphael began his work in the Stanza della Segnatura, the room where the pope put his seal on official Vatican documents and that may originally have served as Julius's private library. The general theme, perhaps suggested by the pope himself, concerns the major branches of intellectual endeavor—Law, Poetry, Theology, and Philosophy—a Renaissance *summa*, embracing the totality of important knowledge as it was understood in the early 1500s. For each of these Raphael provided a fresco.

The artist probably began with the scene representing Theology. Although called the *Disputa*, it is not about a dispute but is a dramatic and exalted presentation of the Holy Sacrament as an eternal theological truth. The upper segment shows Christ, Mary, and John the Baptist enthroned on clouds. Above Christ is God and below him the dove of the Holy Spirit hovering over the altar, a reference to the Trinity. A circular golden glory incised with rays like a gigantic sun appears behind Christ and a segment of an even larger one, glittering with stars, glows behind the figure of God. A row of seated figures flanks the group of Christ, Mary, and John. As befits a painting made for a pope, St. Peter has a privileged position as the first figure on the left, balanced by St. Paul in a corresponding position on the right. Between the two princes of the apostles are ten other figures, among them Adam, King David with his harp, Moses holding the tablets of the Law, and (half-hidden behind John the Baptist) Judas Maccabeus in full armor. The last, an ancient Hebrew warrior-hero, seems to have appealed to Julius II for his combination of military prowess and religious devotion.

The center of the painting is a gold and crystal monstrance, a vessel used to hold the Holy Sacrament—the consecrated bread of the Mass—placed on a golden altar. In the lower portion of the painting Raphael has arranged on both sides of the altar lively groups of figures whose glances and gestures lead our eyes back toward the altar or upward toward heaven. These include bishops, cardinals, popes, theologians of the early and medieval Church, and a number of contemporary portraits. Just to the right of the

altar an unidentified man points emphatically upward, linking the lower portion of the scene with the heavenly realm.

Even within this one painting we can begin to see that Rome had affected the artist. Raphael started painting at the top of the wall and worked his way down. The upper part of the fresco, with its carefully ruled golden light rays and somewhat rigid, highly symmetrical composition, would have looked at home on the walls of a church in Florence. The lower portion is at once more monumental and more relaxed, touched with the spacious, classical grandeur that only Rome could impart.

Raphael next moved to one of the side walls containing a large window at its lower center. Over and around this opening the painter composed his visual celebration of Poetry: *Mount Parnassus,* named for the hill in southern Greece sacred to Apollo and the Muses. This scene is as pagan as the *Disputa* is sacred. Disposed in a half-circle around the central figure of Apollo, the god of poetry and songs, and his nine seductively lovely muses is a mixed group of ancient and modern poets. The hatchet-faced Dante stands in profile at the upper left, with his green-clad guide, Virgil; between them is a poignant image of the blind Homer, who gropes forward uneasily. Taken together, these three epitomize Italian, Latin, and Greek culture, brought triumphantly together in the High Renaissance Rome of Julius II.

Not surprisingly, given the male-dominated worlds they represent, all but one of the poets are men. But the one female figure, the beautiful Sappho of Lesbos, is the most striking of all and the only one whom Raphael identified by name. Seated at the lower left, the Greek poetess leans against the edge of the actual window, provided by Raphael with a painted architectural frame. With her sensuous body, one bared shoulder, and her abundant blonde hair caught up in a laurel wreath, she belongs to a world of pagan pleasures far removed from the spiritual realm represented by the theologians of the *Disputa*. But for this brief, brilliant High Renaissance moment they are neighbors and there is no conflict between them.

Across from the *Parnassus* is another wall pierced by a window, this an off-center one. Raphael did what he could with this awkward space, which is devoted to Law. In the uppermost part he placed personifications of the three Virtues most relevant to Law and Justice: Fortitude, Temperance, and Prudence. In the narrow space to the left of the window he squeezed in the scene of the Emperor Justinian Receiving the Pandects, a compendium of Roman civil law this sixth-century ruler had ordered codified. On the right side is a corresponding scene from the area of canon (Church) law; it is Pope Gregory IX Receiving the Decretals, a collection of papal decrees brought together by that thirteenth-century pope to establish a basis for Church law as the Pandects

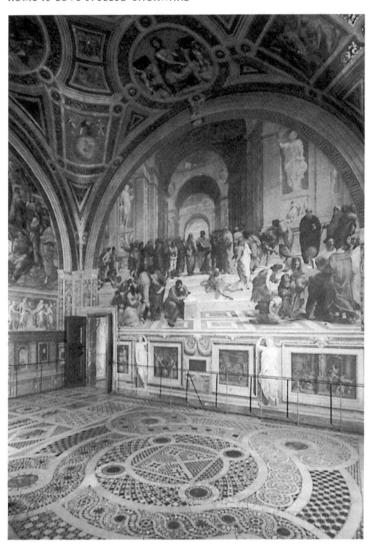

Raphael, *School of Athens,* Stanza della Segnatura, Vatican Palace. Raphael's brilliant
painting is an ideal evocation of all the great thinkers of the Western tradition.

did for civil law. The surface has deteriorated and the face of Gre-
gory has been repainted, but even so, the figure of the pope re-
mains impressive, and the features recognizably those of Julius II.

Raphael's painting of Philosophy is the most famous feature of
the Stanza della Segnatura. Misnamed the *School of Athens* in the
eighteenth century, the work neither shows a school nor is it set in
Athens. What we see is a gathering of the greatest thinkers from

every age of the Western world, come magically together beneath the soaring vaults of an ideal building. The images for this noble structure may have come to Raphael from Bramante, who was then at work on the new church of St. Peter's. Raphael's painting leads us not merely into another room, but into another, nobler world. Here Raphael truly becomes a Roman High Renaissance painter.

The artist faced a daunting task in this scene: how to make something visually interesting out of the unpromising subject of a group of men thinking. The way Raphael solved the problem is simple and brilliant: he translated mental effort into physical movements. In a sweeping arc around the composition several dozen philosophers communicate with one another, discussing ideas with great zest and animation, gesturing to one another, ticking off points on their fingers, demonstrating mathematical theorems, and in a few cases perhaps musing on the ideas they have just received. At the lower right edge Raphael's own boyish face peers out from behind the smiling visage of an older man, sometimes identified as Sodoma, the artist whose frescoes were re-moved to make room for Raphael's, and sometimes as Raphael's teacher, Perugino.

At the center of this busy but beautifully controlled scene, two handsome figures stand silhouetted against the open sky visible behind a tall, vaulted archway. Identified by both the books they carry and the gestures they make, they are the philosophers Plato and Aristotle, the Athenian founders of Western philosophy—hence the title, the *School of Athens*. Plato carries a copy of one of his most difficult and abstract Dialogues, the *Timaeus,* and Aristotle holds a volume of his *Ethics*. It is unlikely that Raphael had read the works of either man (he had the equivalent of an eighth-grade education), but he must have informed himself about the essential qualities of their philosophies, for their gestures perfectly sum up their ideas.

Plato, an old man with a long white beard (perhaps a portrait of Leonardo da Vinci, whom Raphael admired) raises his right hand and points toward the heavens, to suggest that there is a higher realm beyond the world of appearances in which we live. Aristotle, who had been Plato's pupil, appears as a younger man, whose face possesses the ideal beauty of a classical statue. With the palm of his hand he gestures forcefully toward the ground, as if to contest Plato's claims and assert the primacy of life here on earth as the proper subject of philosophy.

Raphael finished this fresco about 1510, at the same time Michelangelo completed work on the first half of the Sistine Chapel ceiling. In contrast to Raphael, who worked imper-turbably amid a perpetual hubbub of assistants, friends, and admir-ing women, Michelangelo kept the Sistine Chapel under lock and

key, reluctantly allowing only Pope Julius to inspect his frescoes. The necessity of removing and re-erecting scaffolding so Michelangelo could continue meant that the chapel was opened briefly, however, and Raphael got his first look at his colleague's work. Always ready to admire and absorb the achievements of other artists, Raphael was overwhelmed by what he saw on the Sistine ceiling; so much so that he immediately resolved to include a portrait of Michelangelo among the great intellects who populated his fresco of Philosophy.

The prominent figure of Michelangelo sits in the left foreground, isolated from the discussions that swirl around him. His gloomy, bearded face—easily recognizable through other portraits of the artist—rests on his left hand; with his right he leans toward a boxlike table and scribbles something on a piece of paper. He is dressed in the rumpled smock he habitually wore while working on the Sistine ceiling and the soft suede boots that Vasari tells us he often failed to remove for weeks at a time. If Michelangelo responded to Raphael's extraordinary tribute, it is unrecorded.

Raphael began work on the next room, called the Stanza d'Eliodoro, in 1511, even before the Segnatura was finished. Here a series of powerful paintings reveals episodes of God's intervention on behalf of the Church, as well as the impact on Raphael of Michelangelo's Sistine ceiling. The room takes its name from one of the frescoes, the *Expulsion of Heliodorus*. The story appears in the Second Book of Macabees (8:24–27) and describes the violation of the Temple in Jerusalem by the pagan general Heliodorus. In the midst of his attempt to carry off the Hebrews' temple treasure God "gave a great evidence of his presence" by sending three avenging angels in the form of "a horse with a terrible rider upon him," and "two other young men beautiful and strong, bright and glorious," who beat the offending general until he fell blinded and helpless to the ground.

These biblical descriptions seem made to order for the brush of Raphael at this particular moment in his career, fresh from his encounter with the stupendous forms of the Sistine ceiling. The *Expulsion of Heliodorus* is very different from the *School of Athens*, painted only a year or so earlier. The figures are much more strongly muscled and active than any Raphael had ever painted before and yet retain a gracefulness that is the hallmark of his style.

At the center of this composition is the altar of the temple and the figure of the high priest kneeling in prayer, an anachronism that bears not the remotest resemblance to Jewish ritual. But the reason the Hebrew high priest looks like a Catholic bishop is easy to discover. On the left side of the painting, just behind a group of agitated women and children, we see Julius II being carried into his own fresco. The pugnacious old pope arrives on his ceremonial

Raphael, *Expulsion of Heliodorus,* Stanza d'Eliodoro, Vatican Palace. Painted after Raphael had seen Michelangelo's frescoes on the ceiling of the Sistine Chapel, the work is full of muscular figures and dynamic action.

chair and seems to be glaring at the fallen Heliodorus. Julius no doubt saw a parallel between this biblical event and his own struggle to expel the French invaders from Italy.

Over one of the side windows in the Stanza d'Eliodoro Raphael painted another example of divine intervention in human affairs: the *Mass at Bolsena.* This scene depicts a thirteenth-century miracle in which a priest who doubted the Real Presence of Christ in the bread and wine of the Eucharist was celebrating Mass. Suddenly, the consecrated Host began shedding drops of blood, which formed a cross on the cloth where the Host rested. The blood-stained cloth still exists as a relic in the cathedral of Orvieto and Julius had spent a full day adoring it during a pause in one of his military campaigns in 1506. Therefore it is no surprise to find Julius himself attending this miraculous Mass. In full papal regalia he kneels at the right, across the altar from the celebrant.

Across the room from the *Mass at Bolsena* is the *Liberation of St. Peter from Prison,* the only fresco in the room that does not feature Julius II, although here as well the story is relevant to him. The fresco illustrates an episode from the Acts of the Apostles in which Peter, having been arrested by Roman authorities, was sleeping in prison, bound by two chains and guarded by two soldiers. An angel appeared, filling the prison with light. The angel awakened Peter, caused the chains to fall from his hands, and then led him to

freedom. The episode ends with this dreamlike account: "and he knew not that it was true which was done by the angel, but thought he saw a vision" (Acts 12:9).

Raphael's version of the subject is breathtaking. On the left side of another inconveniently located window are the doorkeepers of the prison, their armor gleaming faintly in the light of torches and a crescent moon. At the center, above the window, Raphael painted the grate through which we look into the dungeon. There a magnificent golden-haired angel in salmon-colored robes leans over to touch Peter's prone body. The circle of light surrounding the angel radiates through the room. The angel is quintessential Raphael. No other artist could persuade us of both the tenderness and the superhuman power of this being who awakens the imprisoned Peter, then leads him like a dreaming child through the prison walls.

The fresco's theme of divine liberation may have appealed to Julius for its parallel with the deliverance of the papacy from the French invaders, but it received another, unexpected level of meaning when the pope died while Raphael was at work on it: the liberation of the pope's soul from its earthly prison and into the realm of eternal light. This is the last of the *stanze* frescoes that is indisputably all Raphael's work.

The last scene in the Stanza d'Eliodoro, called the *Expulsion of Attila,* dates from 1513–1514, the beginning of the papacy of Leo X, and is mostly the work of Raphael's assistants. Leo had only a limited interest in the completion of a fresco cycle so obviously intended to glorify his predecessor, but Raphael managed to find a way of paying tribute to his current papal patron. The event shown took place in the fifth century, when the unarmed Leo III routed Attila, the terrifying king of the Huns, through the miraculous intervention of Saints Peter and Paul. Originally the masterful figure of Leo III, on horseback on the left side of the scene, was intended as a portrait of Julius II. But with the election of Leo X, the obvious solution was to give the earlier Leo the facial features and rotund body of the current one. There are actually *two* portraits of Leo in this fresco. One is the portrayal of Leo III just noted and the other is the portly cardinal behind and to the left of the figure of pope. The latter shows Leo X when he was still Cardinal Giovanni de' Medici.

Suggested reading

James Beck, *Raphael: The Stanza della Segnatura* (New York, 1993).

RAPHAEL IN ROME
The Villa Farnesina

While still employed at the Vatican, Raphael found time to contribute some enchantingly playful and romantic frescoes to Agostino Chigi's delightful suburban love nest, known today as the Villa Farnesina. Chigi (1466–1520) was Raphael's chief secular patron in Rome, a flamboyant and fabulously wealthy Sienese banker who administered the papal finances and greatly expanded his personal fortune while doing so. In addition to designing chapels for the Chigi family in two Roman churches, Raphael helped decorate Chigi's residence, one of Rome's most seductive private spaces. The villa's present name comes from its purchase in the late 1500s by the Farnese family, who connected it by a (now destroyed) covered bridge to Palazzo Farnese, their immense family headquarters across the Tiber. Farnesina means "little Farnese."

No other Renaissance site offers such a complete and enthusiastic re-creation of pagan antiquity. The building itself, the masterwork of the Sienese architect and painter Baldassare Peruzzi, was constructed between 1508 and 1511 and is classical in appearance, as befits a structure erected on the ruins of an ancient Roman villa. At the time the spot was outside the city—hence the name Chigi gave it, Villa Suburbana. The building, shaped like a squared-off letter C, opens onto a spacious garden from a series of loggias, or external porches.

Because of Rome's expansion, Chigi's retreat from urban noise and stress is now within the city and most of his private gardens

overhanging the river have been replaced by traffic on the heavily traveled road that runs along the Tiber embankment. Once inside the villa's walls, however, the visitor can still feel something of the original enchantment of the place. The remaining gardens are carefully tended and the splash of fountains mingles with the sound of birdsong. The villa itself, weathered but intact, opens its arms to visitors. In Chigi's time the villa would have seemed even more inviting, because the loggias, now enclosed with glass, were then all open. Visitors could move back and forth between gardens full of antique statues and the open-air loggias whose painted surfaces are full of stories from classical antiquity. Chigi's dinner parties, held in this gorgeous environment, were the stuff of legend. His guests sat on a now destroyed loggia overlooking the Tiber and ate their multicourse meals from solid gold and silver plates. After each course, servants apparently tossed the precious plates into the Tiber, but there was a net concealed under the water and after the parties the servants would haul it up to retrieve the dinnerware.

The reasons Chigi built this villa combine hard-headed business practicality with Renaissance humanist idealism, and reckless romanticism with cynical sexual opportunism. Chigi enjoyed a close relationship with Julius II, since loans from Chigi had provided much of the money the pope had used as bribes to ensure his election in 1503, and Julius remained dependent on Chigi's financial acumen. Consequently Chigi moved in the highest social circles in Rome and needed an appropriately grand home in which to entertain the cardinals, noblemen, and others who thronged the papal court. He also entertained poets, scholars, and artists, so his new villa had to be not only lavish but also learned in its decoration.

Chigi's more personal motives for building the villa involved his habit of keeping elegant and expensive courtesans. He had originally intended the house as a retreat for himself and his mistress who, when the villa was begun in 1508, was a noted Roman lady of the evening named Imperia. Chigi and Imperia had a falling-out, however (or so the story goes); she took up with a new lover who treated her badly and in 1511 she committed suicide by swallowing poison.

Chigi wasted little time in mourning. Later that same year he made a trip to Venice to close a business deal and returned home with a trophy: one of the city's courtesans, Francesca Ordeaschi. Their liaison proved enduring. Francesca bore Chigi four children (all baptized and legitimized by Leo X) and in 1519, a year before his death, Chigi married his mistress, with the ever-obliging Leo officiating. We might note that, during the busy year 1511, Chigi also tried to marry an illegitimate daughter of the marquis of Mantua. This attempt to attach himself to the nobility fell through

because of the girl's strong resistance. There were some things even Chigi's money could not buy.

Once the physical structure of the villa had been completed, Chigi hired the best artists in Rome to decorate it. Only Michelangelo did not participate; his involvement with painting the ceiling of the Sistine Chapel, and perhaps his puritanical disposition, excluded him. Peruzzi, who had designed the building, also painted many of the frescoes. Others are by Sebastiano del Piombo, Sodoma, and Raphael, who worked at the villa about 1513 and who returned in 1518–1520 with several of his assistants.

Raphael and Chigi had much in common and became friends. Both had risen to the top of their professions by making the most of their considerable talents and opportunities. Both reveled in the fashionable society of aristocratic Rome and the papal court without losing themselves in it. They shared an interest in classical antiquity as well as a streak of sensuality and preferred the company of mistresses to conventional married life. Raphael had an "official" fiancée, a niece of Cardinal Bibbiena, one of Leo X's least edifying cronies, but he paid her little attention and never married her. Raphael left two ravishing portraits of his Roman mistress, a local beauty known only as "La Fornarina," the baker's daughter. One, now in Florence, shows her in the elegant cream and gold satins of an aristocrat; the other, in Rome's Galleria Nazionale in Palazzo Barberini, portrays her regarding us coolly, naked from the waist up.

Given the personal relationship between Raphael and Chigi, many have wondered why we do not find more work by Raphael's own hand in the Farnesina. There are several possible explanations. Clearly the artist's first priority was the cycle of frescoes in the Vatican Palace commissioned in 1509. By the time the walls of the Farnesina were ready to be frescoed, Raphael was painting the Stanza della Segnatura, and Julius II would have tolerated no interruption of that project. Another, more colorful explanation was offered by Vasari, who claims that Raphael was distracted by his love affair with "La Fornarina" and could not bear to be parted from her. Although this passion does not seem to have affected the progress of his work at the Vatican, it supposedly brought his work at the Farnesina to a standstill. So Chigi (perhaps a bit of a romantic at heart but also a patron who wanted his frescoes finished) brought the young woman to the Farnesina, where he gave Raphael a room, and allowed her to live there with him.

Whether or not as the result of fulfilled love, Raphael's single painting in one of the ground-floor loggias—his radiant and triumphantly sensual *Galatea*—is the most famous painting in the villa. The Sala di Galatea, entered by a doorway just to the right of the entrance to the Farnesina, is unprecedented in the completeness of its exuberant pagan imagery. The ceiling, painted by

Raphael, *Galatea,* Sala di Galatea, Villa Farnesina. Although occupied with Vatican commissions, Raphael took some time to paint this sensuous fresco for the private villa of his friend, papal banker Agostino Chigi.

Peruzzi, is thronged with classical gods and goddesses in complex pairings, forming Agostino Chigi's personal horoscope: the precise positions of stars and planets on the day of Chigi's birth, November 29, 1466. Lunettes (the half-circle-shaped areas above the windows) on the side walls display Sebastiano del Piombo's paintings of episodes from Ovid's *Metamorphoses,* a favorite classical poem among Renaissance humanists.

Chigi probably hoped to have all the wall surfaces of this room covered with large frescoes by Raphael, but only the *Galatea* was ever executed, perhaps around 1513. Raphael himself claimed that he based her beauty not on any one woman, but on the best features of all the beautiful women he had ever seen, and if we can believe Vasari's report, he had seen quite a few. The artist had little interest in Ovid's story about the nymph Galatea fleeing the unwelcome attentions of an ugly giant named Polyphemus. Although Polyphemus is present, in a rather ludicrous neighboring fresco by Sebastiano del Piombo, Galatea ignores him. Instead, she is in triumphant control of her own destiny, joyriding on a shell pulled by two playful dolphins and helped along by a paddle wheel. Her sturdy, sensual body twists in rhythm with the churning motion of her boat; her scarlet cloak and golden hair stream out behind her head. Wheeling around her are a collection of mythic sea creatures: sea horses, sea nymphs, and tritons blowing trumpets. One triton—his upper body a tanned and muscular man, his lower half an alarming green monster—grabs a sea nymph, who responds not with fear but with tolerant amusement. Cupids aim arrows of love at Galatea from the upper part of the fresco and a particularly splendid Cupid floats across the foreground, getting a free ride by clinging to the bridle of Galatea's dolphins. The whole picture, pervaded by a clear sea light, radiates an unabashed sexual energy.

After completing the *Galatea,* Raphael returned to his Vatican commissions. Meanwhile, work at the Farnesina went on. Chigi's bedroom, on the second floor of the villa, received an appropriately suggestive fresco showing the *Marriage of Alexander the Great and Roxanna.* Although painted about 1516 by Sodoma, it may be based on a sketch provided by Raphael. The painting serves its purpose well by setting an amorous mood. Roxanna leans back suggestively on an immense canopied bed, probably similar to Chigi's own fabled furniture, which included a bed lavishly decorated with gold, ivory, and precious stones.

Also upstairs is a spacious and elegant living room lit by south-facing windows and called the Sala delle Prospettive, or Room of the Views. The fresco decoration is the work of Peruzzi, who "painted away" the walls that he himself had designed, creating the ingenious illusion that the visitor is looking out from between columns onto balconies from which views of the city and country-side appear. We can still recognize the city, even after so much time, but it is startling to realize that in the early 1500s the Farnesina was at the very edge of Rome, with little but open country beyond it.

In approximately 1518 Raphael returned to the Farnesina, this time accompanied by a group of talented pupil-assistants who had been working with him at the Vatican. Their project was another ground-level porch called the Loggia di Psiche, which opened

Assistant of Raphael, Mercury, detail of ceiling of the Loggia di Psiche,
Villa Farnesina. A mischievous image of the god Mercury suggests
the room's amorous mood.

onto the villa's gardens. This time, the amorous program dealt with
the classical myth of Cupid and Psyche, a love affair at once celes-
tial and sensual, the perfect subject for what amounts to a painted
garden bower. Even more than the Sala di Galatea, this room is
pure, sensuous magic. The frescoes were designed by Raphael and
executed by his assistants under his direction and occasionally with
his direct participation.

The structure of the Loggia di Psiche bears a resemblance to
the arrangement of the Sistine Chapel ceiling: a long rectangular
section down the middle, supported by triangular vaults along the
sides. But there the similarity ends, for while Michelangelo's Sis-
tine frescoes explore the great themes of Judaeo-Christian theol-
ogy, Raphael's take us into a lush dreamworld of the senses. Richly
colored bands of fruit and floral ornament outline each of Pe-
ruzzi's vaults, turning the architecture into a garden bower. The
episodes from the myth of Cupid and Psyche take place against a
blue background, as if appearing in the open sky above the bower.
The two main scenes, the Marriage of Cupid and Pysche and Cu-
pid and Psyche Received on Mount Olympus, unfold along the
center of the ceiling, seemingly painted on two huge tapestries at-
tached to the ceiling like awnings.

The side vaults are full of gods, goddesses, and nymphs, all of them nude or nearly so. Most were executed from Raphael's designs but with the somewhat harsh execution typical of Raphael's followers. In one of the vaults the god Mercury floats among the flowers, smiling blandly and pointing up to our right, where an erect phallus emerges from amid the foliage. In this atmosphere of limitless sensuality, it is easy to believe that such objects really do grow on trees.

Raphael's contributions to the Sala di Psiche were to be his final works at the Farnesina and among the last of his career. He was back at the Vatican in the spring of 1520, working on an immense painting, the *Transfiguration of Christ,* for Cardinal Giulio de' Medici when he was taken ill and died, probably of pneumonia. He was only thirty-seven years old. Vasari implies that the artist died from exhaustion caused by combining prodigious artistic creation with a hectic love life, but whatever the cause, the artist's contemporaries deeply mourned his passing. At his own request he was buried in the Pantheon, the greatest of all surviving imperial Roman buildings. It is difficult to imagine a more perfect resting place for the man who did so much to revive what was finest in the spirit of ancient Rome.

Suggested reading

Felix Gilbert, *The Pope, His Banker, and Venice* (London, 1980).

LEO X AND CLEMENT VII

Art Patronage and Political Disasters

Historians are still trying to figure out why the fabulously wealthy, clever, and cultured Medici family of Florence produced, in succession, two of the most disastrous popes in the history of the Catholic Church: Leo X and Clement VII. Both were educated, intelligent men who began their papacies with high expectations of success. Instead, Leo allowed Luther's local rebellion of 1517 to escalate into a permanent split between Catholics and Protestants which plunged Europe into more than a century of religious warfare. Clement engaged in international diplomacy so inept that it brought down on Rome the most destructive military action in a thousand years, the devastating Sack of 1527. Yet both men had been raised to revere the arts and even with the accumulating crises of their papacies they found some time to devote to art patronage.

LEO X

Born in Florence in 1475, the third of Lorenzo the Magnificent's seven children, the plump, near-sighted Giovanni de' Medici had been destined since childhood for a career in the Church. He had taken holy orders at age seven and been named a cardinal at fourteen. Although the boy had journeyed from Florence to Rome in 1491 to assume his place in the Curia, he had never been ordained and so, when he was elected pope, he had to be rushed through that ceremony with unceremonious haste.

Leo's coronation took place in a tent in front of the dilapidated facade of Old St. Peter's and was a rather makeshift affair, but the great procession from St. Peter's to the Lateran that followed was one of the most splendid spectacles seen in Rome since the days of the Caesars. At the end of Leo's lengthy and magnificent cavalcade came the new pope himself, riding an Arab stallion and preceded by the colorfully uniformed Swiss Guard, the tough band of warriors recruited by Julius II as the pope's personal bodyguards. Leo was flushed and perspiring heavily (and also, according to witnesses, unconcernedly breaking wind), but smiling and bestowing his benediction. Behind him came two papal chamberlains, each carrying bags of gold and silver coins from which they flung handfuls of money into the jubilant crowds lining the route.

The degree of extravagance displayed in this ceremony (known as the *sacro possesso*) was to prove typical of Leo's attitude toward money and life in general. Unaccustomed to administrative duties, ignorant of the intricate Vatican bureaucracy, and interested in neither Church reform nor international politics, Leo flung his considerable bulk into an endless round of banquets, balls, hunting parties, and elaborate entertainments. Always eager to be liked, he fell quickly into the habit of granting any and all requests for money, no matter how frivolous the purpose or how unworthy the petitioner.

Given such generosity combined with the Medici heritage of lavish support of the arts, Leo might have become a great papal art patron, but his patronage seems less significant when compared with the grand projects of Julius II. (In all fairness, he was more interested in literature than the visual arts.) Although he permitted the projects begun under Julius to continue, Leo was more concerned with advancing the fortunes of his native Florence than with the glorification of the papacy. At heart a timid man, he had always been frightened of Michelangelo. The pope was eager to get the artist out of Rome and soon sent him back to Florence to work on various Medici projects there.

Raphael continued in the service of Leo, who put him in charge of continuing the construction of St. Peter's and gave him responsibility for overseeing the antiquities of Rome. Raphael also created the full-scale designs for a series of tapestries intended for the Sistine Chapel. Today the tapestries are in the Vatican Museums. The pope also had Raphael continue the fresco series he had begun for Julius II, but much of his work for Leo reflects the new pope's inattentive attitude. In a heavy-handed attempt to glorify Leo, the paintings—mostly by Raphael's assistants—immortalize the actions of earlier popes of the same name, each given the facial features and rotund body of Leo X.

Raphael's finest achievement for Leo was a portrait (now in the

Uffizi Gallery in Florence) that shows the corpulent pope seated at a table, about to employ a gold-and-crystal magnifying glass to examine a beautifully illustrated Bible. Behind him are two of the many cardinals he created during his papacy, usually in exchange for large sums of money. The cardinal on the left is the pope's cousin, Giulio de' Medici, now about five years away from his election as Clement VII.

Raphael painted this unexpectedly revealing portrait of the cultured, pleasure-loving, and politically oblivious pope close to the fateful year 1517, when Luther nailed his ninety-five theses to the door of the church in Wittenberg, precipitating a conflict that reverberates to this day. The theses Luther set out for debate concerned the sale of indulgences. Leo had continued the policy of Julius II, using indulgences to finance the construction of St. Peter's, and he remained deaf to the chorus of complaints aimed at this form of papal fund-raising.

Leo's first response to Luther was a misstep from which the pope never recovered. He dismissed Luther's protest as a "monkish squabble" that would die a natural death if everyone would just ignore it. The pope, however, was no match for the crafty German princes who chose to protect the young Augustinian monk and theology professor whose criticism of one Church policy had turned him into the leader of a full-scale religious rebellion.

Leo excommunicated Luther on January 3, 1521, but if he had expected this action to end the protection Luther continued to receive, he was wrong again. Luther appeared before the German princes and the Holy Roman Emperor Charles V at the meeting of the Imperial Diet in the German city of Worms in April 1521. In a famous confrontation he refused to retract any of his ideas and was therefore condemned as a heretic. Under the protection of Friedrich of Saxony Luther disappeared, spirited away to one of Friedrich's remote mountain fortresses. The pope, delighted with the emperor's condemnation of Luther, died on December 1, 1521, convinced that nothing more would be heard from this troublesome German crank. Once again, Leo could not have been more wrong. A crisis that would change Christianity forever had barely begun.

CLEMENT VII

Any man born out of wedlock a few months before his father's murder could be said to have had an unfortunate start, and yet it was the murder of Giulio de' Medici's father that permitted the ascent of his son to the highest office in Christendom. The career of Giulio as Clement VII would amply bear out his inauspicious beginnings. Although he commissioned some works of art of con-

sequence, no pope had a more disastrous effect on Rome.

Guilio's father, Giuliano de' Medici, fell victim to a botched plot against the Medici family. In 1478 a group of assassins attacked Giuliano and his older brother Lorenzo as they were about to receive Communion at the high altar of Florence Cathedral. Lorenzo, the main target of the conspirators, escaped with superficial wounds, but the politically insignificant Giuliano died on the spot, his body mangled by sword thrusts and his skull split open by a heavy blow to the head. Shortly after his brother's death the grief-stricken Lorenzo learned that a young woman in the city had recently given birth to Giuliano's son. She had called the boy Giulio and made no attempt to conceal his illustrious parentage. Lorenzo's agents persuaded her to turn the child over to the Medici family, and Lorenzo raised Giulio as one of his own children. He was three years younger than Lorenzo's son Giovanni, and the two boys soon became inseparable.

Some three decades later, when Giovanni de' Medici became Leo X, he did not forget his cousin Giulio. Although Giulio had taken holy orders, his illegitimate birth was an impediment to a career in the Church. Leo therefore legitimized his cousin and bestowed on him a series of ecclesiastical offices, making him archbishop of Florence and finally a cardinal. Giulio served Leo honorably. Although never called upon to make decisions or initiate policy, he was intelligent, had a good grasp of Vatican politics, a noble name, and a spotless reputation, all qualities that should have made him at least an adequate pope.

After the death of Leo X in 1521 the cardinals selected a pious but feeble and ineffectual Dutch cardinal who took the name Adrian VI, the last non-Italian pope until the election of John Paul II. He lived less than two years. The next conclave was harrowing: it lasted fifty days and featured such bizarre goings-on as the imprisonment of the cardinals behind bricked-up doors and windows; the reduction of their food allowance to bread, wine, and water; and the suspension of even the most essential sanitary services, all in the interests of goading them into making a decision. Finally, on November 17, 1523, Giulio de' Medici emerged as the exhausted cardinals' grudging choice. He took the papal name Clement VII.

A reserved, dour, and rather stingy man, Clement did not attempt to revive the carnival atmosphere that had prevailed during the papacy of Leo X. He did keep Raphael in his service, however. He had a taste for exquisite metalwork and commissioned several pieces from the Florentine goldsmith and jeweler Benvenuto Cellini, who also designed Clement's papal coinage. He had hoped to hire Michelangelo to paint the Resurrection of Christ on the altar wall of the Sistine Chapel but died before this project progressed beyond some preliminary drawings.

The greatest work to come out of Clement's patronage had been commissioned in 1517, while he was still a cardinal; it was Raphael's *Transfiguration of Christ,* the artist's last major painting. Originally the cardinal had planned to send it to Narbonne cathedral in France, but it was still unfinished at the time of Raphael's death in 1520. After two assistants of Raphael's completed the

Raphael, *Transfiguration of Christ,* Vatican Pinacoteca. This complex and dramatic work, commissioned by Cardinal Giulio de' Medici and unfinished at the time of Raphael's death, illustrates a significant change in the artist's style.

work, the cardinal decided to keep it with him in Rome. Today it is in the Vatican Pinacoteca, with a mosaic copy in St. Peter's.

The huge painting (nearly fourteen feet high) reveals a side of Raphael's art hardly suspected from his earlier work—turbulent drama. Christ brought three apostles to the top of a high hill to witness an extraordinary revelation during which Christ's body rose off the ground, Moses and Elijah appeared in the sky, Jesus' face and garments glowed, and the voice of God came out of a bright cloud, saying, "This is my beloved Son, in whom I am well pleased." The terrified apostles crumpled to the ground. This scene, dramatic in itself, forms half of Raphael's picture. The artist also illustrates the sequel—a boy possessed by demons, whom the remaining apostles could not cure in Christ's absence.

Raphael designed a complex composition that unites both events. The upper portion centers on a glowing blue-and-white whirlwind containing the figure of Christ. The three prone apostles, the floating prophets, and two kneeling Medici saints on the left side seem to circle the floating form of Jesus. The lower portion, united to the upper by means of dramatically pointing hand gestures, lies in semidarkness, illuminated only by fitful flashes of light from the Transfiguration above.

It is not difficult to tell at what point in this work Raphael lay down his brush for the last time. The upper part and the figures in the lower left and center portions of the painting, animated by that unique combination of power and grace, are surely all Raphael's own work. The group on the right, however, including the cartoonish demoniac boy with his rolling eyeballs and his equally pop-eyed father, is no doubt by Giulio Romano and Gianfrancesco Penni, who completed the work.

As pope, Clement would have little time to devote to art. The European political scene confronted the new pope with urgent issues requiring the utmost in diplomatic skill, courage, and decisiveness. Instead, his endless vacillations, intended to keep from alienating either party in the disputes, only succeeded in angering both sides and making the pope twice as many enemies as he would have acquired had he made clear decisions. In the first year of his papacy he made a bitter enemy of a potential ally, emperor Charles V, by concluding a secret alliance with Charles's archenemy, King Francis I of France. When Charles heard of this action, he swore revenge on "that fool of a pope" and added, ominously, that Luther had perhaps not been so far wrong in his judgment of the papacy. It is a perverse tribute to Clement's ineptitude that he could bring Luther's most bitter secular opponent to utter such a statement.

In the next three years Clement blundered deeper into the thickets of international politics, unable to choose any course and stick to it. When the crisis finally came, none of the rulers of

Europe would support him and some were eager to destroy him. Historians agree that Clement himself is largely to blame for creating the conditions that led to the Sack of Rome in 1527.

In late 1526 Charles V sent a fleet to Italy from Spain, filled with armed men eager for combat and booty. They were joined by some unlikely allies, German mercenaries who were mostly followers of Luther, but with an ancient tribal loyalty to the emperor, especially in a struggle against the hated Italian pope. In February 1527 the Spanish and German armies united to form a force of more than twenty thousand men. The huge army began moving south, but still the pope hesitated, negotiating treaties one day and abandoning them the next. A treaty and a ransom might have saved Rome, but Clement was neither the first nor the last leader to make the fatal miscalculation of trusting that Rome's sacred character would protect it. In a burst of incomprehensible optimism he even disbanded his own troops and the spiritual capital of western Christendom lay undefended before the advancing horde.

The attack began in the early morning of May 6, 1527. For eight days and nights the invading armies committed every form of torture, murder, arson, rape, robbery, and wanton destruction, with particular emphasis on the looting and burning of churches and the humiliation and killing of members of the clergy. The Sack continued for five months.

At the moment the armies broke into the Vatican Palace, Clement was praying in his private chapel. When his chamberlain told him what had happened, the pope burst into tears and fled headlong down the covered passageway that connects the palace with Castel Sant' Angelo. (This passage still exists, snaking its way between the more modern buildings that now surround it.) Someone thought to throw a dark cloak over Clement's white papal robes in an attempt to make him less conspicuous in his terrified retreat. A few days later the Venetian ambassador commented that even hell had nothing to compare with the condition of Rome.

Throughout that horrifying summer Clement and a small group of bedraggled cardinals remained prisoners in the Castello, living in filth and privation. (Although the papal apartments were comfortable enough, food was scarce and the seige made the disposal of garbage and sewage impossible.) To raise money, the pope gave Cellini a final task: removing precious stones from the papal regalia and jewelry and melting down the gold to be used for ransom. Clement left Rome in disguise and took refuge in Orvieto. Later, driven from there by famine, he moved to Viterbo, from whence he returned to a ruined Rome in October 1528.

Clement survived another six years, still enmeshed in international intrigues. His death came on September 25, 1534, when he was fifty-six years old. The Roman people, disgusted with his cowardice and indecisiveness, made an irreverent pun on his Latin title and name, *Papa Clemens;* they dubbed him *Inclemens Nonpapa.* As far as the Romans were concerned, this unfortunate and ineffectual Medici was unworthy of being called a pope.

Suggested reading

Judith Hook, *The Sack of Rome* (London, 1972).
Bonner Mitchell, *Rome in the High Renaissance: The Age of Leo X* (Norman, Okla., 1973).

POPE PAUL III AND HIS
ART PATRONAGE

In Rome's long history many men have tried to place their personal stamp on the Eternal City, but few have succeeded as brilliantly as Paul III (1534–1549). Three of Rome's most imposing architectural monuments—the Farnese Palace, the Capitoline Hill, and St. Peter's—owe their existence or their present form to his ambitious building programs. The two final painting projects of Michelangelo, the famous Sistine *Last Judgment* and the Pauline Chapel, were both his commissions. And his emphatic support of Ignatius Loyola was instrumental in the founding of the Jesuit order, whose own architecture had such a great impact on the urban fabric of Rome. The Farnese pope was also wise enough to entrust his official image to the Venetian master Titian, the greatest portraitist of the age, whose paintings of him are among the most fascinating and penetrating of papal portraits.

The future pope was born Alessandro Farnese in 1468. He came from a wealthy family established near Viterbo and accustomed to luxurious and frequently licentious living. The youthful Alessandro spent some time at the court of Lorenzo de' Medici in Florence, an experience that helped form his remarkable responsiveness to the visual arts. Although he was highly educated and cultured, as a young man Alessandro seems not to have behaved much differently than any other Roman nobleman. Made a cardinal at the tender

age of twenty-six, he continued to enjoy all the pleasures of secular life; he had numerous mistresses and fathered at least four illegitimate children.

If this seems like inappropriate behavior for a cardinal, consider the circumstances under which Alessandro received his red hat. His sister, Giulia Farnese, then a bewitching beauty of sixteen, had caught the eye of that most debauched of popes, Alexander VI Borgia (1492–1503), who was some forty years her senior. She was soon installed as the pope's favorite mistress, and the irreverent Romans promptly dubbed her "the bride of Christ." She was the model for the golden-haired Madonna in one of the frescoes by Pinturicchio that decorate the Borgia apartments in the Vatican. If the Farnese family had any objections to their daughter's fate, the pope stilled them by making Giulia's brother Alessandro a cardinal in 1494. The Roman populace contemptuously nicknamed him "the petticoat cardinal."

Alessandro Farnese grew old awaiting his opportunity to become pope. But unlike most ambitious men he managed to disguise this quality in himself and patiently cultivated good relations with each successive pontiff. He was on friendly terms with Julius II, whom he persuaded to legitimize two of his sons. His friendship with Leo X dated from his youth and his stay with the Medici family. Leo, with his typical generosity, showered many monetary favors on Cardinal Farnese. With these extra funds the cardinal began the construction of Palazzo Farnese, which eventually grew into one of the largest and most impressive private residences in Rome. His relations with Clement VII were strained, since the ineptitude of that pope sorely tried the patience of Cardinal Farnese. In later years, when he had finally become pope himself, he grumbled that the incompetent Clement had deprived him of a decade of his papacy.

After Clement's death in 1534 the cardinals were deadlocked for three weeks but eventually settled on the aged Cardinal Farnese as a compromise choice. He was nearly sixty-eight, apparently in frail health, and not expected to live long. Just how carefully the wily old cardinal had cultivated this image of senile debility soon became evident.

During the conclave Farnese had shuffled about leaning on a cane, had appeared to be deaf, and had seemed to fall asleep as soon as he sat down. But the moment he was elected pope an amazing transformation occurred. He no longer needed his cane; younger men had to trot to keep up with his brisk walking pace. Far from being deaf, he could discern a whisper across a room, and nothing escaped his notice. He slept only about four hours a night and devoted the rest of his time to papal business. The fragile, doddering old man the cardinals had chosen on the assumption that he would

soon die and could be easily manipulated while he lived turned out to be a prime specimen of vigorous physical health and notable intellectual independence. Paul III had the longest and most productive pontificate of any sixteenth-century pope.

Scholars who attempt to situate Paul III historically refer to him as the last Renaissance pope and the first pope of the Catholic Counter Reformation. His worldly attitudes and behavior belong to the Renaissance; he casually assumed that no one would object to his continuing role as *paterfamilias* to his brood of illegitimate children and their spouses, as well as an even larger brood of papal grandchildren. In addition to presiding over big family parties Paul loved the spectacles and ceremonial processions so dear to earlier Renaissance popes. And yet it was this same, worldly pope who began the Counter Reformation, the Catholic Church's belated response to Luther's rebellion. At last the Church had a leader who understood the need for internal reform. It was Paul III who convened the reforming Council of Trent in 1545.

Although the diminutive, diplomatic Paul III had little in common with the towering, turbulent Julius II, he shared with that earlier pope a profound understanding of the role public monuments play in creating an image of papal grandeur and authority. As an art patron, he was the century's only true heir to the princely patronage of Julius II. Of the artists who had served Julius, only one still survived, fortunately the greatest of them all: Michelangelo. In Paul III Michelangelo found a patron who fully appreciated his genius, and the pope found an artist who could transform his ambitious plans into reality.

Paul knew exactly how to handle the proud, sensitive, and increasingly irritable Michelangelo. As soon as the artist returned to Rome, after his long exile in his home city of Florence during the pontificates of the Medici popes Leo X and Clement VII, Paul made him a member of the papal *famiglia,* the pope's own household, and in 1535 appointed him chief architect, sculptor, and painter of the Vatican Palace. The pope even made a personal visit to Michelangelo's modest home and studio, an unheard-of honor that helped convince the sullen and suspicious artist of his patron's good intentions. Paul also released Michelangelo from his obligations to the della Rovere family, so he no longer had to work on the tomb of Julius II. The stage was now set for the last, astonishing phase of Michelangelo's long career, during which he produced for Paul III works that permanently altered the face of Rome.

The two great public monuments Michelangelo created for Paul, the Campidoglio and St. Peter's, were to stamp both their names upon the Eternal City. Michelangelo also worked on the Farnese Palace, which Paul expanded and enriched after he

became pope, but that building was essentially complete when Michelangelo took charge of it.

Paul's determination to have the partly ruinous Capitoline Hill, or Campidoglio, renovated by Michelangelo stemmed from an embarrassment suffered when Holy Roman Emperor Charles V visited Rome in 1536. The Capitoline Hill was in such a sorry state—choked with weeds and brambles, dotted with goat droppings, its crumbling buildings accessible only by muddy footpaths—that the emperor's procession was obliged to detour around it. The task Michelangelo faced was daunting.

When, in a rare moment of civic enthusiasm, the city government had decided to build a communal hall in the twelfth century, the spot chosen was atop the ancient Roman Tabularium, on the summit of the Capitoline Hill, a site that loomed above the buried remains of the Roman Forum. Perhaps the civic officials were inspired by some dim dream of imperial glory; perhaps they just needed a place for the city's Senate to meet and the ruins of the Tabularium, topped by an eleventh-century fortress, provided a ready-made foundation. In the 1400s another building, called the Conservators' Palace (now Rome's city hall), had been added on the south side of the Capitoline Hill. The nearer part of the hill's north side was empty, although the medieval church of the Ara Coeli stood further to the north. On the west side, facing the city, the hill descended sharply, creased only by muddy footpaths.

The pope's first act in his campaign to clean up the Campidoglio came in 1538, when he ordered the famous bronze equestrian statue of the Roman emperor Marcus Aurelius (then thought to be either Constantine or Antoninus Pius) transferred from its location near St. John Lateran to the center of the Campidoglio. Although Michelangelo had advised the pope against this project (because he hoped to have a statue of his own adorn the site) and the clergy of the Lateran howled in protest at losing their statue, the pope persisted. Michelangelo designed a base for the work, and the inscription on it makes clear that Paul III, the wise and powerful lord of Rome, is the ancient emperor's true successor.

The oval shape of the statue's pedestal and its prompt placement at the center of the Campidoglio suggest that by 1538 Michelangelo had already roughed out an overall plan for the site and that it had been approved by the pope. The early details of the artist's plan are unknown, as is the extent of the pope's personal contribution. Michelangelo no doubt used various suggestions from others to create his own brilliantly original plan. He transformed the disorderly and ramshackle site into a single symmetrical space that unified five entrances, a trapezoidal piazza, an oval pavement, three

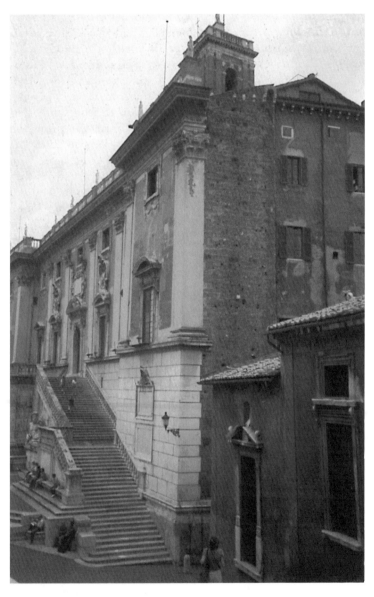

Senators' Palace, Capitoline Hill. Although designed by Michelangelo for Paul III,
the buildings of the Capitoline Hill were not completed until the 1600s. This
facade view shows clearly that Michelangelo designed a kind of screen
over the pre-existing medieval structure.

palace fronts, a variety of ancient statues that had been scattered about the site, and a monumental *cordonata* "a gradual, ramplike staircase."

It is unlikely that any other architect of the era could have successfully carried out a project of such scale and complexity. Although neither pope nor architect lived to see the Campidoglio completed, some work got under way during Paul's lifetime, and the refacing of the two pre-existing palaces on the site commenced in 1563. The oval pavement with its striking pattern of interlocking and radiating oval shapes was finally executed from Michelangelo's designs only in 1938.

Because Paul had ordered Michelangelo not to tear down any existing buildings, the plan the artist submitted called for new fronts to be placed on the Senators' and Conservators' palaces, and for the site to be regularized by the addition of a third palace on the north side (today housing the Capitoline Museum). The only purpose of this building was to balance the Conservators' Palace across from it. The two facing palace fronts are identical twins: two-story structures displaying a colossal order of pilasters, a motif used for the front of the Senators' Palace as well. To see how thin these facades really are, the visitor need only look at the corners of the Senators' and Conservators' palaces, where Michelangelo's architecture extends back only a few yards before it abruptly ends and the older masonry begins.

In photographs the observer is often artificially suspended above the site as if floating over it in a balloon. On the ground it is impossible to grasp the totality of the place from a distance; it unfolds gradually and dramatically as the visitor walks up the broad flight of steps Michelangelo designed to bring the observer into the striking space of the piazza. The spot at the center, where a copy of the equestrian statue now stands, offers a view across Rome, all the way to the dome of St. Peter's. A victim of pollution, the original magnificent, gold-spangled, larger-than-life equestrian statue of Marcus Aurelius is now in the adjoining Capitoline Museum. I happened to be on the Capitoline Hill the night the restored equestrian statue was first displayed to the public in its new location: sealed inside a huge, humidity-controlled glass box. Nearly all the visitors that evening were Romans. One elderly gentleman stared at the enclosed figure, shook his head sadly and intoned: *"Poverino! Non scappa mai!"* ("Poor fellow! He'll never escape!").

When Cardinal Farnese became pope in 1534, the construction of St. Peter's was at a standstill. Reports and pictures of the time describe trees growing out of the abandoned piers intended to support the immense dome Bramante had designed for Julius II, and portions of the early Christian basilica, which Julius had ordered torn down, were still standing. Despite the usual problems with

money Paul managed to have work resumed under the direction of Antonio da Sangallo the Younger. Sangallo had designed the Farnese Palace and the pope had great respect for his competence.

After Sangallo's death in 1546 Paul appointed Michelangelo architect of St. Peter's. Now seventy-two years old and in poor health, Michelangelo dreaded dealing with the hostile workmen, loyal to the memory of the genial Sangallo. Although he agreed to accept the post, he struck an unusual bargain with the pope. He would take no salary but would have complete freedom to pursue the work as he saw fit. He would tolerate no interference, not from the pope nor from the host of Vatican busybodies and sidewalk superintendents on the scene. Both men kept their word. Paul paid the staggering bills for materials and labor that Michelangelo regularly sent him and the gigantic bulk of St. Peter's at last began to rise. Paul III died in 1549, at age eighty-two, but the seemingly inexhaustible Michelangelo went right on working. He continued to supervise the construction of St. Peter's until a week before his own death, at age eighty-nine, in 1564. He lived to see the essential outlines of the building completed: three sides (but not the front) and the drum of the dome.

Although the church owes its foundation and its gigantic scale to Julius II and Bramante, St. Peter's in many ways is a monument to Michelangelo and Paul III, the supreme achievement of their rich artistic collaboration. Modern observers who stand on the Capitoline Hill and look across to the dome of St. Peter's can see what the pope and his architect envisioned: the persistent dream of Roman imperial glory united with the spiritual authority of the Church.

Suggested reading

James Ackerman, *The Architecture of Michelangelo* (Baltimore, 1971).

ROMA AMOR XXII

St. Peter's

An Epic Poem in Stone

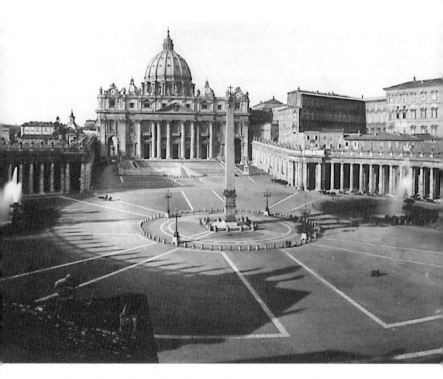

St. Peter's and piazza with colonnade. The present St. Peter's, constructed
over the course of nearly 150 years, is the product of more than a
dozen architects and the patronage of twenty popes.

It is much more than just another of Rome's innumerable churches. Although not Rome's cathedral (that honor belongs to St. John Lateran), it is the largest church in Christendom and arguably the most famous. Its history spans not just decades or centuries, but nearly two millennia. The church that awes visitors today has a story stretching back to the early years of Christianity in Rome and forward to our own times. A modern writer declared it the architectural equivalent of an epic poem. St. Peter's has always seemed to me a metaphor of the Roman Catholic Church itself, a living edifice that is always under construction, never really complete, not static but continually growing and changing, yet recognizably the same entity throughout the ages.

Technically St. Peter's is not in Rome at all but within the world's smallest sovereign state, the Vatican. A high wall, originally built for defensive purposes, surrounds this miniature nation in the middle of modern Rome, and the piazza in front of St. Peter's forms the only public access to the Vatican City, the last remainder of a papal domain that once included the entire city of Rome and stretched like a broad belt across central Italy.

Although St. Peter's is not the cathedral of Rome and is not even really *in* Rome, it has become a powerful symbol of the city and one of its principal landmarks. Churches all over the world are dedicated to St. Peter and yet only this one is instantly identifiable as *the* church of St. Peter. The origins of its renown take us back to apostolic times, when imperial Rome was approaching the height of its power and Christianity was a small, sporadically persecuted sect.

The whole, vast church could be described as a tomb marker for Simon Peter, the Jewish fisherman from Galilee to whom Christ delegated his divine authority and who became the probable founder of the Christian community in Rome. Catholics regard him as the first pope, even though it is doubtful he ever saw himself in that role. A devout Jew to the end, Peter died believing that Jesus was his people's promised Messiah.

Peter is said to have been crucified about 65 A.D. in Nero's Circus on the Vatican Hill. He was probably buried in a nearby Roman cemetery and the site became a desirable place for Rome's Christians to be interred, close to the body of their martyred leader. As early as 90 A.D. there may have been an oratory, or place of prayer, located here, although some archaeologists date that shrine to about 160 A.D. The spot, now deep beneath the ground directly under the dome of the present church, marks the spiritual center of St. Peter's. Excavated in the 1940s, the niche identified as St. Peter's tomb yielded some bones apparently belonging to an elderly but strongly built man. Pius XII declared them to be the bones of St. Peter. Although the identification may never be set-

tled with certainty, it is clear from the other tombs crowded around this one that the place had been hallowed since the early centuries of Christianity.

As the nascent Church grew in power during the next three centuries, the site remained important. After Constantine granted freedom of worship to Christians in 313, he also sponsored the construction of the city's first large churches, among them one built over the presumed site of St. Peter's grave. The original church, begun in 319, was a basilica. The form seems to have been chosen for its associations with the great law courts of Rome, such as the Basilica Aemilia, Basilica Julia, and the recently completed Basilica of Maxentius and Constantine. Pope Sylvester I consecrated the church on November 18, in the year 326.

For the next thousand or so years, the church accumulated art treasures, tombs, and prestige. Splendid frescoes and mosaics adorned its walls; gold and jewel-encrusted vessels served its altars. Popes, saints, and emperors were buried here, often in regal monuments. But by the mid-1400s the basilica, more than a thousand years old, was showing signs of imminent collapse. Nicholas V turned his attention to St. Peter's about 1450 and after consulting with the Florentine architect Leon Battista Alberti, decided to replace the old basilica. Although Nicholas had 2,500 cartloads of stone from the Colosseum hauled across the city to St. Peter's, and some work got under way, nothing had progressed very far by the time of his death in 1455. Subsequent popes quailed at the idea of replacing the ancient church; so patching and tinkering with the tottering edifice continued for the remainder of the century.

With the election of Julius II in 1503 a new and dramatic chapter in the history of St. Peter's began. At first Julius planned only to renovate the old basilica, making it into a more appropriate setting for his own tomb, but under the influence of his chief architect, Bramante, the pope decided on a complete rebuilding. Always attracted by the grand, definitive gesture, he ordered work to begin on the demolition of the ancient church in 1506, at the same time he accepted Bramante's plan for the construction of an entirely new church.

The new structure would dwarf the original one and would, Bramante claimed, put the Pantheon on top of the Basilica of Constantine. This statement was a tribute to the architectural heritage of ancient Rome, whose remains he had carefully studied. The huge dome of the Pantheon and the gigantic vaults, piers, and pilasters of Rome's ruined imperial basilicas and baths were both an inspiration and a challenge to the first architect of the High Renaissance. He was determined to surpass his models.

The plan Bramante designed was stupendous in size and grand in conception. Although altered during the century-long construction

of the church, every subsequent architect remained bound to some extent by the scale and shape of Bramante's plan: an equal-armed cross formed of huge barrel vaults, inscribed in a square, and crowned with an immense dome. Such a plan fit in the tradition of the *martyrium,* a typical shape of martyrs' tombs, going back almost to the beginnings of Christianity. Here, however, raised to a higher power, so to speak, it was on a scale undreamed of since the days of the Roman Empire.

The announcement of Julius's plan to tear down Old St. Peter's met with shock and disapproval throughout Rome. Many people believed that disturbing the bones of saints would bring the wrath of God down upon the city. Others felt that the pope was destroying the most powerful evidence of the Church's uninterrupted connection with its apostolic foundations. Julius and Bramante ignored them all and work went forward with a vengeance. The marble columns holding up the nave of Old St. Peter's were pulled down with such violence that many shattered on the pavement. Bramante's workmen demolished decaying walls and discarded anything for which the architect saw no further use, including mosaics, statues, tombs, and altars. Meanwhile, although large portions of the old church were still standing, other work crews began the new church. Load after load of marble and travertine, much of it plundered from the Colosseum, as well as the volcanic ash, sand, and lime needed to make concrete, arrived on the site and construction started on the four gigantic piers that would support the massive dome.

All of this work cost immense amounts of money, and critics claimed it would bankrupt the papacy. But Julius justified his church as a new version of King Solomon's temple, reconstructed in honor of the Christian God, and insisted that paying for it was a religious act. He financed the work with new taxes, loans from papal banker Chigi, money raised from the sale of indulgences, and riches derived from the recent discovery of America. Lest he be accused of excessive concern with personal glory, Julius had papal medals struck bearing the words *Non nobis, Domine, sed tuam gloriam* (Not for us, Lord, but for thy glory).

Neither Bramante nor Julius lived to see St. Peter's anywhere near completed. They died within a year of one another, the pope in 1513 and the architect in 1514. But what they had accomplished in eight years was impressive. The four dome piers were complete to the level of the pendentives (the concave masonry supports that fill the corners of a square area and rise to meet the circular base of a dome); the western walls of the choir had been raised to the point where the vaults begin; and a pair of nave piers east of the crossing of the north-south and east-west aisles were in place.

Julius's successor, Leo X, witnessed one last burst of energy from

the elderly Bramante, who enlarged the plan still further in the year before his death. Leo then appointed the painter Raphael to the post of chief architect, despite the latter's modest experience in that field; his selection was supposed to have been Bramante's dying wish. Working with two experienced assistants, Fra Giocondo and Giuliano da Sangallo, Raphael produced a plan that changed the shape of St. Peter's from an equal-armed, or Greek, cross to the crucifix-shaped Latin cross. Next came a series of deaths in close succession: those of Julius and Bramante in 1513 and 1514 were followed by the deaths of Fra Giocondo in 1515, Sangallo in 1516, Raphael in 1520, and Leo X in 1521. Many in Rome saw them as divine punishment for the destruction of Old St. Peter's.

At this point construction languished. Antonio da Sangallo, another member of that architectural family, had marked Raphael's death in 1520 by sending Leo X a memorandum critical of Raphael's plan for St. Peter's. As he had hoped, the next pope, Clement VII, appointed him chief architect of the project but the building campaign of 1524–1527 ended abruptly with the Sack of Rome. In the next ten years nothing more was accomplished. In 1537 Paul III ordered Sangallo to produce another design for the church, incorporating everything already built. The architect obliged and before his death completed the vaulting of the nave and the left arm.

The responsibility for St. Peter's then passed to Michelangelo. Although he claimed to have accepted the commission unwillingly, he probably had long harbored the desire to put his own stamp on the church. Before accepting the commission, he stipulated that he be allowed to reduce the gargantuan size of the building he had inherited from his predecessors. He dismissed Sangallo's plan with a scalding critique; he declared the church would be dangerously dark inside, a perfect place for all kinds of crimes, ranging from thievery and muggings to counterfeiting money and impregnating nuns. Michelangelo instead returned to Bramante's plan, which he simplified and made one-third smaller. He also greatly thickened and strengthened the central piers and supporting walls and replaced Bramante's shallow, Pantheon-style dome with a taller one.

More of Michelangelo's work can be seen on the exterior than on the interior of St. Peter's. His designs for the interior show only in the drum of the great central dome and the vaulting of the choir and transepts. The exterior walls, however, remain much as he had built them. Because he realized that small decorative elements would look trivial against such gigantic expanses of wall, he designed a system of colossal pilasters that extends around the church. Invested with enormous power and energy, they stand in pairs at various angles around the exterior, on the north, south,

and west, reflecting the shapes of the interior spaces. Although this aspect of St. Peter's is difficult to see, since most of the exterior is inaccessible to visitors, the Vatican bus route departing from the front of St. Peter's and going to the Vatican Museums provides a marvelous view of the south side of the basilica, where Michelangelo's colossal structure rises toward heaven, one of the greatest of Rome's many architectural marvels. (The Vatican bus service was suspended in 1997, but there are plans for its return.)

The dome of St. Peter's is among Michelangelo's finest achievements. He rejected Bramante's plan for a shallow, hemispherical dome like that of the Pantheon, and planned a taller one closer to, and slightly larger than, that of Florence Cathedral. He even wrote home to his nephew in 1547, asking for the measurements of the *cupolone,* Brunelleschi's great dome that was the pride of Florence. Although Michelangelo lived to see the drum of his dome constructed, the dome itself was built by his successor, Giacomo della Porta, who modified the design considerably, making the dome even taller. Despite della Porta's significant role, it remains in spirit Michelangelo's dome, one of the most powerful and impressive ever built. It has had innumerable progeny, both religious and secular. In buildings all over the Western world, including Washington, D.C., governments and churches carry on their functions under versions of the dome of St. Peter's.

The final chapter in the construction of St. Peter's took place in the early 1600s. Conservatives had been fretting for decades over the central plan of the church; the equal-armed cross shape seemed less proper to them than the more traditional crucifix shape. In 1606 Paul V eliminated the centrality of Bramante's and Michelangelo's church by ordering the extension of the nave, returning the church to the crucifix shape suggested by Raphael almost a century earlier. The architect, Carlo Maderno, must have realized that the extension, which doubled the length of the nave, would impede the front view of the great dome, the central focus of the building, but Paul was determined to see the church completed during his papacy and work went on. The last remains of the old basilica were demolished, the nave lengthened, and a facade, also designed by Maderno, completed by 1612.

As the visitor approaches St. Peter's today, the dome seems to sink, slowly disappearing behind Maderno's extended nave. The pope was delighted, however, as the broad facade gave him an opportunity to memorialize his own contribution to the church. Above the colossal pilasters that define the first two stories of the facade runs a Latin inscription that never mentions the name of St. Peter but highlights the name of the pope. It begins on the left with a dedication of the church *ad principem apostolorum* (to the prince of the apostles). Then, as the inscription reaches the central

entrance, emphasized by a temple front that protrudes from the facade, the words *Paulus V Burghesius Romanus* (Paul V Borghese, Roman citizen) appear, followed on the right side by the date of the completion of the facade and the year of Paul's papacy in which this took place. Although it may seem odd that the facade would contain the name of the pope who completed it, rather than that of the saint to whom the church is dedicated, often church facades in Rome feature the name of the patron—an instance of human ambition taking precedence over holiness.

Below Paul V's inscription and above the doorways that pierce the facade are nine large windows, each provided with a balcony. From the central one, directly below the pediment of the temple front that forms the center of the facade, the pope customarily gives his blessing *urbi et orbi* (to the city and to the world). Here, too, at the time of a papal election, the cardinal-deacon appears to announce and identify the newly elected pope.

The lengthening of the nave had an impact also on the appearance of the interior. The length of the basilica from the front entrance portico to the choir at the west end is now close to eight hundred feet, a distance so great that visitors sometimes feel they may never reach the far end. I once overheard a young American sailor who had just entered St. Peter's, presumably for the first time, exclaim: "You could lose an aircraft carrier in this place!" And yet, despite its colossal scale, the interior of St. Peter's has never struck me as oppressive or intimidating but, rather, awe-inspiring and uplifting. It is spacious rather than gargantuan. Nothing presses down on the visitor; everything soars, carrying the eye upward. The interior Michelangelo created is filled with ample illumination from windows on all sides, as well as from a ring of windows around the base of the dome.

In subsequent centuries Maderno, Bernini, and others transformed Michelangelo's grayish white marble interior by covering the walls with colored marble panels and innumerable other decorations, including relief sculpures, gilding, and dozens of statues. But because the building has such a great scale, it seems populated rather than cluttered by all this decoration. The many vigorously gesturing statues of saints, some close to ground level, and other statues of angels seemingly in flight or perched among Michelangelo's immense architectural elements help to humanize the vast spaces of the basilica. The colors of the marble paneling of the walls and floors are wonderfully rich and harmonious. The color scheme recalls that of the interior of the Pantheon; rich, dusky apricot orange, deep yellow, dark red, gray, and charcoal black add imperial dignity and splendor to a building that is, as the Pantheon was for the Romans, the spiritual center of an international empire.

When inside St. Peter's, particularly when a Mass is being

St. Peter's, interior with Baldacchino. Something of the great size of St. Peter's is conveyed here, although the area visible is only a small portion of the vast church.

celebrated, it is tempting to wonder what Peter himself would make of it all: the elaborate formalities of the Mass, what a priest-friend of mine calls the "costumes and equipment" of the clergy, the clouds of incense, the troops of acolytes, the singing of the choir, all taking place above the presumed grave of a Jewish fisherman. And yet, when listening to the Sanctus of the Mass, taken

word for word from the prophet Isaiah, it is possible to believe that Peter might recognize at least some of what is happening. While looking around a building whose scale and architectural vocabulary would have seemed quite familiar to a Roman emperor, we can marvel yet again at the special genius of the Church of Rome, an institution that could envelop, absorb, and nourish itself on elements as dissimilar as Jewish scriptures and Roman imperial architecture.

Work on the basilica continued into the mid-1620s. Paul V did not get his wish to preside over its completion; that honor fell to Urban VIII, who consecrated the church on November 18, 1626, about 105 years after Julius II had begun it and exactly 1,300 years after the consecration of the original church. It had taken the efforts of fourteen architects, untold thousands of anonymous craftsmen and common laborers, and the patronage of twenty popes to complete the structure. Decoration of the interior and the construction of the piazza in front were to take many more decades, and additions continue right up to the present.

Michelangelo's beautiful white marble *Pietà,* created for Old St. Peter's in the late 1490s and the only sculpture that he signed, now sits, remote as the moon, behind bullet-proof glass in the first chapel to the right of the entrance. But not even that barrier can cancel out the work's almost magical power to draw the viewer's attention. The most exquisite woman Michelangelo ever created, the Virgin holds the limp body of her son—also a figure of breathtaking perfection—on her lap and presents him to us with a gesture of her left hand. The work is really a sculptured altarpiece, inviting the viewer or worshiper to contemplate the mystery of Christ's sacrifice. But whatever one's religious beliefs, the sheer sensuous beauty of the piece is irresistible.

The two major altars, designed by Bernini in the mid-1600s, help to define the space of the interior. The gilded bronze Baldacchino—a gigantic canopy atop four spiral-shaped columns at the crossing of the east-west and north-south aisles—covers the assumed site of St. Peter's grave and soars up toward the vast space of Michelangelo's dome. At the far end of the church, where a central window admits a dramatic burst of light, stands the other, the Cathedra Petri, or Chair of Peter, an altar that celebrates St. Peter by elevating an immense bronze chair, the symbol of Peter's divine authority. So large and dramatic that its swirling forms beckon the visitor even from the church entrance, not much short of a quarter-mile away, the Chair of Peter provides a focal point and a goal for those who stand dazzled at the church doorway.

There are innumerable other treasures—including altars, altarpieces, statues, mosaics, doors, plaques, and tombs—that have been placed inside the church over the centuries. To view them all

carefully would take many visits. There are five entrances, for example, inside the portico of the basilica. The central bronze doors—rescued from Old St. Peter's—are the work of Antonio Filarete and date from the 1440s. All four subsidiary doors flanking Filarete's have been added since 1950; the last one, on the extreme left, by the Italian sculptor Luciano Minguzzi, was installed in 1977—this, on a building whose origins go back to the first decades of Christianity. As the Church itself moves on, incorporating the reforms of the Second Vatican Council and changing by infinitesimal increments but changing nonetheless, St. Peter's changes also, taking in the new while retaining its ancient treasures and traditions.

Given the length of time needed to build the church and the number of architects, artists, and patrons involved, the extraordinary reality of St. Peter's is that instead of becoming an incoherent hodgepodge the church remains, again like the Roman Church itself, a cohesive whole. Informed more by the genius and breadth of vision of the Italian High Renaissance than by the impact of any one individual artist or patron, the great basilica has preserved its unity. Although its vastness can sometimes seem overwhelming, few remain unmoved by it. More than any other single building, St. Peter's embodies the Roman Catholic Church.

Suggested reading

James Ackerman, *The Architecture of Michelangelo* (Baltimore, 1971).
George Hersey, *High Renaissance Art in St. Peter's and the Vatican* (Chicago, 1993).

ROMA
AMOR
XXIII

THE SISTINE CHAPEL

The arrangement of the Vatican Museums assures that the Sistine Chapel is the climax of the visitor's pilgrimage through the vast papal art collections, the last stop on that extraordinary journey. Although for most visitors, seeing the Sistine Chapel means viewing the frescoes by Michelangelo, which have given the chapel its worldwide fame, the chapel was not created as a setting for Michelangelo's work. Sixtus IV (1471–1484) built it in the mid-1470s, around the time of Michelangelo's birth, hence the term *Sistine,* from *Sisto,* the Italian version of the pope's name.

Intended for use as the pope's private chapel, it has served over the centuries as a setting for various papal ceremonies. Since the early 1500s it has housed the conclaves of cardinals that select the popes. Appropriately enough, given his later role in the decoration of the chapel, Julius II was elected here, when the ceiling was merely an expanse of plain blue punctuated with gold stars. It is still the site of papal elections. Under the same lofty vault, now filled with Michelangelo's frescoes, the present college of cardinals voted John Paul II into office.

The architect, probably Baccio Pontelli or Giovannino de' Dolci, designed the rectangular chapel to have frescoes on its walls and ceiling. In the early 1480s Sixtus IV commissioned a group of prominent artists, among them Botticelli, Signorelli, Ghirlandaio, and Perugino, to create frescoes illustrating scenes from the life of Moses on the left wall of the chapel (as one faces the altar) and corresponding scenes from the life of Christ on the right. The subjects were carefully chosen to underline parallels between Moses' leadership of the

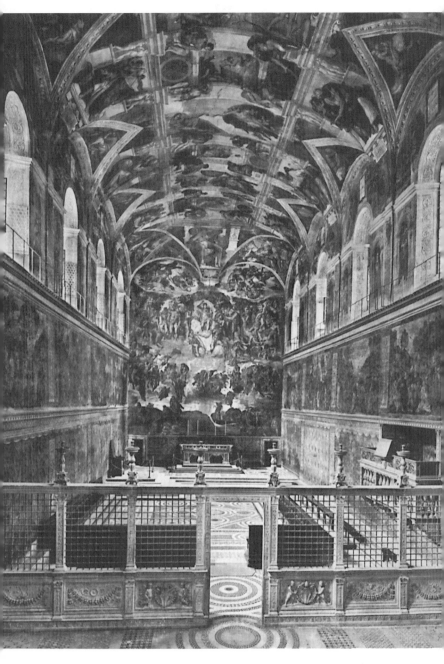

Sistine Chapel, Vatican. The Sistine Chapel is best known for its frescoed ceiling and the *Last Judgment* on the altar wall, both by Michelangelo, although executed at different moments in his career.

ancient Hebrews and Christ's role as spiritual head of the Church. The subtext is that both Old and New Testaments prefigure and justify the papacy's claim to universal authority.

Although these paintings, cleaned in the 1960s and 1970s, are excellent examples of Early Renaissance art, Michelangelo's subsequent contributions tend to overshadow them. The figures in these fifteenth-century frescoes seem almost quaint, and totally earthbound, in comparison to Michelangelo's High Renaissance race of superhuman, airborne beings who populate the ceiling and the immense, intimidating forms of the damned and the saved who loom over us in his *Last Judgment*.

The paintings on the ceiling, executed between 1508 and 1512 for Julius II, are among the masterpieces of Western art and are considered by many to be Michelangelo's greatest works. Covering 2,400 square feet, they constitute one of the largest frescoes ever painted. The cleaning of the ceiling, completed in 1989, revealed a ravishing palette of yellows, oranges, pinks, pale blues, lavenders, and greens, and proved that Michelangelo was as much a master of color as of stone carving.

The program of the ceiling, more ambitious and complicated than that of the side walls, is nonetheless understandable in terms of basic Christian theology. Although some scholars have offered complex and arcane explanations for the program of images, the message is simple and powerful: human sinfulness and insufficiency require a savior and that savior is Jesus Christ.

Nine scenes from Genesis progress down the center of the ceiling: at the altar end of the chapel are three scenes of God creating the world; the middle segments relate the Creation, Temptation, and Expulsion from Eden of Adam and Eve; and the three scenes closest to the entrance relate to the Second Fall of the human race at the time of Noah. Although Michelangelo began painting the ceiling at the chapel entrance with the scenes from the story of Noah (perhaps he wanted the practice of painting human figures before taking on the challenge of portraying God), it makes more sense to read the scenes chronologically, beginning at the altar end and moving toward the entrance. Seen in this way, an epic religious drama unfolds—the vast pattern of human sinfulness and ultimate salvation that forms the very essence of Christian theology.

In the first scene, directly over the altar, a shadowy God seen sharply from below and with his face nearly invisible hovers in a formless void as he begins the creation of the heavens and the earth. God seems in the process of creating himself as well, for in the second scene he is much more distinct. In this Creation episode God appears twice, once on the left with his back turned and once on the right, now a fiercely impassioned, awe-inspiring deity who surges through the universe, flinging stars and planets

from his fingertips. This may be the first time any artist has created a fully convincing image of divine omnipotence. In the third scene God appears as a serene, benevolent creator who stretches out his arms to separate the waters and appears almost to bless them.

The next three scenes, at the center of the ceiling, relate the story of Adam and Eve, the crucial turning point in the history of human sin and salvation. In the best known of Michelangelo's frescoes in the chapel a powerful but gentle God creates—or more precisely, *animates*—an innocent, beautiful Adam, who lies listlessly on the newly made earth, awaiting the spark of life that will pass to him from the dynamic hand of God reaching out to touch him. The Creation of Eve follows; she steps unsteadily from the sleeping Adam's side, beckoned forth by still another manifestation of the deity, a stern old patriarch. The last scene in this group is a dramatic and tragic illustration of cause and effect. On the left are Adam and Eve, their poses interlocked in an implicitly sexual intimacy, both reaching up for the forbidden fruit, handed to them by a snake whose lower body coils around the Tree of Knowledge and whose upper body metamorphoses into a woman. On the right side we see the results of their sin: an angel with a sword prods Adam in the neck as he and Eve stumble out of paradise. Banished from the garden, they are no longer the young and sensuously beautiful immortals who first disobeyed God's commandment; they have become fully human. Burdened with sin, remorse, and mortality, their faces lined and haggard, they enter the harsh world all humanity still inhabits, where they will now age and die.

The last three episodes concern the story of Noah, in which the sinfulness brought into the world by Adam and Eve reached such a pitch that God resolved to destroy his own creation. The scene of the Flood, probably the first Michelangelo painted on the ceiling, swarms with naked human figures making futile efforts to escape the universal deluge. The Sacrifice of Noah shows the leader of surviving humanity making an offering of thanks to God after the floodwaters have subsided. The last episode, the Drunkenness of Noah, suggests another Fall of the human race, where even the one just man whom God saved has gotten dead drunk and lies naked, shamefully exposed before his three sons. God's pure and perfect creation has come to this: a polluted and degraded world where even the best are in dire need of salvation.

Nobody has yet provided a completely convincing explanation for the inclusion of twenty-four beautiful, nude young men who disport themselves in various suggestive postures flanking the nine Genesis scenes. Interpretations have ranged from seeing them as evidence of Michelangelo's homosexual predilections to identifying them as human souls, angels, or altar boys (nude, adult altar boys?), or considering them visual leftovers from the canceled

project for the tomb of Julius II. Michelangelo himself (who cannot always be trusted in such matters—he was often sarcastic and delighted in baffling people) claimed these nudes were servants engaged in the act of displaying oak-leaf garlands and clusters, the emblem of Julius II's family, the della Rovere. (The word *rovere* in Italian means "oak.") Whatever their purpose, the nudes caused no controversy during the heady days of the High Renaissance, when the heroic nudity of the classical statuary in the papal art collections was equally acceptable on the ceiling of the pope's chapel.

Along the sides of the ceiling seated figures of Hebrew prophets, all immense and imposing males, alternate with muscular pagan prophetesses known as sibyls, who also predicted the coming of Christ. In the triangular areas (called spandrels) that help support the ceiling and in the lunettes over the windows are the human ancestors of Christ listed at the beginning of the Gospel of Matthew. In the large corner spandrels, which curve inward like sails in a wind, are the Hebrew heroes and heroines (Moses, David, Esther, and Judith) who saved their own people and who in Christian interpretation prefigure Christ. Although Christ does not appear anywhere on the ceiling (there are no specifically Christian figures in the program) his presence is everywhere implied by those who preceded, prefigured, and predicted him. The divine plan of redemption, although never made explicit, is implicit throughout the ceiling.

Michelangelo's painting of the Last Judgment, executed on the altar wall between 1536 and 1541 for Paul III, radically changed the atmosphere and perhaps even the theological meaning of the Sistine Chapel. The serene optimism of the paintings on the walls and the sublime ideality of those on the ceiling are dominated by the thunderous and threatening chords that emanate from behind the altar. The *Last Judgment* leaps out at us in all its fury, every inch of it announcing that the High Renaissance holiday is over and the day of reckoning is indeed at hand. The predominant color is the cold, brilliant blue of lapis lazuli, an extremely expensive pigment that Michelangelo could not afford when he was painting the ceiling. Julius II had paid Michelangelo a flat fee for his work on the ceiling. Paul III personally assumed responsibility for whatever expenses the artist incurred, however, so Michelangelo bought the best pigments available.

Like the ceiling the *Last Judgment* has been cleaned, and from under layers of grime has emerged a fresco flooded with the light of earth's last day. Some imagery in the painting is biblical; other motifs probably derive from the *Dies Irae* (Day of Wrath), a hairraising medieval poem about the end of the world which forms part of the text of the Requiem, the traditional Mass for the Dead rarely used in Catholic funerals today. Unlike the description in

the *Dies Irae,* however, Michelangelo's world does not dissolve in fire and ashes. In his imagination, as in Emily Dickinson's three centuries later, that final day dawned "excellent and fair." The blue sky is lighter near the horizon and lit at the lower right by the orange flames of hell. The only clouds in this perfect sky are those occupied by the saints and angels who cluster around Christ in the upper part of the fresco. The earth from which the dead arise is a bare grayish green. Michelangelo never had much interest in landscape, and in any case the biblical description of the Last Judgment states that "Heaven and Earth shall pass away." On our right (Christ's left, the bad side) the damned plunge into hell, while on our left the blessed struggle, in St. Paul's words, to "put on immortality." To judge by their heaving and writhing, even the route to heaven is filled with difficulties and terrors.

The first part of the *Last Judgment* that the pope or anyone else entering the chapel from its front entrance would see, on looking straight ahead, is the hell mouth that Michelangelo placed directly over the papal altar. In it crouch a group of devils and next to them a human soul falls headlong into a flaming pit. This would serve as a reminder to the pope that his soul is in the same danger as that of any other mortal. Above a group of angels—blowing trumpets and displaying the books in which all the sins of the world are written (both images from the *Dies Irae*)—looms the huge figure of Christ the Judge, silhouetted against a halo of blazing yellow and blue light.

Once the pope has passed through the doorway in the choir screen that bisects the chapel, the *Last Judgment* is revealed in full. The figure of Christ the Judge is, however, directly below the even larger figure of Jonah, one of the prophets from the ceiling project. This juxtaposition creates an unsettling dissonance, both in terms of scale and meaning. The towering Christ suddenly seems small in comparison with the prophet above. Furthermore, Jonah is the prophet of the Resurrection, not of the Last Judgment. With this in mind we can understand how Clement VII's original plan of 1533 for the altar wall of the chapel, a fresco by Michelangelo of the Resurrection of Christ, might have fit in better than does the *Last Judgment* with the essentially optimistic theological program of the walls and ceiling.

And yet, the painting serves its purpose, adding an unforgettable image of humanity's end to the earlier imagery of the world's beginnings and the working out of the divine plan throughout history. The *Last Judgment* is not only about judgment and punishment but also about justice and redemption. In the words of the offertory for the vigil of the Feast of All Saints, which was the dedication day for Michelangelo's fresco: "The souls of the just are in the hand of God and the torment of evil shall not touch them."

MICHELANGELO'S *LAST JUDGMENT*
The Recent Restoration

How did the nude figures in Michelangelo's *Last Judgment* become draped with the peculiar assortment of painted underwear an American journalist described as "artifices ranging from fig leaves to girdles to something like jock straps to what look like belly bags gone south?" His flippant tone aside, the reporter has asked an interesting question. The draperies indeed seem obtrusive, and how they got there is a question that often occurs to those who view Michelangelo's fresco, especially now that cleaning has made these pieces of drapery so obvious.

The answer involves a look at the history of the fresco and at various overpaintings that have occured through the centuries, as well as the controversy attending the most recent restoration concerning whether to remove these overpaintings. This controversy is only the latest chapter in a long series that have simmered for centuries concerning the "decency" of these particular nudes and their appropriateness for the altar wall of the popes' private chapel.

The surface that Michelangelo's painting covers was originally intended for the Resurrection of Christ, a project abandoned after the death of Clement VII in 1534. When Paul III took it up again in 1536 he had no intention of continuing the commission of his despised predecessor. He had the Last Judgment in mind, a subject he deemed more appropriate to the devastated Rome he had inherited from Clement. (Most of the damage the city had sustained in 1527 had not yet been repaired.) Although Michelangelo

protested that he was too old to be climbing onto scaffolds again, the determined pope insisted, declaring that he had been waiting thirty years to commission a great work from Michelangelo and that he would not be denied the opportunity to fulfill the ambition of a lifetime.

Before Michelangelo could begin, extensive preparations had to be completed. Windows in the back wall were closed up and some paintings from the fifteenth century removed. Michelangelo even had to destroy some of his own handiwork from the frescoes he had painted in the early 1500s: two lunettes with images of the ancestors of Christ above the now closed-off windows. The wall was then rebuilt, with the upper part projecting slightly outward beyond the lower portion, to prevent dust from settling on the surface.

When the huge fresco was unveiled, many of those who saw it, including Paul III, admired it greatly. From the beginning, however, there had been grumblings of protest. Before the work was completed, several cardinals and other members of the papal court had objected to the presence of so many nude figures, even though nudity is a theologically correct condition for souls brought before their Maker on the Day of Judgment. These protests are an interesting commentary on how radically the atmosphere of Rome had changed since the High Renaissance era, more than thirty years earlier, when Michelangelo had populated the Sistine Chapel ceiling with nude figures, some of them beautiful young men whose presence is only marginally related to the ceiling's themes. Nobody had objected then.

But now, Michelangelo and his papal patron found themselves in the middle of a nasty dispute that pitted the worldly and tolerant pope and his devout but short-tempered artist against a cabal of cardinals and other Vatican functionaries. One cardinal even declared Michelangelo's painting better suited to a brothel than to a pope's chapel. Michelangelo is reported to have responded that this particular cardinal no doubt was in a position to know what sort of paintings appeared in brothels. For his part Paul III adamantly resisted all pressures to have Michelangelo's nudes covered up.

Pietro Aretino, a prominent literary figure but also a notorious libertine and slanderer, in a cleverly publicized letter to Michelangelo insinuated that the nudity of the figures in the still unfinished *Last Judgment* was somehow related to the artist's passion for attractive boys. These intimations of personal immorality continued to plague the artist, who seems to have responded to Aretino's attack by means of an ingenious image in the fresco. St. Bartholomew, who was martyred by being skinned alive, sits just below and to the right of Christ, brandishing a knife in his right hand and holding his own flayed skin in his left. The face of the long-bearded, balding saint resembles Aretino's, but the face on

the limp, flayed skin is Michelangelo's sardonic self-portrait.

What was so shocking about Michelangelo's conception of the Last Judgment? Some may find it difficult to imagine what the controversy was about, although it helps to consider the loud objections to alleged indecency in contemporary art still being raised by conservative religious and political groups. In comparison to the High Renaissance period, the Counter Reformation in Rome was an era of exceptional prudery, particuarly where works of religious art were concerned. Furthermore, Michelangelo had departed from tradition in several ways in his *Last Judgment.*

Most earlier versions of the theme show a few nudes, but the majority of the figures—including the saints in heaven and the rising dead—are clothed. In Michelangelo's painting, however, the only fully clothed figure is the Virgin Mary, who does not enact her traditional role of interceding with her Son on behalf of sinners. Instead she turns away sadly from the spectacle of his wrath. Christ, at the upper center of the composition, is a burly figure with the musculature of an ancient wrestler. He is neither fully clothed nor entirely naked; a cloak falls across his left shoulder and covers his lap. The other figures in the fresco—the male and female saints who crowd and glower around Jesus in the upper portion of

Michelangelo, *Last Judgment,* detail, Sistine Chapel, Vatican. The focal point of Michelangelo's stupendous painting is the huge figure of Christ the Judge.

the composition, the angels who blow their trumpets or lift the blessed into heaven, and the multitudes of damned and saved— originally were almost all nude.

In another departure from tradition Michelangelo's painting shows very little hellfire, only a few flickers of flame in the lower right-hand corner. Just to the right of the altar we see the infernal boatman, Charon, a figure from Greek mythology, who ferries souls from the land of the living to the land of the dead. Here too, the inclusion of this one pagan character raised a storm of protest even though, directly above, the ceiling swarms with pagan figures.

There was even a complaint about the way Michelangelo had painted Satan. In the lowest portion of the painting, in the far right corner, we see a large, flabby man with donkey ears and a savagely caricatured face. A huge snake coils around him. It is believed that Michelangelo based the figure and face on a particularly obnoxious and obtrusive papal chamberlain named Biagio da Cesena, who had persisted in his criticisms of the nudity of Michelangelo's figures. Although a piece of drapery was eventually painted over the groin area of this figure, early copies of the fresco show the marvelously fitting revenge Michelangelo took on his tormentor: the snake is biting off the man's genitals. In 1541, just after the fresco was completed, the furious chamberlain confronted Paul III and demanded that he order Michelangelo to remove his likeness from the fresco. Paul responded (and we can imagine him suppressing a smile) that if the artist had placed Biagio in Purgatory, he might have been able to help, but that even a pope cannot rescue people from hell.

Popes do, however, have the power to destroy as well as to commission works of art, and we have reason to be grateful that the *Last Judgment* survives at all. It narrowly escaped destruction by the fanatical Paul IV (1555–1559), while Michelangelo was still alive. This fire-and-brimstone pope gave serious thought to demolishing the altar wall, where the *Last Judgment* is located, on the pretext of enlarging the Sistine Chapel. Although he was somehow deflected from his demolition project, the pope requested Michelangelo to *acconciare l'affresco*. The Italian phrase can mean either to "fix up" or to "dress up" the fresco, and the pope's unfortunate choice of words provoked a sarcastic retort from the artist: "Tell the pope that this is a small thing and that it can easily be fixed up; let *him* fix up the world, since paintings are so quickly fixed up." Michelangelo refused to alter his painting and Paul IV backed down; we hear nothing more from him on the subject. It was not until after Michelangelo's death that anyone had the nerve to tamper with the fresco.

When Paul III had convened the Council of Trent in 1545, as part of the Catholic Church's program of internal reform, he could not have imagined that this same council, still in session in

1564, would order the covering of the *pudende* (shameful parts) of the nudes in Michelangelo's *Last Judgment,* the work Paul had struggled so hard to protect. But that is what happened. Michelangelo, nearly ninety years old, died a few weeks after the promulgation of the decree, mercifully unaware of the decision. (While they were at it, the council members also ordered plaster fig leaves placed over the genitals of the male statues in the Vatican collection of antiquities. The fig leaves are still there.)

Now that the great artist was gone, the would-be purifiers of the *Last Judgment* finally had a free hand, and a series of interventions began that continued intermittently for the next two centuries. In 1565 Pius IV hired Daniele da Volterra, who had been a pupil and friend of Michelangelo, to provide the nudes in the *Last Judgment* with concealing draperies, an unenviable task that earned Daniele the nickname *Il Braghettone* (the britches maker). Precisely how many figures Daniele clothed and how many other artists eventually participated in the "cover-up" remains unknown, but it is clear from the variety of pigments used and the varying levels of skill displayed that different artists at widely separated intervals worked on clothing the nudes.

Adding to the problems faced by the present-day restorers are various attempts made in the past to clean the fresco. An eighteenth- or early nineteenth-century cleaning with a corrosive agent damaged the surface, particularly the sky. Others, attempting to brighten the colors in the painting, employed animal glues and vegetable oils, both of which provide ideal conditions for the growth of micro-organisms, especially fungus, that further damaged the fresco. With all these insults to the fresco's surface it comes as a surprise to learn that, beneath a murky, 450-year accumulation of lamp and candle black, soot, glue, and oil, Michelangelo's masterpiece proved to be in relatively good condition.

The slow, gentle cleaning of the *Last Judgment* took four years. The restoration team spent the first year, 1990, in a painstaking study of the condition of the fresco. After that, the restorers worked on one small area at a time, first sponging the surface with distilled water alone, then with a solution of distilled water and ammonium carbonate. After a day's wait, the same area would again be sponged with ammonium carbonate, this time applied through four layers of highly absorbent Japanese paper, which kept the solution in contact with the fresco surface. After twelve minutes, the paper was removed and the loosened dirt wiped away with a sterile sponge soaked in the same ammonium carbonate solution. As a last step the area again was rinsed several times with distilled water. Repeating this process over nearly six hundred square feet of fresco took another three years.

The cleaning and restoring of the fresco, completed in the

spring of 1994, revealed a palette of dramatic colors, dominated by the brilliant blue sky that forms the backdrop for the masses of rising and falling figures. With the surfaces of both the figures and the background now free of the layers of dirt that had obscured them for so long, the added draperies stood out even more clearly against the flesh tones of the figures. A vexing issue now faced the restorers: which of the thirty-eight different pieces of modesty drapery added over the centuries should be removed? Although our first response might be to take them all off, the issue is not so simple.

At the urging of the Vatican the restorers of the *Last Judgment* preserved the draperies that they ascertained had been painted by Daniele da Volterra in fulfillment of the Council of Trent's decree. As with the plaster fig leaves on the statues in the Vatican Museums, the explanation is that the decrees of the Council of Trent are a part of Church history and the restorers have no authority to contravene them.

It was not difficult for the restorers to determine which draperies were painted over Michelangelo's pigments and which over newly laid plaster. In the instances where Michelangelo's original work was gone, the draperies have stayed in place, cleaned to blend in better with the restored surface. Where the draperies dated from the seventeenth and eighteenth centuries, and Michelangelo's painting still existed underneath, some (although not all) of these later additions were removed.

Here and there a bit of nudity has emerged. On the lower left side a male soul soars toward the waiting arms of angels, his back toward us and his buttocks fully exposed. But just above him another male remains swathed in gray britches. St. Catherine, at upper right, is still wearing a bright green garment that looks like a pinafore. The explanation for her continuing to be clothed is simple and sad: all of Michelangelo's original pigment and even the plaster on which he painted her body have been removed. Although this kind of radical defacement of Michelangelo's work did not occur elsewhere in the fresco, the decision of the restorers was to leave most of the clothing and loincloths in place.

And what was the restorers' verdict concerning the draperies over the groin of Satan? Perhaps because this figure represents the Prince of Darkness and not a human soul or a saint, the decision was to remove the overpainting and restore the snake to his rightful role. The snake is definitely back, and what he is biting off is anatomically unmistakable.

Suggested reading

Carlo Pietrangeli, ed., *The Sistine Chapel: A Glorious Restoration* (New York, 1994).

The Rome of St. Ignatius Loyola

The name of Ignatius Loyola is so closely associated with Rome that some people might assume this sixteenth-century saint was born and raised there. Although it is true that Ignatius spent his later years in Rome, that the Jesuit order he founded was confirmed in Rome, and that two of the city's finest churches, Il Gesù and S. Ignazio, are associated with him, the saint himself was a Spaniard. No matter what his origins, his impact on Rome was profound, for the growth of the Society of Jesus permanently changed the face of the Eternal City.

The youngest of thirteen children, Iñigo Lopez de Loyola was born in 1491 to a noble and warlike family in the Basque region of northeastern Spain. The example set by his father and older brothers was hardly of the kind to inspire sainthood; proud and aggressive, they were only too ready to draw their swords, and most of them, including his father and a brother who was a priest, sired numerous illegitimate children. As a young man Iñigo seemed destined to follow the same path. Handsome, vain, and arrogant, a gambler, drinker, and swordsman, an enthusiastic lover of women, he was the perfect embodiment of Spanish *machismo.*

Yet a series of conversion experiences, beginning in 1521 with a severe battle wound that shattered his right leg, transformed this worldly courtier, made him recoil in profound disgust from the life he had been leading, and filled him with a powerful desire to serve God. Pilgrimages, fasting, and severe asceticism took up the next years of his life, along with the visions and mystical experiences from which grew his famous *Spiritual Exercises,* one of the

most influential books of the Western religious tradition. Because he realized that he could not accomplish his religious goals without ordination, Iñigo returned to school at age thirty-three to study languages and theology and spent nearly a decade at various universities, first in Spain and then in Paris. On several occasions his religious ardor aroused the suspicions of the Inquisition and he was briefly imprisoned. In Paris the group of six companions that formed around Iñigo (now called Ignatius) later became the nucleus of the Jesuit order.

After being ordained a priest in Venice in 1537, Ignatius made his way to Rome. At a roadside shrine at La Storta, a few miles outside the city walls, he experienced one of the most powerful and influential of his mystical visions. He beheld both Christ and God and heard the voice of God say to him, "I will be propitious to you in Rome."

There was little about Rome in 1537 to inspire optimism. A decade after the Sack the city was ruinous, malarial, and depopulated. Wolves roamed the Palatine and goats munched on the weeds that covered the muddy Capitoline Hill. The Roman Forum was a cow pasture and trees were growing out of the abandoned piers of the new St. Peter's, still incongruously incomplete amid the remains of the early Christian basilica.

But the extraordinary Alessandro Farnese had become Paul III in 1534 and indeed proved "propitious" both for Rome and for the future success of Ignatius Loyola. Highly cultured and intelligent, he was also diplomatic, shrewd, determined, and (except where his own children were concerned) a fine judge of character. He lost no time in sizing up Ignatius Loyola and deciding that the energy, devotion, and reforming zeal of this Spanish priest could be put to excellent use in Rome.

Paul granted Ignatius and his companions lodgings in the city as well as a place to preach and administer the sacraments. At first Ignatius and his followers apparently had no plans to form a religious order. Only after many requests for their services from various parts of Europe did these reforming priests consider a new order as a means of preserving their unity. It is possible that the idea first arose from Paul's suggestions and only later was taken up by Loyola and his group. The "Companions of Jesus" received their charter in a papal document of 1540 and to no one's surprise elected Ignatius as their first superior general in 1541. The Jesuit order had been born and Rome would soon feel its impact.

Ignatius now made use of his early training as a soldier, for he reconnoitered the city as thoroughly as any military commander before deciding where he wanted his headquarters. He chose a site at the very heart of Rome, just to the west of the present-day Piazza Venezia. On one side of the area was the old papal palace of

S. Marco (now called Palazzo Venezia), where Paul III often resided. The offices of the city government were nearby as well, housed in the mostly ramshackle buildings of the Capitoline Hill. Farther down toward the Tiber lay the city's ancient Jewish community.

This irregularly shaped piazza, where Ignatius decided to establish his new religious order and build a church, was a kind of island in the busy flow of streets, a place where people paused to

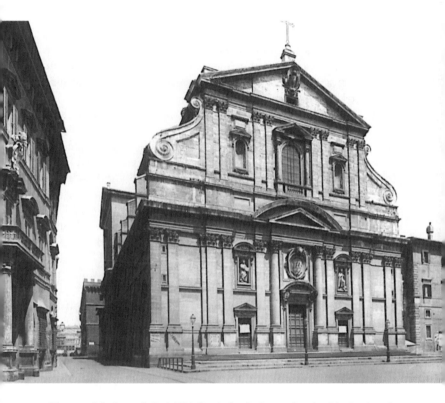

Giacomo della Porta, Il Gesù. This facade for the home church of the Jesuit order proved to be one of the most influential in Rome; hundreds of churches in the city and throughout the world are based on it.

chat, shop, have a bite to eat, and pass the time of day. It was prime urban real estate, and Ignatius did not obtain it without a long and sometimes bitter struggle. But by the time of his death in 1556 the Jesuits had secured a permanent foothold there, a place that eventually became the modern Piazza del Gesù, site of the Jesuits' principal church, Il Gesù, and until 1927 the site of the headquarters of the Jesuit order as well.

Instrumental in the success of Ignatius's efforts to obtain this property was the first Italian Jesuit, Pietro Codaccio. A former

chamberlain of the papal court, he left a lucrative and relatively easy post for a complex and demanding role as Ignatius's real estate agent. Thanks to his influence at the papal court, Codaccio was able to obtain title to the tiny church of S. Maria della Strada, at the center of the area Ignatius had chosen. This was the Jesuits' first major property acquisition. Although from the beginning the church and its decrepit outbuildings were far too small, it was the site that Ignatius wanted. On that spot, more than a decade after his death, the mother church of the Jesuit order, Il Gesù, finally rose—and next to it, in the early 1600s, the huge residence for members of the Jesuit order known as the Casa Professa.

But Rome wasn't built in a day, and neither was the Jesuit community at the city's center. Although property acquisitions proceeded smoothly as long as the urbane Codaccio was in charge, things deteriorated after his death in 1549. The Muti family, who owned neighboring property, mounted a war of nerves against the Jesuits using every means, legal and illegal, to prevent the expansion of the order's buildings. Lucrezia Muti placed screaming peacocks under the priests' windows. The family refused to grant the Jesuits permission to have windows opening toward the Muti property, so the fathers had to eat lunch by candlelight. The Muti even hired a gang of thugs to attack the Jesuits' bricklayers. Fistfights between members of the order and members of the Muti contingent became common. Although the cornerstone for a new church was laid in 1550, in the face of such hostility Ignatius gave up his attempts at expansion.

When Francis Borgia came to Rome in 1550 he found Ignatius still living in what this nobleman and future general of the Jesuit order considered squalor and the Jesuits' little church of S. Maria della Strada totally inadequate for the crowds that their sermons were drawing. Although even Borgia's considerable influence failed to make any headway against the Muti family, the nobleman was effective on another front, helping Ignatius open the Collegio Romano in 1551, where Jesuit seminarians from all nations could be trained. The site of this institution—Piazza del Collegio Romano, just a few streets to the north of Il Gesù—was to become another focus of Jesuit enterprises. Although the Collegio Romano is no longer owned by the Jesuits, its presence and severe late sixteenth-century architecture still dominate the piazza.

One of the jewels of the Roman Baroque is also a part of the Collegio Romano complex—the church of S. Ignazio, begun in 1626 to commemorate the canonization of St. Ignatius Loyola in 1622. Originally Jesuit architect Orazio Grassi had planned to crown his building with a monumental dome only slightly smaller than that of St. Peter's. Funds were running low, however, and in addition the Dominicans at the nearby monastery of S. Maria so-

pra Minerva, who resented the presence of the Jesuits, protested that any dome atop S. Ignazio would prevent sufficient light from entering their library. The solution came from another Jesuit artist, a northern Italian expert on illusionistic perspective named Andrea Pozzo, who painted an ingenious false dome instead—a flat disk over the crossing that creates an uncannily convincing illusion of the interior of a large dome.

The ceiling of the nave, painted in 1692 with scenes symbolizing the missionary work of the Jesuits throughout the world, is also the work of Pozzo. Here, in a breathtaking feat of illusion, he adds an entire story of painted architecture and makes the ceiling disappear into the infinite spaces of heaven. The small piazza in front of the church, designed in the 1700s and resembling a stage set, is among the most delightful in Rome.

To return to the story of Ignatius, the favorable atmosphere created for the Jesuits by the wise and humane Paul III and his coarse but good-hearted successor, Julius III, changed in 1555 with the election of Cardinal Gianpietro Carafa as Paul IV. The last year of Ignatius's life was to be made difficult by this foul-tempered and fanatical pope. The Holy Father's list of hatreds included women (banned from the Vatican), homosexuals (he wanted them burned at the stake), Jews (enclosed behind the ghetto walls he ordered built around their Roman neighborhood), and Spaniards, of whom Ignatius Loyola was a prime example. To make matters worse, Ignatius had offended the pope some years earlier (when he was still Cardinal Carafa) by criticizing the Theatines, the religious order Carafa had helped found and to which he belonged. As pope he had not forgotten that affront. Perhaps most important, the pope was a deeply conservative traditionalist who saw the unconventional Ignatius as a dangerous religious radical.

The pope disapproved of almost everything Ignatius was doing. He cut off financial support for the Jesuit colleges in Rome and revived the old suspicions of heresy against their leader. He also opposed two of Ignatius's prized projects: his missions to help Rome's numerous prostitutes and his efforts to convert Jews. In contrast to Ignatius's compassion for fallen women and his desire to help them lead better lives, Paul thought only of punishment. Although today Loyola's eagerness to convert Jews might be considered less positively, he was no anti-Semite, and his attitude was surely more desirable than the pope's implacable hostility.

In the summer of 1556 no one believed the forever frail but seemingly indestructible Ignatius was dying. His end came so quickly that there was no time even to find his confessor; he died on July 31 without the last sacraments of the Church he had served with such devotion. Today St. Ignatius lies buried in the church of Il Gesù, at the center of the site he had chosen for his religious order.

It was not until 1568, twelve years after Ignatius's death, that the Society of Jesus finally succeeded in buying out the families, including the Muti, who had blocked Jesuit expansion. Their major financial benefactor was Cardinal Alessandro Farnese, a namesake and grandson of Paul III. Just as Paul III had played a crucial role in the founding of the Jesuit order, his descendant would take an active role in the design and development of the Jesuits' principal church.

Because this was papal Rome, intrigues abounded. During the early 1560s one faction, led by Francis Borgia, had pressed for a conservative, practical building and a local Jesuit architect. But Cardinal Farnese, true to his princely Roman heritage, wanted a dramatic, powerful structure and a famous architect. The man he had in mind was Michelangelo, the greatest artist of the age. Although Cardinal Farnese and his money ultimately won out, Michelangelo was too old and too busy with other projects, including the rebuilding of the Capitoline Hill and the completion of St. Peter's, to take on this work, so the commission eventually went to the cardinal's next choice, the northern Italian architect Giacomo da Vignola.

As originally designed and built by Vignola, the interior of Il Gesù was extremely austere: a single, huge, barrel-vaulted space, flanked by side chapels. Cardinal Farnese kept a close eye on the progress of the church and when he was dissatisfied with Vignola's plan for the front he dismissed him in favor of a young pupil of Michelangelo named Giacomo della Porta. The design della Porta created in 1575 proved definitive; innumerable church fronts in Rome and throughout the world are based on it. Pairs of pilasters define the lower story and become actual columns at the center, to emphasize the entrance, which is also crowned with a pediment. (This same arrangement appears on the facade of St. Peter's about forty years later.) The second story continues the motif of paired pilasters topped with a pediment and at the sides are dramatically curving, S-shaped decorations called volutes. The inscription on the facade mentions neither Jesus nor Ignatius, but immortalizes the ambitious patron, Cardinal Farnese.

The sumptuous decoration inside Il Gesù is the product of the late 1600s, the exuberant age of the Italian High Baroque. Gilded bronze and stucco work, dramatically gesticulating statues, glittering veneers, and brilliant paintings overwhelm Vignola's severe structure. In the vault above the nave, a combination of stucco sculptures by Antonio Raggi and a fresco painting by Giovanni Battista Gaulli do their best to convince the viewer that the architecture has suddenly dissolved to reveal a heavenly vision, the Adoration of the Holy Name of Jesus (represented by the monogram IHS, also the emblem of the Jesuit order). Above the tomb of

St. Ignatius in the north transept is an altar-monument of such dazzling splendor that we can only wonder what this austere saint would have thought of such an altar dedicated to him. We know what at least one visitor thought of it and the rest of the decorations in the church: a seventeenth-century grand duke of Tuscany commented that the Jesuits' monogram, IHS, should stand for the words *Iesuiti Habent Satis* (the Jesuits have enough).

Whatever Ignatius's opinion might have been about his tomb marker, he would have every reason to be satisfied with his decision concerning the site of his Jesuit complex. More than 450 years later, Piazza del Gesù is still near the heart of Rome. Although the city that gave Ignatius a home and a headquarters could surely claim him as an honorary Roman, he has achieved world citizenship as well. The founder of a religious order whose influence has stretched from the Imperial Palace in Beijing to the jungles of Paraguay, Ignatius had an impact far beyond Rome. As Gregory XV (the first Jesuit-trained pope) declared during canonization proceedings, Ignatius "had a heart large enough to hold the universe."

Suggested reading

Philip Caraman, *Ignatius Loyola* (San Francisco, 1990).
Thomas M. Lucas, ed. *Saint, Site, and Sacred Strategy: Ignatius, Rome, and Jesuit Urbanism* (The Vatican, 1990).

POPE SIXTUS V AND
HIS URBAN PLANNING

 F ew popes have had as much impact on the appearance of Rome
as Sixtus V (1585–1590), and few have received so little recogni-
tion for their efforts. Although visitors to Rome can often call to
mind the names of popes such as Julius II and Paul III who were
the High Renaissance patrons of Michelangelo, or Urban VIII and
Alexander VII, the patrons of Bernini during the Baroque era, the
name Sixtus V may draw blank stares. And yet, in a papacy that
lasted a mere five years his accomplishments were monumental
and enduring.

Felice Peretti (his name before he become pope) did not come
from one of the aristocratic families that customarily produced the
popes of the Renaissance; he was the son of a poor peasant
farmer. At the age of twelve he had taken vows as a Franciscan
monk (a common method of obtaining an education and escaping
poverty at that time) and quickly rose to a position of promi-
nence. He was named cardinal in 1570 and elected pope in 1585.
Although he maintained a personal life of great simplicity and
austerity, he was eager to use his position of authority as pope to
accomplish his ambitious plans for the improvement of the Vatican
and the city of Rome. To a remarkable extent he succeeded. He
was responsible for building the Acqua Felice, an aqueduct termi-
nating in a famous fountain adorned with an ungainly statue of
Moses; he built the new Lateran Palace and a major addition to
the Vatican Palace, as well as a new wing of the Vatican Library; he

had numerous obelisks raised; and he commissioned a network of straight roads that are still among the most important in Rome and have provided the core of many later urban developments.

Although generally mild mannered, Sixtus had a ruthless streak. Determined to wipe out the gangs of bandits who plagued the countryside around Rome, he offered generous monetary rewards to anyone who could deliver these brigands into his hands. Once captured, the criminals faced immediate execution in the piazza adjoining Castel Sant' Angelo and their severed heads were displayed on the bridge leading to the Castello. But robbery was not the only crime severely punished during the reign of Sixtus. People who broke the Sabbath risked being sent off to certain death as galley slaves, and rumormongers had their tongues cut out. Other crimes punishable by death included incest, abortion, and homosexual activity. The pope's one failure in his anticrime campaign was his effort to rid Rome of prostitutes. In a city with a predominance of unmarried males, largely due to the clerical population of the Vatican, prostitution was inevitable.

Even before he became pope Sixtus had been interested in building. As a cardinal he had begun the construction of a private villa on the Esquiline Hill, near the ancient church of S. Maria Maggiore, employing a then little known architect named Domenico Fontana, who would remain in his service after he became pope. This choice had considerable consequences and not only because of the papal commissions Fontana himself received. Thanks to Fontana's connections with the pope the architect's nephew, Carlo Maderno, was later summoned to Rome and eventually designed the facade and extended the nave of St. Peter's. Another distant relative who made it to Rome through Fontana's help was Francesco Borromini, among the most original of Roman Baroque architects.

As soon as he was elected pope, Sixtus moved to the new papal residence on the Quirinal Hill, an area fast becoming Rome's most fashionable neighborhood. The only problem with this area was that it had no adequate water supply. Sixtus therefore immediately ordered work to begin on the construction of an aqueduct. Using the remains of an ancient aqueduct from the reign of the emperor Alexander Severus, work went forward rapidly, in retrospect a little too rapidly, since the engineering was sloppy and by the time the aqueduct reached Rome the water coming from it was barely a trickle. Furious, Sixtus fired the architect and replaced him with Domenico Fontana, who successfully completed the project in 1589. In honor of the pope it was called the Acqua Felice, which also means "happy water," an apt name for a project that transformed an entire sector of Rome.

At the spot where the aqueduct ended and its waters were

distributed to the thirsty neighborhood (now Piazza S. Bernardo) Domenico Fontana built a grandiose fountain with three arches and a flowery inscription on top praising Sixtus. At the center, between two relief sculptures of watery Old Testament subjects by Giovanni della Porta, Flaminio Vacca, and Pietro Olivieri (Aaron

Domenico Fontana, Acqua Felice, Piazza S. Bernardo. The waters of the Acqua Felice, an aqueduct brought into Rome by Sixtus V, first enter the city at this showplace.

Leads the Hebrews to a Well and Gideon Leads His People over the Jordan River), stands a colossal statue of Moses Striking Water from a Rock. It is a clumsy, ill-porportioned travesty of Michelangelo's famous statue of Moses in S. Pietro in Vincoli and was the object of such derision among the Romans that according to a story of the time the sculptor committed suicide in despair.

Sixtus also embarked on an ambitious program of urban development. The first street to be built was a long, straight thoroughfare from S. Maria Maggiore to the church of S. Trinità dei Monti on the Pincian Hill, at the top of the Spanish Steps in Piazza di Spagna. Like the aqueduct, it was named Via Felice after the pope; renamed Via Sistina in 1870, it is one of only two sites in Rome

that bear the papal name of this remarkable builder-pope. (The other is an obscure piazza hidden behind Rome's central railroad station.) In the opposite direction the street extends all the way to the church of S. Croce in Gerusalemme. The segments now bear several different names, but a glance at a map of Rome shows a single straight line extending across nearly the entire city as it existed in Sixtus's time.

The pope completed a road begun by his predecessor, Gregory XIII; the Via Merulana runs from S. Maria Maggiore to St. John Lateran in another straight shot across the city. Sixtus built still another ramrod of a road, Via S. Giovanni in Laterano, to connect the Lateran with the Colosseum. Other, more ambitious plans for roads were never carried out; still others had to wait centuries before they were implemented. If all of Sixtus's plans had worked out, a network of straight roads would have connected most of Rome's ancient and Christian monuments with one another, simplifying the task of navigating the city and making its principal sites much more accessible to pilgrims and visitors.

There was nothing new about the idea of constructing long straight roads through Rome. The ancient city had a series of consular roads, built by important city officials called consuls, that radiated out from the city center like the spokes of a wheel. The descendants of many of them are still in use today. One aspect of ancient culture revived in Renaissance Rome was the practice of building straight roads to replace the city's winding medieval lanes. Alexander VI had built the first of these in 1499; it runs from Castel Sant' Angelo to the Vatican Palace and now is called Borgo Pio. In the early 1500s Julius II built Via Giulia and named it after himself. Of the three avenues that radiate from Piazza del Popolo, two had been built during the first half of the 1500s: Via di Ripetta, nearest the Tiber, and Via del Babuino (Baboon Street), connecting Piazza del Popolo with Piazza di Spagna. They flank the ancient consular road originally called Via Flaminia and now known as Via del Corso.

Sixtus's road building was different because of both the monumental scale on which the roads were carried out and the pope's indifference to steep inclines and other obstacles. His roads cleave their way through the city, going up and down its hills. Had Sixtus lived a few years longer, he might have transformed the entire city and given Rome a single, comprehensive urban plan. As it is, the urban planning of Sixtus V determined much of Rome's future development up to the twentieth century.

Linked to the concept of the long straight avenue was the idea of erecting antique obelisks surmounted by crosses to serve as dramatic focus at far ends of thoroughfares. Sixtus proved to be an enthusiastic raiser of obelisks. (The obelisks in Rome had been

brought from Egypt as trophies by various emperors.) The first erected by Sixtus was the massive granite obelisk that now stands in the piazza in front of St. Peter's. It had originally been brought from Egypt by the emperor Nero and erected in his circus, just south of the Vatican Hill, where it was still standing when Sixtus became pope. Nobody since ancient Roman times had dared tackle the problem of moving such an immense object, but Sixtus was undaunted. His architect-engineer Domenico Fontana produced a viable plan and carried it out.

The process of taking down, moving, and reerecting the obelisk lasted from April until September of 1586. On September 10, with the help of 40 winches, 140 horses, and 800 men, the obelisk was finally put in place. As a reward Fontana not only received a large sum of money but also was raised to the ranks of the nobility. The workmen got bonuses and a party supplied with bread, sausages, cheese, and wine.

Other obelisks raised by Sixtus are the one in front of the Lateran basilica; another in Piazza del Popolo just in front of the city's northernmost gate, the Porta del Popolo; and the slightly smaller one in front of the apse of S. Maria Maggiore. Marking the farthest point of a thoroughfare with an obelisk was a new and striking idea. Such a monument gives the road a visual focus that emphasizes its direction and destination.

Other activities of Sixtus which affected the city of Rome, although less profoundly than his system of roads, reflected his desire to demolish certain ancient monuments he considered ugly and his determination to put others to practical uses. He was deflected from demolishing the Tomb of Cecilia Metella, one of the finest ancient Roman tombs bordering the Appian Way, but he did succeed in destroying the remains of the Septizonium, a once-splendid imperial monument with columns and cascading fountains in front of the Palatine Hill. Toward the end of his pontificate, Sixtus put Fontana in charge of a project to transform the Colosseum into a wool-weaving shop, complete with work spaces and dwellings for the craftsmen in the building's arcades. Work was about to begin when Sixtus died and the project was abandoned.

Because of its proximity to the cathedral of St. John Lateran, the medieval popes had lived in the Lateran Palace, but by the 1400s the building was in such a state of disrepair that it had become uninhabitable. Sixtus ordered the entire complex torn down and replaced, in one summer of frenetic building activity, with a rather plain structure designed by Domenico Fontana. The new papal palace proved impractical and uncomfortable. Sixtus rarely stayed there for any length of time and the Lateran never again became an important papal residence.

The Lateran Palace was barely underway when Sixtus commis-

sioned Fontana to add an extension to the Vatican Palace. Without tearing anything down Fontana added a large wing to the existing palace complex. Begun in 1589 and finished after the pope's death, it is a complete palace in itself. Its massive cubic shape, decorated in the same conservative style as the Lateran Palace, towers above the right side of the piazza in front of St. Peter's. This part of the complex is still the pope's residence today.

Sixtus then commissioned Fontana to add a new wing to the Vatican Library. Unfortunately this wing cuts right across Bramante's magnificent Belvedere Court, designed in the early 1500s for Julius II. The library really did need more space, however, and Fontana's series of low, vaulted rooms, lined on each side with cabinets for books, did the job. The walls and ceilings are covered with generally dull frescoes, but some of them include views of Rome which provide valuable documentation of the city's appearance in the late 1500s. One shows the raising of the Vatican obelisk and another presents the facade of St. Peter's as it might have looked had it been completed according to Michelangelo's plans. Visitors pass through these rooms, which link the two wings of the Belvedere Court, as they make their way through the Vatican Museums.

Rome's other Sistine Chapel (in addition to the one in the Vatican) is also the project of Sixtus V. As Cardinal Peretti he had already started to build a small chapel in S. Maria Maggiore to house the church's most precious relic, a copy of the cave and manger of the Nativity. When he became pope he abandoned his original plan and had a virtual church within a church constructed in the shape of a Greek cross, once again designed by Domenico Fontana and richly decorated with colored marble taken from the recently demolished Septizonium and the dismantled Lateran Palace. As Sixtus intended, the chapel serves as the site for his own tomb and that of a predecessor, Pius V.

In addition to all these projects Sixtus saw to it that work went forward on St. Peter's, which by the 1580s was still far from finished. In 1588 Giacomo della Porta, Michelangelo's successor as chief architect, began the exacting task of constructing the dome. Sixtus was so eager to see the dome completed that he had eight hundred men employed on it. For two years they worked at a frenzied pace, including a night shift, and even had a special papal dispensation to work on Sundays. The dome was substantially completed by May 1590, although at the time of Sixtus's death in August much else remained to be done, including demolition of the remains of the ancient basilica, decoration of the interior, and construction of a facade. These would be the work of the next century.

With the help of Domenico Fontana, Sixtus had succeeded in changing the face of Rome within a remarkably short time.

Although not all the pope's plans were realized, his avenues and obelisks had given the city a new appearance. The Acqua Felice had made the Quirinal Hill inhabitable; the new Lateran Palace and the additions to the Vatican Palace and Library had become permanent features of the Vatican's urban fabric, and his Sistine Chapel at S. Maria Maggiore had helped to lay the groundwork for the Roman Baroque. Not a bad legacy for a papacy that lasted only five years.

Suggested reading

Torgil Magnuson, *Rome in the Age of Bernini,* trans. Nancy Adler (Stockholm, 1982), vol. 1.

ROMA AMOR
PART IV

BAROQUE ROME

CARAVAGGIO

The Bad Boy of the Roman Baroque

Not many men have the distinction of being known as both a major painter and a murderer. The lurid career of Michelangelo Merisi da Caravaggio (ca. 1571–1610) seems more like the script of a melodramatic movie than the life of one of Italy's greatest and most influential artists. Short, ugly, and irascible, Caravaggio cut a swathe the length of the Italian peninsula and beyond. From Milan to Messina, the list of his offenses, assaults, arrests, and imprisonments is almost as long as his list of paintings. But this complex and unpredictable man created some of the most original and compelling works of Italian art. Although many of his paintings are now scattered around the Western world, a remarkable number remain in Rome, making it possible to follow the entire trajectory of the artist's brief but productive career. The quest for Caravaggio in Rome can take the visitor into some of the city's principal museums as well as into several interesting churches.

It is not difficult to understand why Caravaggio is such an object of fascination today. His headlong pursuit of pleasure, ambivalent sexuality, sudden outbursts of senseless violence, and harrowing, premature death all make him seem unsettlingly like certain modern artists such as Jackson Pollock and, more recently, Robert Mapplethorpe. Much of what we think we know about Caravaggio comes from hearsay and the testimony of hostile individuals, but even if we make allowances for prejudiced judgments, the image

that emerges is of a deeply disturbed and unhappy man whose art soared even as his private life deteriorated into sordid chaos.

Trained by a mediocre teacher in Milan and already rumored to have killed someone, Caravaggio arrived in Rome in 1592. His first years there were difficult. Initially he found a place in the household of Monsignor Pandolfo Pucci, a stingy cleric who treated Caravaggio like a common servant and fed him nothing but vegetables, a miserable hospitality that led the artist to nickname Pucci *Monsignor Insalata* (Father Salad).

The painter's days as an obscure vegetarian ended when he came to the attention of a very different kind of cleric, the wealthy and cultured Cardinal Francesco Maria del Monte. A lover of music as well as art, del Monte dabbled in alchemy, included Galileo among his friends, and was rumored to have a taste for attractive boys. Installed in del Monte's palace, Caravaggio quickly entered into the spirit of the cardinal and his circle, producing in the 1590s a series of paintings of languid, sensual, sexually ambiguous young men accompanied by musical instruments, flowers, and/or gorgeously ripe fruit. The artist's *Youth with a Fruit Basket* (Rome, Galleria Borghese), in which a doe-eyed boy with parted lips and one bare shoulder displays both himself and a basket of fruit, is a typical example. Although some have tried to find moral or religious meanings in such works, they are more likely frank celebrations of the hothouse homoerotic atmosphere discreetly cultivated by Cardinal del Monte and his friends.

The extent to which Caravaggio shared the sexual tastes of the del Monte circle is uncertain, but he seems to have found the artistic and social environments congenial. During this early period he also painted his *Sick Bacchus* (Rome, Galleria Borghese), an evocation of the Roman god of wine as a sultry but pallid and slightly tipsy street boy, as well as his *Fortuneteller* (Rome, Museo Capitolino), in which a young woman appears to be suggestively tickling the palm of a fancily dressed young man. Even Caravaggio's religious paintings of the 1590s share something of the same sensual atmosphere. In his *Rest on the Flight into Egypt* (Rome, Galleria Doria-Pamphili), a nearly nude boy angel serenades the Holy Family on a violin. In his *Ecstasy of St. Francis* (Hartford, Wadsworth Atheneum), probably a personal commission from Cardinal del Monte, the saint swoons unconscious into the arms of a beautiful, solicitous, adolescent male angel. His *Young John the Baptist with a Ram* (Rome, Museo Capitolino) portrays the saint as a saucy exhibitionist who eyes the viewer flirtatiously, while seeming about to commit some sort of unnatural act with the ram he embraces around the neck. A fascination with bloody violence asserts itself in *Judith Decapitating Holofernes* (Rome, Palazzo

Barberini), probably painted in the late 1590s, in which the heroine hacks grimly at the neck of Holofernes, while her victim shrieks and blood splatters the bedsheets.

From such beginnings we would expect Caravaggio to have become primarily a painter of secular subjects, but just the opposite occurred. After 1599 nearly all his paintings are religious. They are also increasingly revolutionary in form, as the artist began to explore new ways of expressing his singular spirituality.

In curious contradiction to the religious nature of his art a rising level of antisocial behavior marked Caravaggio's personal life from 1600 on. In November of that year Girolamo Stampa sued Caravaggio for a physical attack on him. In 1603 a fellow artist, Giovanni Baglione, also sued Caravaggio, accusing him of writing insulting verses in response to one of Baglione's works. Early in 1604 Caravaggio was arrested for flinging a plate of artichokes and hot oil into the face of a waiter in a Roman tavern, an attack that left the man blinded. That same year Caravaggio was arrested for throwing stones at the window of a woman with whom he was involved and, still later, arrested again and jailed for insulting some muncipal guards. In 1605 he wounded a man in a sword fight after a dispute over a woman named Lena, who seems to have been a prostitute. This pattern of verbal and physical violence culminated on the night of May 28, 1606, in Rome's Via della Scrofa. There, Caravaggio and his friends got into a fight over a bet on a tennis game; the men drew their swords and Caravaggio received a severe head wound. But his opponent lay dead on the street, a victim of Caravaggio's sword. After hiding for a few days to recover from his injuries, Caravaggio fled the city. He never returned to Rome.

For the remaining ten years of his life the painter led a wandering existence, pursued by the law and by enemies real and imagined. He went to Naples in 1607 and then to the island of Malta, where he somehow succeeded in becoming a member of the prestigious Order of the Knights of Malta. But here too his temper got him into trouble. After attacking a knight for some unspecified insult, he was jailed and expelled from the order. Perhaps with the cooperation of the knights, who were anxious to be rid of him, Caravaggio escaped his Maltese prison and fled to Sicily. By 1609 he had returned to Naples, where he was attacked and severely beaten in a notorious Neapolitan tavern, perhaps by someone avenging his earlier assault on Malta. Informed that a pardon of his offenses by Paul V was in the making, Caravaggio attempted to return to Rome in 1610. He set sail from Naples and landed at Port' Ercole, north of Rome, in blistering July heat. There, mistaken for a wanted criminal, he was seized and thrown into prison, while thieves made off with his boat and possessions. Released two days

later, he went charging furiously down the beach in a futile search for his boat. Overcome by rage, exhaustion, and heatstroke, he contracted a fever and died in a peasant's shack. He was not quite forty years old.

Throughout this decade of mounting violence, flights, and imprisonments, Caravaggio never stopped painting. Wherever he was, masterpieces flowed from his brush. In Rome in the first six years of the 1600s, despite lawsuits, brawls, and arrests, he completed more than a dozen works, among them the decoration of the Contarelli Chapel in the church of S. Luigi dei Francesi with three large paintings of the life of St. Matthew, and the Cerasi Chapel in S. Maria del Popolo, where he painted the *Conversion of St. Paul* and the *Crucifixion of St. Peter.* Also from this period are the somber and powerful *Entombment of Christ* (Vatican Pinacoteca); the tender and touching *Madonna dei Pellegrini* (Rome, S. Agostino); the *Madonna dei Palafrenieri* (Rome, Galleria Borghese), a sinister representation of the Virgin and Child with St. Anne in which a harsh-faced Mary helps a thin, red-haired Christ Child to crush a snake; a sullen, brooding *St. John the Baptist* (Rome, Galleria Corsini); and the controversial *Death of the Virgin Mary* (Paris, Louvre), in which the artist was rumored to have used the body of a dead whore fished out of the Tiber as his model for Mary.

All these paintings raised clerical eyebrows with their adventurous compositions, unrelenting naturalism, harsh lighting, and audacious rethinking of traditional subjects. Some were even rejected by those who had commissioned them. Offended by the bulging bare legs and dirty feet of the yokel Evangelist in Caravaggio's first version of the *Inspiration of St. Matthew,* painted for the Contarelli Chapel, the patrons refused to pay for the work. Although the immense horse, rear end foremost, that dominates Caravaggio's *Conversion of St. Paul* caused mutterings at S. Maria del Popolo, the church authorities reluctantly put the painting in place. The clergy at S. Maria della Scala refused to have anything to do with the *Death of the Virgin,* which was then purchased by the duke of Mantua at the advice of Flemish painter Rubens, who was working in Rome at the time.

After his flight to Naples in 1607, Caravaggio's paintings become even gloomier. Many of his Neapolitan works, such as the *St. Jerome Writing* (Rome, Galleria Borghese), are full of dark, empty spaces. On the island of Malta Caravaggio painted a bone-chilling *Beheading of John the Baptist* (Malta, St. John Museum) in which John's head is still not quite free of his crumpled body and the executioner reaches down to complete his work. Blood streams from the severed neck and with it Caravaggio has smeared his own name, the only work he is known to have signed. Back in Naples in 1609, Caravaggio painted a *Young St. John the Baptist*

(Rome, Galleria Borghese) in which the saint resembles a sick, weary boy prostitute, aged beyond his years and without a trace of innocence, and yet with eyes that could break your heart.

We do not know which of Caravaggio's late paintings was his last, but a likely candidate is *David with the Head of Goliath* (Rome, Galleria Borghese). Severed but seemingly still alive and howling in agony, the head is the dramatic focus of the work, held gingerly at arm's length and regarded with a mixture of pity and revulsion by the youthfully handsome David. An early biographer assures us that the work contains Caravaggio's self-portrait—not as David but as Goliath's head.

Was this Caravaggio's last, despairing testament, a confession of a hopeless passion for beautiful boys? Or was it a revelation of his fear that he, who had lived by the sword, would one day die by it? In its Christian interpretation the story of David killing Goliath symbolizes Christ's triumph over evil. Did the artist's personal involvement in mayhem and murder perhaps lead him to a profounder understanding of penance and salvation? Part of Caravaggio's enduring interest to modern viewers stems from the difficulty of ever finding definitive answers to such questions.

Suggested reading

Howard Hibbard, *Caravaggio* (New York, 1983).

Caravaggio Up Close
The Contarelli and Cerasi Chapels

Two groups of religious paintings executed by Caravaggio in Rome in the first years of the 1600s contain images and raise ideas that still have the power to shock and disturb but also to move and fascinate. For me, these are among the greatest paintings in Rome, works of elemental power which have continued to haunt my imagination long after they became familiar. Adding to their impact, they all remain in their original locations, in the chapels for which Caravaggio painted them.

THE CONTARELLI CHAPEL IN S. LUIGI DEI FRANCESI

To the left of the main altar in S. Luigi dei Francesi, the church of the French community in Rome, is a dim, shallow chapel endowed by a French cardinal named Mathieu Cointrel, a name Italianized as Contarelli. It contains three canvases by Caravaggio, all concerned with the story of St. Matthew. What Cardinal Contarelli might have thought of them we shall never know, since he was long dead by the time the executors of his estate hired Caravaggio to decorate the neglected chapel. But there is no lack of evidence for the reactions of the clergy at S. Luigi. They refused to accept Caravaggio's first version of the *Inspiration of St. Matthew,* believing that the spectacle of the bare-legged, ungainly Evangelist was irreverent and inappropriate. The *Calling of St. Matthew,* on the left wall, was an unwelcome shock as well, since Caravaggio

showed the event taking place in a grimy Roman tavern. Only in the *Martyrdom of St. Matthew,* on the right wall, did the painter produce a conventional scene and, as far as we know, one to which the clergy raised no objections.

The opening episode, the *Calling of St. Matthew,* depicts the Evangelist's single, brief passage of autobiography: "[Jesus] saw a man, named Matthew, sitting at the receipt of custom: and he saith unto him, 'Follow me.' And he arose, and followed him" (Matthew 9:9). Caravaggio grasped the power latent in those words, for he understood that Matthew had been transformed. Jesus did not choose an exemplary man as his Evangelist, the artist reminds us, but a corrupt and venal one, a man made uncomfortable among his shady friends by the sudden appearance of Jesus and Peter. We have only to look at Matthew's face, with its sheepish expression, or at his finger pointing halfheartedly toward himself and at the same time hopefully toward the two men still engaged in counting money, to feel the depth of his embarrassment.

Matthew is in bad company. The two men at the far left are classic studies in greed; the older leans forward to peer at the money on the table and adjusts his glasses the better to see it, while the younger man studies the coins with single-minded avidity. At the other end of the table two insolent young dandies stare at Jesus and Peter, one a pretty boy who leans back suggestively against Matthew and the other a thug with a brutal profile, prominent sword, and threatening posture.

On the far right stand Christ and Peter, two dusty, shabby intruders. Although the figure of Peter is in the foreground and almost blocks our view of Jesus, the unforgettable face of Christ—swarthy, virile, and confident—rises out of the shadows and looms above Peter's head. Peter's tentatively pointing hand, held close to his body, seems a mere prologue to the hand of Christ that arches powerfully across the space between the holy men and the tax collectors. The visual quotation is clear; it is the hand of God from the earlier Michelangelo's *Creation of Adam* on the ceiling of the Sistine Chapel, reaching across the void to instill a soul into the first man. Seen in the light of its source, Christ's gesture toward Matthew is more than a mere beckoning; it is also an emblem of creation. Just as the first Michelangelo's God gave Adam a soul, so Caravaggio's Christ with the same gesture *re*-animates Matthew.

The *Calling* is full of light, as magical as any ever painted. Piercing the darkness of the room, it falls where the artist wills it to fall, in magnificent disregard of the laws of nature. A beam from below and to the right of the scene strikes the faces of the men at the table, sharply outlines the side of the armed man at the center of the composition, and more softly picks out Peter's bent back and the face of Jesus. Another shaft of light enters from

above and behind Christ, making a line across the canvas directly to Matthew, whose face is illuminated by two light sources, neither of them rationally explainable.

More painted light falls on the tax collectors than on either Jesus or Peter, who seem to emerge out of a dark void, with no sign of a doorway behind them. This odd reversal—the sacred figures

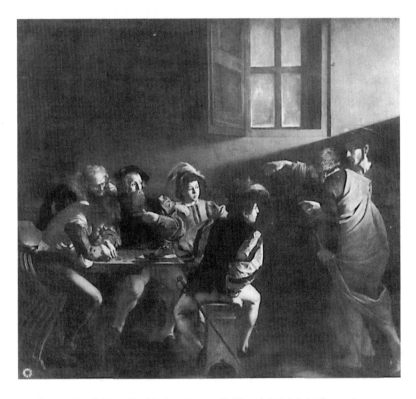

Caravaggio, *Calling of St. Matthew,* Contarelli Chapel, S. Luigi dei Francesi. This revolutionary work shocked viewers with its placement of a religious subject in a lower-class setting.

in relative darkness, the evil ones bathed in light—is no doubt significant. Playing on the double meaning of illumination as both a physical and a spiritual event, Caravaggio's light focuses on Matthew like a searchlight's beam, yet at the same time suggests the fulfillment of prophecy. Matthew, when writing about Jesus in his gospel (4:16), would refer to the words of the prophet Isaiah: "the people that sat in darkness have seen a great light."

When we turn from the *Calling* it may be to wonder what will become of this man so transformed by his encounter with divinity.

Caravaggio had a clear idea about this subject and expressed it in such blunt and discomfiting terms that the clergy refused to accept the painting and the artist had to produce a second version of the *Inspiration of St. Matthew*.

The rejected version (which found its way to Berlin, where it was destroyed during World War II) showed Matthew dressed in a short tunic and sitting with his legs crossed, writing on a tablet placed on his lap. The weight of the top leg pressing down causes the calf muscle to protrude in an unsightly bulge and reveals the grimy bottom of the Evangelist's left foot. His hand is guided by that of a boyish angel who snuggles up seductively to his adult pupil. This image was too much for the clergy of S. Luigi, who demanded a more dignified portrayal. In the second version, which now hangs over the altar of the chapel, the saint half-kneels on a bench, the sole of his foot no longer visible. He wears a robe the golden color of a Roman stucco wall and has a red cloak thrown around him. No longer a bald, unshaven peasant getting a writing lesson from an indulgent angel-teacher, he has become a classical philosopher.

The final painting in the series is the *Martyrdom of St. Matthew*. Here, nothing seems convincing, neither the suffering of the martyred saint, lying prone in the foreground, nor the fury of his attackers. They all remind me of mediocre actors in a bad play. There is something sad about the artistic progession within the Contarelli Chapel paintings. The brilliant *Calling* fairly leaps off the wall to involve the viewer in the drama of Matthew's miraculous conversion. The original version of the *Inspiration* had some of the same direct and powerful appeal, but the second *Inspiration* edges toward the conventional. The *Martyrdom* seems a betrayal of Caravaggio's most basic instincts. An artist capable of gripping his viewers with imagery of great power and originality appears to have surrendered, perhaps a bit sullenly, to the requirements of a conventional patron. In the background just to the left of the central figure in the *Martyrdom* we see a face, rumored to be Caravaggio's self-portrait, regarding the scene with a mixed expression of dismay and disgust. It is not difficult to imagine this as the artist's commentary on his own painting.

THE CERASI CHAPEL IN S. MARIA DEL POPOLO

The church of S. Maria del Popolo houses two more of Caravaggio's most compelling works, the *Crucifixion of St. Peter* and the *Conversion of St. Paul*. The impact of these two paintings can be exceptionally strong and disconcerting, for they venture into territory not often explored. Conventional religious platitudes and pieties did not interest Caravaggio. His real subject here is the

terror that so often lies at the heart of the most profound religious experiences.

The Cerasi Chapel is just to the left of the main altar of the church. Above the chapel altar is the *Assumption of the Virgin* by that most proper of seventeenth-century painters, Annibale Carracci, a work whose bland piety makes a telling contrast to the revolutionary religiosity of Caravaggio's works. Perhaps Monsignor Tiberio Cerasi, who endowed the chapel about 1600, appreciated the divergent approaches of the two artists.

In both theme and composition Caravaggio's paintings are meant to be viewed as a pair. In the *Conversion of St. Paul* we see the miraculous but violent beginning of sainthood, and in the *Crucifixion of St. Peter* we see its violent end. Both events take place against a background of total darkness, lit by Caravaggio's arbitrary but breathtaking light. Paul sprawls toward us on a descending diagonal, head first, while men raise the body of Peter on a corresponding diagonal, with his bloody feet, already nailed to the cross with large spikes, thrust out at the viewer.

The *Crucifixion of Peter* is, among other things, a picture of difficult physical labor. Ignoble as their task may be, the men who raise Peter's cross are working hard. No doubt Caravaggio obscured the faces of these three men to focus our attention on the expression of Peter. On his aged face pain, astonishment, and outrage mingle as he glares openmouthed at his own crucified left hand, the fingers already beginning to clench involuntarily around the nail. He seems unable to believe that the moment has finally come; the long-accepted, perhaps even eagerly awaited martyrdom suddenly seems incredible, infuriating. Peter is an old man with thinning hair, a gray beard, and a deep crease in the flesh of his lower abdomen, but there is no resignation in his face or his tensed body.

Other artists might draw a veil of piety between the viewer and the suffering saint, but not Caravaggio. He forces us to confront not only the dirt and violence and pain but also the indignity of Peter's death. Peter had asked to be crucified upside down, declaring himself unworthy of dying in the same way as his Lord, but now nothing, not even his faith, separates him from his physical torment. His expression of astonishment and outrage may reflect his realization of just how terrible—and how utterly humiliating—the end will be. There are many bloodier scenes of martyrdom to be found in Roman churches, but no other conveys with such force the unwelcome fact that even faith does not always protect us against the agonies, terrors, and indignities of impending death.

Caravaggio's rendering of the *Conversion of St. Paul* is surely the most powerfully imagined and most disturbing version of the subject ever painted. We may accept the violence of a martyr's death,

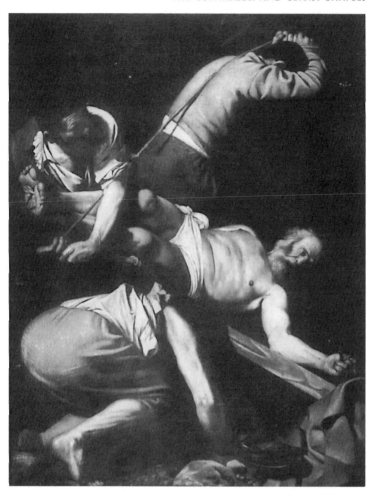

Caravaggio, *Crucifixion of St. Peter,* Cerasi Chapel, S. Maria del Popolo. An unusual version of the martyrdom of St. Peter, the painting shows the elderly saint as angry and incredulous that the moment of death has finally come.

but we are apt to be less prepared for the artist's unnerving assertion that conversion can be an equally violent experience. Although in our era religious conversion can be either a gradual change of convictions brought about by rational argument or a dramatic illumination of the spirit by emotional persuasion, we rarely imagine it in terms of physical, let alone sexual, violence. But it seems to me that is the way Caravaggio painted it. The biblical description of Saul's conversion inspired the artist to an

unprecedented exploration of an aspect of Christ most Christians would rather not encounter, or even consider: a bullying Savior who blinds a man with a bolt of light and sends him sprawling, stunned and terrified, to the ground. Yet we also learn from the biblical text that Saul apparently would not have responded to anything less. This is the unpleasant reality Caravaggio's painting forces us to face: that people who are impervious to persuasion sometimes respond to violence.

The Acts of the Apostles (9:1–18) states that Saul, "breathing out threatenings and slaughter" against the followers of Jesus, volunteered his services to arrest any of them he might find. Saul was traveling toward Damascus on this mission when a great light suddenly shone around him, causing him to fall to the ground. He then heard a voice saying, "Saul, Saul, why do you persecute me?" When Saul asked who was speaking, the voice answered that it was Jesus, he whom Saul was persecuting. The "trembling and astonished" man put himself at the mercy of his invisible accuser, asking: "Lord, what wilt thou have me do?" Instructed by Jesus to rise and go into Damascus, the blinded Saul was led there and cared for by followers of Jesus. He regained his sight after three days and accepted baptism taking the name of Paul to indicate that he had become, like Caravaggio's Matthew in the Contarelli Chapel, a new and fundamentally different man.

In this painting the artist strips the scene to its essentials: two men, a horse, and a beam of light. The men are Saul and one of those who accompanied him on his journey. The presence of the horse, not mentioned in the Bible, is suggested by the long distance the men are traveling from Jerusalem to Damascus. The huge horse raises its hoof restively, sensing, as animals often do, that something disturbing is happening. The sheer physical bulk of the horse plays its part in the composition, creating an oppressive sense of heaviness that is the physical counterpart to the unseen force that has thrown Saul to the ground.

In the midst of his conversion experience, Saul, who has fallen flat on his back, instinctively raises his arms as if to defend himself. But this movement merely emphasizes his inability to do so. Caravaggio has chosen a gesture rich in other associations—the blind man's groping efforts to feel his way in the dark as well as both an attempt at warding off and the beginning of an embrace. It also recalls the ancient gesture of prayer shared over millennia by pagans, Jews, and Christians.

Here was a miracle made to order for the particular genius of Caravaggio. Christ, the main actor in the drama, remains invisible, manifesting himself only through his voice and through light. As a painter Caravaggio could not portray a voice, but few artists have possessed his ability to transform light into a living presence.

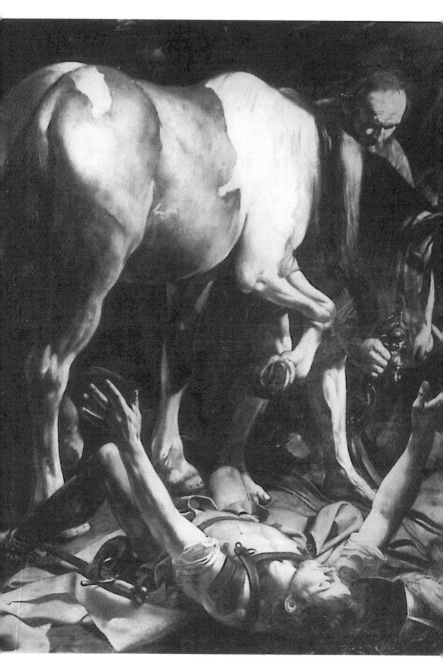

Caravaggio, *Conversion of St. Paul,* Cerasi Chapel, S. Maria del Popolo.
This original and disturbing work reveals the future saint at the mercy
of his invisible divine accuser.

Although we see no apparition in the dark sky and no angels announce the Lord's arrival, this tangible, terrifying intensity of light, coming from a place we cannot rationally locate, compels us to realize that this is no mere accident. This is an assault of the divine upon a human being. Saul's position—he is sprawled on his back with his knees drawn up and his legs parted (as no previous painter had ever dared to show him)—leads me to believe that Caravaggio intended us to see him as the victim of what might be termed a spiritual ravishment or even a rape.

Although this may seem a bizarre and even offensive idea at first, I believe that Saul's pose offers a clue to Caravaggio's intentions. The artist has used this pose—so powerfully charged with sexual meaning—to convey a man's complete vulnerability and ultimate surrender. Light strikes the edges of his polished helmet and the pommel of his sword, bringing to our attention implements of earthly warfare now useless against his divine assailant. Saul's eyes appear sealed closed, weakening him still more. Overpowered, stunned, and blinded, the future saint lies on the ground, not merely vanquished by a more powerful adversary but exposed to his God like a woman at the mercy of a rapist.

How could Caravaggio dare to cast Paul in such a role? Would not the same sensibilities offended by the first version of the artist's *Inspiration of St. Matthew* be far more outraged by a representation of Paul that suggests he was the victim of a rape, to say nothing of the blasphemy inherent in casting God in the role of rapist? But before we assume that such an interpretation, however irreverent it may seem to us, would be unacceptable to viewers in the early 1600s, we should recall that stories of dramatic religious conversions, even lurid and violent ones with sexual undertones, were an important part of seventeenth-century European culture. The idea of presenting religious conversion under the imagery of sexual assault was not unique to Caravaggio or even to Catholicism. About 1610, hardly a decade after Caravaggio's painting, the great English poet and Protestant clergyman John Donne wrote of his own difficult path to grace in his Holy Sonnet XIV, using the same daring and disturbing paradox; with certain sinners, gentle persuasion is useless, only a violence comparable to rape will effect the desired spiritual transformation:

> Batter my heart, three person'd God; for you
> As yet but knock, breathe, shine, and seek to mend;
> That I may rise and stand, o'erthrow me and bend
> Your force to break, blow, burn and make me new
> Take me to you, imprison me, for I
> Except you enthrall me, never shall be free,
> Nor ever chaste, except you ravish me.

Neither Caravaggio nor Donne portrays an actual rape, but instead they both use rape metaphorically, as an image of the forcible penetration of reluctant mortal flesh by a determined divine spirit. We now see rape as an absolute evil and assume that the victim must invariably be left hating the attacker. No wonder it is difficult for modern viewers to accept the idea presented to us by Donne and Caravaggio, that even God occasionally resorts to such violence in the cause of human salvation. In this religious conversion the artist reminds us that there really is such a thing as holy terror.

Today most people enter the Cerasi Chapel and stand facing one or the other of Caravaggio's paintings, craning their necks in vain attempts to see them properly. But the best way to view the paintings is to stand, or even better to kneel, at the entrance to the chapel, facing the altar, and then to look to the left and right at each of them. From this angle the plunging, diagonal perspectives make better visual sense and the power and directness of the scenes strike the viewer like physical blows.

In these paintings, as in so many of Caravaggio's works, dramatic lighting effects transform seemingly sordid events into miraculous ones. The world of Caravaggio is one of prevailing darkness, a violent and threatening void only occasionally and fitfully lit by the beams of divine grace. With Caravaggio the artist's work and his life seem tragically to intersect.

GIANLORENZO BERNINI

Rome's Resident Genius

*Bernini ... gave a public opera wherein he painted the scenery,
cut the statues, invented the stage machinery, composed the music,
writ the comedy, and built the theater.*

—John Evelyn, 1644

Every great city needs its resident genius, and Rome in the seventeenth century had Gianlorenzo Bernini (1598–1680). If any one artist could be said to personify the Baroque era in Rome, it is this versatile virtuoso. His brilliantly dramatic, sensuous, and often theatrical sculptures display extraordinary technical mastery, and his architectural designs, while more conservative, also display considerable originality. Alexander VII said the artist would have excelled at anything he tried, and as the dazzled British traveler to Rome quoted above reported, Bernini really did try his hand at virtually all the arts.

As if all that were not enough, he was also slim and darkly handsome, with large, brilliant eyes and—despite a rather short stature—a commanding physical presence. He could be temperamental but was also soft-spoken, diplomatic, witty, and charming. Cardinals, popes, and princes stood in awe of his genius, and women adored him. Although he was married and the father of eleven children, his various affairs were avidly followed by the city's gossips.

A child prodigy nearly on a par with Mozart, Bernini was working in marble before he was ten years old, urged on by his father, Pietro Bernini, a sculptor of talent who recognized and en-

couraged his son's genius. An important source of inspiration for the young Bernini were ancient Greek and Roman sculptures in the Vatican collection. Since Bernini's father was employed in minor sculptural work for various popes, the boy had a chance to visit the collections frequently, and according to Bernini's son, Domenico, his father "made so many sketches you wouldn't believe it!" At the Vatican the young Bernini could also study the works that form the climax of the High Renaissance style in Rome: Michelangelo's Sistine Chapel ceiling and Raphael's frescoes in the Stanza della Segnatura and the Stanza d'Eliodoro.

After some early sculptural efforts that seem somewhat tentative only in comparison with what was to come, Bernini burst onto the Roman art scene with three astonishing works, all of them carved in the early to mid-1620s for Cardinal Scipione Borghese: *Pluto and Persephone, Apollo and Daphne,* and *David.* Although some scholars think the three statues were all originally placed against walls, rather than out in the middle of rooms as they are today, it is difficult to accept that either Bernini or his patron would have wanted even an inch of any of them to be unviewable. These brilliant works still occupy ground-floor salons of the Villa Borghese, the wealthy cardinal's summer residence and today one of Rome's most marvelous museums. (Other works by Bernini in the same museum include an early and not entirely successful statue group called *Aeneas, Anchises, and Ascanius Fleeing Troy* and the artist's superb portrait bust of the plump, pleasure-loving Cardinal Borghese, who also possessed one of the city's most extensive collections of pornography.)

Bernini's *Pluto and Persephone* depicts Pluto, the Greek god of the underworld, carrying off the maiden Persephone to be his bride. In this work the sculptor's virtuoso technique as a marble carver enabled him to treat the stone as if it were soap. We can see differences in the textures of the skin, the flying hair, and the god's fingers sinking into the soft flesh of Persephone's thigh. The terrified girl is even crying marble tears.

With the theatrical instincts that would serve him so well in later years Bernini depicts the action at the climactic moment. Pluto seems to have just now snatched the struggling girl who twists, thrashes, and cries out in vain, as the triumphant god steps past the border of Hades, indicated by the four-headed hellhound, Cerberus, who here also serves as a support for the human figures. Although interesting from every angle of view, the statue is best seen from the front, as if we were watching the action take place on a stage.

Apollo and Daphne treats another version of the theme of a male divinity pursuing a mortal female, but one with an unexpected ending—the object of Apollo's desire turns into a tree. This subject is rare in sculpture, since neither passionate pursuit nor the

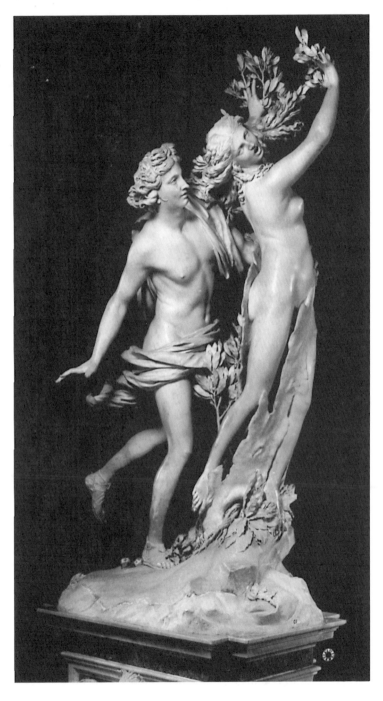

Gianlorenzo Bernini, *Apollo and Daphne*, Museum of the Villa Borghese.
A sculpture for Cardinal Scipione Borghese, the group displays the
artist's dazzling virtuosity in carving marble.

transformation of a person into a tree seems remotely suited for representation in three motionless dimensions. How did Bernini solve this problem, which baffled many previous artists? Again he chooses the crucial moment. Just as Apollo achieves his goal of seizing Daphne, she calls for help from her father, a river god who, perhaps displaying an odd sense of humor, responds by turning his daughter into a laurel tree—no doubt a most disheartening development from Apollo's point of view.

Bernini based his figure of Apollo on the Apollo Belvedere, a Roman statue still in the Vatican collections, but he enlivened his model considerably. The ancient Apollo stands in a frontal pose; Bernini's figure is running. In contrast to the cloak that hangs loosely from the shoulder of the Roman statue, the cloak of Bernini's Apollo swirls around his hips and then whips out into the air behind him, heightening the impression of movement. Bernini has even given a high polish to Apollo's face, to suggest the sheen of perspiration caused by his exertions.

Just as Apollo's hand grasps Daphne's hip, her body begins to be enveloped by bark, her hair turns to twigs, her fingers sprout leaves, her toes take root. Branches grow up from behind her knees and with a touch of earthy humor, Bernini makes the leaves teasingly tickle Apollo's groin. Daphne looks back over her shoulder, her mouth open in a frozen scream. The virtuosity of the marble carving is amazing: at the tips of Daphne's fingers, where laurel buds blossom with an almost audible "pop," the solid block of marble dematerializes before our eyes into a filigree of wafer-thin leaves.

Bernini's *David,* the last of the statues for Cardinal Borghese, is no less dramatic. The biblical hero stands with his feet planted wide apart, twisting his torso to gain the maximum force for his slingshot. The carved stone rope that forms a part of this weapon is another of Bernini's passages of dazzling virtuosity. David's head remains facing straight forward, so he can maintain his concentration on his unseen adversary, Goliath. His unruly hair, frowning brow, and especially his clenched mouth, lips sucked in and compressed by his jaws, indicate the intensity of his effort. David's face is reputed to be Bernini's self-portrait and legend claims that another friend of the artist, Cardinal Maffeo Barberini (the future Urban VIII), held the mirror for Bernini while he worked.

In the other two pieces the objects of the gods' attention are close-by; Pluto holds Persephone, and Apollo has almost gotten hold of Daphne. But David's opponent is not visible. We must imagine Goliath towering behind us and so we become involved in the action. David's eyes look past us; we get the feeling that our space will soon become a part of his. The statue makes us want to duck, to get out of the line of fire.

The election of Barberini as Urban VIII in 1623 marked the

beginning of a remarkable series of commissions for St. Peter's that would occupy Bernini on and off for the rest of his life. Urban put him in charge of decorating the interior of the church and also commissioned the Baldacchino altar. A later pope, Alexander VII, hired him to execute the Cathedra Petri altar and put him in charge of designing the piazza in front of the church.

The death of Urban VIII in 1644 marked a brief period of papal disfavor for Bernini. Urban's successor, Innocent X, was more interested in advancing the interests of his family, the Pamphili, than in continuing the work on St. Peter's, so Bernini turned to private patrons. Between 1645 and 1652 he designed and executed the decoration of a chapel for the wealthy Cornaro family, in the church of S. Maria della Vittoria. For this chapel Bernini created one of his most brilliant works: the *Ecstasy of St. Teresa of Avila.*

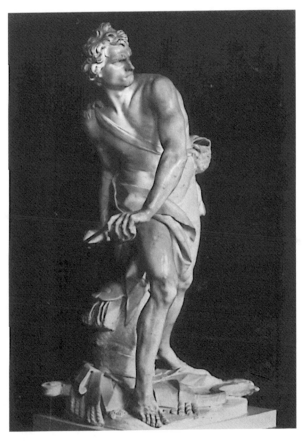

Gianlorenzo Bernini, *David,* Museum of the Villa Borghese.
In Bernini's version, the biblical hero's concentration on his unseen adversary
pulls the viewer into the action.

The Cornaro Chapel is a true multimedia work, a combination of painting, architecture, sculpture, and light. Above the altar and set slightly back are the white marble figures of St. Teresa, a six-teenth-century Spanish nun shown swooning in mystical ecstasy and standing over her a smiling, boyish angel, about to plunge a golden arrow into her body. Architectural elements resembling a stage set frame the figures. Gilded bronze rays, dramatically lit by natural light from a hidden window above, shine down on the pair, illuminating their gleaming surfaces as if by a theater spot-light. The angel seems to have descended from the chapel ceiling, painted by Bernini's assistants with hosts of angels adoring the Holy Spirit. On the left and right walls, in niches resembling the-ater boxes, Bernini's portrait busts of members of the Cornaro family witness the event as if it were a theatrical performance.

And what a show they see! St. Teresa swoons back, yet at the same time seems to strain upward, as if in the grip of some super-human force. Her head is thrown back, her eyes roll up into her head, her lips are parted as if she is moaning or crying out. Even her clothing has a life of its own, its external agitation conveying her internal state of excitement. The angel makes a wonderful contrast with the saint. He stands upright, while her body lies on a diagonal; his body is partly bare and his clinging, silken draperies look completely different from the coarse, concealing cloth of the nun's habit worn by Teresa. As he prepares to plunge his golden ar-row into the swooning saint's abdomen, he looks down at her with a tender, seductive smile.

No one who views the group of St. Teresa and the angel can avoid the ambiguity inherent in the scene, a tableau both intensely spiritual and astonishingly sexual. (After examining the face of St. Teresa, a woman friend once remarked to me that Bernini must have been a wonderful lover, as well as an observant one; he seemed to know how a woman could look in the midst of an orgasm.) Some critics in the nineteenth century denounced the work as obscene, a thinly veiled excuse for an erotic episode, entirely inappropriate for a church. But others have acknowledged how true Bernini remained both to the spirit and the letter of St. Teresa's vision. This is the way St. Teresa herself described the vision Bernini depicted:

> Beside me . . . appeared an angel in bodily form. . . . In his hand I saw a great golden spear. . . . This he plunged into my heart several times so that it penetrated to my entrails. When he pulled it out, I felt that he took them with it, and left me utterly consumed by the great love of God. The pain was so severe it made me utter several moans. The sweetness of this intense pain is so extreme that one cannot possibly wish it to cease, nor is one's soul content with anything but God. . . . This is not a physical but a spiritual pain, though the body has some

share in it. . . . So gentle is this wooing which takes place between God and the soul that if anyone thinks I am lying, I pray God in His goodness to grant him some experience of it.

Needless to say, psychoanalytically oriented people can—and do—describe St. Teresa as a severe case of sexual repression sublimated into religious mysticism. But if we want to understand this work of art the way Bernini and his contemporaries did, we should recall that both Bernini and St. Teresa were devout Catholics, deeply influenced by the *Spiritual Exercises* of St. Ignatius Loyola, a work that encouraged readers to put all five senses into the service of their imaginations and to conjure up visual images of the experiences of earlier saints to prepare their own souls for mystical experience. Here Bernini has achieved a synthesis nearly impossible even for a genius and totally beyond the reach of lesser artists. In the angel he shows spirit made flesh, and in the figure of St. Teresa the penetration of human flesh by divine spirit. As in Caravaggio's *Conversion of St. Paul,* the work blurs the line between the world of the spirit and the world of the senses.

Like many visionary mystics, St. Teresa claimed to be subject to levitation, floating above the ground in defiance of natural laws. To portray her in that state, while carving her image from a block of marble weighing several tons, Bernini again made use of his experience in the theater. The saint seems to be floating on a fluffy white cloud, an effect Bernini created by leaving the part of the marble surface under her rough. A closer look at the lower part of the statue group reveals, however, that Bernini has employed one of the oldest devices of the stage designer's art: he has painted the actual base of the statue a dark brown, so it blends in with the wall behind it and becomes virtually invisible.

Rome's numerous fountains are one of the city's most delightful features and those that Bernini designed are among the city's finest. For Urban VIII Bernini designed the Triton Fountain, located close to the pope's family residence, the Palazzo Barberini. Today the playful fountain is sadly stranded in the middle of the traffic that roars around Piazza Barberini. Four dolphins rear up from the pool, supporting plaques with Urban's family coat of arms and balancing a huge shell on their noses. From the shell emerges a mythical sea creature, half-human and half-fish: the Triton. He blows on a conch shell trumpet and seemingly by his efforts a tall plume of water rises from his aquatic musical instrument and splashes into the pool below.

The subsequent pope, Innocent X, officially held Bernini in disfavor, but even that stubborn pontiff eventually came to realize he could not do without the artist's genius. Innocent spent much of his papacy transforming one of Rome's most striking urban

spaces—the huge, oblong Piazza Navona—into a family preserve. The piazza, built over the ruins of a stadium from the time of the Roman emperor Domitian (hence its shape and its name, which comes from the Greek word *agon,* meaning "an athletic competition"), became the site of the Pamphili family palace, as well as their parish church, S. Agnese.

At the center of his piazza Innocent wanted a giant fountain constructed to feature an ancient Egyptian obelisk that had been dug up from the Circus of Maxentius. Innocent invited virtually every sculptor in Rome to submit a design for this project—except Bernini. But Bernini made a dazzling little model in silver and somehow managed to get it smuggled in to where the pope would notice it. Innocent saw Bernini's design and became ecstatic over it. When he found out whose model it was, he exclaimed that Bernini was "born to serve great princes" and that the only way to resist creating from his designs was not to see them.

The model that so enraptured Innocent eventually became Bernini's most famous fountain: the Four Rivers. Constructed between 1648 and 1651 with the help of many assistants, the fountain is made mostly of travertine. It depicts some sort of fantastic island that has risen out of the ground, the mythical source of four great rivers: the Danube (Europe), the Nile (Africa), the Plate (South America), and the Ganges (India). Each river is personified by a huge, flailing figure of a river god and the structure is topped by Innocent's obelisk, crowned by a dove, an emblem from the pope's family coat of arms. The surface swarms with the most astonishing display of beautifully carved natural elements: animals, rocks, tropical plants, and exotic seashells. Live birds (mostly pigeons) and bits of wild-growing greenery in the crevices of the fountain blend in perfectly with the carved stonework.

We might expect such a huge structure to be solid, but Bernini realized that this would make the fountain appear too massive, so his design is full of holes. Light and air penetrate it, interspersed with sheets of water falling from narrow horizontal slits, an effect Bernini invented. The area under the obelisk, the heaviest part of the fountain, is hollowed out, making it seem as if the obelisk is floating. The whole effect is magical. Innocent swore that the pleasure he received from the Four Rivers Fountain added years to his life. The fountain still lends its exuberant energy to the bustling life of Piazza Navona.

Suggested reading

Howard Hibbard, *Bernini* (Baltimore, 1965).
Torvil Magnusson, *Rome in the Age of Bernini,*
 trans. Nancy Adler (Stockholm, 1982), vol. 2.

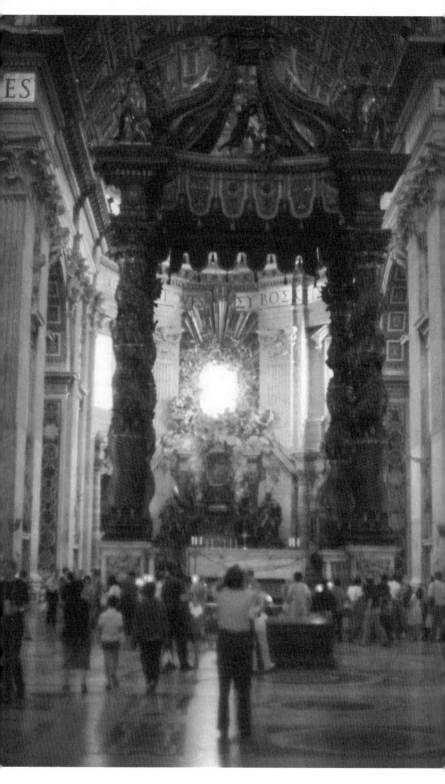

Gianlorenzo Bernini, Baldacchino and Cathedra Petri Altars, St. Peter's. Bernini's two great altars help to define the immense space of the interior of St. Peter's and make triumphant visual statements about the divine authority of the pope.

ROMA
AMOR
XXX

BERNINI AT ST. PETER'S

More than any other artist except perhaps Michelangelo, Bernini determines our experience of St. Peter's. Although not involved in the construction of the church, he supervised the decoration of the interior, designed the two principal altars, and created the colonnades that form the immense piazza in front.

In 1623 the new pope, Urban VIII, needed an artist of the stature of Michelangelo to take on the artistic challenge of decorating the interior of St. Peter's. With great insight he put his friend Bernini in charge. It is easy to imagine the disaster that might have resulted if a lesser artist had been entrusted with such an overwhelming task. Thanks to his strong relationship with the pope, Bernini began a series of commissions for St. Peter's and its surrounding which would occupy him for the rest of his life. Bernini designed the marble medallions, chose the colored marble panels for the walls and floors, and provided the designs for the gigantic statues of saints and angels that populate the basilica, carved by more than three dozen different sculptors working from Bernini's designs. The gargantuan scale can be appreciated when one realizes that the smallest of these statues, the babies who hold up the holy water fonts, are nine feet high.

The most pressing need was for a memorial monument to be placed over the presumed site of St. Peter's grave, directly under the dome. The stupendous size of the church required something well beyond an ordinary tomb marker to fill the yawning space. Bernini's ingenious solution was both functional and decorative. As his main image he chose the baldachin form, which in actual

church usage is a small square canopy of silk, held up with four wooden poles and used to shelter the consecrated bread and wine of the Mass when they are carried in a procession. A baldachin has also been used to shield the pope while he was seated on his ceremonial chair and carried in official processions. Since the Middle Ages smaller baldachin forms have also been used as altar monuments. With enthusiastic support from Urban VIII, Bernini carried out the work between 1625 and 1633.

Bernini took this familiar object, enlarged it to the height of a twelve-story building, and cast it in bronze. He thus transformed something that is usually quite small, and often mobile and temporary, into something huge, stable, and permanent. Somehow he managed to unite two seemingly irreconcilable qualities, lightness and monumentality, without impairing either. The work had to be huge, so as not to seem trivial in such an immense space, but it could not be so blocklike that it would obscure the view down the central nave to the apse.

The Baldacchino rests on four marble blocks, each about eight feet high, with huge bees (the emblem of Urban's family, the Barberini) carved on the fronts. From each base rises a spiral column of bronze, designed in imitation of the late classical twisted columns that had supported the nave of Old St. Peter's. The spiral shape of the columns also has the artistic advantage of avoiding the rigid effect of straight columns. They seem almost to dance. These columns in turn support a frame from which hang thin curtains of bronze, cast to resemble cloth embroidered with Barberini bees. Above this rises the final motif of four S-shaped volutes soaring toward the dome, surmounted by an orb and a cross. On the inner surface a painted dove of the Holy Spirit hovers above the altar. Between all these elements is sufficient space to enable the viewer to see the curve of the dome and to have an unimpeded view toward the main altar, at the far end of the church.

To find enough bronze for this project the pope ordered the bronze stripped off the porch of the Pantheon. This bit of papal piracy earned Urban one of the best known of all Roman pasquinades—a justifiable joining of the pope's family name, Barberini, with Rome's past barbarian invaders: *Quod non fecerunt barbari, fecerunt Barberini* (What the barbarians didn't destroy, the Barberini did).

The Baldacchino has several functions. It is first of all a tomb marker for St. Peter. In Catholic doctrine St. Peter was the first pope and his authority, given to him by Christ, has been handed down in an unbroken line to the present pope. High above the Baldacchino, around the base of the dome, a Latin text set in nine-foot-high black letters against a glittering gold ground repeats the words Christ spoke to Peter, which are the foundation of papal

authority: "Thou art Peter and upon this rock I will build my church and unto you I will give the keys to the kingdom of heaven." Only the pope may celebrate Mass under the Baldacchino and whenever he does so he confirms the link between himself and St. Peter. In a Europe irrevocably split into Protestant and Catholic camps the monument served as the Church's triumphant statement of the claims of Roman Catholicism.

In 1657, nearly twenty-five years after he had completed the Baldacchino, Bernini began work on another great altar for St. Peter's, the Cathedra Petri, which dominates the apse of the church just as the Baldacchino dominates the space under the dome. Like the Baldacchino this monument relates to the idea of the Church Triumphant and to the saint to whom the church is dedicated. The patron this time was Alexander VII, a descendant of the papal banker Agostino Chigi whose fortune had helped to finance the Roman High Renaissance.

For this altar Bernini's basic image derives from a small, battered wooden chair kept at that time in the treasury of St. Peter's. According to tradition St. Peter himself had sat on this chair when he conducted the earliest Christian assemblies. (Modern archaeologists believe the present chair dates from the ninth century but is probably a copy of a first-century original.) Bernini placed this chair in a huge gilded bronze reliquary also in the shape of a chair but majestic enough to be a throne, thus making this powerful symbol of the popes' legitimate succession both the central image of the altar and the focal point of the worshiper's journey through St. Peter's.

The symbolism of the Chair of Peter is still very much alive. When a pope speaks *ex cathedra,* that is, from the chair of St. Peter, Roman Catholic doctrine declares that he speaks with divine inspiration and that his utterances are not subject to error. In addition the reigning pope figuratively "occupies the Chair of Peter," and Italians refer to the Vatican as the *Santa Sede,* or Holy See, a term that derives from a Latin phrase meaning "sacred chair."

Bernini placed this symbolic chair over the altar where a daily succession of cardinals, visiting bishops, and newly ordained priests celebrate Mass. It seems to hover in midair, directly above the altar table, barely supported by the bronze statues of the four major Church Fathers: Saints Augustine, Jerome, Athanasius, and John Chrysostom. In a dramatic climax the window above the altar seems almost to explode in a great fanfare of gilded bronze light rays, gilded stucco clouds, and angels. Both the rays of light and the angels appear to emanate from an image of the Dove of the Holy Spirit, painted at the center.

This window, which faces west, had initially posed a problem of excess light for Bernini, and he had even considered bricking it up. Instead he turned it to his advantage and made it part of the

ensemble. To resolve the problem of glare, he painted the Dove of the Holy Spirit on it in oil paint; since this medium is translucent but not transparent, it allows light to enter but eliminates the glare of direct sunshine. The window now appears as a source of divine rather than earthly light. The wall seems to have been penetrated by heavenly glory; light and clouds that carry a tumbling mass of golden angels pour in between the colossal pilasters of Michelangelo's apse to confirm the legitimacy of the pope.

A closer look at this gigantic altar reveals that, unlike the Baldacchino, it is not made entirely of bronze. The clouds and angels are gilded stucco. This was a cost-cutting measure made necessary by the staggering expenses involved in Bernini's last and greatest project at St. Peter's, which was being carried out at the same time outside: the colonnades of the piazza.

After the completion of the facade there remained the organization of the vast space in front of the church. In the late 1500s Sixtus V had ordered a large ancient obelisk erected in the center of that space, but other than this central focus the piazza had imprecise and irregular limits. In 1656 Alexander VII called on Bernini to prepare designs for the piazza, which he envisioned as a conventional square with palaces built around it. Bernini instead proposed enclosing the space with a double colonnade on a grand scale, in the shape of an oval and attached to the facade of the church by two extensions. Far more clearly than the pope, Bernini realized that the approach to St. Peter's should not be just another piazza. St. Peter's must have a special space that would enhance its beauty, stress its unique character as the heart of Catholic Christendom, and be of a size adequate to hold the immense number of pilgrims the church attracted.

Bernini's colonnades are suprisingly simple and severe. Two double rows of massive columns form one-half of an oval on either side of the facade and support a plain entablature adorned with a variety of statues. In working out the proportions Bernini sought to counteract a characteristic of Maderno's facade—its excessive width in relation to its height. By making the colonnades lower than the facade and thicker in their proportions, Bernini succeeded in making the facade appear taller and more graceful.

At the widest point of each half of the colonnades as well as at each end is a small protruding segment called an exedra, in the form of a temple front, which picks up the same motif found on the center of the church facade. Paul V had used the frieze of the facade to publicize his own part in the construction of St. Peter's. Alexander VII, not to be outdone, had his own name emblazoned on each exedra of the colonnades.

The purpose of the colonnades as Bernini conceived them was not only to give shape to the piazza, which can hold more than

two hundred thousand people, but also to shut out the sight of adjacent buildings. He had originally planned a gigantic triumphal arch at the entrance to the piazza, at the farthest point from the church facade. This was never built and now there is only an empty space. This arch, pierced by relatively small entrances, would have delayed our view of St. Peter's until we actually walked through the arch and entered the piazza. Then the church and the vast space in front of it would have been revealed all at once, as if the curtain had risen on the Western world's largest stage.

An urban planning project of Mussolini, begun in the 1930s and completed after World War II, has meant that St. Peter's is now visible from nearly a mile away, down a length of road that extends from the entrance of the colonnades all the way to the Tiber. Whatever element of surprise Bernini had planned no longer exists. The only surprise is how long that street really is. St. Peter's is so huge that it confuses the visitor's sense of scale. Viewed from the Tiber, the church looks quite close, but many a weary visitor standing on the Tiber embankment discovers that it can take the better part of twenty minutes to reach the front steps of the church.

Although Bernini's name appears nowhere on or in St. Peter's (he and his descendants are buried in S. Maria Maggiore), his creative spirit is in evidence everywhere. The appearance of the interior and the shaping of the space around the church are his work. Bernini's colonnades define our experience of the exterior of the church, giving the impression of arms opening in a gigantic gesture of welcome to the millions who have flocked here over the centuries. Once within the piazza and facing the church, the visitor has a comforting impression of being encircled by the colonnades but never limited or crowded by them. Instead the image that comes to mind is exactly the one Bernini intended: *mater ecclesia* herself, the Mother Church, reaching out to embrace her children.

The last three decades of Bernini's life were taken up principally with these seemingly endless projects for St. Peter's. Even so, he still found time for portrait busts and other private commissions. Active until the end, he died in 1680 at the age of eighty-two, leaving behind a remarkable body of work to influence sculptors and architects in Rome and throughout the world and to astound and delight visitors to the Eternal City.

Suggested reading

Howard Hibbard, *Bernini* (Baltimore, 1965).
Richard Krautheimer, *The Rome of Alexander VII* (Princeton, 1985).

THE ARCHITECTURE OF
FRANCESCO BORROMINI

Imagine a physically handsome man lacking in social graces; an extremely sensitive man with a violent temper; a lonely man with a neurotic fear of human contacts; a brilliantly creative man terrified that others would steal his ideas; an irritable, melancholy, nervous, idealistic, and uncompromising man forced constantly to deal with demanding people and practical problems; a man passionately involved with life who nevertheless ended as a suicide; and you will have some impression of the complex, contradictory personality of one of Rome's greatest Baroque architects: Francesco Borromini (1599–1667).

Although he came from northern Italy, Borromini was fortunate to live in Rome at the very time a series of ambitious and art-conscious popes were transforming the Eternal City and creating the Baroque style in the process. The renewed optimism and aggressiveness of the Catholic Church in the 1600s required a new kind of architecture that was spacious, dramatic, and brilliantly lit—a sacred theater for the performance of religious rituals.

Borromini's wonderfully inventive architectural forms seem well suited for this new era, yet he only rarely received major commissions. Few papal projects came his way, and princely Roman families often avoided him. Consumed with frustration and envy, he watched as the choicest architectural plums fell into the lap of his hated rival, the charming and diplomatic Bernini. The

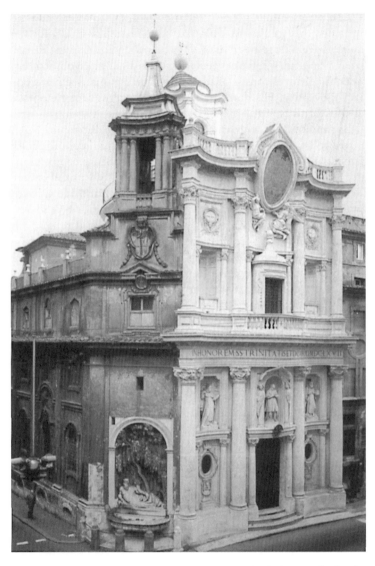

Francesco Borromini, S. Carlo alle Quattro Fontane. This little gem of a church demonstrates Borromini's ingenuity in utilizing a small and irregularly shaped site to create a building of beauty and originality.

problem with Borromini lay not in his talents but in his personality. The man was impossible to deal with. He quarreled with everybody, from the lowliest stonemasons to the most exalted patrons. Given his ability to alienate people, the wonder is that he managed to complete as many buildings as he did.

And what buildings! The structures he designed are among the most original in Rome. They are usually rather small, yet the interiors seem large because of their billowing and flowing spaces. Their shapes are often unexpected, such as a star hexagon or a diamond. The fronts consist of undulating surfaces that seem in constant movement. His domes, belfries, and lanterns sometimes take fanciful forms as well.

Borromini's first independent commission in Rome, in 1634, proved to be symptomatic of his future. An austere order of Spanish Trinitarian monks who possessed an oddly shaped piece of property at a difficult location hired Borromini to design a small church for them. The church Borromini built, called S. Carlo alle Quattro Fontane, stands at the intersection of two busy streets, Via Venti Settembre and Via delle Quattro Fontane, named for the fountains Sixtus V had ordered built at each of the piazza's four corners a generation earlier. Since a corner of the monks' property was cut off by one of the fountains, Borromini faced the challenge of incorporating the fountain into an exterior wall of his church. The result is a structure in the shape of a diamond, with each of its four points rounded off; one of them contains the pre-existing fountain.

Once inside, a gorgeously complex space envelopes the viewer, with hardly a right angle in sight. Instead the curving surfaces of the walls seem to ebb and flow around the spectator as they rise toward an oval dome. The inner surface of the dome is honeycombed with an ingenious pattern of hexagons and octagons that join to produce crosses in the intervening spaces. Partially concealed windows located in the uppermost portion of the dome permit light to filter in and give the dome a gleaming brightness.

Although completed after Borromini's death, the front of S. Carlo follows his designs. Alternating concave and convex walls produce a flow of curvilinear forms that allows a maximum play of Rome's dramatic light and shade over their surfaces. Above the door is a statue of St. Charles Borromeo, to whom the church is dedicated. Flanking the statue are two sculpted cherubim, whose wings meet above the saint's head to form an elegant arch.

Because of its small size S. Carlo alle Quattro Fontane has acquired the nickname "San Carlino." Once, during one of my first visits to Rome, I became lost while trying to find this church, so I stopped an elderly woman and asked, in halting Italian, where I would find the church of S. Carlo alle Quattro Fontane. She looked at me in perplexity. So I tried the church's nickname instead and immediately her face was wreathed in smiles. "Oh, San Carlino!" she exclaimed, as if I had just asked after her favorite grandson. She pointed me toward the church. Only in Rome, a city on intimate terms with saints for almost two thousand years, could a church dedicated to so austere a figure as the Counter

Reformation saint Charles Borromeo be called the Italian equivalent of "Charlie."

The climax of Borromini's career as an architect came quite early in his life, in his design for the church of S. Ivo della Sapienza. Originally the church was part of the Vatican-run Collegio della Sapienza, the old and wonderfully named College of Wisdom that had trained impoverished young men for the priesthood since the early 1200s. Over the altar of Borromini's church is an inscription from Psalm 110 that clarifies the significance of the institution's name: *"Initium sapientiae est timor domini"* ("The beginning of wisdom is fear of the Lord"). St. Ivo was surely the world's most spectacular college chapel and is still one of the finest buildings in Rome. But it is symptomatic of Borromini's fate that his superb creation is squeezed into the back of a courtyard and that the chapel itself is nearly always locked, so many visitors to Rome remain unaware of the existence of this architectural jewel.

Unlike some of Borromini's other projects, S. Ivo was completed within the artist's lifetime (between 1643 and 1660) and entirely under his personal supervision. The construction of the chapel began during the papacy of Urban VIII and continued under Innocent X and Alexander VII. As with his earlier design for S. Carlo alle Quattro Fontane, Borromini faced the problem of fitting a church into a small and constricted space, this time an area at the end of a long, rectangular courtyard constructed in the late 1500s. Hemmed in by existing buildings, property lines, and the necessity of preserving the courtyard space, a lesser architect might have produced a simple little square chapel. But not Borromini. Within that square area Borromini constructed a building in the shape of a star hexagon: two superimposed equilateral triangles, one with the points rounded off to form flower-shaped lobes, the other with the points pressed inward. These features appear in the floor plan, continue through the walls, and then sweep on into the dome, producing a shape of the most startling originality.

No Renaissance architect and none of Borromini's contemporaries had ever created anything remotely like S. Ivo. Precedents can be found, however, among the most unconventional of classical buildings, some of the structures of Hadrian's Villa at Tivoli. This gigantic imperial ruin, scattered across acres of hilly countryside east of Rome, fascinated Borromini, no doubt because many of its buildings seemed to break the rules of classical architecture. The unusually shaped domes and sinuously curving surfaces of these ancient structures justified and spurred Borromini's own creative license.

At first glance the exterior of S. Ivo seems consistent with the two stories of arches in the courtyard where it stands. But a closer look reveals that Borromini has made the front of the church

concave rather than flat. Above it rises the six-lobed drum of Rome's most fantastic dome. Surmounting the dome is a tall lantern on which perches a spiral-shaped construction terminating in a delicate filigree of ironwork and carrying aloft an orb and a cross.

The interior of S. Ivo is one of Rome's most marvelous spaces. Recently restored to its original pristine white, the concave walls seem to billow like huge sails, carrying the viewer's eye upward toward the astonishing dome. The continuously undulating surfaces carry the eye around in a ceaseless, swinging motion. Such surging and receding walls scarcely need any decoration; we could almost say that Borromini was a sculptor who used architecture as his medium.

Borromini fared less well with the two major projects he subsequently undertook in Rome, both of which involved the continuation or reconstruction of buildings designed by others: the completion of the church of S. Agnese in Piazza Navona and the rebuilding of St. John Lateran. Although Innocent X, whose favor

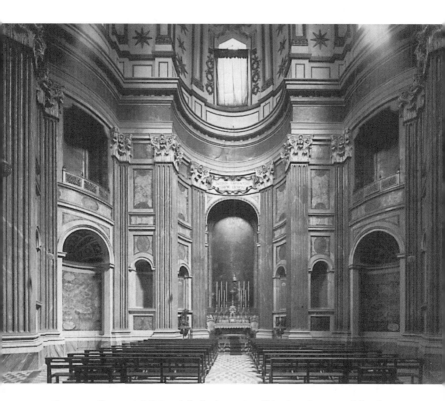

Francesco Borromini, S. Ivo della Sapienza. A striking interior space, S. Ivo has a floorplan in the shape of a star hexagon that continues up into the dome.

he enjoyed, put him in charge of these two projects, neither worked out to the architect's satisfaction.

The huge Lateran basilica had fallen into such decay by the 1600s that it was in danger of collapsing. In 1646 the pope gave Borromini the complex task of restoring this ancient church. Innocent wanted the basic work finished by the Holy Year of 1650 and Borromini delivered it, but at the cost of great personal anguish and stress. His subsequent activity at the Lateran dragged on for years.

The story of S. Agnese in many ways is the saddest in Borromini's career. The church was the final and most important portion of Innocent X's project for improving Piazza Navona. Although Innocent invited Borromini to submit a design for a fountain to be built in the piazza, Borromini was not a sculptor and was no match for the brilliant Bernini, who subsequently got the commission. Borromini fumed in helpless rage.

The church of S. Agnese proved an equally frustrating project. Borromini was called on in 1653 to complete a building already well underway; Innocent X had fired the original architects, Girolamo and Carlo Rainaldi. Despite this inauspicious beginning Borromini worked rapidly. He had the unfinished facade torn down and proceeded with his own design. By 1655 both the front and the interior were finished up through the first story and the dome was complete except for the lantern. Borromini had every reason to expect his building would be a triumph, for he had brilliantly solved the problem that had defeated Carlo Maderno, the designer of the facade of St. Peter's: how to create a front that would not obscure the view of the dome. Borromini's solution was to use the same concave shape he had employed at S. Ivo.

At this point Innocent died and Borromini lost the only patron with whom he had enjoyed rapport. The Pamphili heir left in charge had no interest in the project, and Borromini became increasingly discouraged and embittered. Complaints mounted that he rarely visited the site of S. Agnese. Workmen grumbled that they had no idea how to proceed in the architect's absence and that when he was there all he did was fight with them.

Meanwhile the new pope, Alexander VII, appointed a commission to look into the complaints against Borromini concerning his work at S. Agnese, and in 1657 the group recommended that Borromini be dismissed. To avoid that humiliation he resigned from the project. As a further insult to Borromini's pride, Alexander rehired Carlo Rainaldi, the architect Borromini had replaced. Still later, in 1667, the last year of Borromini's life, he had to endure a final indignity; his hated rival Bernini took charge of the project. After Borromini's death, the interior was completed by various artists under Bernini's direction who made lavish use of high

reliefs, frescoes, and multicolored marbles, none of which would have pleased Borromini.

Borromini's unhappy relationship with Alexander VII must surely have hastened the deterioration of the architect's mental state. Alexander loved to tease and tweak Borromini. The latter, unable to parry or return the pope's taunts, instead would fly into screaming rages, which Alexander found highly entertaining. The prickly but emotionally fragile Borromini brought out some previously hidden vein of cruelty in this otherwise most genteel and decorous of popes.

Alexander disliked Borromini's architectural style as well as his personality. He criticized the architect's use of "needless ornaments," grumbled about the lack of clarity in his designs and his tendency to underestimate his costs, and chafed at the delays caused by Borromini's compulsive attention to detail. After four years of wrangling with Alexander over designs, funding, and timetables for completion, in 1659 Borromini quit his post as architect of the Lateran. Papal diplomat Virgilio Spada, who actually was a Borromini advocate, noted that Borromini refused to allow anyone to see his notes and drawings for the Lateran and that the irascible and increasingly uncommunicative architect was unwilling to render any account of the project.

The last years of Borromini's life were full of increasing frustration and escalating conflicts with patrons. Despite all his problems Borromini did manage to complete one last project, the building of the Collegio di Propaganda Fide, an organizing center for Catholic missionary activity located near Piazza di Spagna. Although he had received the commission in 1646, he did little work on it until the 1660s. Here too the architect faced an irregular site with scarcely a right angle anywhere, as well as the additional difficulties of working amid a hodgepodge of pre-existing buildings. Once again, Borromini solved the problems with great ingenuity. One aspect of the project must have given him particular satisfaction: in 1660 he received permission to have an earlier church within the complex torn down and replaced with a design of his own. The demolished church was the earliest architectural commission of Gianlorenzo Bernini.

Borromini's front for the Propaganda Fide, which faces the very narrow Via di Propaganda, is a striking mixture of the severe and the unexpected. A single central entrance gives access to both the church and a courtyard leading to the seminarians' residential area. Flanking it are giant pilasters that rise to the second story. Instead of having the pilasters on either side of the doorway directly face the street, Borromini set them at a slight angle, which makes the entrance seem more open and inviting. The cornice that separates the second and third stories is not straight but curves in and out.

Designed to be seen at a steep angle and always at close range in the sharp Roman light, the facade has much of the familiar Borromini magic. It stands out as an exotic, undulating surface among the pedestrian, planar fronts of the neighboring buildings.

Yet not even this success could console Borromini for what he felt was the failure of his architecture to gain him the kind of fame and recognition he craved. As his lifelong rival Bernini moved from triumph to triumph, Borromini's despair and depression deepened. He went for weeks without leaving his house, and according to his few remaining friends he spent his time making designs for "great and fantastic buildings."

Finally, on the morning of August 2, 1667, Borromini suffered an episode of acute despair. Although a servant had been instructed to watch him, he found a sword in his room and flung himself on it with such force that he ran it through his entire body. He died several hours later, but not before dictating a detailed and surprisingly lucid account of the event. It is perhaps just this combination of emotional intensity and rational intelligence that made him such an extraordinary artist.

Suggested reading

Anthony Blunt, *Borromini* (Cambridge, 1979).
Richard Krautheimer, *The Rome of Alexander VII* (Princeton, 1985).

ROMA
AMOR
XXXII

THE TREVI FOUNTAIN

None of the numerous, twisting little streets that take the visitor to the Trevi Fountain line up exactly with it, so the element of surprise, even to those who know perfectly well what awaits, is constantly renewed. In Rome's echoing stone streets, the sound of rushing waters seems nothing short of miraculous—an illusion rather than a reality. But visitors actually can believe their ears. The great triumph of the Trevi, and its whole reason for being, is its water. The water's movement, sound, sparkle, and vitality animate the fountain and give it an abundant sense of life, magically uniting its sculpture and architecture.

The exuberant and theatrical Trevi has enjoyed such tremendous popularity over the centuries that some refuse to take it seriously as art. I was guilty of this myself; for years I ignored the Trevi because the name brought to my mind old films such as *Three Coins in a Fountain* or *Roman Holiday* and images of Anita Ekberg plunging into the Trevi's waters in *La Dolce Vita*. But eventually I realized that the Trevi is much more than a tourist attraction or a commercial picture postcard come to life. It is one of Rome's great permanent spectacles.

The Trevi embodies the full sweep of Roman architectural history, from the first century B.C. through the eighteenth century, and if we include improvements to the water delivery system made in the 1930s and the thorough restoration completed in 1991, the fountain takes us to our own time. The conquering of water, harnessing it for the benefit and pleasure of human beings, is one of the great themes of the Eternal City and one that links

the fountain's past history to the present. The fountain we enjoy today is the result of a millennial process beginning in the time of Augustus, when Marcus Agrippa first brought to Rome the water that still feeds the Trevi.

On June 9, 19 B.C., an aqueduct the Romans named the Aqua Virgo (Virgin Water) for its great purity first began supplying Rome with what is still considered the city's best water. From its source in a spring to the east of Rome, the water reaches the city through more than ten miles of conduit, some parts above ground, others buried below the surface. No doubt Marcus Agrippa, the son-in-law and chief adviser of the emperor Augustus, was present for the opening ceremonies, since he had financed the construction of the aqueduct to supply water for his bath complex, which stood near the original Pantheon.

Constructed with the superb engineering that characterized so many of ancient Rome's major public works, the Aqua Virgo aqueduct functioned for nearly six hundred years. But during the disastrous sixth century, the city was besieged by a northern barbarian tribe known as the Ostrogoths, and in 537 they cut off Rome's water supply by destroying sections of all of the city's aqueducts. Although repairs were eventually made to the Aqua Virgo, it no longer extended across the city but ended near the spot where the Trevi Fountain is located today. During the Middle Ages a modest fountain was built here, and as the Latin language gradually developed into Italian, the Aqua Virgo of the Caesars became the Acqua Vergine of the medieval popes.

A network of streets converge on the site; the modern Via delle Muratte, Via dei Lavatori, and Via della Stamperia closely follow the course of the ancient Roman streets. The intersection of these three streets (tres viae) is the most likely source for the name Trevi, although legend suggests it comes from the name of the virginal girl (Trivia) who first pointed out the spring from which the water originates to a group of Agrippa's thirsty soldiers.

The Trevi remained inconspicuous until the mid-1400s, when Nicholas V, advised by the Florentine humanist and architect Leon Battista Alberti, had the fountain renovated and adorned with inscriptions commemorating the pope's restoration of the Acqua Vergine aqueduct in 1453. Alberti's Trevi Fountain, a relatively modest structure on the east side of the piazza rather than on the north, where the present fountain is, became the main display of the water brought to Rome with much effort and expense. The Acqua Vergine was repeatedly repaired during the 1400s and 1500s because it was the only functioning aqueduct in Rome before Sixtus V brought the Acqua Felice in during 1587.

During the late 1500s and early 1600s the neighborhood of the Trevi, now supplied with water, became increasingly desirable and

wealthy families erected palaces in the area. These buildings now had to be taken into consideration in any plans to change or expand the Trevi Fountain. During the 1500s and early 1600s many fountain projects were proposed, but none were executed; the conflicting interests of the papacy, the city government, and the property-owning families were too complex to reconcile.

Starting in 1629, however, the Trevi underwent major changes. Urban VIII put Gianlorenzo Bernini in charge of the Acqua Vergine, and Bernini produced a plan to move the fountain from its site on the east side of the piazza to one on the north. The pope was enthusiastic and in 1640 authorized work to begin. Bernini had Alberti's fountain destroyed, as well as some neighboring houses, and built the semi-circular basin in which the present fountain now stands. But the death of Urban in 1644 was also the death of Bernini's Trevi. The plan was never completed and no drawings survive, so we have only a vague idea of what the Trevi might have looked like had it been built by the great architect-sculptor of the Roman Baroque. The next pope, Innocent X, diminished the importance of the unfinished Trevi when, in an unparalleled act of aquatic piracy, he diverted the Trevi's waters to Piazza Navona to supply Bernini's fountain the Four Rivers.

In 1678 another event occurred which had important consequences for the future of the Trevi. The powerful dukes of Poli (a branch of the Conti, the family of the future Pope Innocent XIII) acquired the rambling building behind the Trevi and renamed it Palazzo Poli. They added two new wings, one on either side of the Trevi conduit, bringing the building closer to the fountain.

During the papacies of Innocent XIII (1721–1724) and Benedict XIII (1724–1730) work on still another Trevi fountain began, this time using the designs of Paolo Benaglia. But the next pope, Clement XII (1730–1740), halted the project for artistic and political reasons. Benaglia's design was unpopular and Benedict XIII's reign had been notoriously corrupt, so Clement decided to disassociate himself from both. He wanted the new fountain to express not narrow family interests but papal benevolence and pastoral care for the public good.

However idealistic Clement XII's motives may have been, he ran into trouble with the Conti family. They objected strenuously to any plan that would mask their new Palazzo Poli facade. The result was a two-year standoff. Finally, in 1732, Clement took decisive action; he held a competition for the fountain design and appropriated the entire width of Palazzo Poli. The Conti family was furious. Not only would they lose the light from some of their south-facing windows, but all the architectural decoration on their facade would disappear as well. (It disappeared so thoroughly that few visitors to the Trevi today even know they are looking at

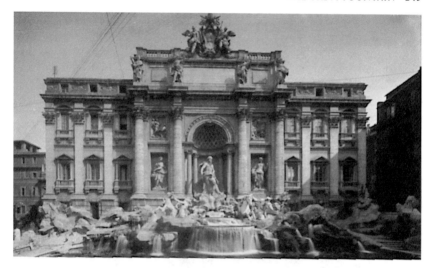

Nicola Salvi, Trevi Fountain. One of Rome's great permanent spectacles,
the exuberant Trevi is a marvelous marriage of architecture and sculpture
brought to life by a constant and varied play of water.

a palace behind the fountain.) And to make the Conti defeat even
more galling, the fountain would be crowned by the coat of arms
of a member of a rival family, Clement XII Corsini.

The winner of Clement's competition was Nicola Salvi, a
thirty-five-year-old native Roman. A quiet, intellectual man, Salvi
had a deep interest in the city's ancient monuments and the works
of those two great sculptor-architects of the Renaissance and
Baroque periods: Michelangelo and Bernini. Although Salvi exe-
cuted other projects, the Trevi dominated his career and eventually
cost him his life, destroyed by nearly twenty years spent off and on
in the mists and damps of the Acqua Vergine's underground con-
duits. But the fountain he designed assured his immortality, for it is
Salvi's Trevi that we see today.

No man could have executed such an enormous project single-
handedly. Salvi had the help of nine sculptors and innumerable
stonemasons, all working from his designs. Salvi oversaw every de-
tail of the construction, not only the visible portions but the vast,
unseen hydraulic system that lies beneath and behind one of the
world's most dazzling manmade displays of water.

The central feature of the Trevi Fountain is a huge triumphal arch
three stories high, an image that calls to mind two landmarks of the
ancient city: the Arch of Septimius Severus and the Arch of Constan-
tine. The fountain's center arch frames a gigantic statue
of Oceanus, who personifies water in all its forms. He holds a scepter,
the symbol of his authority over all the earth's waters. The statue,

carved in several segments, is nineteen feet high. Oceanus appears to be skimming the waves on a shell chariot pulled by a pair of winged sea horses, their high spirits only partially held in check by two Tritons, mythic sea creatures with reptilian lower bodies and human torsos. The lord of waters seems to issue forth from his own palatial residence (which, in fact, is the palace of the hapless Conti family). There is nothing two-dimensional about Salvi's design; the fountain moves

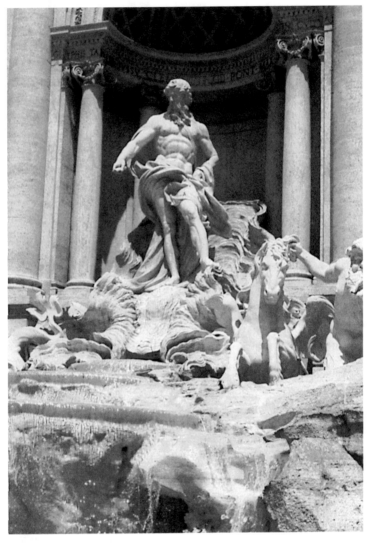

Salvi, Trevi Fountain, statue of Oceanus. The mythic god
of the waters seems to be emerging from his palace to take possession of
the small piazza in front of the fountain.

out aggressively to take possession of the small piazza.

In niches flanking the dramatic and dynamic figure of Oceanus are two calmer female figures that symbolize the beneficial effects of the Acqua Vergine: on the left is Fertility, on the right, Health. Above each figure is a relief sculpture illustrating the history of the Acqua Vergine in antiquity. On the left we see Agrippa supervising the construction of the Aqua Virgo aqueduct, and on the right is the story of the Roman maiden Trivia. Four more allegorical figures, all symbolizing the various beneficial effects of water, are on the top level. At the center and highest point is an enormous sculptured image of the Corsini family coat of arms of Clement XII, held aloft by two figures representing fame. Below it is an oblong inscription beginning with the pope's name and praising him for his achievement in restoring the Acqua Vergine and building the fountain.

On either side of the forward-thrusting central unit are the two projecting wings of Palazzo Poli, transformed by Salvi, who had all the original ornament removed and replaced with his own designs, making the decoration consistent with the fountain. A colossal order of pilasters rises through two stories and echoes the half-columns adorning the fountain. This arrangement bears a resemblance to Michelangelo's designs for the palace facades of the Capitoline Hill—Salvi's tribute to that Renaissance master.

So far the Trevi Fountain sounds like a rather formal and almost pedantic exercise: allegorical figures embedded in an architectural framework that consciously recalls great monuments from Rome's past. The Trevi's unique and vivid character, however, comes from its lavish use of a type of sculptural ornamentation known as *scogli* ("rocks" or "crags") combined with the ingenious, almost riotous play of water throughout the ensemble. At the level of the Palazzo Poli foundations Salvi designed what appear to be rugged natural rock formations, creating the illusion that the smooth masonry and elegant ornament of the palazzo have somehow grown naturally out of the irregular *scogli* below. Architecture seems to rise miraculously out of living rock. In reality Salvi had the enormous blocks of travertine from which his stonemasons carved the *scogli* transported to the site, so many that the backup blocked streets halfway across the city. Work on the *scogli* went on for decades; following Salvi's designs, the workmen carved not just rocks but reeds, marsh marigolds, prickly pears, and snails, a total of more than thirty different species of flora and fauna.

Because the level of the Trevi's conduit was low, Salvi could not have the water pressure necessary to produce rising jets of water. So, to maximize the play of water, he sank the fountain basin as far below street level as possible and designed the broad, horizontal shelves of *scogli* over which the water spills. Salvi created rich and varied water effects. Hidden jets shoot water into the air and even

project it backward. A set of nozzles beneath the feet of the sea horses that pull the chariot of Oceanus shoot the water upward to suggest the splashing of frenzied hooves on the surface of the sea. More than two dozen different openings and nozzles disperse the water into the basin in a wonderfully inventive aquatic choreography. Tiers of seats leading down toward the basin complete the theatrical impression and allow for an unhurried viewing of the Trevi's spectacular water show.

Clement XII, who had expended so much money and energy on the fountain, did not live to see it completed. After his death in 1740 work continued under the next pope, Benedict XIV, who grudgingly authorized the minimum amount of money needed; he just wanted the project finished. But even Benedict was not immune to the idea of immortalizing himself through the Trevi Fountain. He made sure his name appeared in large bronze letters on the frieze that runs just above Salvi's giant pilasters. By 1743 Salvi had advanced far enough in his work that the water was allowed to flow. Nevertheless, the fountain was far from finished.

Salvi died in 1751 and without his guiding hand work on the Trevi halted. It recommenced in 1758, after the death of Benedict XIV and the accession of Clement XIII, who presided over the completion of the fountain, mostly by the same sculptors and masons who had worked for Salvi. It was inaugurated on May 22, 1762, thirty years after Salvi had begun the project. Clement XIII, determined not to be forgotten, managed to squeeze in an inscription referring to his role in completing the fountain on the only space still left: the narrow little frieze that separates the first and second stories. He did succeed in getting his name centered directly over the head of Oceanus.

The custom of throwing a coin into the Trevi to assure one's return to Rome cannot be traced back further than the nineteenth century, but some scholars insist it is much older and relate it to ancient rituals involving magical brooks and springs. Since the general theme of the Trevi is the role of water as the animating principle of all nature and all life, it is perhaps not such a stretch of the imagination to see some ancient magic constantly renewing itself in the waters of Rome's *fontana eterna*. Where else but in Rome can a person lean against a classical column built into the facade of a medieval house that has been transformed into a Renaissance palazzo whose ground floor is a modern shop and look across a piazza at an eighteenth-century evocation of the ancient Roman god of the waters?

Suggested reading

John Pinto, *The Trevi Fountain* (New Haven, 1986).

ROMA AMOR
PART V

MODERN ROME

THE QUARTIERE COPPEDÈ

Critics have called the buildings architectural madness, marvelously overripe, and totally anachronistic. Others have declared them exquisitely Italian and a wondrous confection. The poet Gabriele d'Annunzio considered them a disgrace and an insult to Rome, and an Italian newspaper columnist compared them to an indigestible ice cream cake.

All are referring to a group of apartment blocks and private houses constructed in the 1920s on what was then the northeastern outskirts of Rome, between Via Salaria and Corso Trieste and bounded on the south by Viale Regina Margherita, around an obscure little square called Piazza Mincio. The designer was a Florentine architect named Gino Coppedè (1866–1927). The results of his efforts are so singular that the area is today called the Quartiere Coppedè. In a city full of buildings by some of the Western world's greatest architects, this is the only neighborhood in all of Rome that takes its name from the man who designed it.

Gino Coppedè was an odd character. Outwardly conservative and conventional, the happily married father of three daughters, and a determined pursuer of professorships at Italian universities, he was architecturally an eccentric. Although his style owes something to the late nineteenth-century aesthetic movements called Art Deco, Art Nouveau, and Liberty (all of which emphasized fluid lines and intricately patterned surfaces) his works are also full of nostalgia for the Middle Ages and the Renaissance. They do not fit comfortably into any stylistic pigeonhole. He could perhaps be

considered a late example of Victorian medievalism—a taste shared by the English Pre-Raphaelite painters and the designer William Morris. A French architectural historian sniffed that Coppedè's style might pass for a Roman version of Liberty but was far too extravagant and fantastic. Italian historian Irene de Guttry characterized Coppedè's work as a late example of Liberty that is totally anachronistic and *spaesato,* a word perhaps best translated here as "out of it." De Guttry is unusual in even acknowledging the existence of Coppedè, whose work is so far outside the mainstream of modern Italian architecture that critics and historians concerned with twentieth-century developments rarely even mention him.

Coppedè's style was formed in the late nineteenth century, in the Florentine workshop of his father, Mariano Coppedè. The elder Coppedè was a wood sculptor whose particular interest was the production of finely carved furniture and interior architectural ornament covered with small, precise details. About 1875 Mariano had founded a firm called La Casa Artistica, and in this workshop Gino, the oldest of Mariano's three sons, received his earliest training. Mariano's shop was itself an anachronism in the 1800s: a small, family-based operation consciously modeled on the workshops of Florentine Renaissance artists. Gino's two younger brothers, Carlo and Adolfo, enjoyed successful careers as decorators. Only Gino turned his talents to architecture. After attending the Scuola Professionale di Arti Decorativi Industriali in Florence, Gino returned to his father's studio, where he worked until 1890. But he had other ambitions. In 1891 he managed to get himself appointed to the Accademia di Belle Arti in Florence as a professor of architectural design and spent the subsequent years of his life as an architect.

His first big success was an astonishing creation in Genoa called the Castello Mackenzie. The patron, Evan Mackenzie, was a wealthy oddball Scots insurance executive who worked in the Genoa office of Lloyds of London. When not poring over insurance records, he was an enthusiastic antiquarian and collector of Dante texts. Between 1897 and 1906 Gino Coppedè designed and built for Mackenzie a fantastic fairy-tale dwelling, a combination of medieval English castle and Italian Renaissance palazzo.

Coppedè conceived of his buildings almost as if he were a stage designer rather than an architect, seeing them as a backdrop for costume dramas and theatrical fantasies set in bygone eras and creating a kind of medieval Italy of the imagination. Indicative of this state of mind is a fresco in the Castello Mackenzie, which shows both Coppedè and his patron in elaborate Renaissance dress. In a composition based on actual Renaissance paintings of artists in consultation with their patrons, we see Coppedè showing an architectural plan to Mackenzie, while family members, servants, and the architect's shop assistants look on.

Although the Castello Mackenzie may seem a bit bizarre to us today, its style appealed to some wealthy Italians, and Coppedè made a reputation for himself designing private villas and castles in this quasi-medieval, pseudo-Renaissance manner in and around Genoa. In 1912 he designed the temporary architecture for the Mostra di Marina ed Igiene Marinara in Genoa, producing a field full of fantastic pavilions and towers that looked like a resurrection of ancient Babylon.

But Coppedè always had his eye on Rome, the capital of the still young Italian republic. Fresh from his success with the Mostra di Marina buildings in Genoa, in 1913 he tried to win the chair of General Architecture at the University of Rome. The conservative Faculty of Architecture there, however, wanted no part of this Florentine eccentric, and he failed to obtain the appointment. Disappointed by what he considered academic snobbery, he nonetheless continued his career as an architect, designing buildings as far afield as Lugano, Seville, and Messina.

Finally in 1917 Coppedè received a commission he coveted; he was hired to design an entire neighborhood in Rome. His employer this time was the Società Anonima Cooperativa Edilizia Moderna, a group of businessmen dedicated to the construction of houses for the rapidly expanding middle class of professionals and government functionaries being drawn to Rome by the city's new role as the Italian capital. The Italian government's now infamous bureaucracy was then still relatively small, though growing fast. If the businessmen who formed the cooperative were principally interested in making money, the idealistic and visionary Coppedè hoped to provide both affordable and attractively unique homes—something that would break up the banality of the ordinary urban planning evident in Rome's other developing neighborhoods.

By that standard Coppedè succeeded. There is nothing at all banal about the neighborhood he created. The original project included plans for eighteen large apartment blocks and twenty-seven smaller dwellings, divided among apartments and private houses. Not all of them were built, since Coppedè soon ran into the usual Roman construction difficulties: rising prices for labor and materials, strikes, and shortages of materials. His insistence on high standards of craftsmanship in the numerous decorative details of his buildings slowed the work still further. The buildings he did manage to complete are, in their own weird way, delightful.

Today Piazza Mincio forms the center of a small, ultra-elegant neighborhood; Coppedè's dream of providing affordable housing for the middle class has gone the way of all fine Roman real estate, which is to say straight through the roof in value. Only the wealthy can now afford to live in Coppedè's exquisitely detailed private houses and condominiums. Many apartment units and

Gino Coppedè, entrance to Quartiere Coppedè. This unusual but delightful little
neighborhood in the northeastern sector of Rome is the only area in the
city that bears its designer's name.

even some houses are presently occupied by businesses; the units
are often too expensive for private individuals to maintain. Most
have been preserved in flawless condition, but a few of them, sadly,
appear deserted and are falling into disrepair.

A walk though the Quartiere Coppedè can give the visitor to
Rome a welcome respite from ancient Roman ruins and papal
grandiosity. Coppedè made a point of ignoring the architectural
vocabulary of both the emperors and the papacy, turning instead
to the Middle Ages and Renaissance Florence for his inspiration.
Every building is unique and yet all are clearly the product of a
single architectural imagination.

The visitor enters the Quartiere Coppedè through a low arch-
way flanked by two richly decorated buildings set on a diagonal.
Over the keystone of the arch is a huge, disembodied stone head,
held in place by two seated figures. Above is a carved image of six
gold balls on an oval shield, the coat of arms of the Medici fam-
ily—Renaissance rulers of Florence and legendary patrons of the
arts. Dragon masks punctuate the curve of the arch, and a frieze of
theater masks and garlands of fruit marches across the wall above it.

Fanciful decorations swarm over the exteriors of the various
buildings, some painted, others in the form of relief sculpture. A
colorful Renaissance panorama of Coppedè's native city of Flo-
rence adorns the side of one house; others sport intricately carved
stone dragons and monsters, sinuously beautiful women, or intri-
cate abstract patterns. The brick and stucco walls glow with shades

Gino Coppedè, private house in the Quartiere Coppedè. The fanciful combination of elements from the Middle Ages and Renaissance with Art Nouveau and Liberty styles created a neighborhood of unique, exquisitely detailed houses.

of ochre, dark orange, and deep red. Towers large and small, balconies and loggias, parapets and exterior staircases all add to the prevailing mood of fantasy. It is hard to believe these fanciful buildings are the product of the twentieth century; they are the very opposite of anything we would call modern. One of the buildings, however, bears the date 1926, the year of its completion and the last year of Coppedè's activity on the project.

The date is significant: it is one year before Coppedè's death and four years after Mussolini's Blackshirts first marched into Rome, launching Italy on its tragic path to attempted imperial grandeur and ultimate defeat. The Quartiere Coppedè is the last notable architecture of pre-Mussolini Rome, a gaudy, frivolous but somehow touching memorial to one man's dreams of individualism and beauty in everyday life. A comparison of Coppedè's buildings with the sterile piles so often produced by Mussolini's architects speaks for itself.

MUSSOLINI'S "THIRD ROME"

In five years Rome must appear marvelous to all the people of
the world: vast, ordered, powerful as it was in the days of the first empire
of Augustus. . . . The Third Rome will spread onto other hills along
the shores of the sacred river, until the beaches of the Thyrrhenian Sea.

—Benito Mussolini, address to the City Council of Rome, 1925

Popular legend about Mussolini claims that he made the trains
run on time, but in Rome the Fascist dictator left a much more
enduring legacy. Between 1922 and 1942 his megalomaniac ur-
banism made a profound impression on the Eternal City. Mus-
solini used the phrase *la terza Roma* (the third Rome) to distin-
guish his city from that of the ancient empire and the papacy, and
it is true that only a few Roman emperors and ambitious popes
can make claims to have so changed the face of Rome.

Although the threatened total destruction of medieval Rome
called for by Mussolini's grandiose plans was never completely
carried out, whole neighborhoods vanished, including thousands
of houses and dozens of small streets, along with fifteen ancient
churches. What replaced them was often appalling, but in other
cases Mussolini's urban planning freed ancient monuments that
had been built over or long buried, revealing important aspects of
Rome's heritage.

We owe the reconstruction of the emperor Augustus's Altar of
Peace, as well as the clearing of the Mausoleum of Augustus, to
Mussolini's efforts. The dictator hoped to be buried in the same
tomb as Augustus, the founder of the Roman Empire. The present

degree of accessibility of the Colosseum, Castel Sant' Angelo, the Forum of Julius Caesar, and the zone of mysterious, pre-imperial temples in the center of downtown Rome known as the Area Sacra Argentina is also due to the efforts of Mussolini's urban planners. Other projects included the restoration of the Roman Senate House in the Forum, the clearing of the Theater of Marcellus, along with the restoration of two nearby Roman temples (the so-called Temples of Vesta and Portunnus), and the stripping away of the tangle of dilapidated tenements clinging to the west slope of the Capitoline Hill. The Capitoline pavement, a complex geometric design created by Michelangelo in the mid-1500s, was finally executed at Mussolini's orders in 1938.

Dearest to Il Duce's heart were the projects that involved road building within the city of Rome, and it is here that Mussolini's mark is easiest to see. Like the consuls who commissioned the ancient roads that radiate out from Rome like the spokes of a wheel, Mussolini was determined to immortalize his own achievements by means of appropriately named public thoroughfares. To this day his Via dei Fori Imperiali (Avenue of the Imperial Forums), which he originally named Via dell' Impero (Empire Avenue), remains central Rome's widest and most heavily traveled road. From the city center in Piazza Venezia, where Mussolini had his office, it runs in a straight line to the Colosseum, past the Forums of Trajan and Augustus on the left and the Forum of Julius Caesar on the right. It then cuts directly across the Forums of Nerva and Vespasian.

This four-lane highway, inaugurated in 1932, thus runs through one of the city's richest archaeological zones, the area of the Imperial Forums, cutting apart what should be an uninterrupted expanse of ancient architectural treasures. At one point it nearly grazes the Colosseum and the vibrations and pollution generated by the thoroughfare have added considerably to that monument's disintegration. Archaeologists are now pressing for the closure of Via dei Fori Imperiali and the reopening of the paved-over ancient sites. But the highway has become one of Rome's principal traffic arteries and there is little chance that what the dictator decreed will soon be undone.

This situation illustrates the curious contradiction built into Mussolini's urbanism. He wanted archeologists to uncover further remains of imperial Rome (the government on which he attempted to model his own, modern empire), but he was equally eager to drive great boulevards through the Italian capital, ruthlessly destroying or covering anything that lay in their paths. In the case of his Empire Avenue, what lay in its path was part of the Forum of Trajan, recently excavated at Mussolini's own orders. No sooner had the excavations been completed (rather hastily because Il Duce was perpetually impatient) when most of them had to be

covered up again to build Mussolini's modern highway.

At Mussolini's orders bronze statues of the emperors who had built the forums were set up along the sides of the new road, as if to compensate the ancient rulers for the destruction of their governmental centers. Another of Mussolini's projects was to have huge stone maps created, showing the growth of Roman power over the centuries, and to have them attached to the northern wall of the Basilica of Maxentius and Constantine on the edge of the Forum. This wall still contains four of the original five maps, showing the development of the empire from the earliest settlement, when the city was just a collection of huts by the Tiber River, up through the height of imperial grandeur in the second century A.D. The fifth map, which showed Mussolini's ephemeral conquests in North Africa, was long ago removed.

Another of Mussolini's major road-building projects—Via della Conciliazione, which leads up to St. Peter's—memorialized the dictator's historic 1929 Lateran Concordat with the Vatican. The concordat reconciled the Catholic Church and the Italian State; the two entities had been at odds since the unification of Italy in 1870 ended papal sovereignty over Rome. No other project of Mussolini resulted in such an enormous visual transformation. Not only did Mussolini's bulldozers sweep away a large portion of the medieval and Renaissance sector of the city called the Borgo to make way for the road; the visitor's whole experience of approaching St. Peter's was altered forever.

Between the Tiber River and the piazza of St. Peter's stood four irregular blocks, bounded on either side by narrow streets. This mass of buildings effectively impeded any view of St. Peter's until the visitor arrived at the opening into the colonnade. Various earlier plans to demolish this *spina,* or backbone, of buildings, had never been carried out, but the reconciliation of the Church and the Italian government encouraged new efforts. In 1934 the architects Piacentini and Spaccarelli collaborated on a plan. The final project was approved by Mussolini and Pius XI in the summer of 1936, and on January 1, 1937, Mussolini himself lifted a pick to symbolically signal the start of the demolition. The project was not completed until 1950.

What replaced the jumble of old buildings and palaces that made up the *spina* is a wide, rather sterile-looking boulevard that offers an unimpeded view all the way from the Tiber to the front of St. Peter's. Not everyone liked the result. Some Romans commented that the architect, Spaccarelli, was all too aptly named, since the Italian verb *spaccare* means "to split." Others mourned the loss of the element of surprise engendered when the visitor suddenly emerged from the warren of gloomy little streets into the sunlit immensity of the vast piazza in front of St. Peter's. But the

most quintessentially Roman reaction was reserved for the monotonous rows of white obelisks that line the sides of the new road and serve as lamp posts. Observing that they resemble monumental versions of suppositories cast in cement, some anonymous city wit dubbed them *"le supposte del An(n)o Santo."* This *could* be translated innocently enough, but it is best to leave the reader to ponder the double meaning.

Another of Mussolini's grandiose projects designed to link his own empire with that of imperial Rome is a complex of monumental buildings in the northern part of the city—now called the Foro Italico, or Italian Forum, but originally named the Foro Mussolini. Plans were under way as early as 1927 to construct a center for the athletic training of Italian youth and to support the regime's Opera Nazionale Balilla, a Fascist alternative to the insufficiently militaristic Boy Scouts. Furthermore, like Hitler Mussolini also hoped to host the international Olympic Games and therefore needed suitably impressive athletic facilities. In the next few years the project grew to include two stadiums, swimming pools, an area where students could practice fencing, educational facilities, a fountain, and an obelisk in honor of Mussolini. By 1934 the educational facility, the obelisk, and both stadiums were complete. The fountain appeared in 1935, and between 1938 and 1939 a bridge, the Ponte Duca d'Aosta, was constructed across the Tiber on an axis with the fountain, obelisk, and ceremonial entrance to the complex.

In 1935 Mussolini decided to move the headquarters of the Fascist Party from the corner of his new Via dell' Impero in the city center to the Foro Mussolini. One of the three architects employed on the project, Vittorio Morpurgo, was Jewish; this was three years before Mussolini decided to imitate Hitler by instituting the notorious racial laws that would ban Jewish participation in such efforts. In any case the building was never completed as planned; finished in the 1950s it now serves as the Ministry of Foreign Affairs.

The most interesting aspects of the Foro Italico are its decorations—the sculpture, mosaics, and obelisk designed in imitation of ancient Roman art. Nowhere else are Mussolini's imperial pretensions made so obvious. The major edifice of the complex is a sports arena capable of seating twenty thousand spectators and designed in partial imitation of the Colosseum. The upper perimeter is ringed with sixty large stone statues of athletes, contributed by the various cities of Fascist Italy. Archaeologists believe that the original Colosseum once displayed a similar collection of statuary in the arches, although not along the top. Mussolini's collection of statues is notable for the mediocre quality of workmanship and the almost grotesque grandiosity of the poses.

Statue of an athlete, Foro Italico (formerly Foro Mussolini). The Fascist dictator's attempt to re-create the glories of imperial Rome led not only to military disaster and defeat for Italy but also to the creation of some ludicrous works of art.

Near the sports stadium is a walkway decorated with ancient Roman-style black-and-white mosaics. Here figures of youthful Fascists, dressed in clothing that curiously combines modern military uniforms with classical togas, salute Mussolini. Next to them the word *Duce* appears repeatedly, like the dialogue balloon of a comic strip. Another portion of the mosaic replaces Roman war chariots with a truck, from which Fascist Blackshirts battle the evil forces of communism. Above them a hero on horseback fights a monster, making the heavy-handed parallel even more obvious. Other mosaics celebrate Mussolini's imperial conquests. One

records a line from a famous speech the dictator made after the conquest of Ethiopia: "Italy finally has her empire." Above this text black airplanes thunder through the white mosaic sky, and nearby a lion stands with its paw on a globe that shows Italy, Ethiopia, and Libya standing out in sharp contrast to the rest of the world.

The fifty-six-foot, gold-tipped obelisk at the entrance to the Foro Italico is a marble monolith inscribed along its length with the words MUSSOLINI DUX. *Dux,* from which we get the English word *duke,* is Latin for "leader" and is the root of the Italian title *Duce* by which Mussolini wished to be addressed. Just as the pseudo-Colosseum, the statuary, and the mosaics of the Foro Italico were meant to recall the glories of imperial Rome, the obelisk was to imitate the ancient obelisks around the city. Erected with great effort in 1934, it is the only monument explicitly dedicated to Mussolini which still survives in Rome. Perhaps we should be grateful that Il Duce contented himself with this relatively modest memorial. He had inititally planned to have the Foro Mussolini dominated by a 250-foot-high half-naked statue of himself in the guise of Hercules.

Suggested reading

Peter Bondanella, *The Eternal City: Roman Images in the Modern World* (Chapel Hill, 1987).
Spiro Kostof, *The Third Rome* (Berkeley, 1973).

THE SHRINES OF
ROME'S MODERN MARTYRS

Not all of Rome's martyrs died two thousand years ago. Although most of the Eternal City's churches memorialize those who died for their faith in the early centuries of Christianity, Rome has provided other opportunities to die a martyr's death. The turbulent period of the German occupation, from July 1943 to June 1944, produced a tragically large number of martyrs, and today two national monuments in Rome commemorate these deaths: the Museum of the Liberation of Rome and the Mausoleum of the Ardeatine Caves.

Although the former has no connection with art and the latter has only a few points of artistic interest, both are worth visiting for the unique glimpses they offer into one of the darkest moments of Rome's (and Italy's) modern history. The two sites are very different, yet each is a powerful and moving memorial. The Mausoleum of the Ardeatine Caves commemorates random victims caught in the web of wartime terror, while the Museum of the Liberation of Rome celebrates those who believed so deeply in the ideal of an Italy free from German and Fascist domination that they were willing to die for their beliefs.

The Museum of the Liberation of Rome, housed in the former Nazi prison at Via Tasso 145, is a somber place. Located on an ordinary street, part of a nondescript middle-class neighborhood, it stands not far from St. John Lateran. Viewed from the outside, the building is as undistinguished as its surroundings. The

Nazis took over an apartment building, bricked up the windows, and used the individual rooms of the apartments as cells for detention, interrogation, and torture. Only the memorial wreath that decorates the wall near the entrance marks off the museum from neighboring buildings.

As soon as the visitor steps into this unusual museum there is a strong sense of the oppressiveness of the place. The cramped, gloomy rooms even have a vaguely unpleasant smell. But no visitor, having come this far, will be put off. Obviously the purpose here is to preserve as much as possible the appearance and atmosphere of the rooms as they were during the German occupation. But of course the Via Tasso prison has been sanitized somewhat. Several walls are covered with photographs of the prisoners, with commemorative texts praising their heroism, their refusal to divulge information about the Resistance even under torture. Other displays recount the months of the German occupation, the increasing strength of the Resistance, and finally, the liberation of Rome on June 5, 1944. Although a reading knowledge of Italian is useful here, the photographs and objects displayed, the latter including pieces of blood-stained clothing, speak for themselves.

One tiny room, probably once a closet, still preserves graffiti inscribed by prisoners. The sheer immediacy of these words is overwhelming. They seem to have been scratched into the walls only yesterday. Some prisoners merely wrote their names. One emblazoned a huge *"Viva l'Italia"* across the wall. Others inscribed poems or notes to their families. A philosophical prisoner wrote, "Meditate, o man, on your nothingness in the face of the vastness of the universe"; another observed, "Death is ugly to him who fears it." Scholarly prisoners wrote in Greek or Latin, and one man started to write out the Italian national anthem but trailed off before finishing the first line. Still another, with gallows humor, quipped anonymously, "Here I was a guest from January 17, 1943 to ____." A different hand completed the line by scrawling in the blank: "March 24, 1944, shot."

Here were men whose devotion to an ideal surpassed any commitment or loyalty to other institutions or even to their own families. In these scratches and scrawls sons bid farewell to their parents, husbands to their wives, fathers to their children. Although these men must have been horrified by what they had already experienced and by the fate they knew awaited them, none chose to commit such sentiments to the wall surface.

And what about the people in the neighboring buildings? Any visitor must wonder about the proximity of this place to their homes. What might still have been audible, even through bricked-up windows? A news report on display reports that, after the Liberation, one woman admitted to having heard "hardly human

screams" coming from the building, sounds immediately drowned out by a radio at full volume blaring dance tunes. Did the neighbors convince themselves that nothing unacceptable was going on behind the blank walls at Via Tasso 145? Or did they fear for their own safety and that of their families if they protested or asked unwelcome questions of their German overlords? And how would we have behaved in their place? This quiet museum is an excellent location to think about such questions, as well as about the ardent idealism that enabled so many prisoners here to face death with the martyr's unflinching courage.

The Mausoleum of the Ardeatine Caves, located on an extension of Via Appia called Via Ardeatina, offers an entirely different experience from the unrelieved grimness of the museum at the Via Tasso prison. Here, on the southern outskirts of the city, not far from the ancient, sacred precincts of Christian and Jewish catacombs, is a spacious site that at first glance seems to be a private estate, or perhaps a park. The entryway consists of two large brick pylons connected by a cast bronze gate, the latter the work of the sculptor Mirko Basaldella. The apparently abstract patterns of the gate prove, on closer inspection, to be not so abstract after all; they bear a disturbing resemblance to barbed wire. This is our first hint of what lies behind the entrance.

Unlike the Museum of the Liberation of Rome, where the organizers made every effort to convey the horror of what took place there, the Ardeatine Caves have been turned into a place of serene beauty. Inside the caves, where the worst massacre in modern Italian history took place, there are now cement floors and electric lights. The walls, reinforced with brickwork, contain plaques with memorial inscriptions, bronze wreaths, and eternal flames. The two huge holes in the ceiling, caused when the Germans blew up the site in an effort to conceal their crime, are now reinforced with concrete and stonework, and rimmed with cascades of vegetation, ferns in particular, which have taken root in the areas of exposed soil.

What happened here? In such a placid place it is now difficult to imagine the carnage from which this shrine was born. On March 23, 1944, at two o'clock in the afternoon, a group of Resistance members disguised as garbage collectors detonated a bomb in the midst of a column of German soldiers marching down Via Rasella, a small street in central Rome, near Piazza Barberini. The resulting explosion killed 32 of the soldiers. In retaliation the German command ordered 10 Italians shot for each German and 3 more for good measure—a total of 335. To meet this quota the Germans emptied their Roman prisons, but even all those already in custody were not enough, so they began rounding up men at random.

Entrance to the Mausoleum of the Ardeatine Caves. The site of the worst massacre in modern Italian history, the Ardeatine Caves have been turned into a national shrine of somber but serene beauty.

The German retaliation took place with extraordinary speed. Within hours of the Resistance attack the Nazis had met their quota. They loaded their prisoners into vans and transported them to the Ardeatine Caves, at that time a secluded site well outside the city limits. With their hands bound behind them the prisoners were

taken off the trucks in groups of two or three and led into the caves, where German officers ordered them to kneel with their heads bowed. As they knelt, German soldiers killed them by shooting them in the backs of their heads. The soldiers then tossed the rapidly accumulating bodies deeper into the caves. The slaughter continued all night and into the next day. When their bloody work was finished (and some soldiers had to get staggering drunk in order to finish the work), the Germans covered the bodies with lime and then set off four or five powerful depth charges, bringing the caves down on top of the tangled mass of corpses. Their revenge accomplished, the Germans went on to other matters, not the least of which were the rapidly advancing forces of the Allied armies.

Shortly after the liberation of Rome in June 1944 the Italian authorities turned their attention to the Ardeatine Caves. By then rumors of the massacre were widespread, fueled by the reports of those who had heard the shots and seen the explosions, by the anguished concern of the families of the missing men, and above all by the terrible stench rising from the site. At the beginning of July, more than three months after the massacre, the caves were finally opened and the grisly task of removing and identifying the dead began.

The hero of this enterprise was Attilio Ascarelli, a Roman physician and forensic expert. He directed a team of volunteers that included personnel from the city's cemeteries, who did the actual work of exhumation, as well as officials from the Ministry of Health and other government agencies, and a group of six other physicians. Wearing gas masks to protect themselves from the overpowering stench, the team of physicians labored to identify the corpses, all of which were in an advanced state of decay. That they were able to identify all but three remains an unparalleled feat of forensic detective work. A priest and a rabbi remained present throughout the long and terrible identification process (more than seventy of the victims were Jewish) and as doctors ascertained the religion of each of the dead, one of the clergymen offered a blessing over the body.

The move to turn the Ardeatine Caves into a memorial began almost as soon as the site had been cleared and the bodies identified. By 1948 a definite plan had been drawn up by the architects Aprile, Culcapino, Cardelli, Fiorentino, and Perugini and work began shortly thereafter.

The place of interment for the martyrs of the Ardeatine Caves is simple but striking. A huge flat slab of cement, rectangular in shape and more than one hundred feet long, seems to hover over the graves like the lid of a single immense coffin. The tomb chamber is sunk below ground level and the retaining walls end about a yard before the roof begins; thick cement pylons rather than walls hold up the roof. This leaves the chamber partially open to the

outside so that it may receive most of its light this way. The interior is dim but not dark.

There is enough light for the visitor to read the inscriptions on each of the plain, roughly carved gray granite coffin lids. All but three are the same: a Cross or a Star of David, a bronze laurel wreath enclosing a photograph of the man, and an inscription giving his name, age at death, and profession. At the base of each coffin is a lighted lamp. Scattered among those identified are the coffins of the three unidentified victims. On these coffin lids there is just a single word—*Ignoto* (unknown).

The dead ranged in age from fourteen to seventy-four. They included shopkeepers, students, university professors, lawyers, engineers, day laborers, and office workers. Also among them were a music teacher, three doctors, and a priest. Family members still tend most of the graves. There are bouquets of fresh flowers at the foot of some of the coffins, while others have flowers scattered over the lids.

After wandering for a while among the dead, the visitor emerges into the rustic setting of the monument. On a raised base near the entrance stands a large stone sculpture by Francesco Coccia, showing a group of three prisoners bound together back to back. The faces of the prisoners, at once suffering and serene, suggest the state of mind not just of the Ardeatine victims but perhaps even more closely of the martyrs commemorated at the Via Tasso site.

It is possible to make a distinction between the two. The political prisoners at the Via Tasso prison died for their ideals, while many of those at the Ardeatine Caves died by chance, simply because they were in the wrong place at the wrong time. But the present-day Romans make no such distinction. They consider all the victims to be *martiri,* as surely as any Christians killed in the persecutions of the third century. Both the Via Tasso prisoners and the Ardeatine Caves victims died for the crime of being Italian, in a city occupied by an enemy.

The story of the massacre at the Ardeatine Caves is not over yet. At the time of this writing, the Italian government has brought to trial Erich Priebke, the German commander who gave the order that led to the deaths of 335 innocent Italians more than half a century ago. Rome, the Eternal City that over the course of more than two millennia has watched so many conquerers come and go, has a long memory.

Suggested reading

Robert Katz, *Death in Rome* (New York, 1967).
Sam Waagenaar, *The Pope's Jews* (La Salle, Ill., 1974).

NOTES

Page 17 "On my return from Spain . . .": P. A. Brunt and J. M. Moore, eds. and trans., *Res Gestae Divi Augustae: The Achievements of the Divine Augustus* (Oxford, 1967), p. 25.

Page 19 "enthusiastic practicers of birth control": discussed in Sarah Pomeroy, *Goddesses, Whores, Wives, and Slaves: Women in Classical Antiquity* (New York, 1975), pp. 166–67.

Page 44 "The Pantheon was made for light . . .": William L. MacDonald, *The Architecture of the Roman Empire* (New Haven, 1982), vol. 1, p. 118.

Page 44 "the temple of the whole world": William L. MacDonald, *The Pantheon: Design, Meaning, and Progeny* (Cambridge, Mass., 1976), p. 24.

Page 92 "an audience hall for Christ . . .": Richard Krautheimer, *Rome: Portrait of a City, 312–1308* (Princeton, 1980), p. 22.

Page 103 "Of the twenty-eight prominent people . . .": Karen Torjesen, *When Women Were Priests* (New York, 1992), p. 33.

Page 109 "I saw the conduct of life . . .": Robert Penn Warren, *Brother to Dragons: A Tale in Verse and Voices* (New York, 1953), p. 36.

Page 130 "Anything that he has been thinking about . . .": Ludwig von Pastor, *History of the Popes from the Close of the Middle Ages* (St. Louis, 1950), vol. 6, pp. 213–14. Von Pastor does not identify the ambassador quoted.

Page 133 "has carved the name . . .": von Pastor, *History of the Popes,* vol. 6, p. 539, quoting Moritz Brosch.

Page 183 "artifices ranging from fig leaves to girdles . . .": William D. Montalbano, *Chicago Sun-Times,* November 27, 1993, p. 16.

Page 220 "Bernini . . . gave a public opera . . .": quoted in Howard Hibbard, *Bernini* (Baltimore, 1966), p. 19.

Page 225 "Beside me . . . appeared an angel . . .": quoted in Howard Hibbard, *Bernini,* p. 137

Page 241 ". . . great and fantastic buildings": Anthony Blunt, *Borromini* (London, 1979), p. 208.

Page 257 "In five years Rome must appear marvelous . . .": quoted in Spiro Kostof, *The Third Rome* (Berkeley, 1973), p. 22.

BIBLIOGRAPHY

The bibliography of works both scholarly and popular about Roman history, art, architecture, and urbanism is so immense that no one person could claim to have read everything. The following are a few of the works that have been especially helpful to me and that may prove of interest to readers wishing to learn more about Rome. I cite only works in English.

Christopher Hibbert's *Rome: The Biography of a City* is a vivid introduction to the entire span of Rome's history and art. No one has written more informatively and eloquently about ancient Roman architecture than William L. MacDonald; the chapter on the Pantheon in volume 1 of his *Architecture of the Roman Empire* and his little book entitled *The Pantheon: Design, Meaning, and Progeny* are wonderful sources of information on this greatest of ancient Roman buildings. Richard Krautheimer's *Rome: Profile of a City, 313–1308,* is a treasure trove of information on the city from the early Christian period through the Middle Ages. Frederick Hartt's *History of Italian Renaissance Art* offers a fine survey of the Renaissance period in Rome. Although more recent and detailed biographies of Michelangelo, Caravaggio, and Bernini are available, Howard Hibbard's brief accounts remain excellent introductions to the careers of these major artists. Torgil Magnuson's two-volume *Rome in the Age of Bernini* provides a detailed background against which to view the achievements of the major sculptor-architect of the Baroque period. Spiro Kostof's *The Third Rome* is valuable for its discussion of the city in the modern era, and Peter Bondanella's *The Eternal City: Roman Images in the Modern World* considers the enduring impact of "the myth of Rome" in the modern world. John Varriano's *Rome: A Literary Companion* offers an entertaining compendium of responses to the Eternal City by a variety of writers; I have often dipped into it for appropriate quotations. William L. Vance's two-volume *America's Rome* is a comprehensive and fascinating presentation of the impact Rome has had on American writers and artists. Most of the essays in the present volume are followed by suggestions for further reading, which extends this abbreviated bibliography somewhat further.

For decades I have also pored over guidebooks, some of which have proven valuable. The Blue Guide volume *Rome and Environs*

is always informative, as is the Touring Club Italiano guide, *Roma e dintorni,* and the formidable German *Reclams Kunstführer Rom und Latium.* Classics of this genre, H. V. Morton's *Traveller in Rome,* Georgina Masson's *Companion Guide to Rome,* and Eleanor Clark's *Rome and a Villa* all have given hours of pleasure; they are as much works of literature as travel guides.

ILLUSTRATIONS

ACKNOWLEDGMENTS

When I recall times spent happily in Rome over the past three decades, many names come to mind of friends, family members, teachers, colleagues, mentors, and students. Because all of these people have in one way or another helped to form this book, I take this opportunity to thank them.

Most closely associated with memories of my first, magical Roman summer of 1968 is Erhard Schlieter, who showed me more of Rome than I have ever again been able to crowd into a comparable period. In 1992 I participated in a National Endowment for the Humanities Summer Seminar held in Rome and directed by John Pinto. Although the seminar focused on architecture and urbanism in Rome during the Renaissance and Baroque periods, it was John who provided the stimulus to start me thinking about the great sweep of art and history in Rome from ancient times to the present. To adapt a phrase from E. M. Forster, John taught me to see Rome steady and see it whole. Although I spent just one Roman morning with William L. MacDonald, the guided tour he gave me of the Pantheon remains among my most memorable hours in the Eternal City. If only I had thought to bring along a tape recorder!

Friends and acquaintances in Rome, and sometimes total strangers, have also increased my understanding and enjoyment of the city. Tullia Zevi, president of the Union of Italian Jewish Communities, took time to answer my questions about the long and eventful history of Rome's Jewish community, as did Sam Waagenaar. Michael Karris and Cinzia Torri, with Mike navigating and Cinzia imperturbably driving, are wonderful companions for exploring the city's treasures, especially the out-of-the-way ones. Pino and Maria Laura Previti Flesca have patiently endured my less-than-perfect Italian and have always offered me the most memorable hospitality. And innumerable anonymous Romans from whom I have requested directions, advice, and information over the years have been unfailingly courteous and helpful.

As a scholar of Northern European Renaissance art, I have often had occasion to thank James Marrow for his help. This time, however, I thank him for suggesting the idea of this book to me. When he and his wife went to Rome several years ago, I sent them, with some trepidation, some articles I had written about the city, half-expecting to be told to stop wasting my time on such

nonsense. Instead, his enthusiastic response inspired me to start thinking about creating this book.

The chapters of the present volume have appeared as articles in *Fra Noi,* the newspaper of the greater Chicago–area Italian American community. All have been rewritten to some degree for book publication, and I acknowledge the support and enthusiasm of the editor of *Fra Noi,* Paul Basile, throughout this process. The quote from *Brother to Dragons* appearing in chapter 15 is copyright ©1953, renewed 1981 by Robert Penn Warren and is reprinted by permission of William Morris Agency Inc. on behalf of the author's estate.

Northern Illinois University, where I have taught since 1969, has also supported my efforts to learn enough about Rome to feel comfortable writing about it. In summer 1994 I received matching grants from the School of Art and the Office of the President, which enabled me to spend five weeks in Rome, an experience that greatly deepened my knowledge of the city. My thanks to Richard M. Carp, chair of the School of Art, and John E. La Tourette, president of Northern Illinois University, for making these grants available with a maximum of ease and a minimum of administrative phumphering.

Among the friends who have provided editorial help (or nuggets of interesting information) are Diane Arne, Robert Bireley, S.J., Linda Dockendorff, Steve Franklin, Solomon Mowshowitz, Chris Nissen, Mary Quinlan, Marilyn Sjoholm, and Heather Warner.

Thanks are due also to Mary Lincoln and the staff of the Northern Illinois University Press, Julia Fauci and Susan Bean in particular, for their intelligent suggestions and assistance throughout, and to Terry Sheahan, who created the map at the front of this volume. The corrections and constructive criticisms of the three outside readers—William L. MacDonald, William Vance, and John Pinto—have done much to improve my text. Any remaining errors are my own.

Two people to whom I owe a debt of gratitude are no longer here to receive this tribute: my paternal grandmother, Anna Santucci Testa, and my father, Emanuel E. Testa. They first made me aware and proud of my Roman heritage. I dedicate this book to their memory.

INDEX

About the Author

Judith Testa received her Ph.D. in Art History from the University of Chicago. Currently a Presidential Teaching Professor at Northern Illinois University, she frequently visits and teaches courses in Rome. She has written widely on northern European and Italian art. Although her travels have taken her throughout Europe, Rome has always been her first and greatest love.